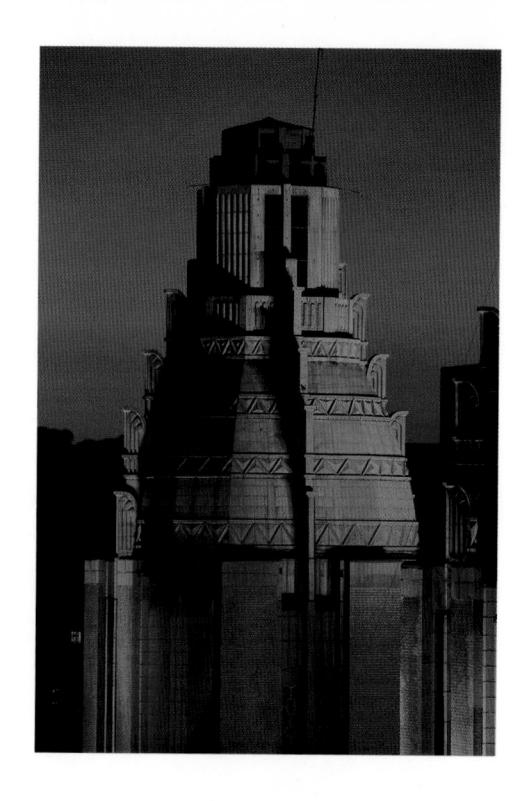

RIZZOLI

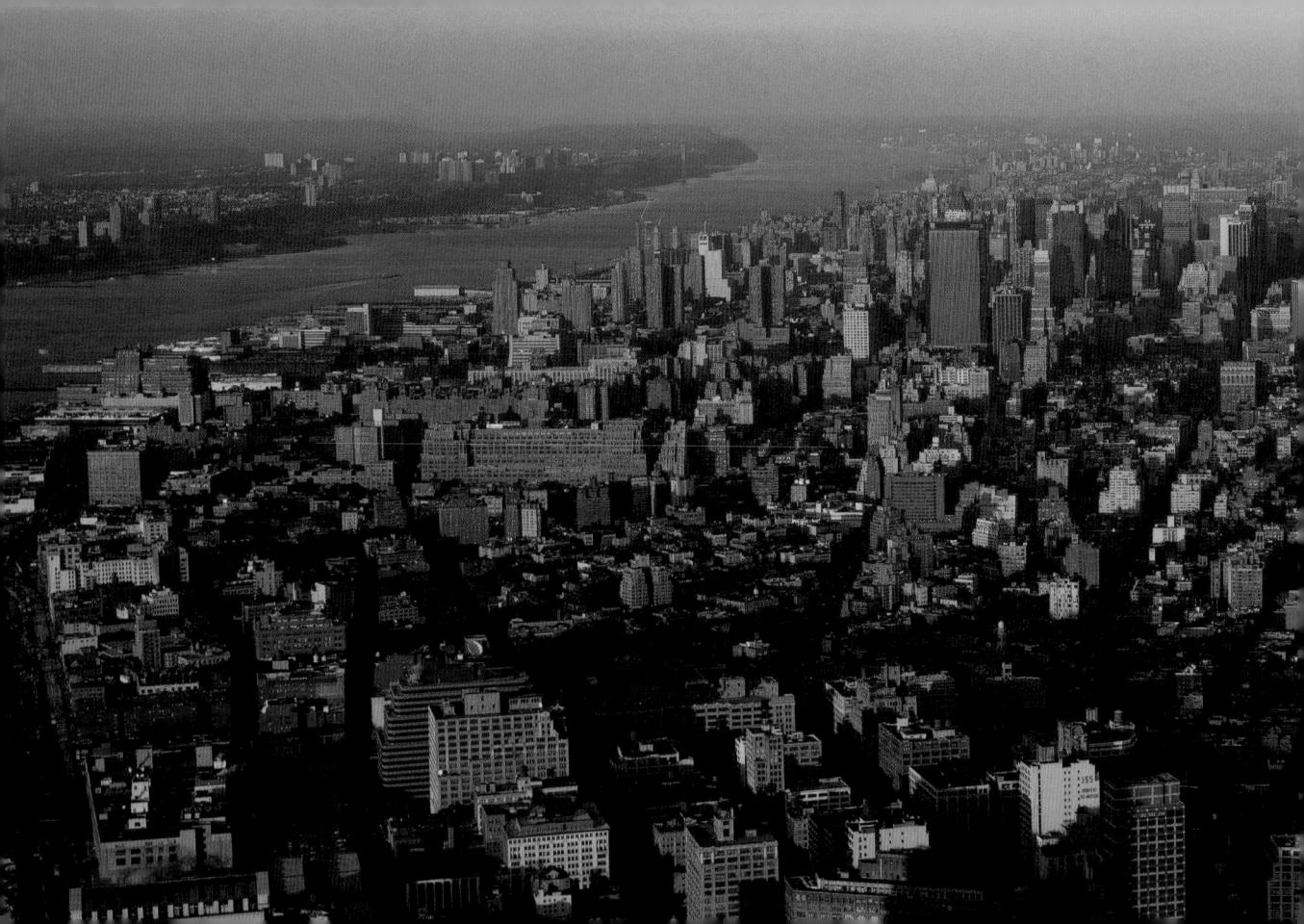

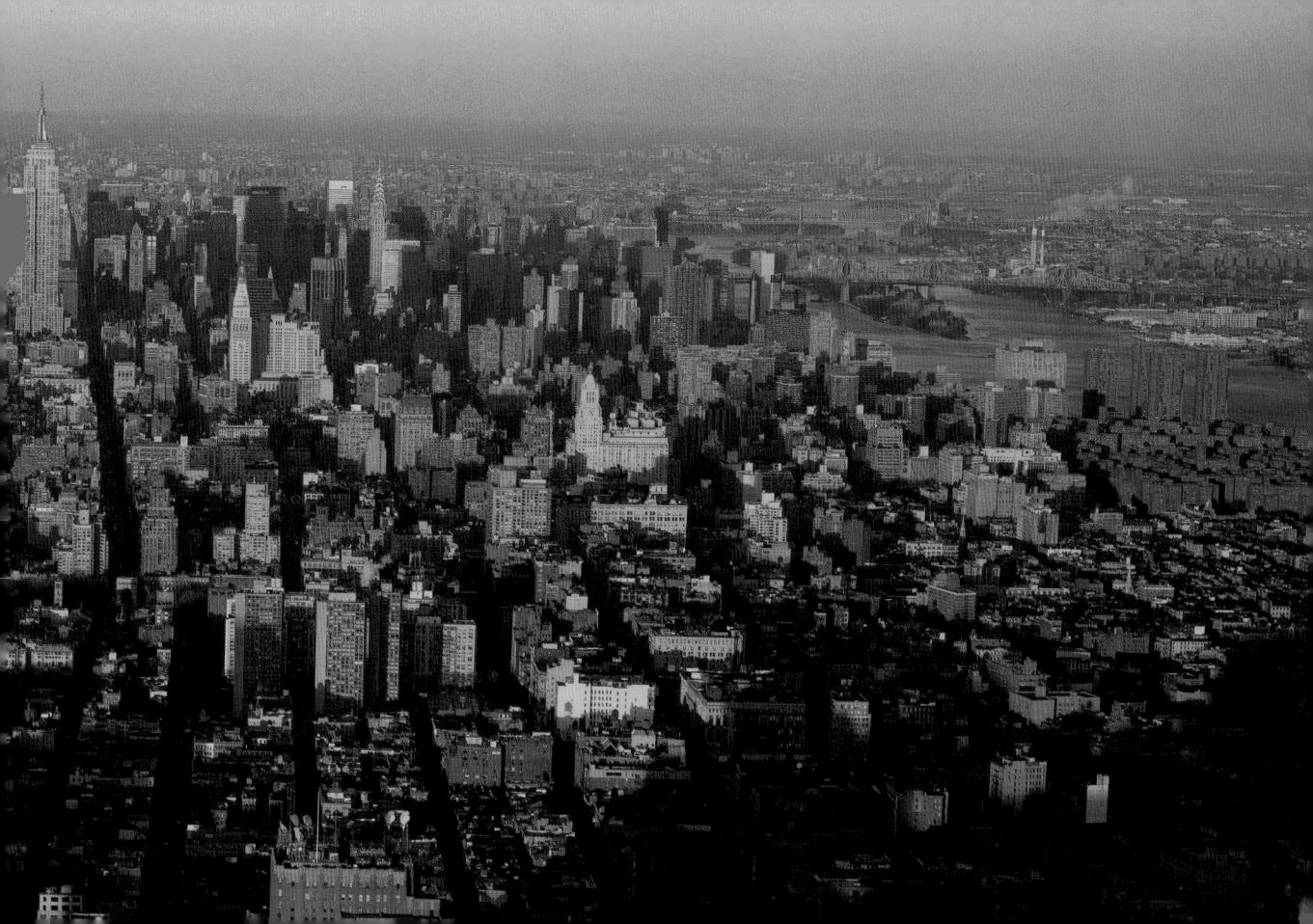

RICHARD BERENHOLTZ

FOREWORD BY KENNETH T. JACKSON

A WELCOME BOOK

RIZZOLI INTERNATIONAL PUBLICATIONS, INC.

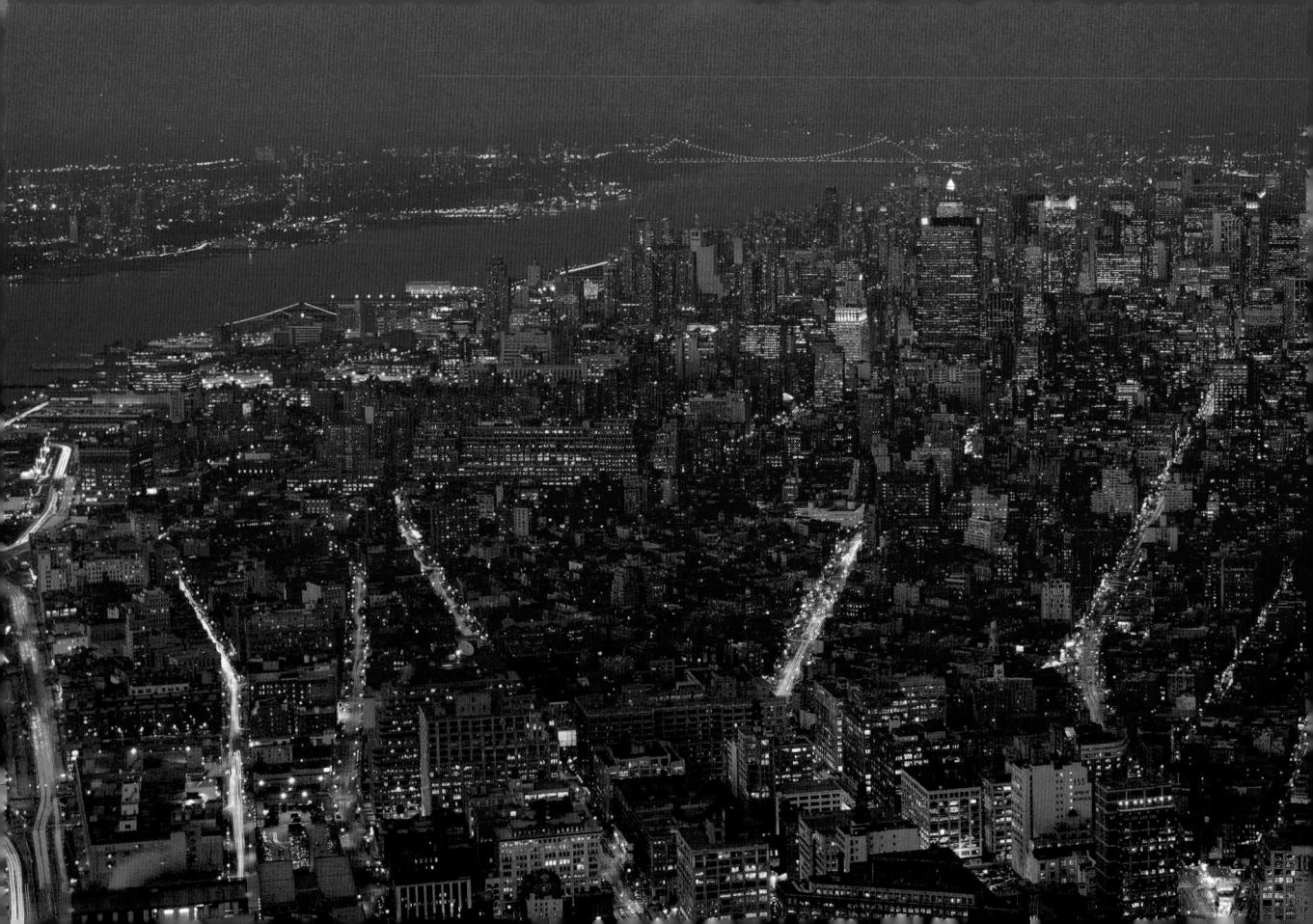

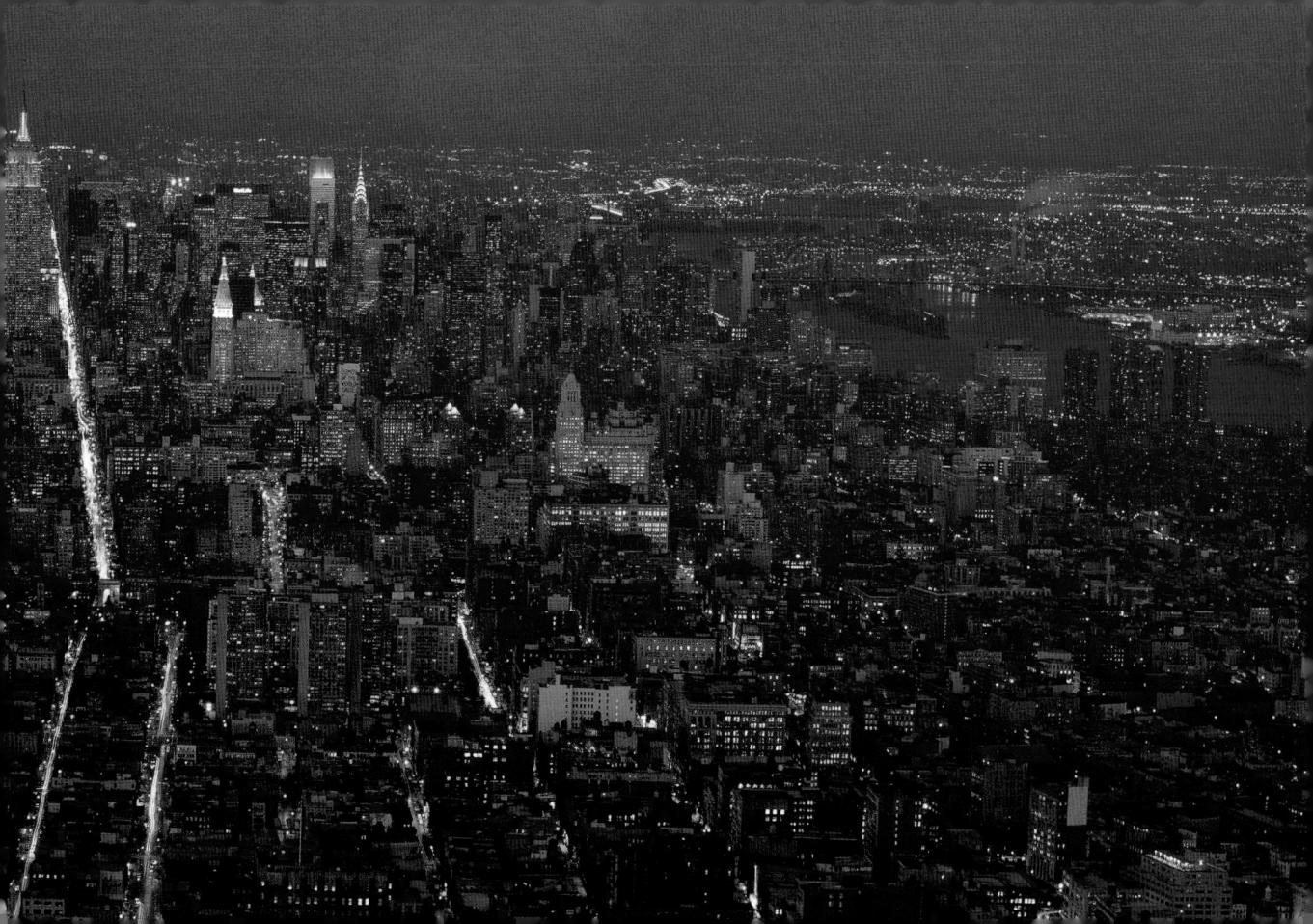

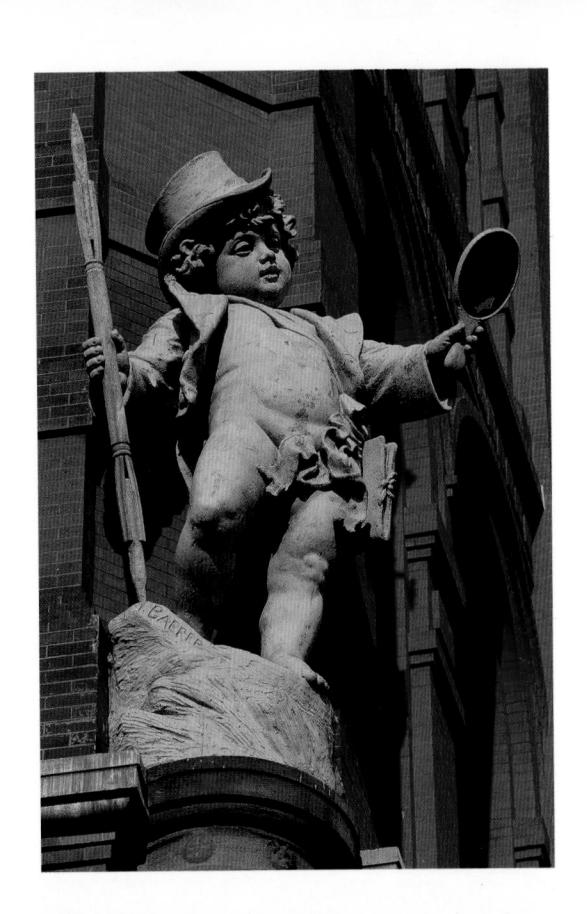

For my son Jack a fifth-generation New Yorker

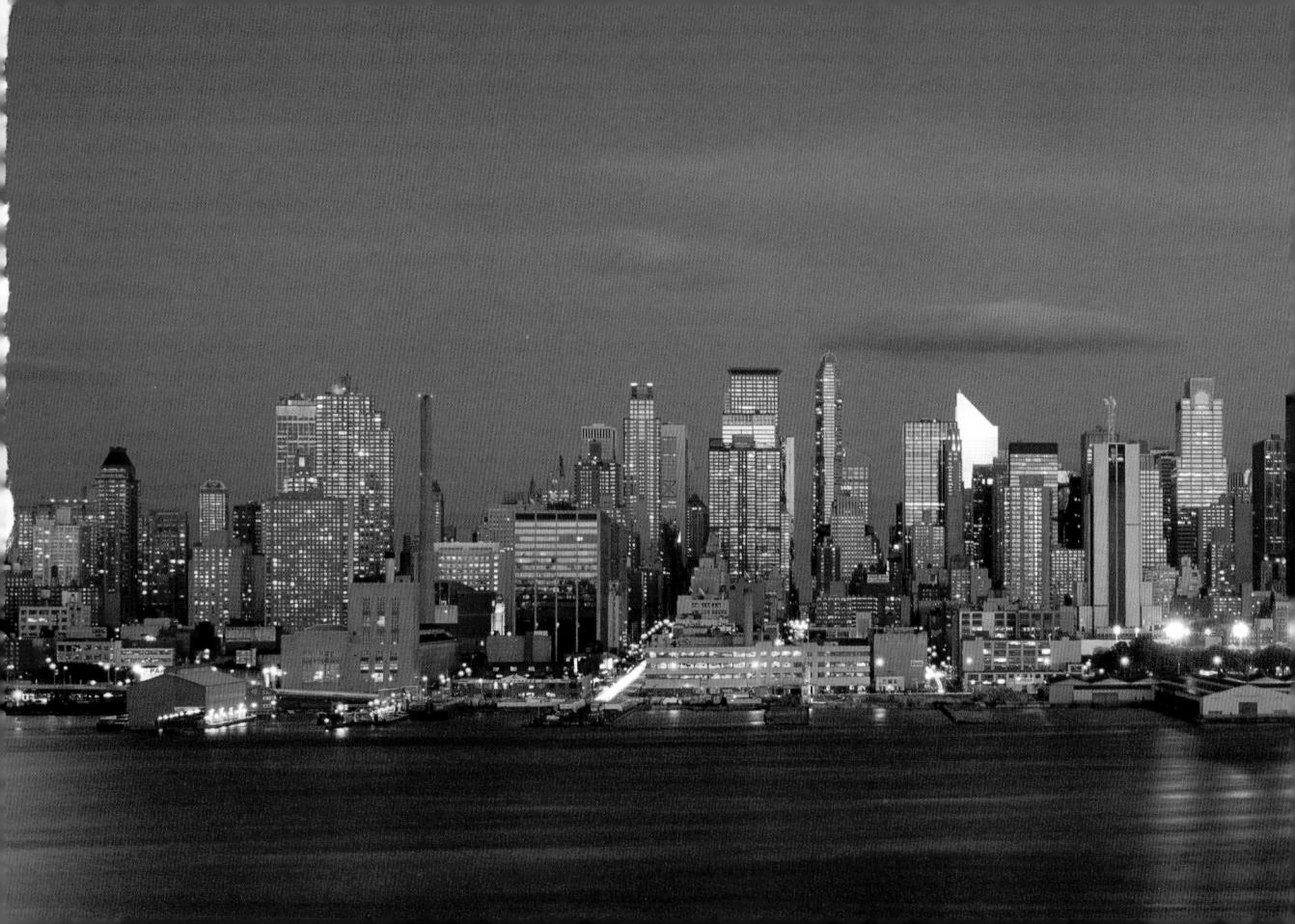

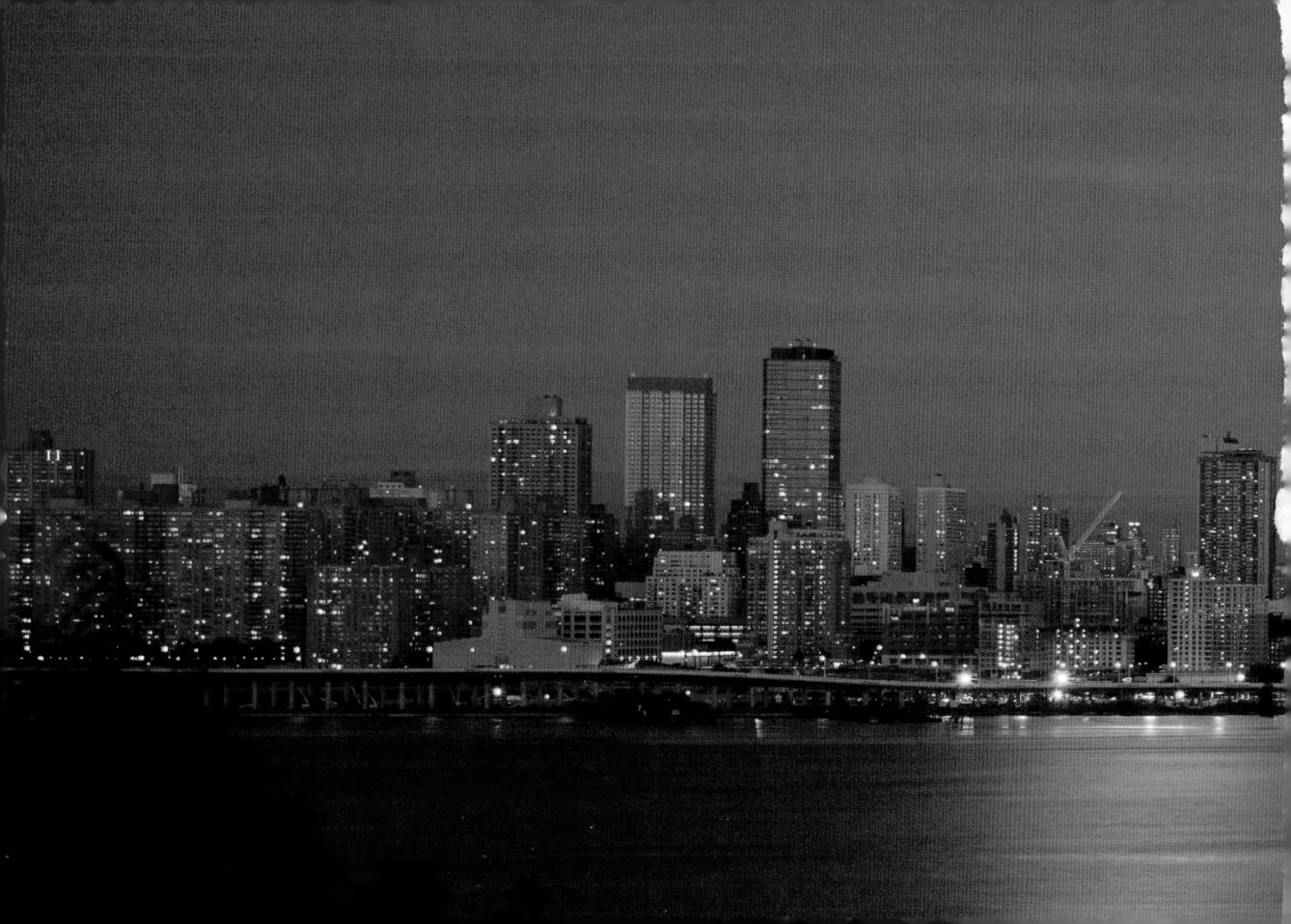

FOREWORD

GREAT CITIES HAVE DOMINATED the globe for several thousand years, and at least since Plato, Socrates, and Aristotle made Athens a vibrant intellectual and philosophical center of the ancient world. Since then, a number of other magical places—especially Rome, Beijing, Tokyo (Edo), Constantinople, Venice, Paris, and London—have in turn become the economic, political, and cultural center of civilization itself.

New York inherited the mantle of world leadership from London in the twentieth century perhaps in 1917, when debt-plagued Great Britain had to turn to Wall Street to finance World War I. Certainly by 1950, New York became the locus of leadership for the world when the establishment of the United Nations on the east side of Manhattan gave physical representation to a new kind of world order, in which the United States of America played a dominant part. Gotham, of course, is not and has never been much like its European and Asian predecessors. Unlike them, it was never the national capital (1785–1790 a temporary exception) and never the official seat of empire. Unlike them, it never pointed to dozens of century-old buildings as emblematic of its glory. And unlike them, it never drew much attention to its storied past.

Similarly, New York has long had a distinctiveness and a greatness that are all its own. Everyone has a particular way of defining the Hudson River metropolis. Some notice instantly and instinctively its unusual heterogeneity, which has been characteristic of the community since the Dutch first set up shop on Manhattan in 1624. Indeed, visitors to the seventeenth century settlement marveled that eighteen separate languages were spoken on its streets at a time when its total population was below one thousand. Other point to Gotham's peculiar vertical shape, which can be noticed at once by glancing at the hundreds of skyscrapers which make the skyline recognizable everywhere. Still others look to its massive size, which is measurable not only in the eight million people who lived within its boundaries in 2000, but by thirteen million others who lived in the adjacent metropolitan region.

Simply put, the colossus that we call New York had become by September 11, 2001, the capital of capitalism and the capital of the world. What will be the impact of the tragedy of that terrible day, when almost three thousand people died in the attack on the World Trade Center? Will fear and flight knock the city from its perch? Perhaps. But it was encouraging how in the weeks and months following the collapse of the Twin Towers New Yorkers found a strength, a resilience, and a sense

of community that few previously thought that they had.

Richard Berenholtz's New York New York captures the sweep, the diversity, the majesty, the energy, the beauty, the glitter, and even the madness of Gotham. From gargoyles to glass towers, from tranquil parks to chaotic Times Square, from details to panoramas, the pages that follow are as oversized and glamorous as the city itself. This book can be examined with pleasure by anyone interested in the human and physical story of what remains the most exciting city in the world.

RENNETH T. JACKSON
President, The New-York Historical Society

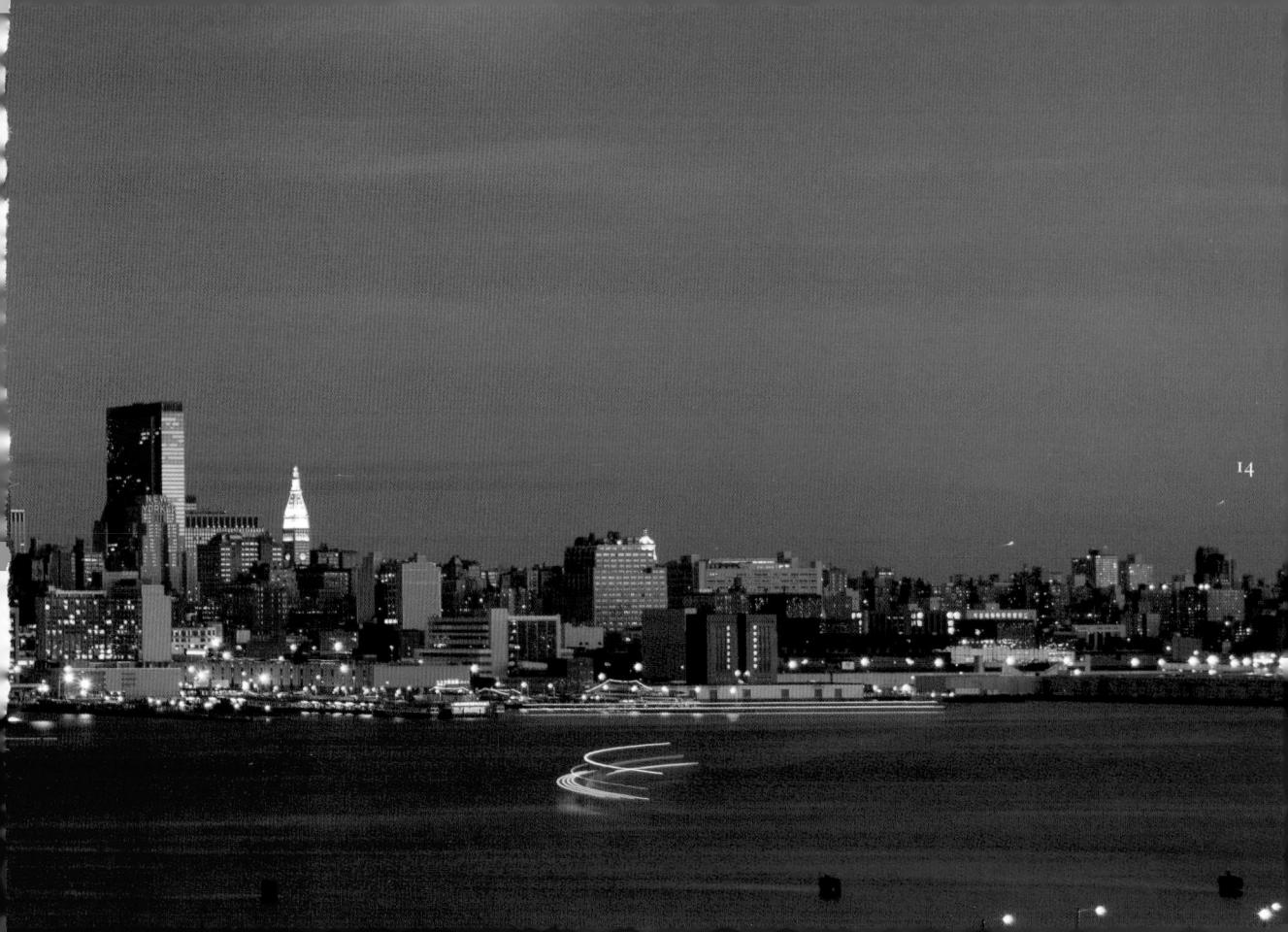

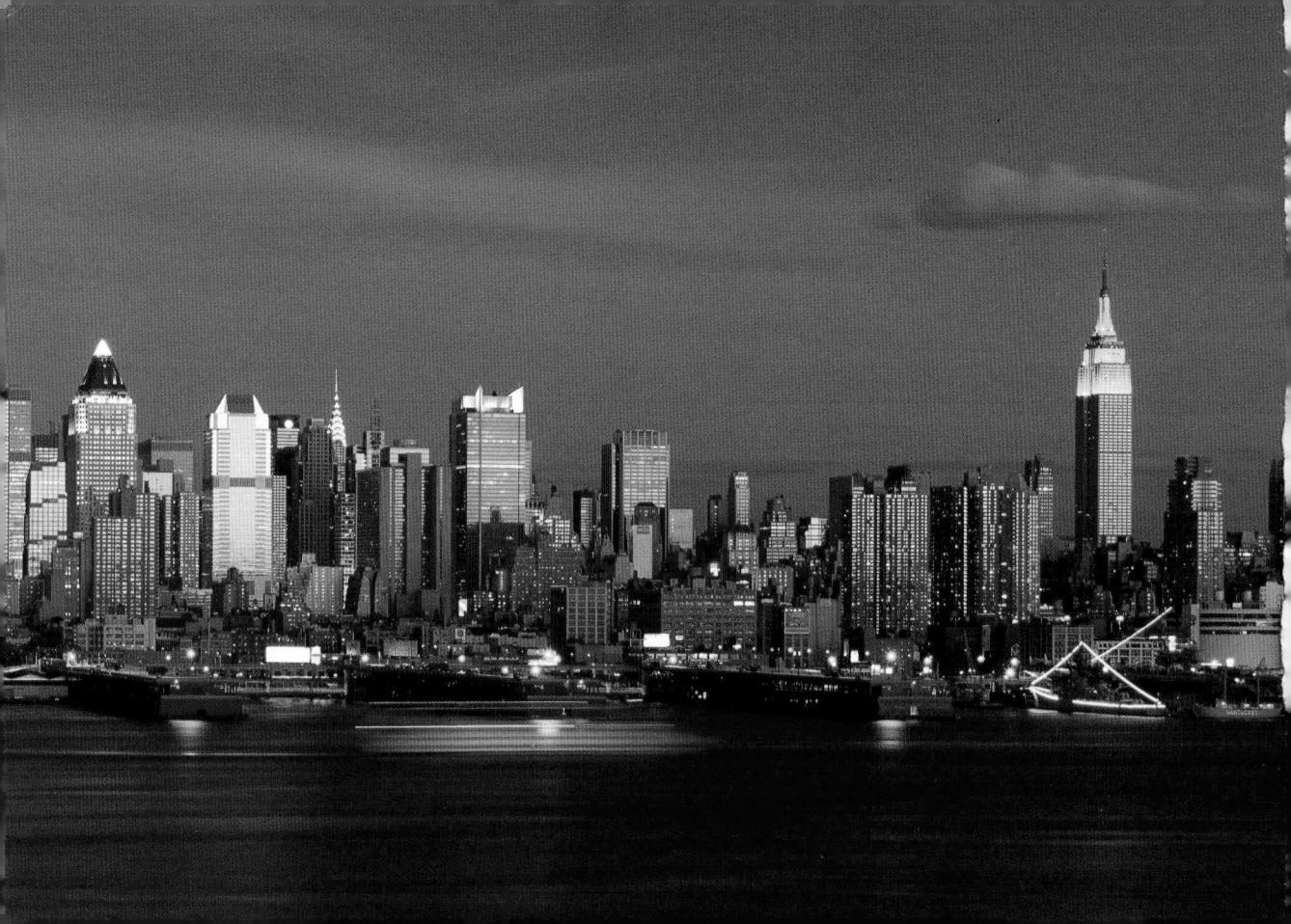

INTRODUCTION

I LOVE THIS CITY, from the smallest carving of an angel on a brownstone façade to the golden light reflecting off the glass wall of towering skyscrapers at sunrise, to the miles of glittering skyline silhouetted at dusk. New York is my birthplace, my workspace, my playground, and my home. I am of that increasingly rare breed known as "Native New Yorkers," and I wouldn't have it any other way.

The New York I love is a city of contradictions, filled with juxtapositions of old and new, past and present. Smooth steel and glass are the backdrop to carved stone gargoyles; a nineteenth-century church spire rises against the mirrored skin of a postmodern monolith; graffitied and postered walls form the bases of elegant cast iron structures from a past era. The architecturally innovative Guggenheim sits within blocks of the stately Metropolitan Museum of Art and the Smithsonian's Cooper Hewitt; restored Broadway show palaces

stand amidst the flourescent glitz of a revitalized Times Square.

Yet, as New York was planned and developed, nature was not forgotten, thanks to visionaries with the sense and foresight to dedicate areas for parks and open spaces. Central Park (with its Conservatory Garden, zoo, and playing fields), Riverside Park, and the exquisite Brooklyn Botanic and New York Botanical gardens are just a few of the protected natural grounds that make up the peaceful center of our active enclave of boroughs. This diverse palette of landscapes and vistas offer us sanctuaries from the noise and confinement of the surrounding concrete canyons.

Still, it is those very canyons that I find most compelling. When I walk this city, I delight in looking skyward. Admiring the view from below, I marvel at the sheer scale and expression of what mankind has chosen to create. From above, New York is yet

another city altogether. Standing on the roof of a tall building, looking down over the endless expanse of towers, I can survey the chaotic criss-crossing of people and traffic from an unexpectedly quiet perch.

Whatever my vantage point, I watch with anticipation the continuous changes of this city, which is forever growing and reinventing itself, as reflected in the seemingly endless alteration of the skyline. We all now know that these changes are neither always desired, nor for the best. We have lost some of the greatest architecture ever created-including the original Penn Station—through the shortsightedness of politicians and developers. These losses have taught us the value of preserving what we can of the fragile and irreplaceable buildings and monuments that form the link between then and now. We have also seen the skyline of one of the greatest cities on earth, and the lives of those who live and work there, violently and forever changed in a matter of moments through a senseless act of terrorism. Some things we can control and some we cannot. Included in this book are photographs of both the skyline that *was* and the skyline that *is* today—for both define the soul of our city.

New York City continues to provide an endless and rapidly changing source of inspiration for my work. I can go back to the same location countless times, and the light and conditions will never be the same. There is always something new to see that was not there before. I hope the photographs in this book will inspire both long-time residents and first-time visitors to look more closely at New York and to discover places and details they may have overlooked or taken for granted. We are never too old to be surprised, and New York, if nothing else, is a city full of surprises.

RICHARD BERENHOLTZ

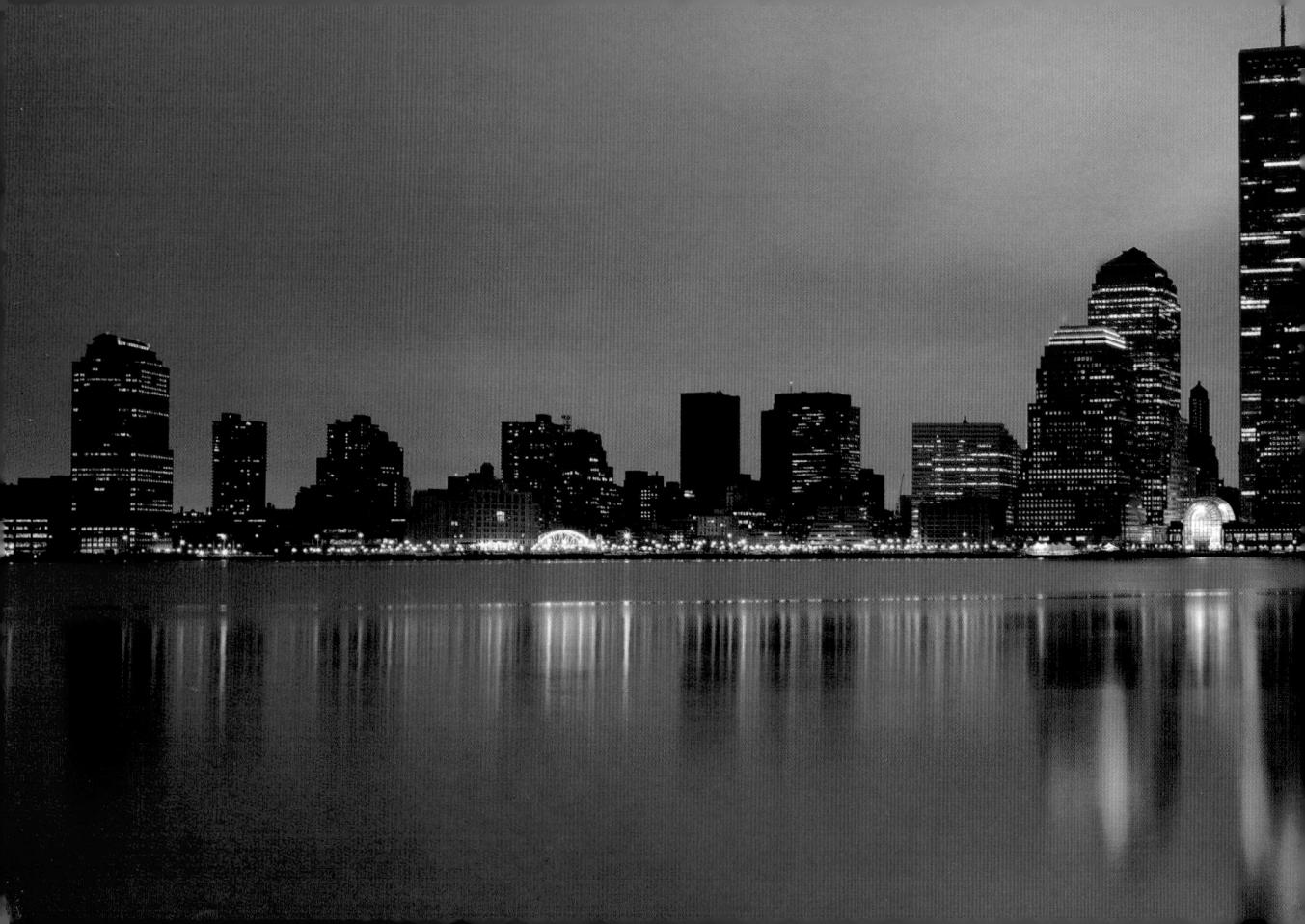

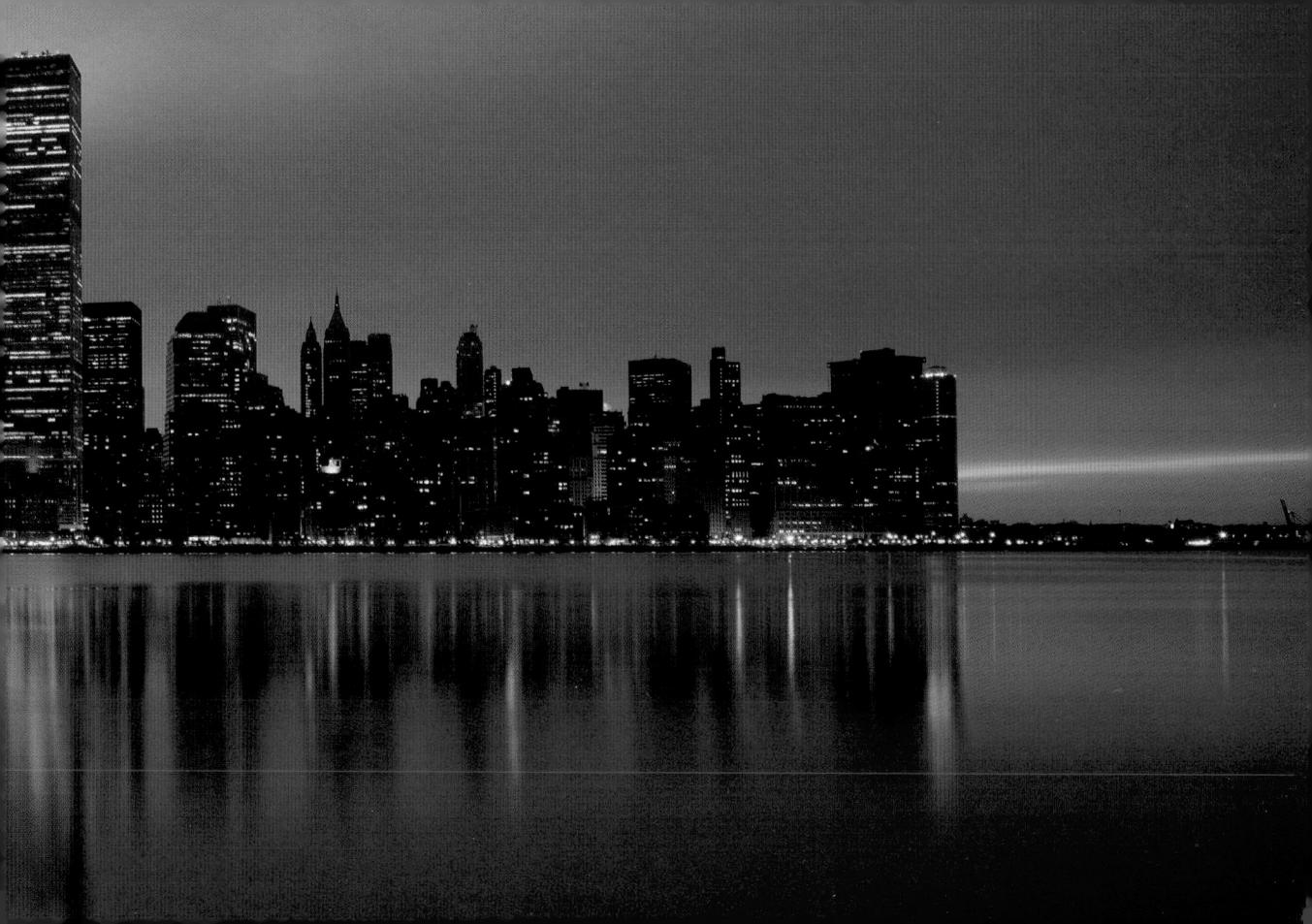

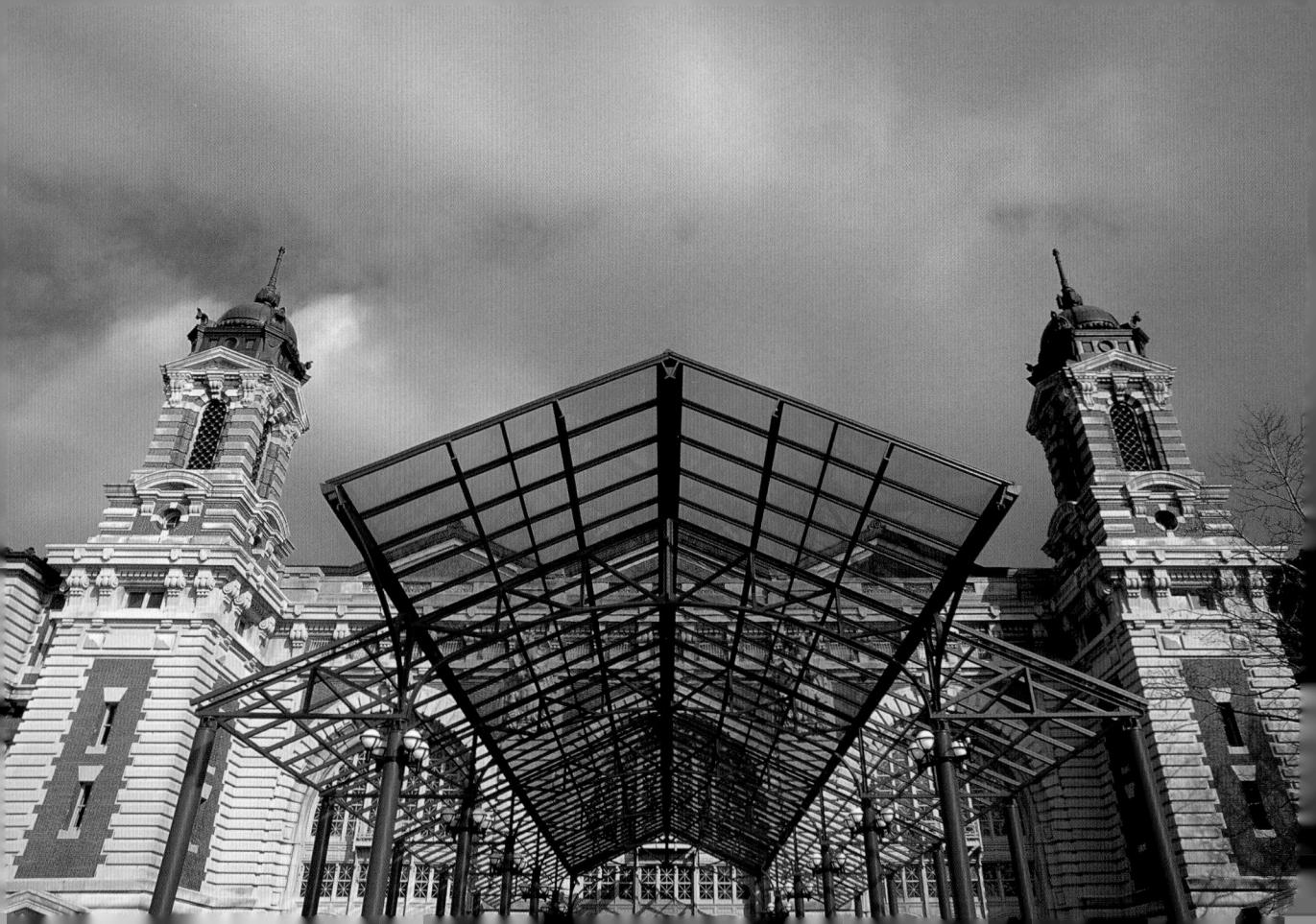

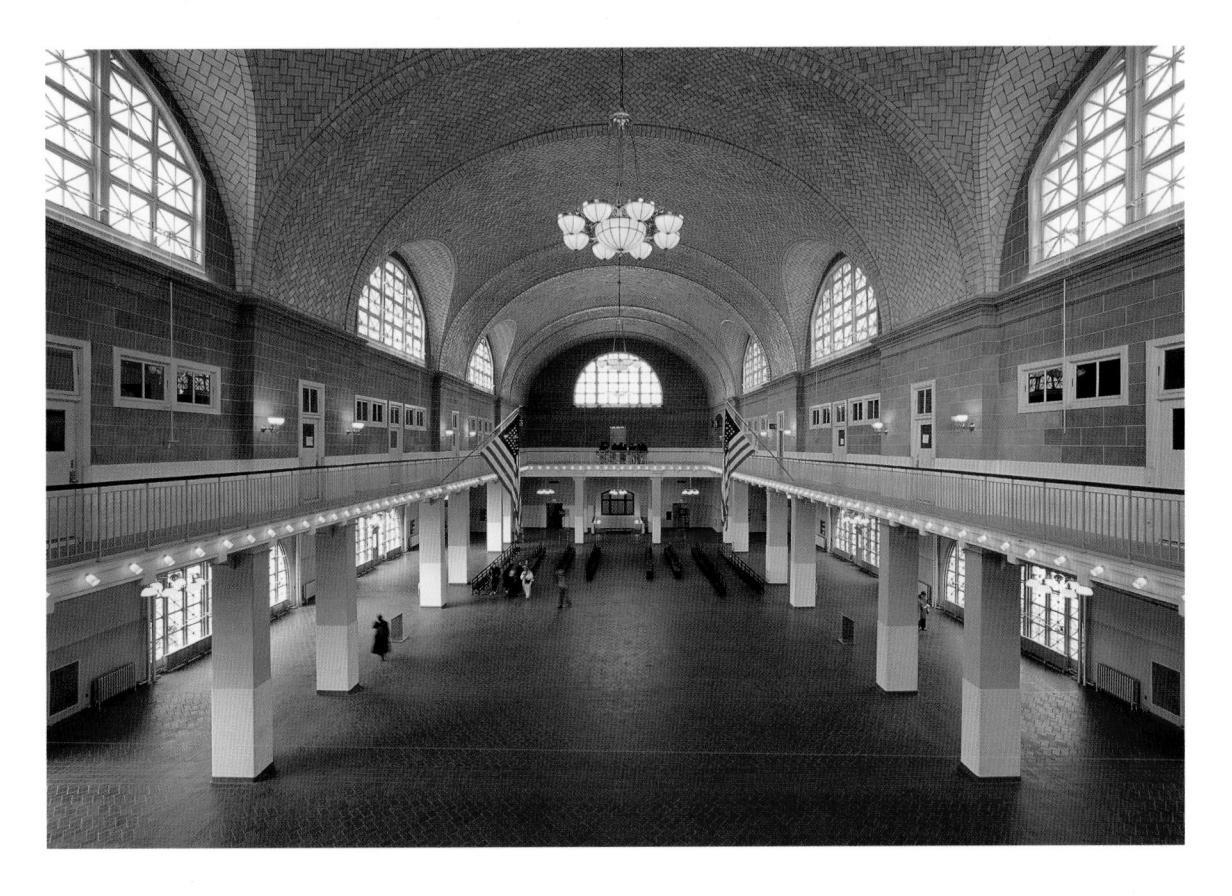

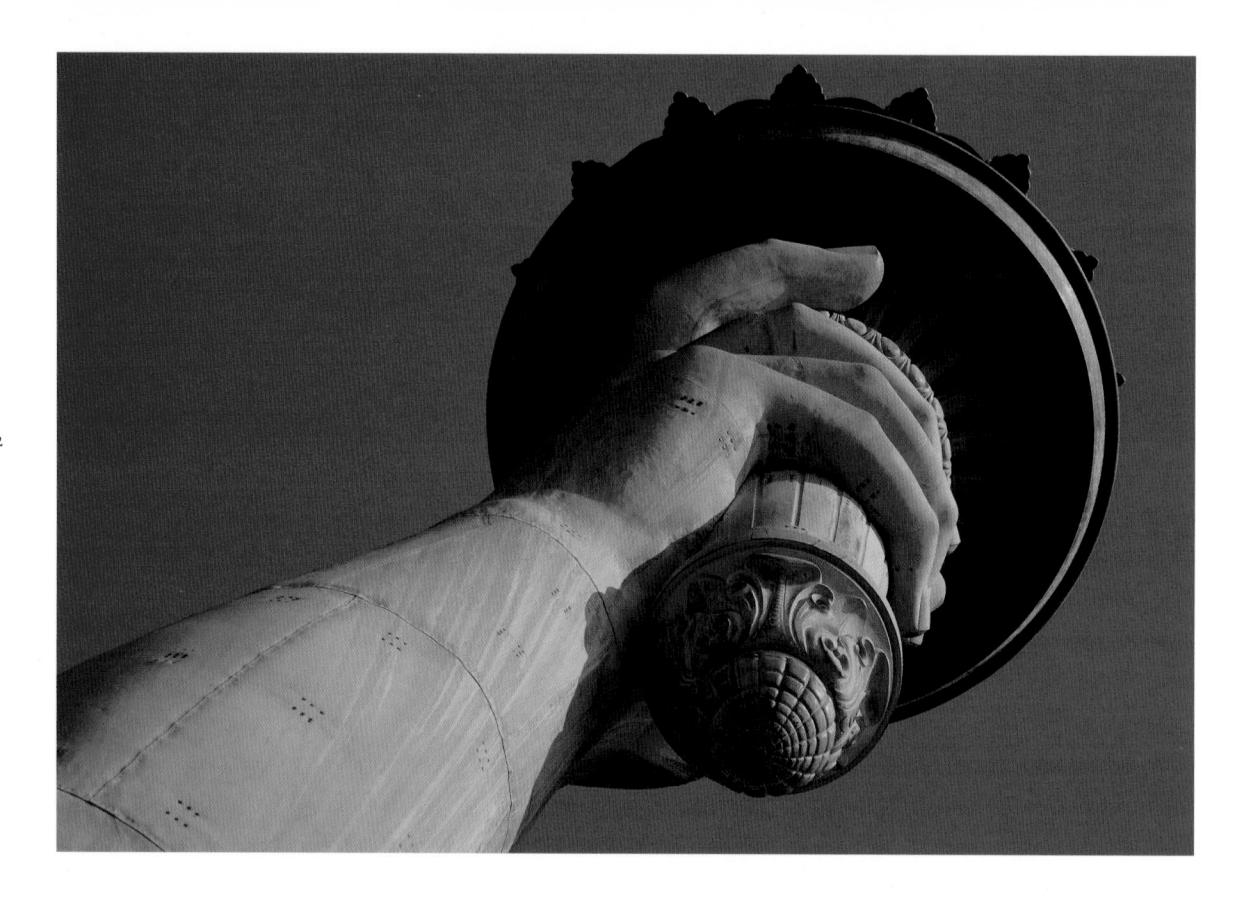

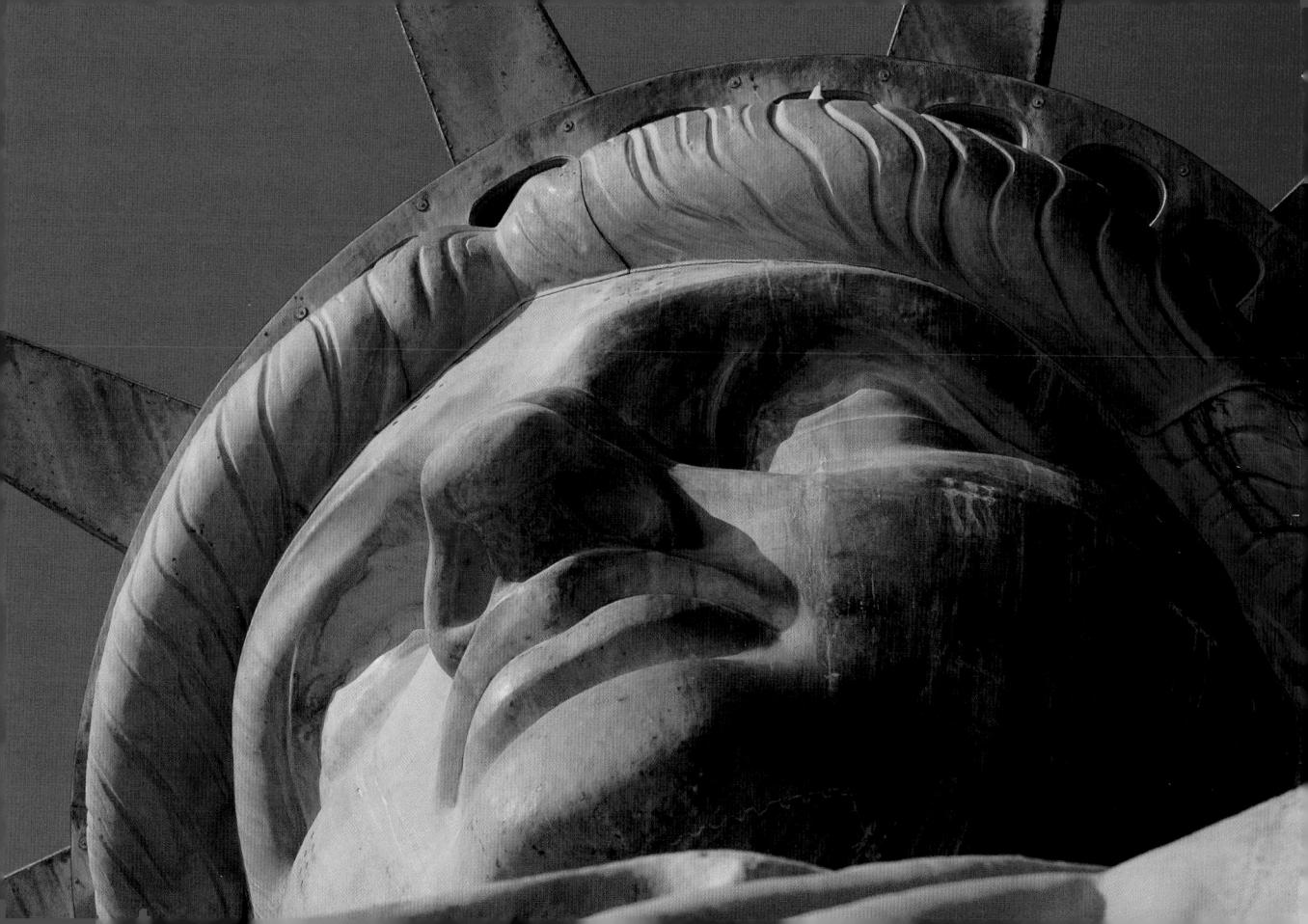

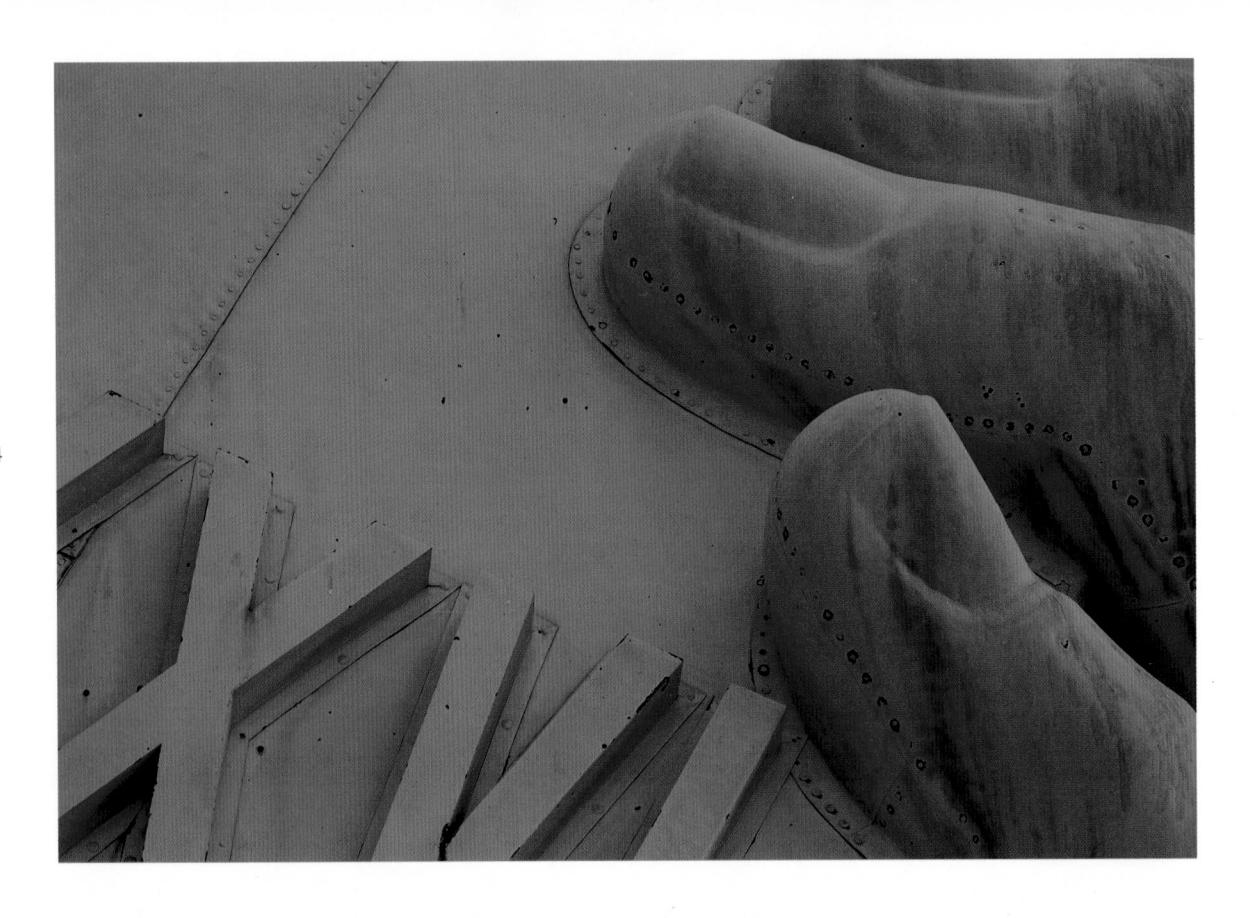

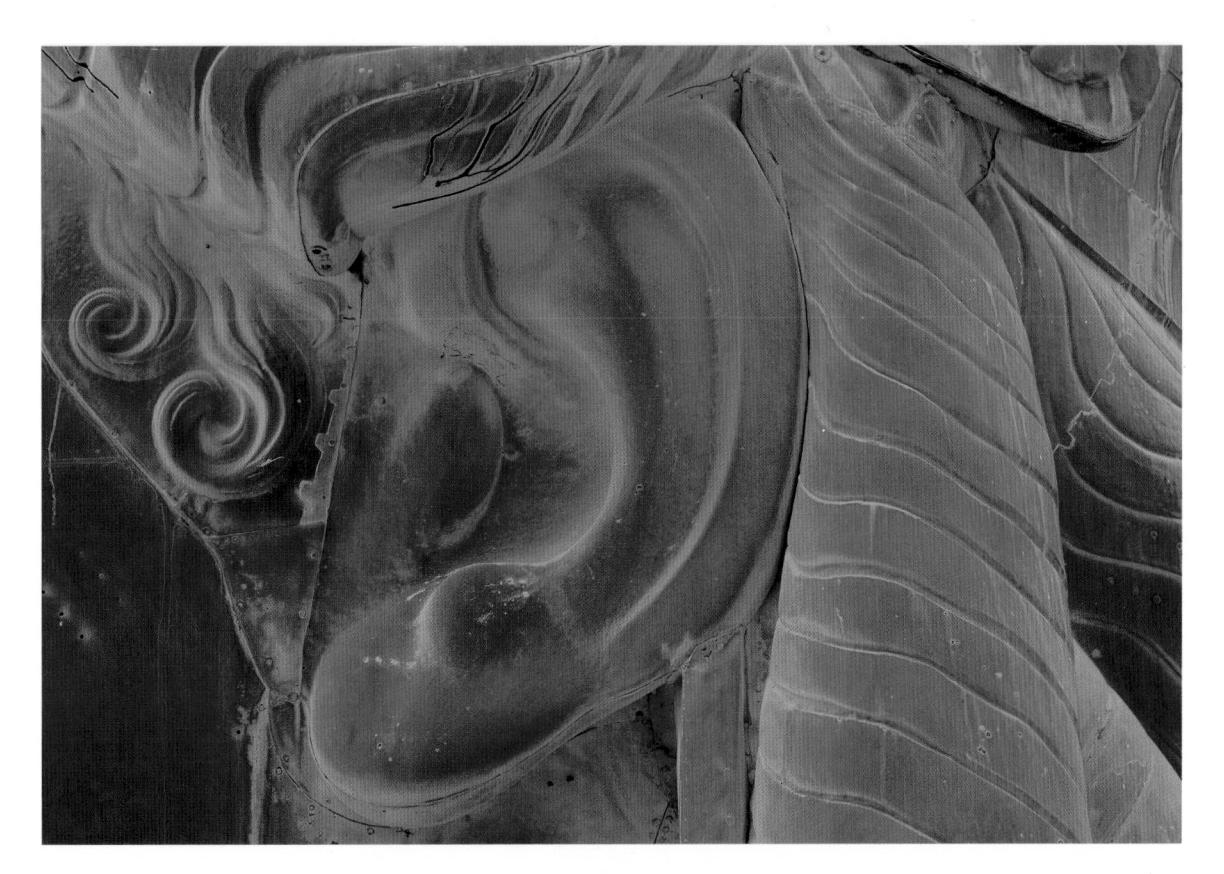

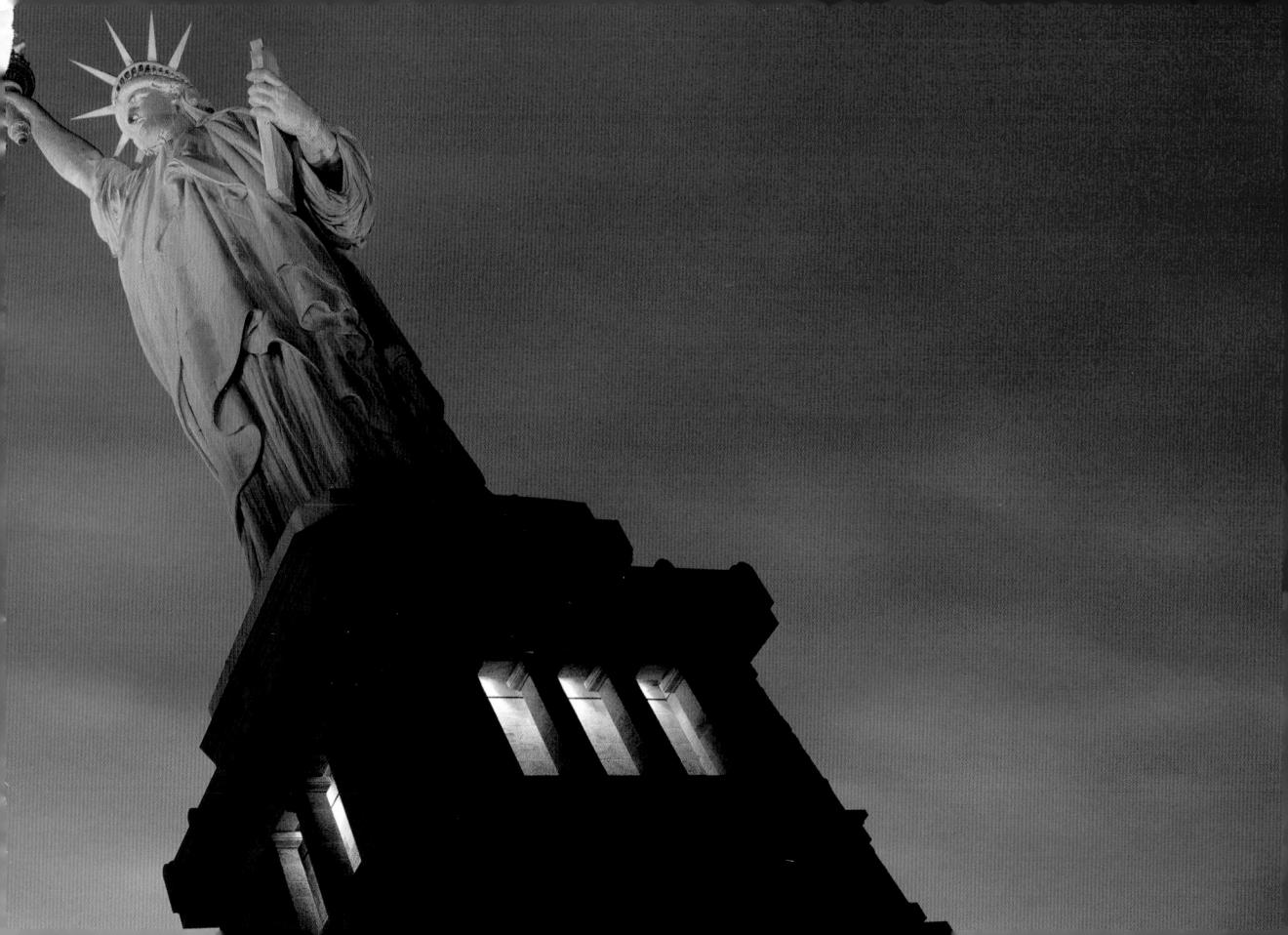

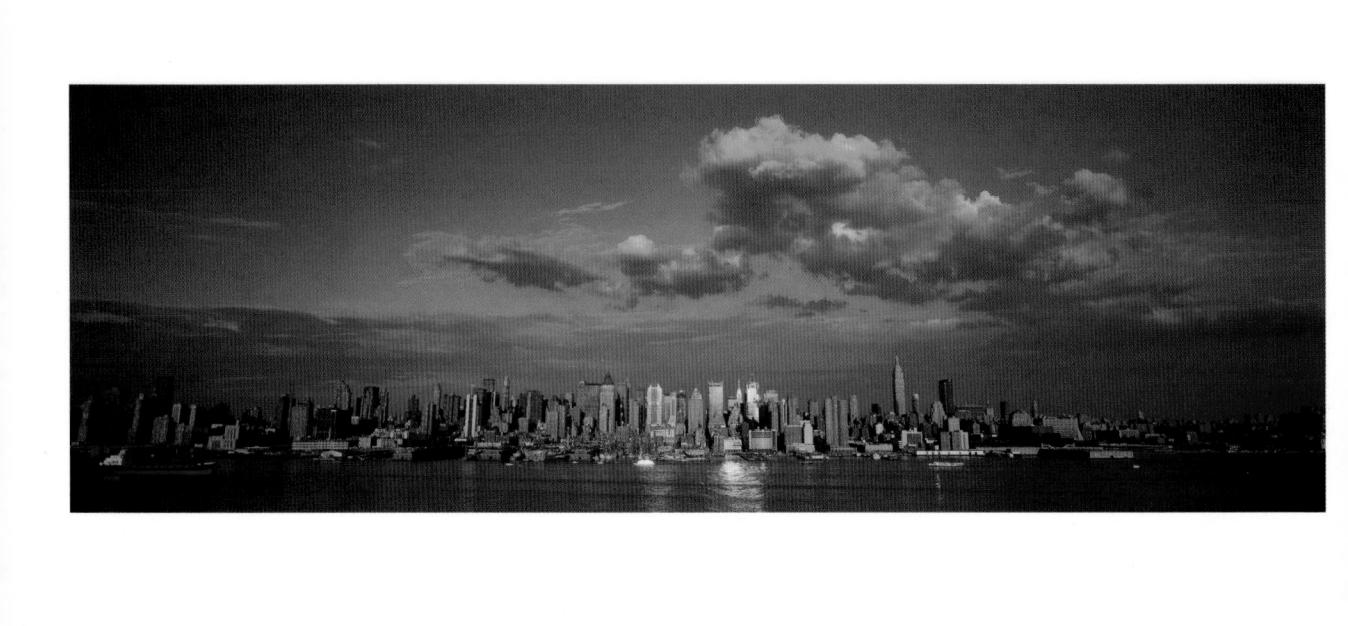

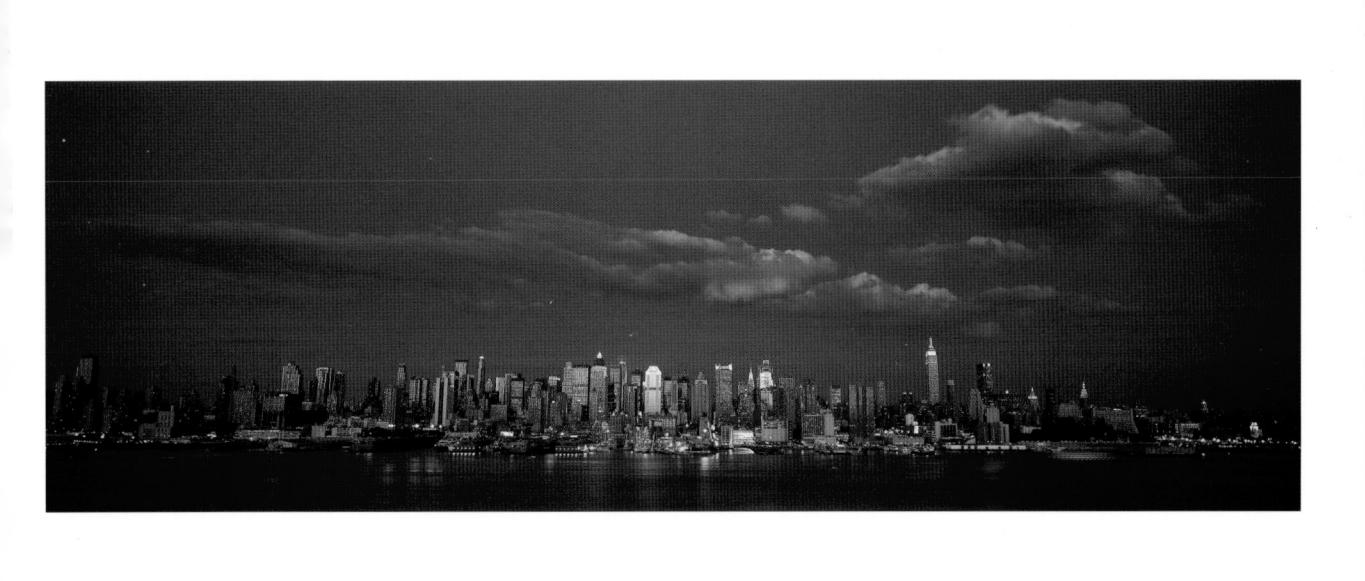

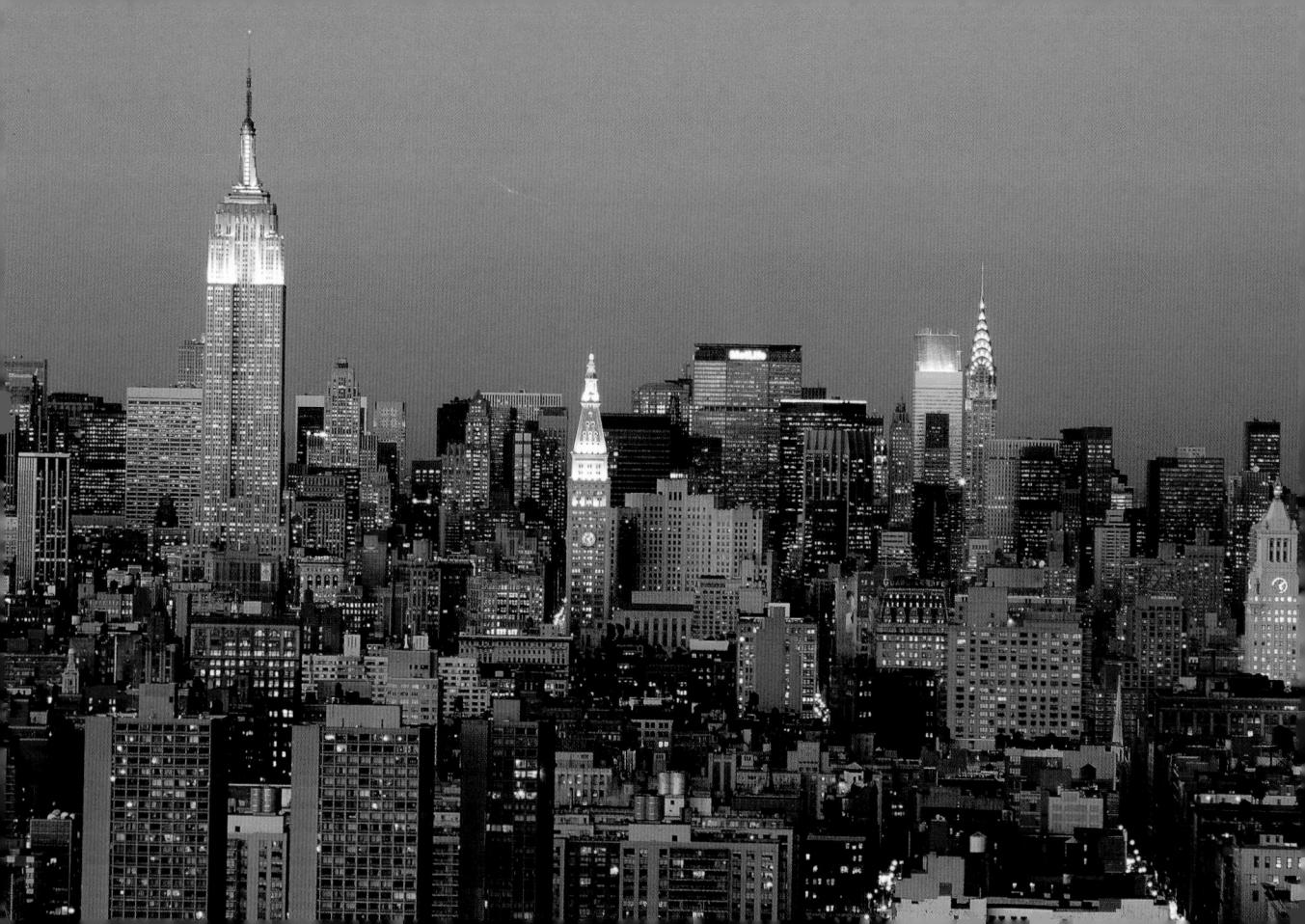

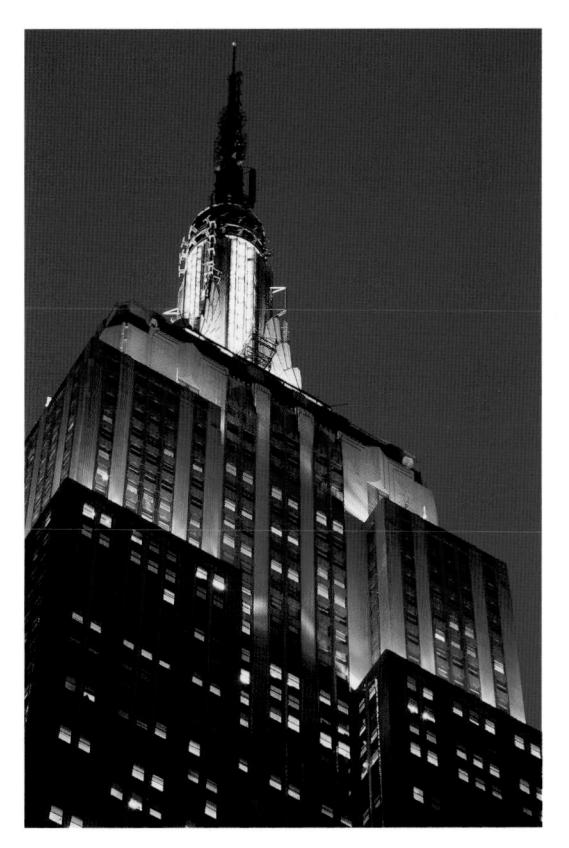

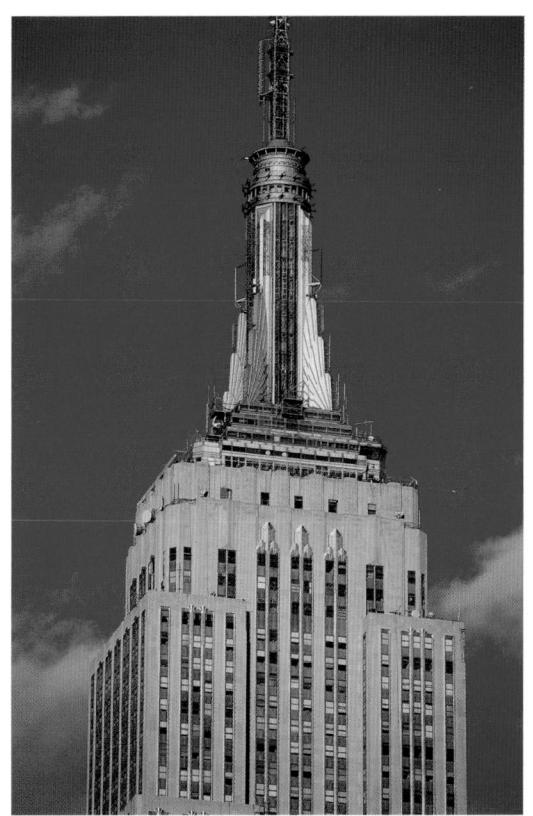

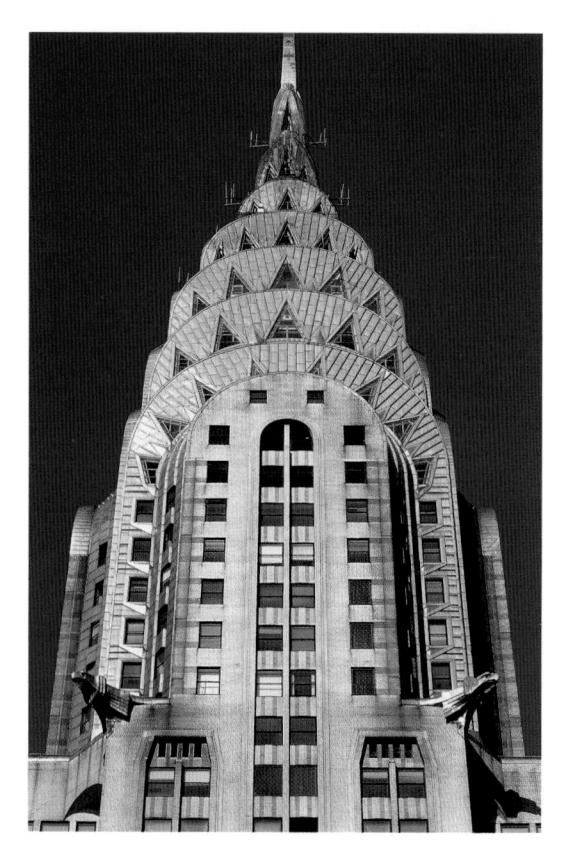

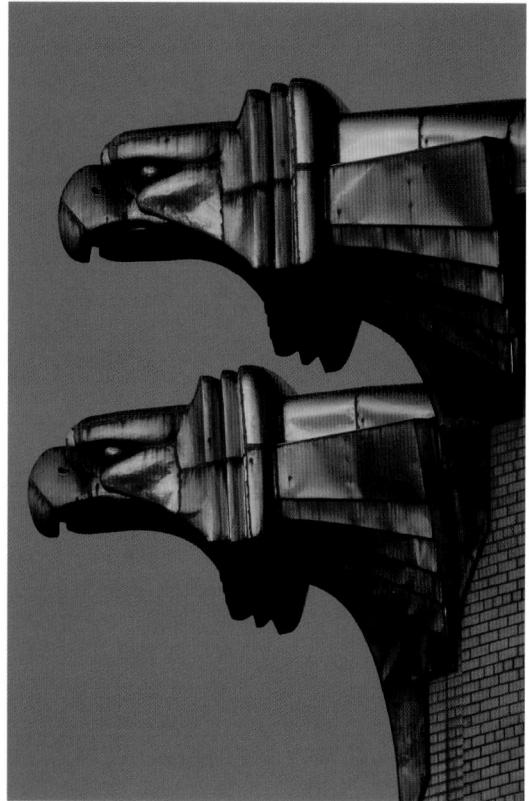

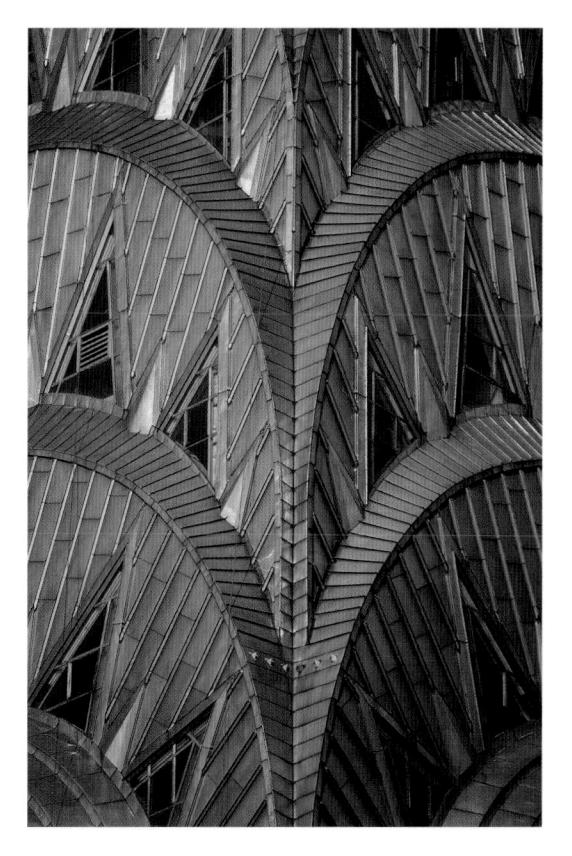

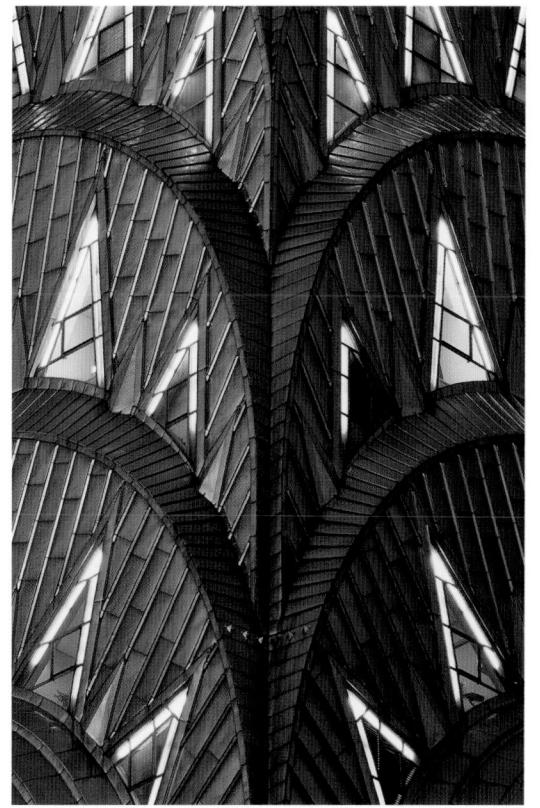

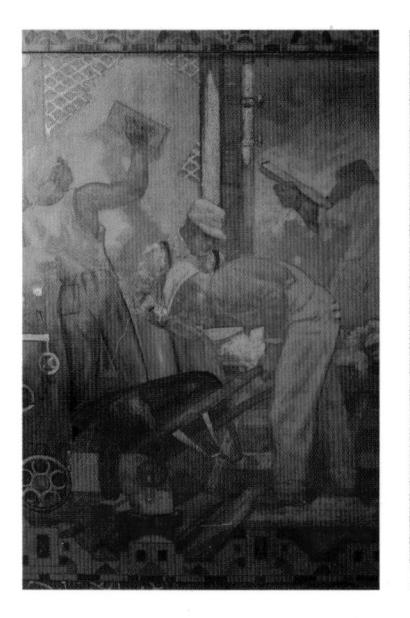

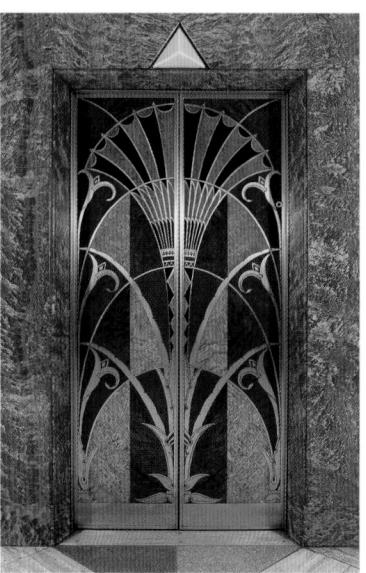

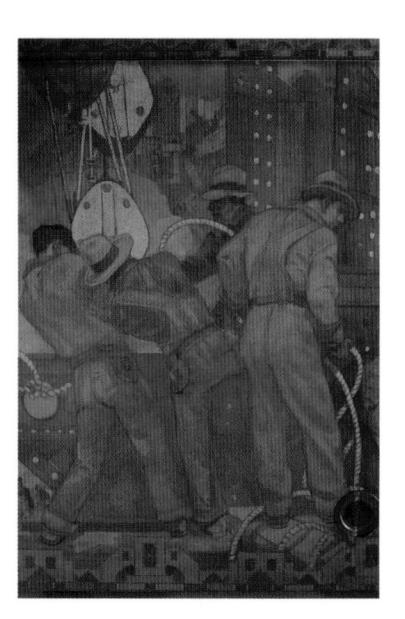
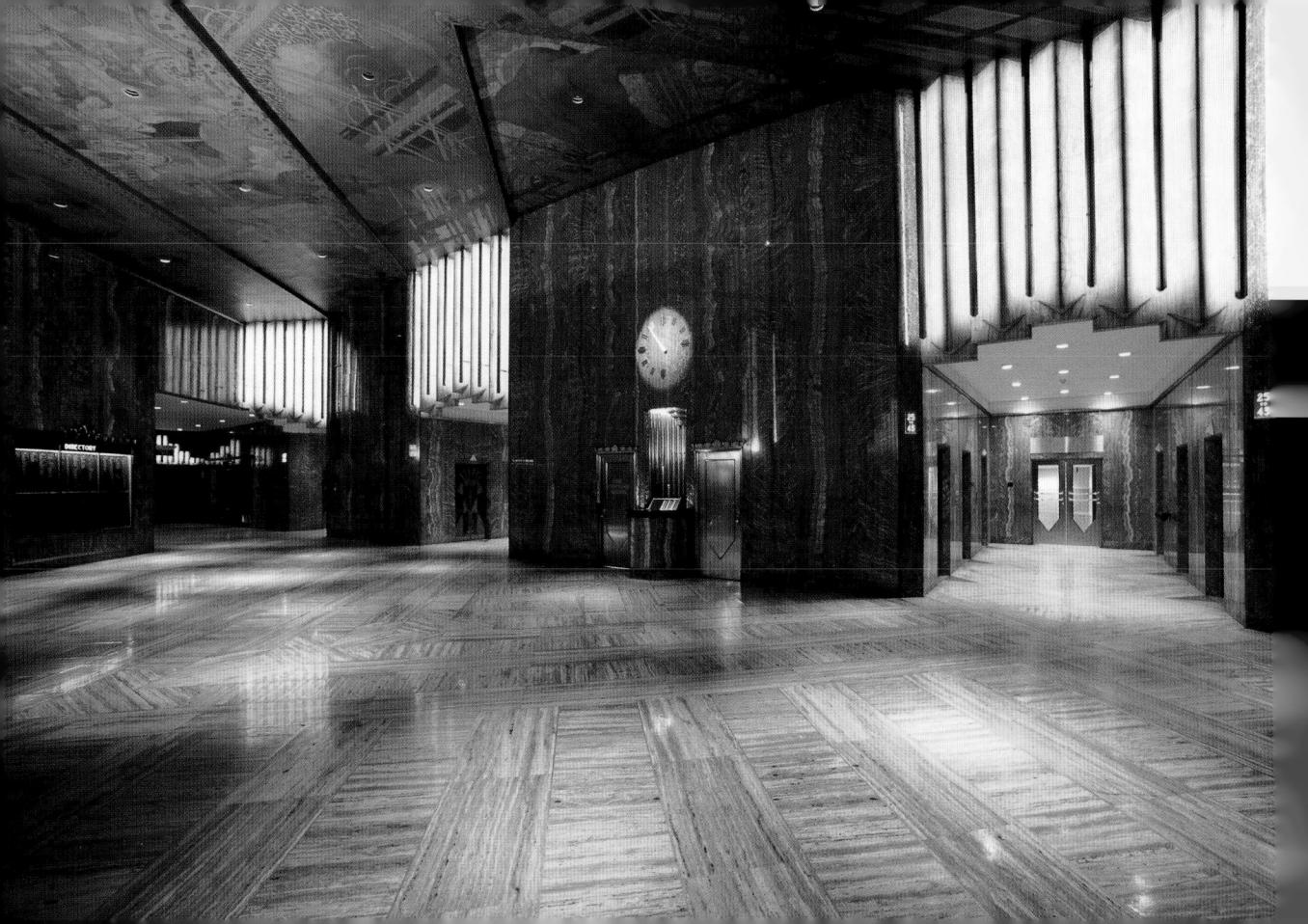

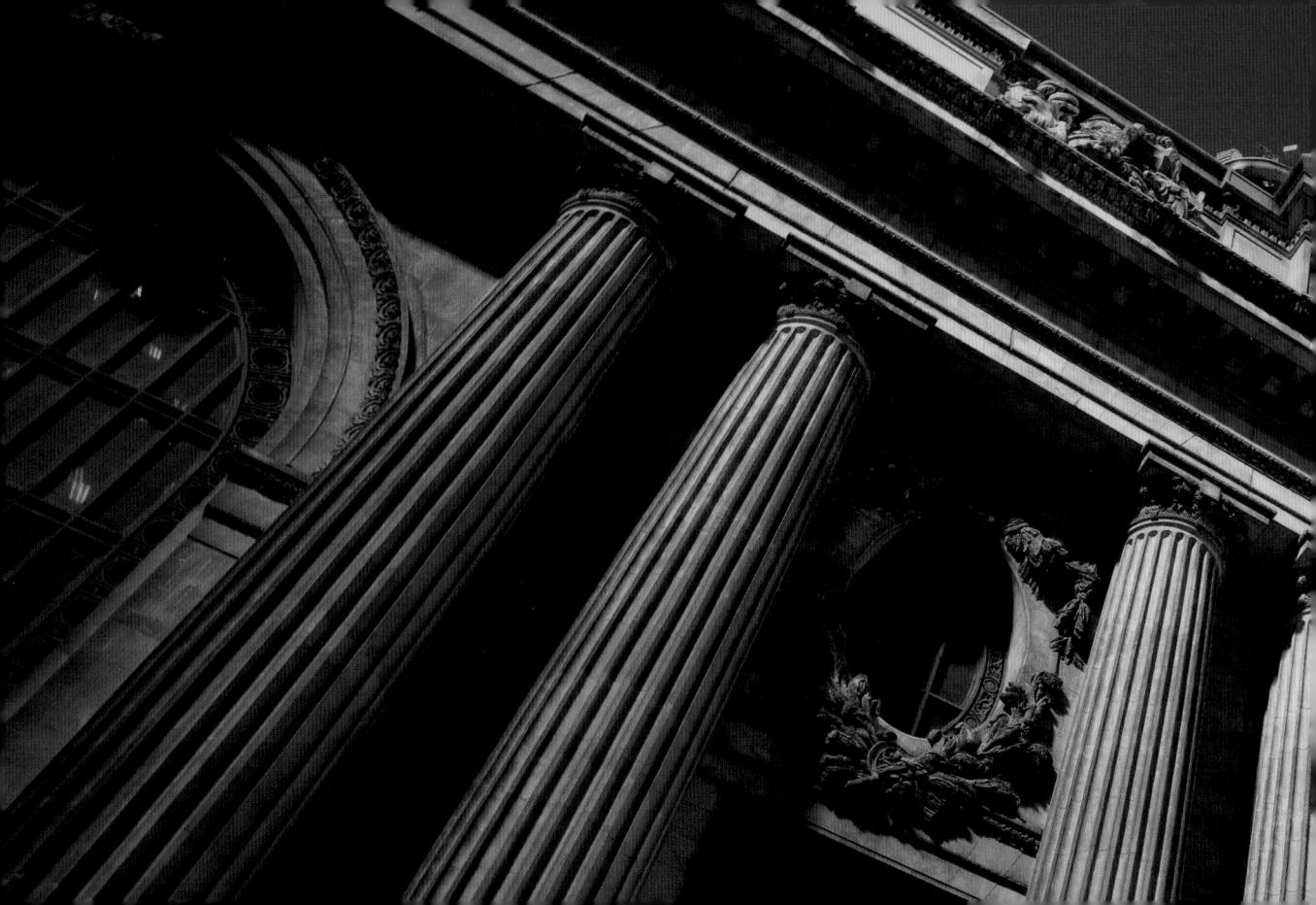

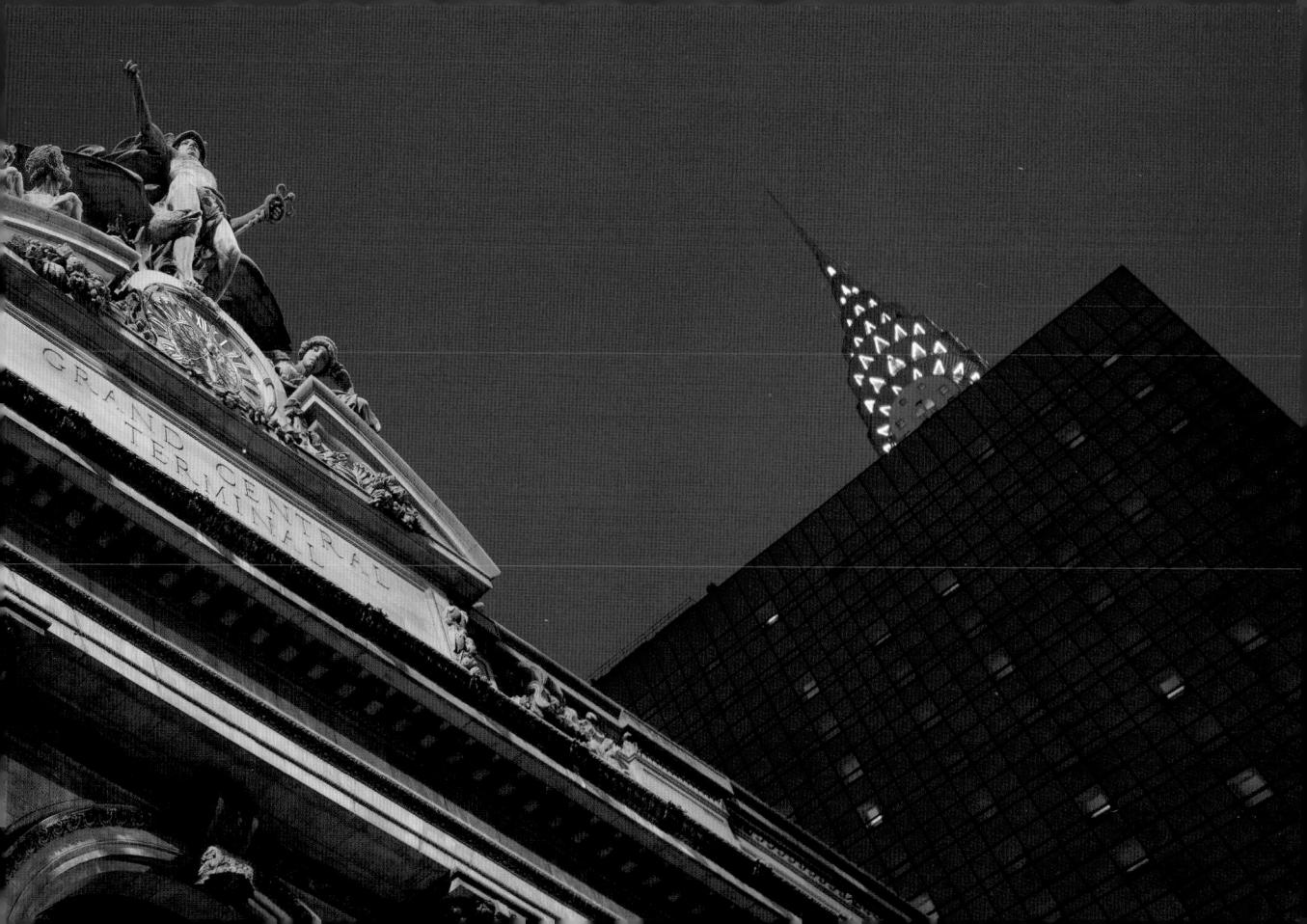

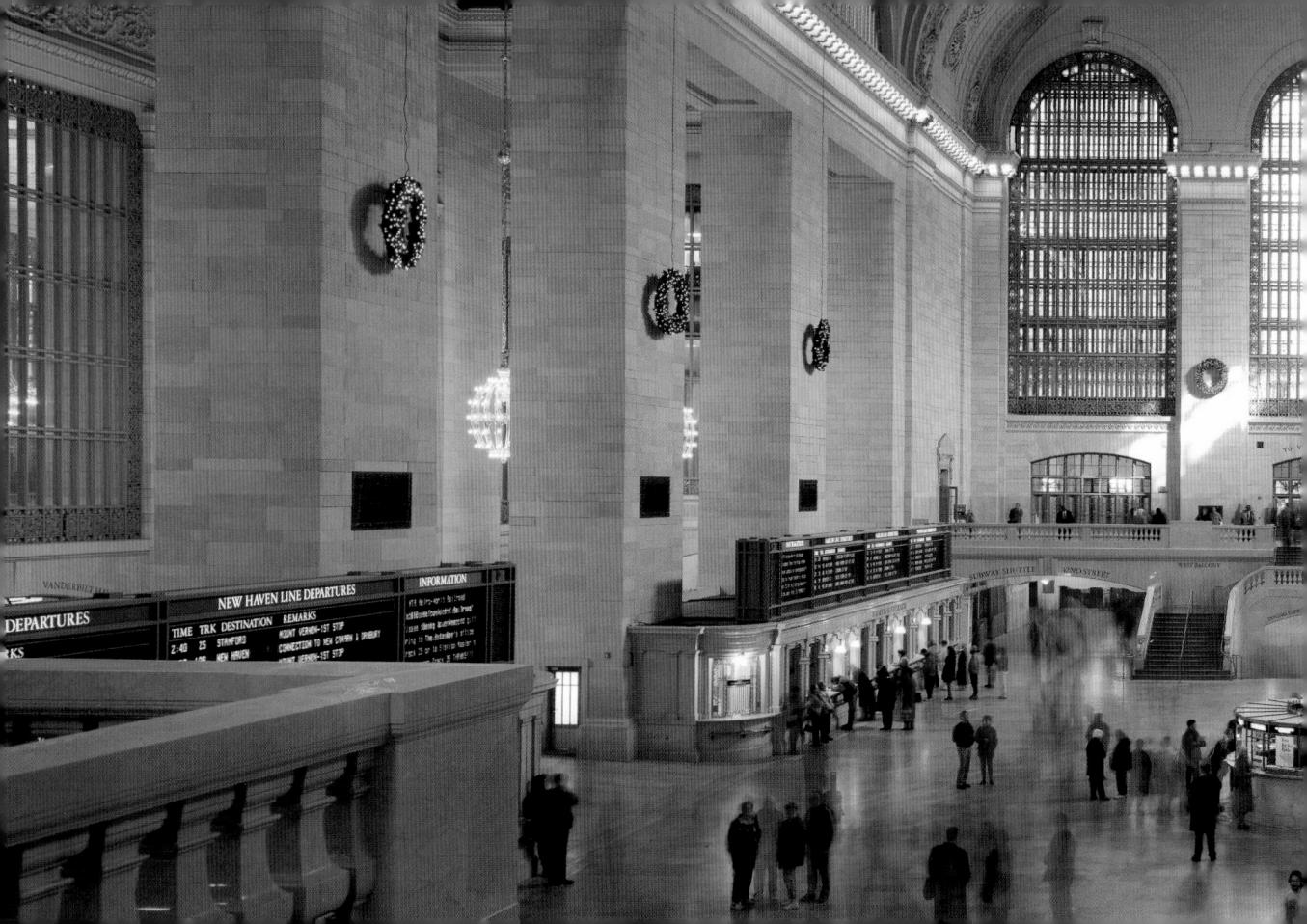

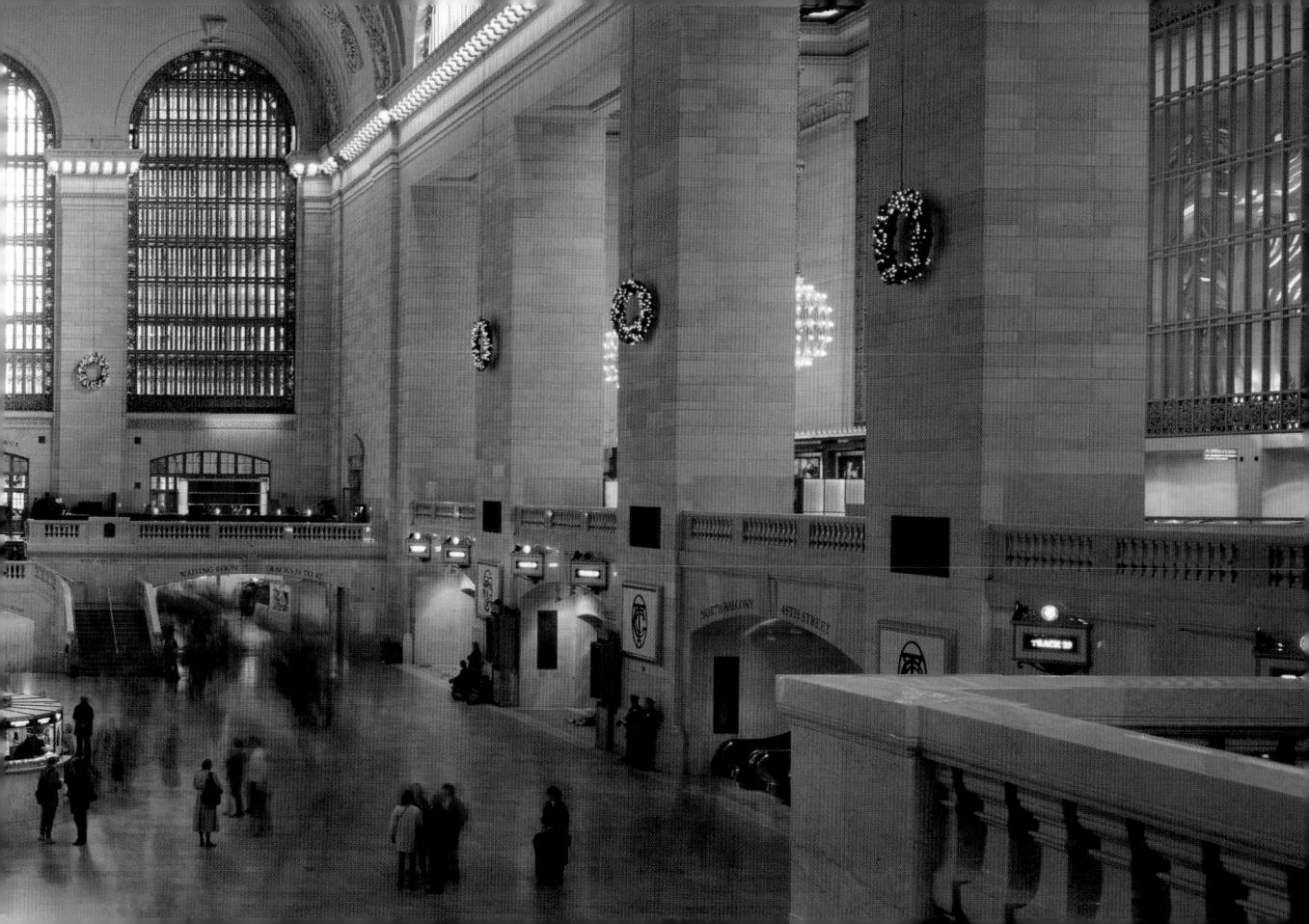

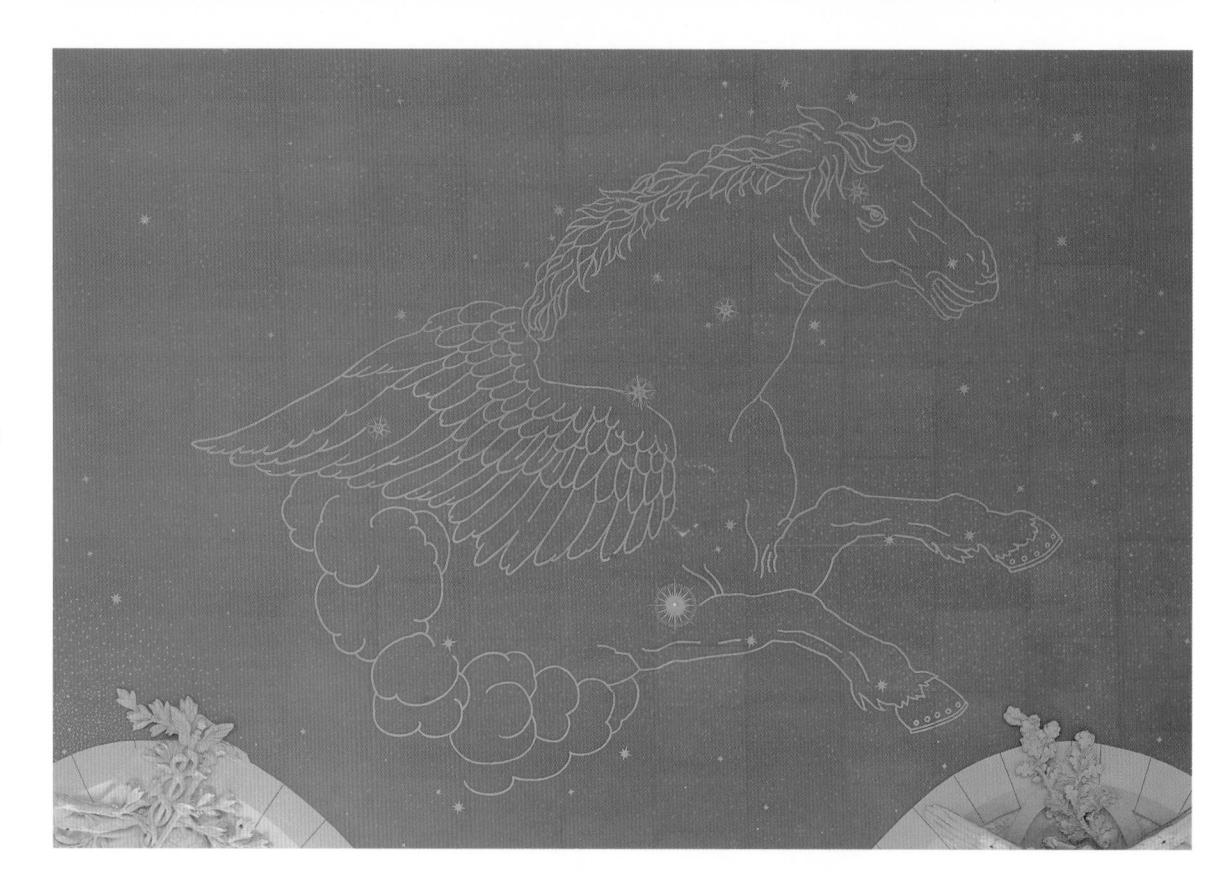

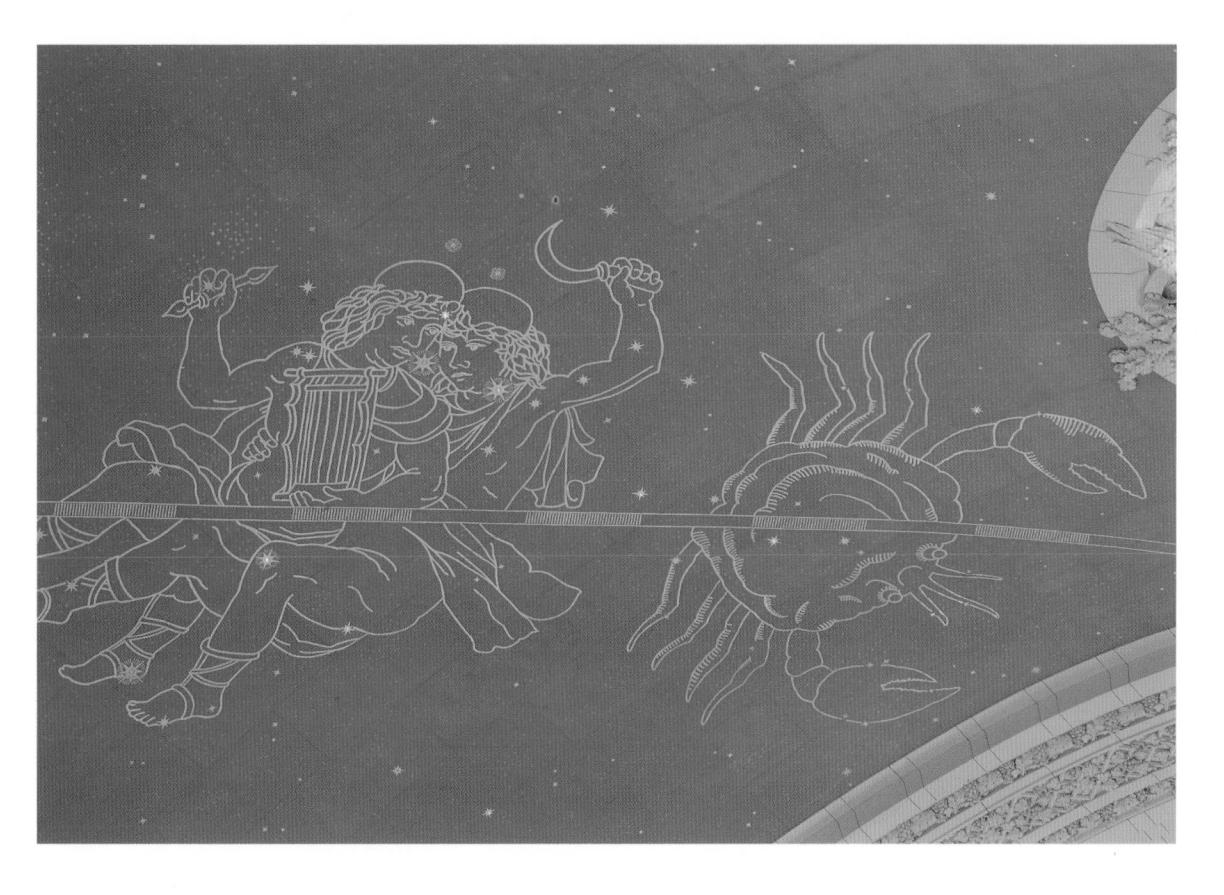

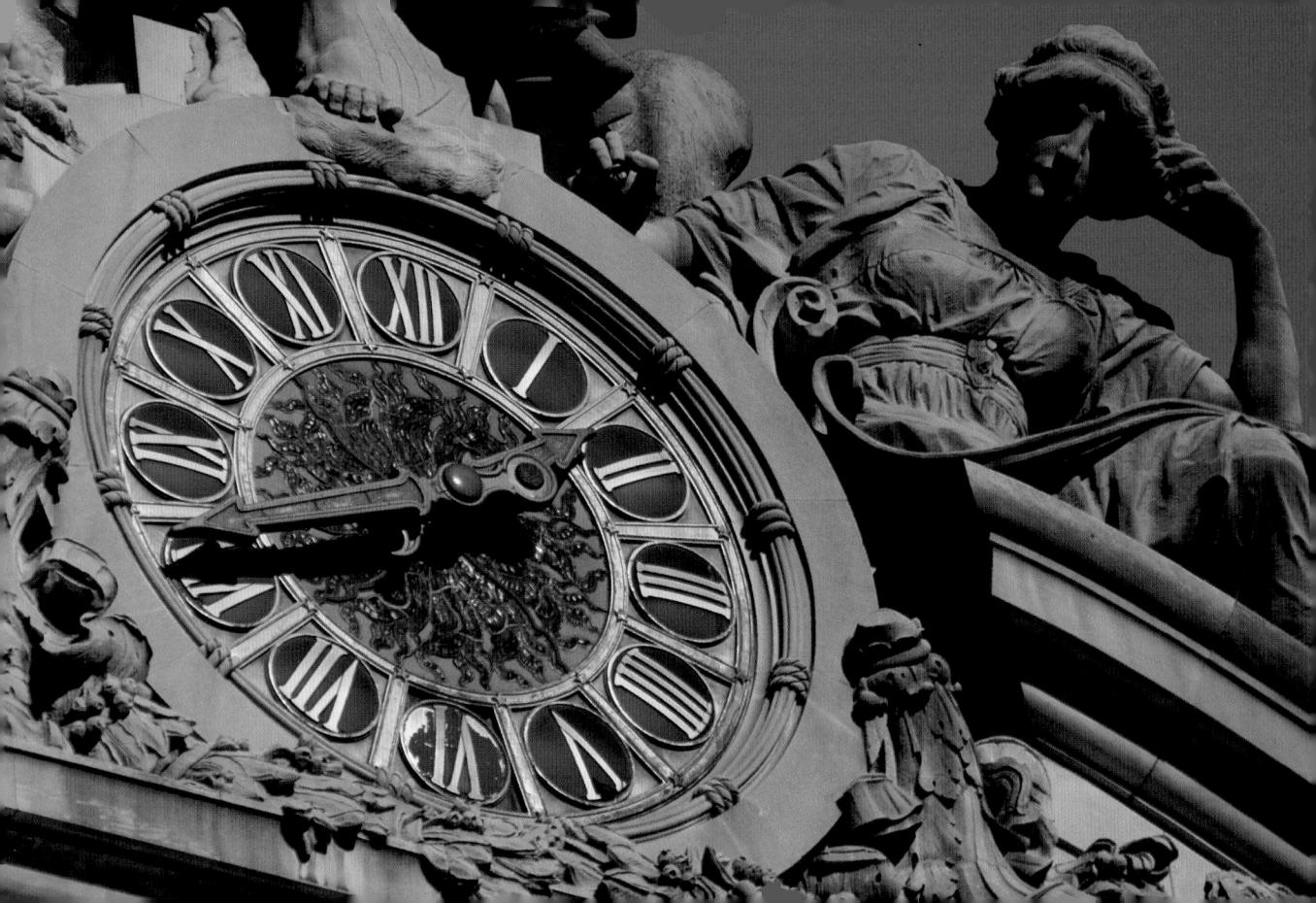

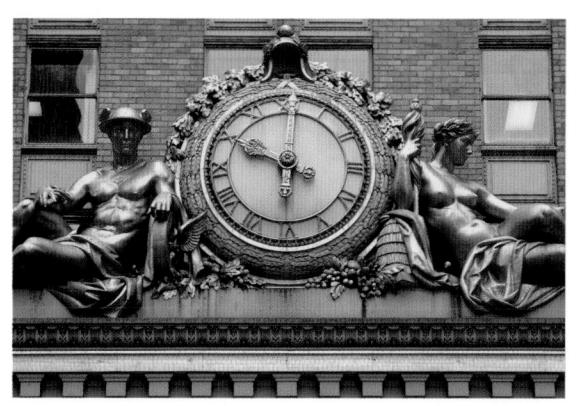

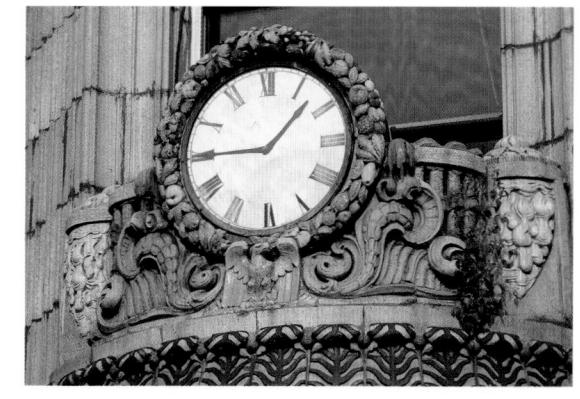

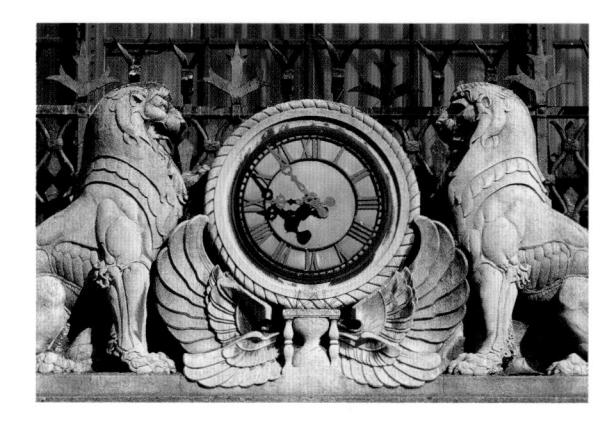

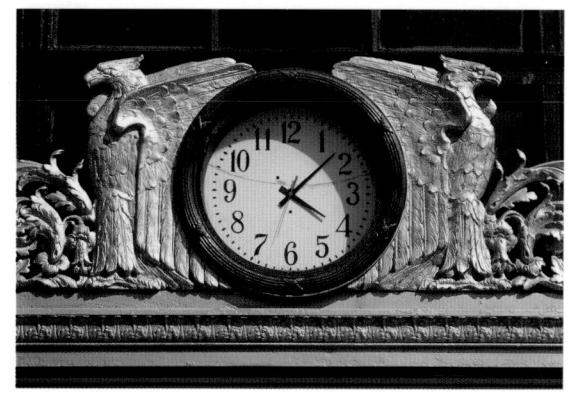

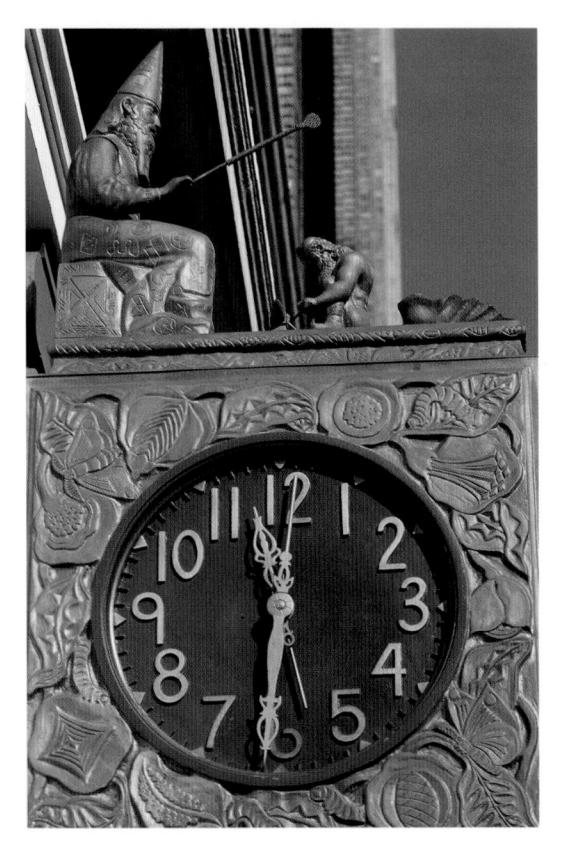

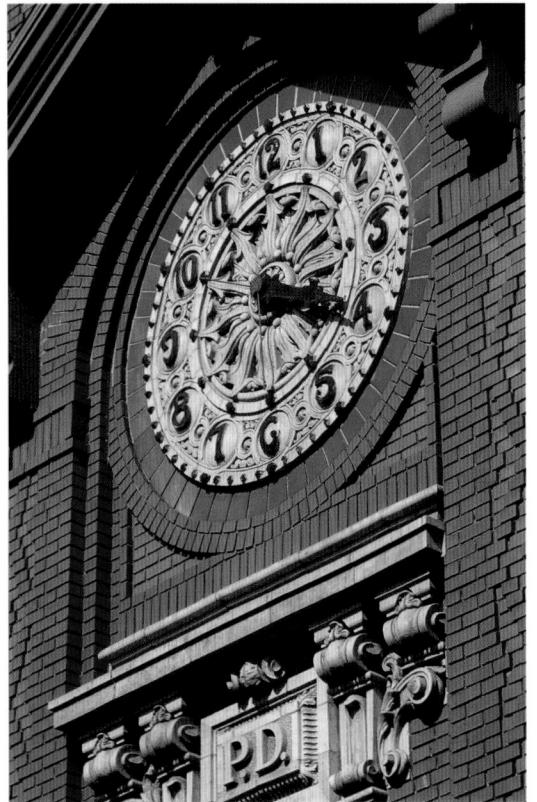

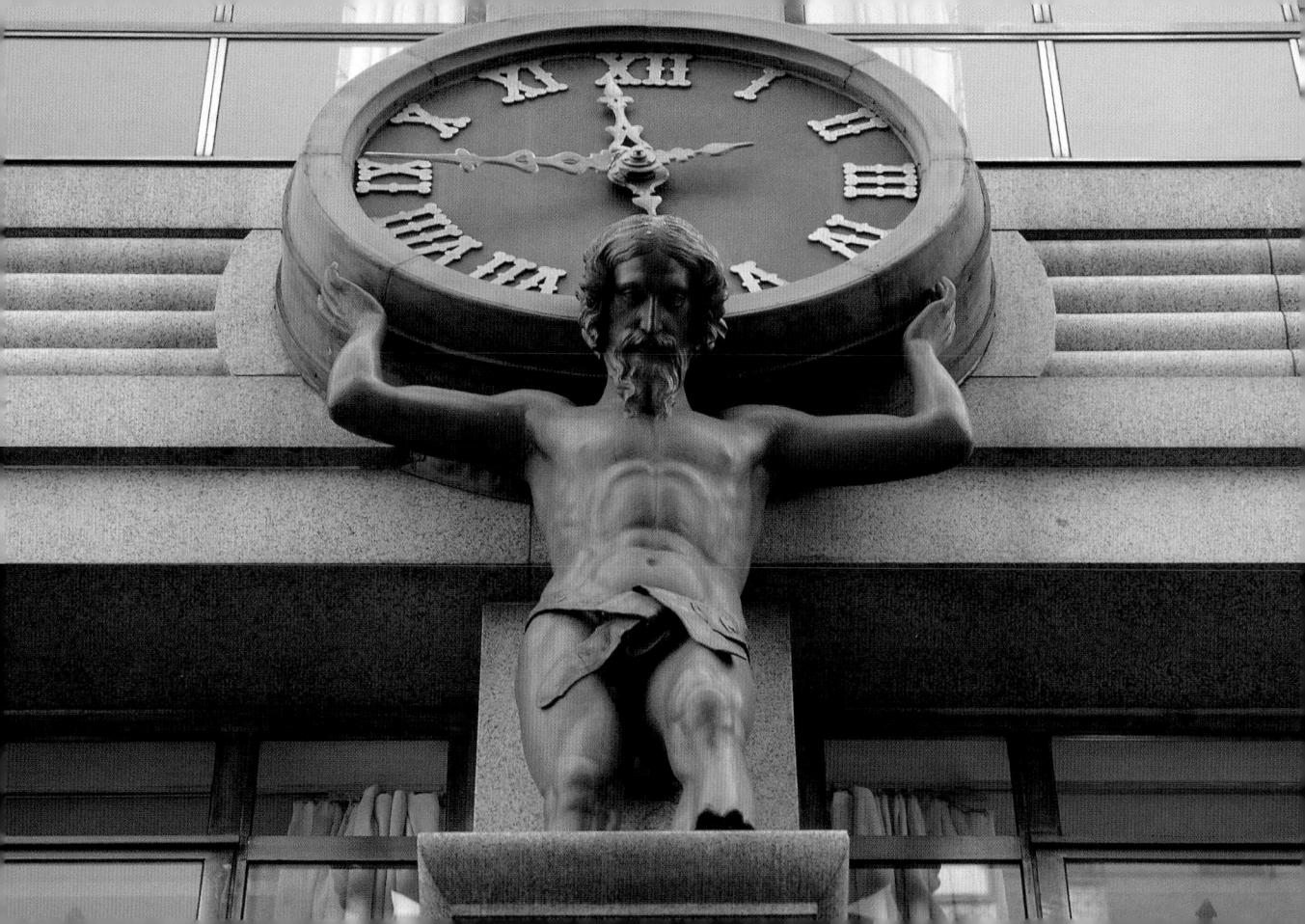

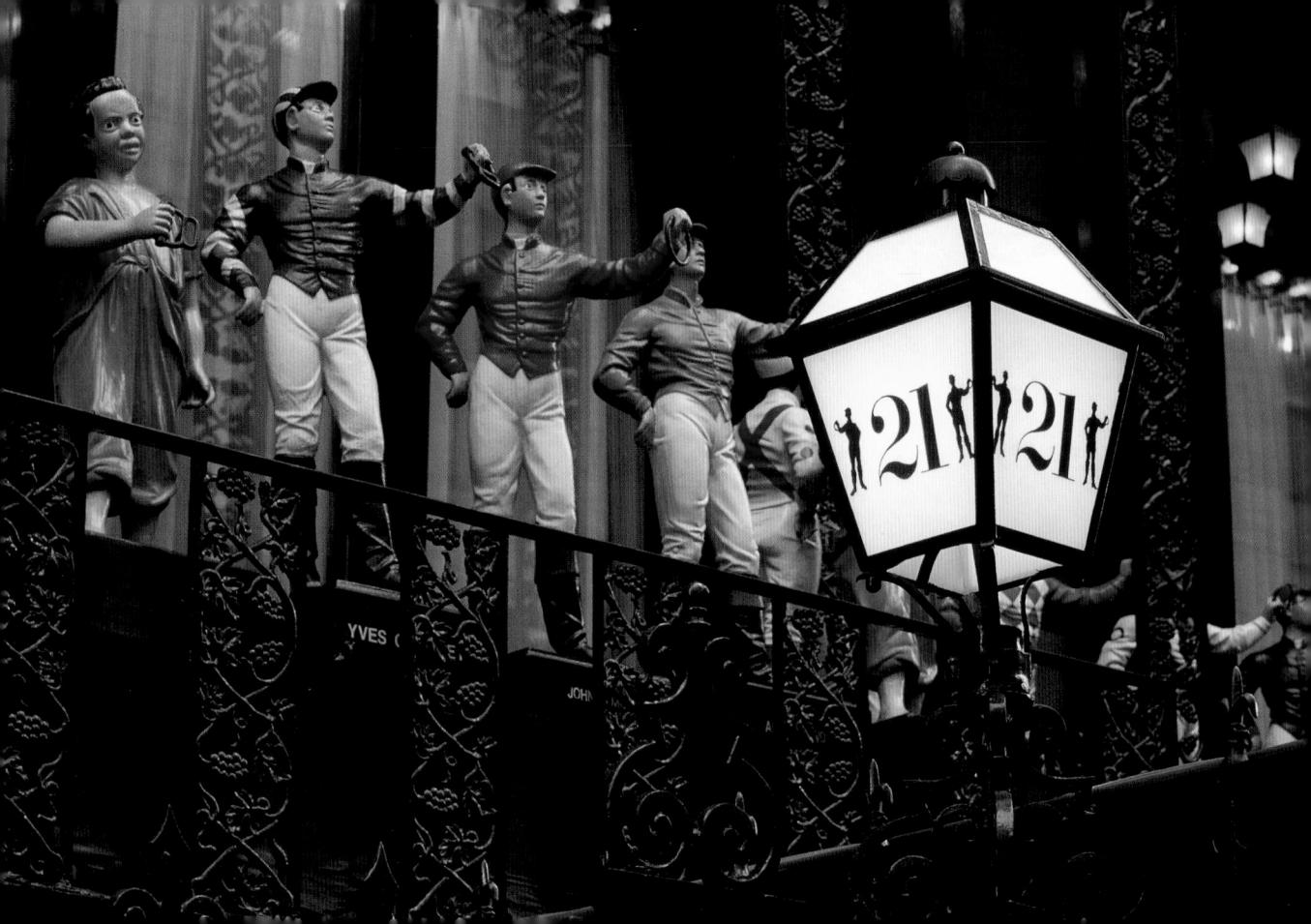

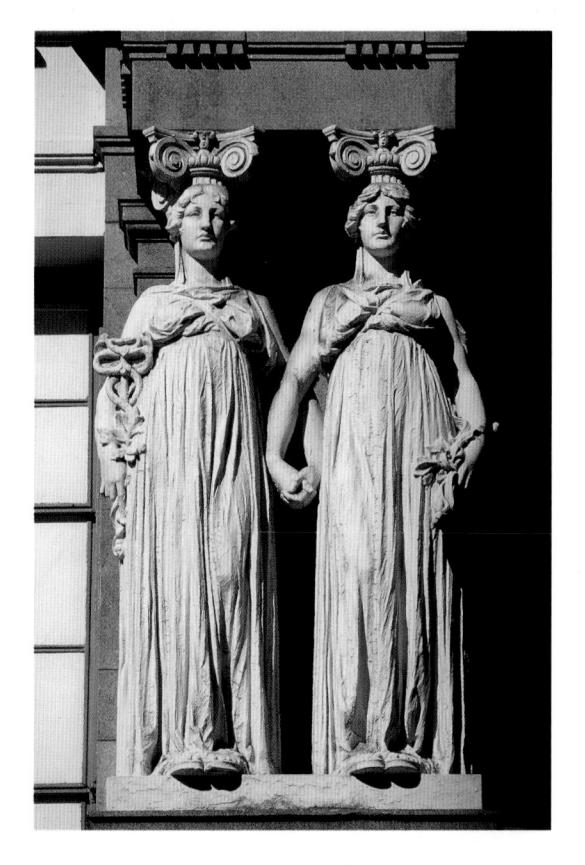

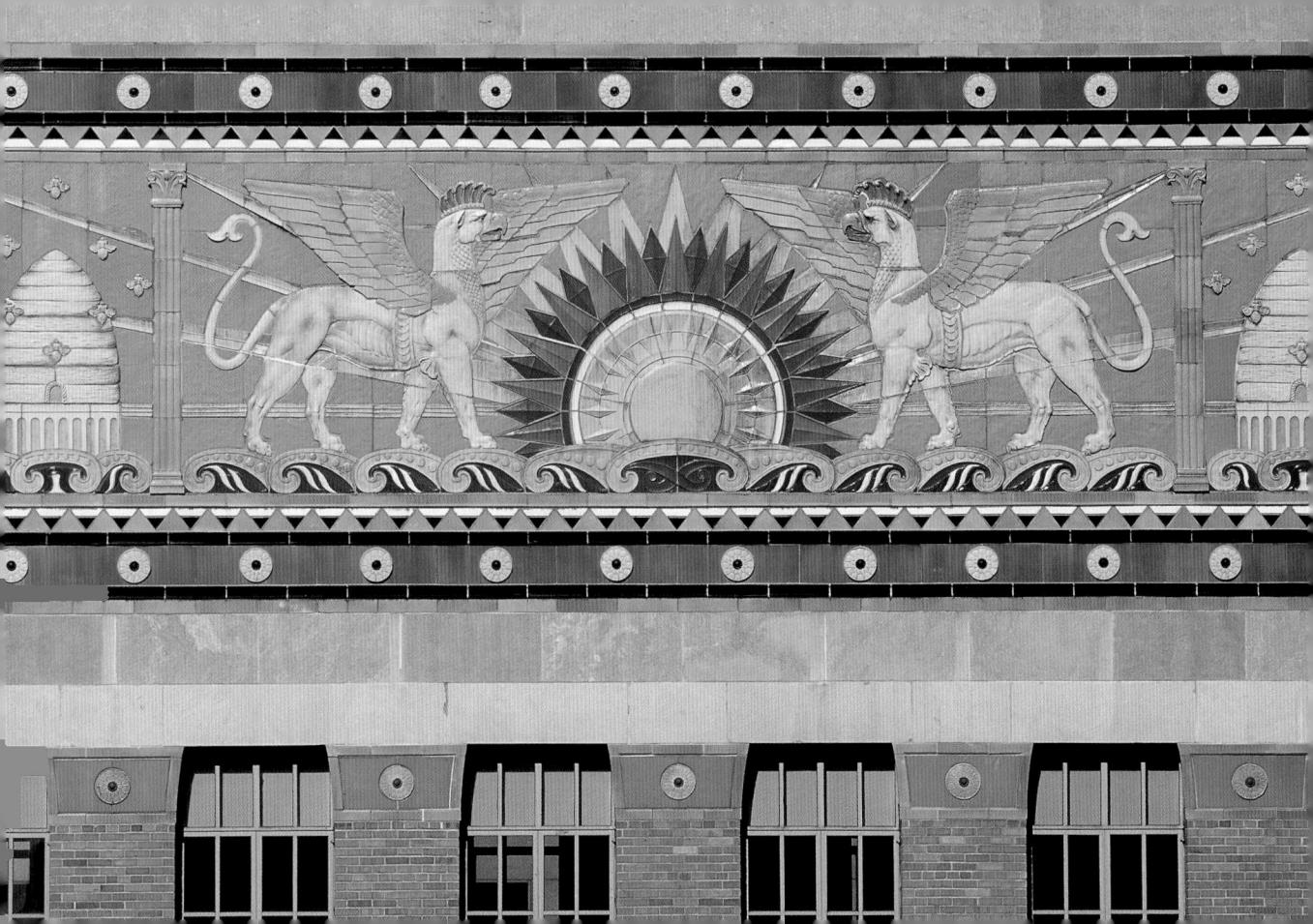

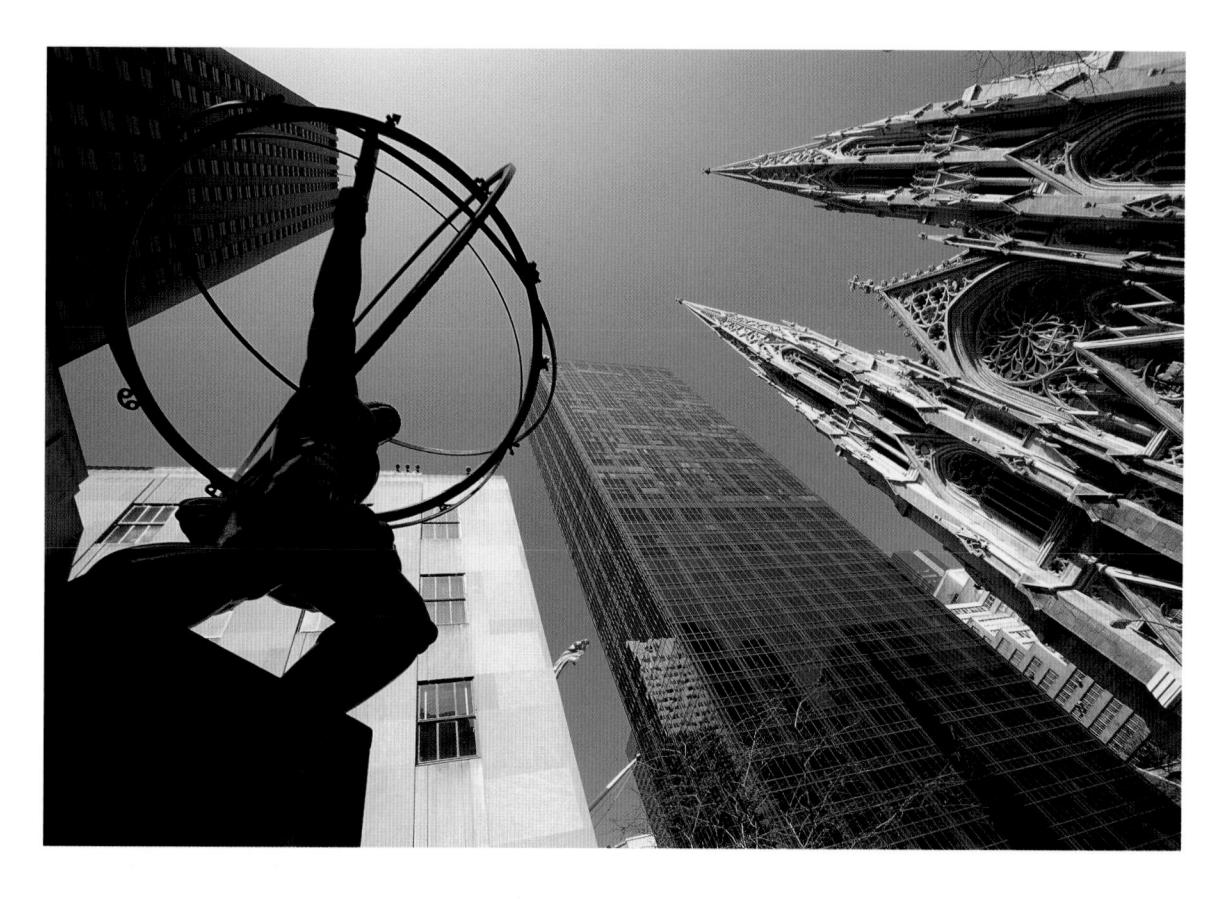

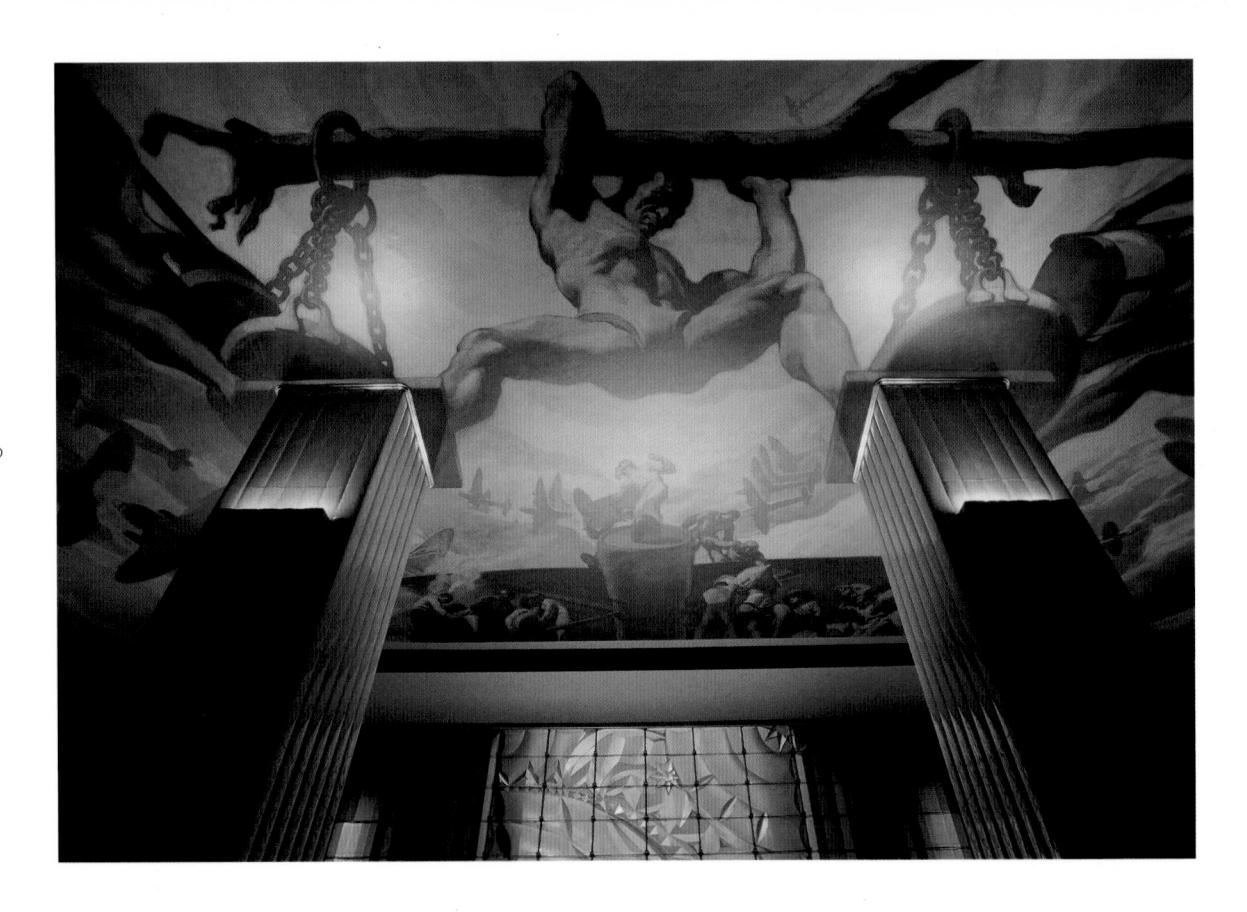

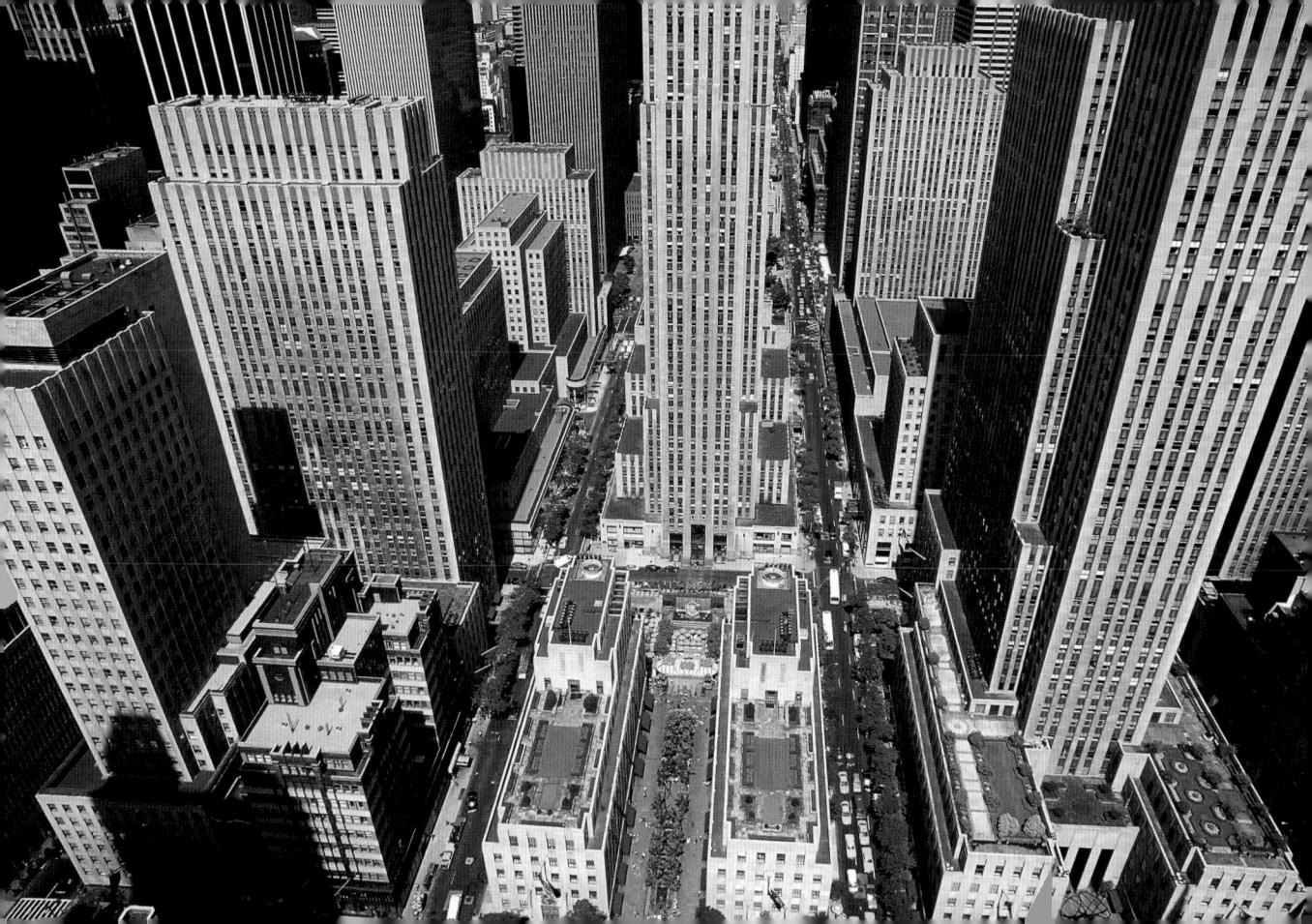

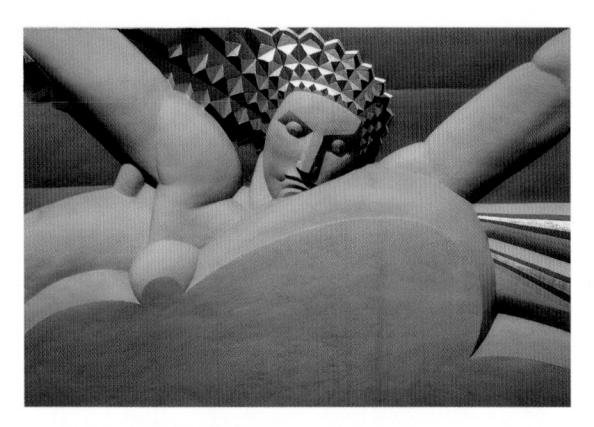

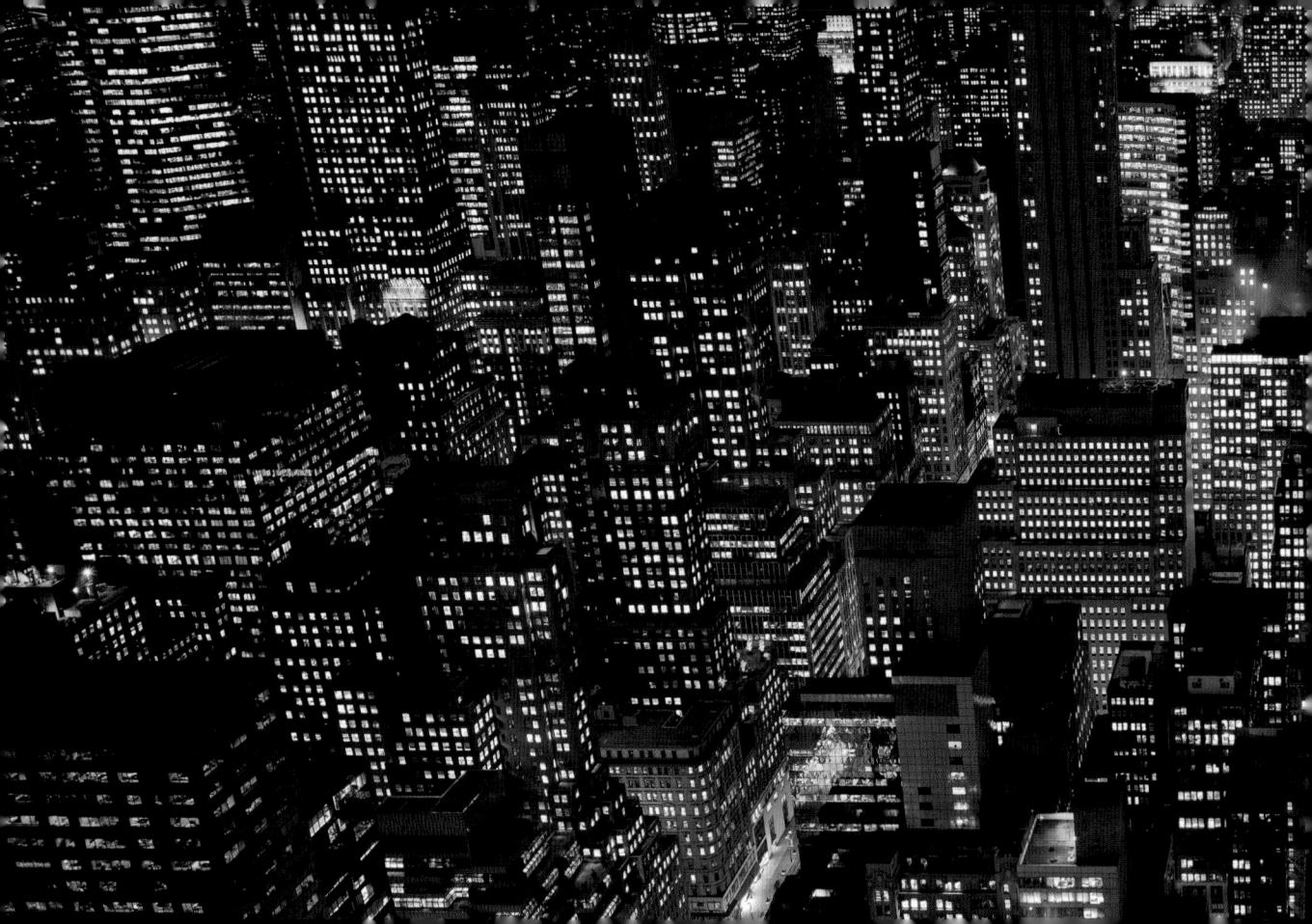

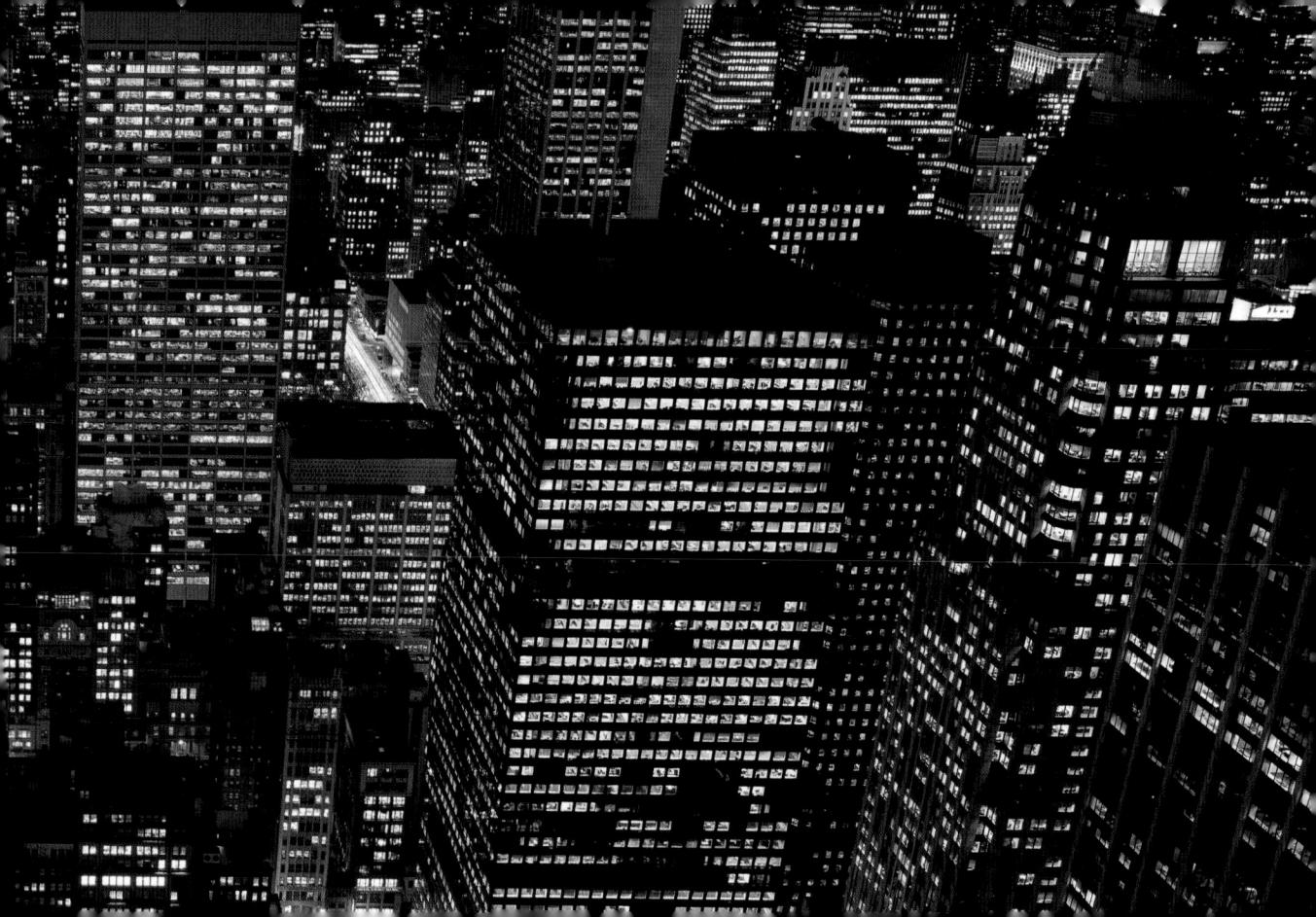

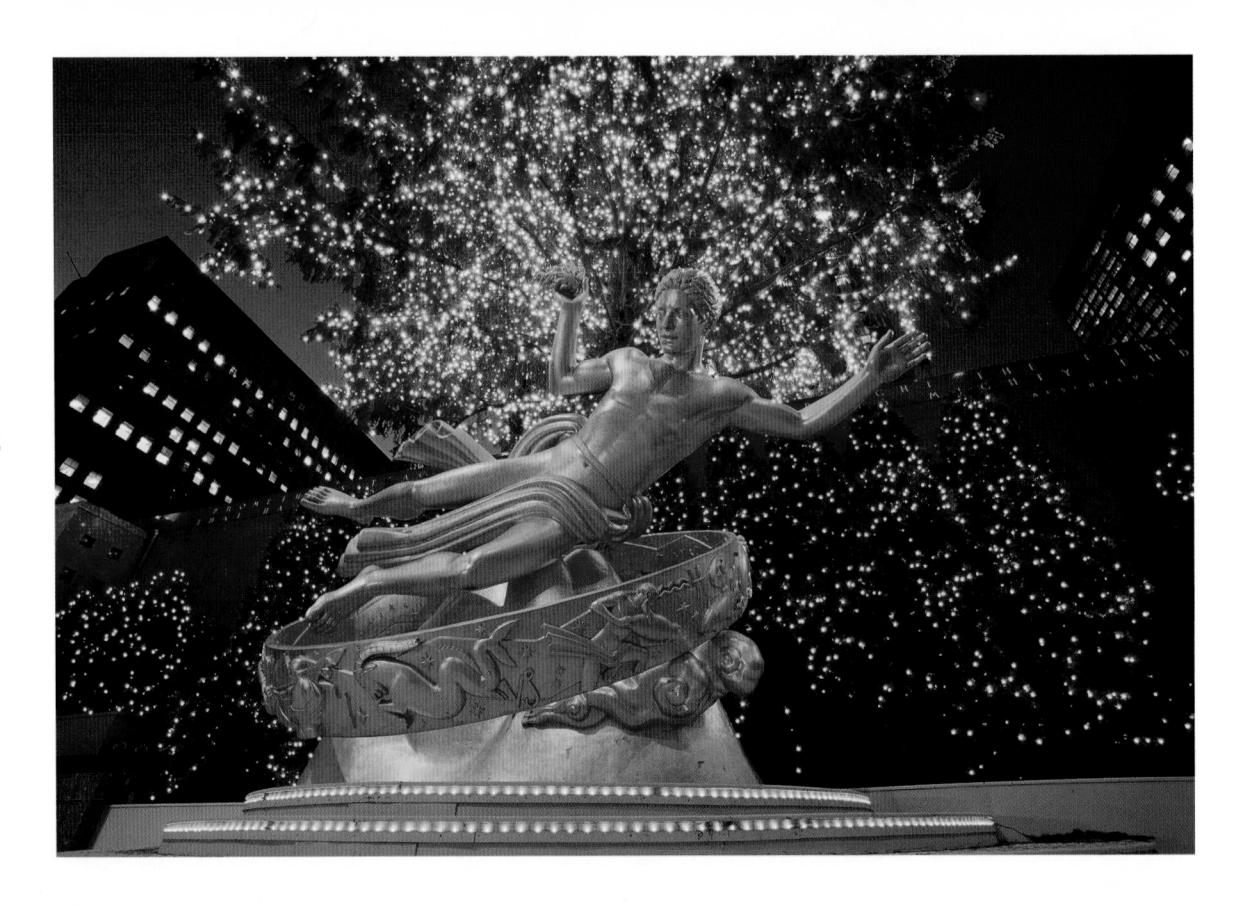

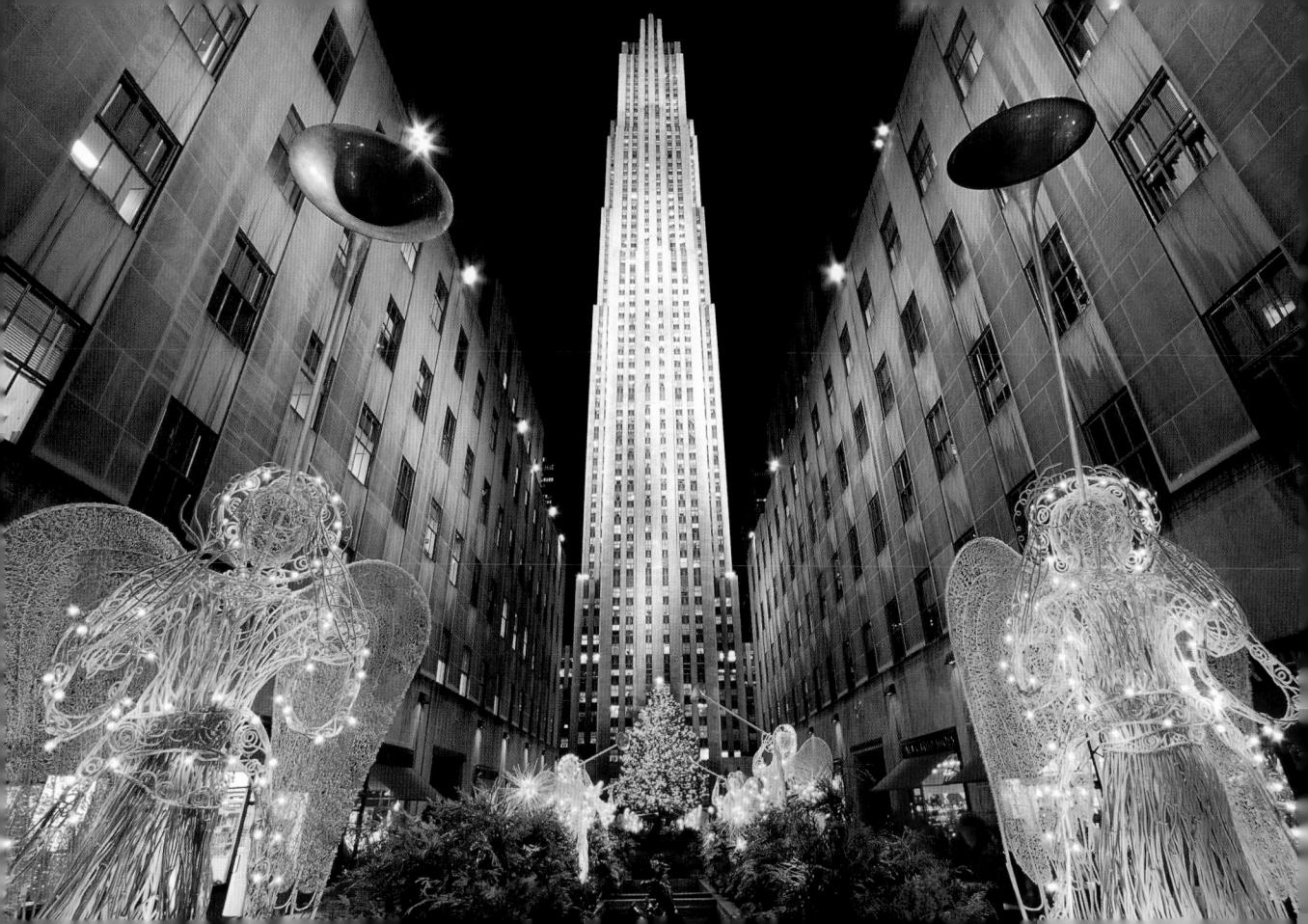

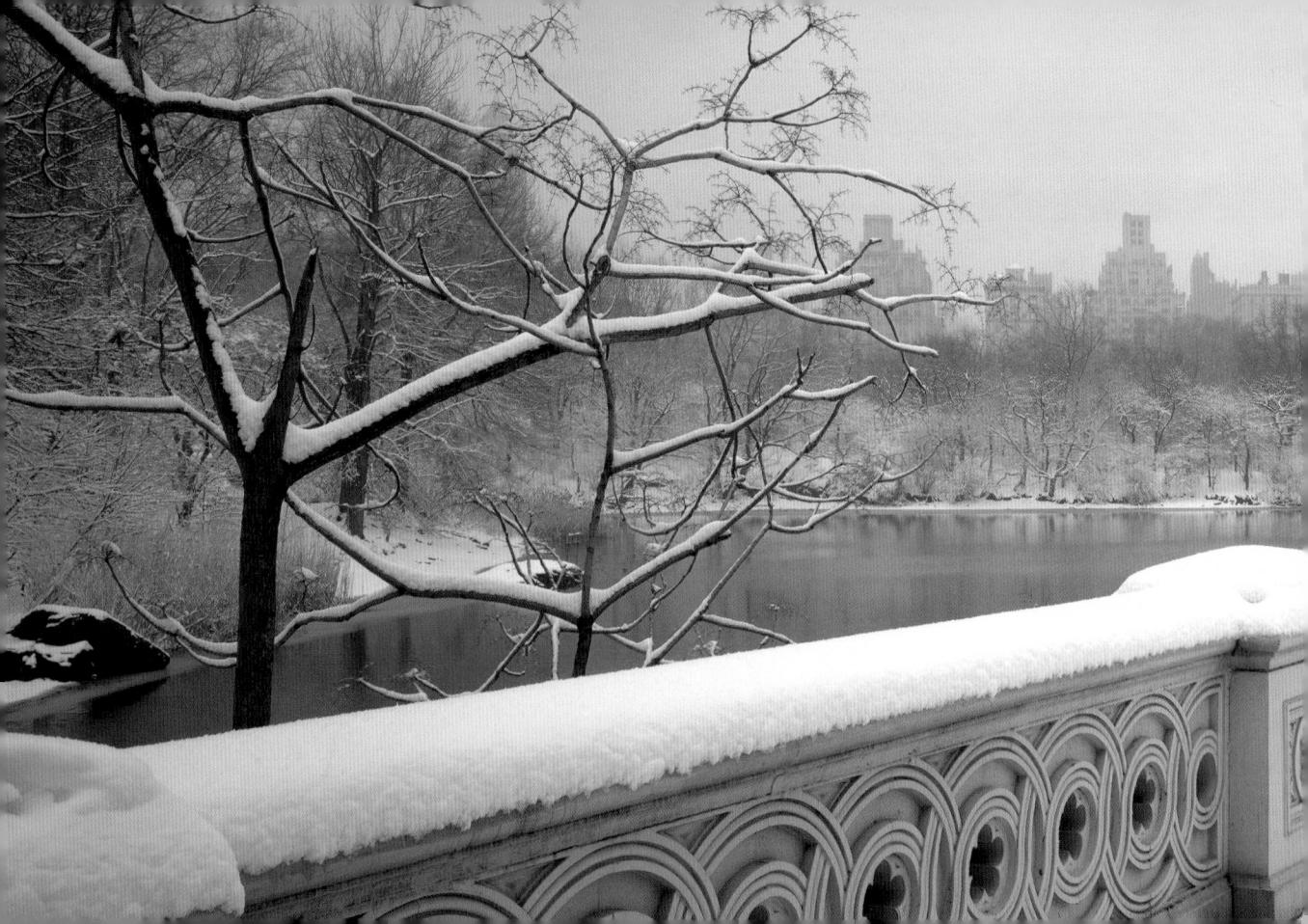

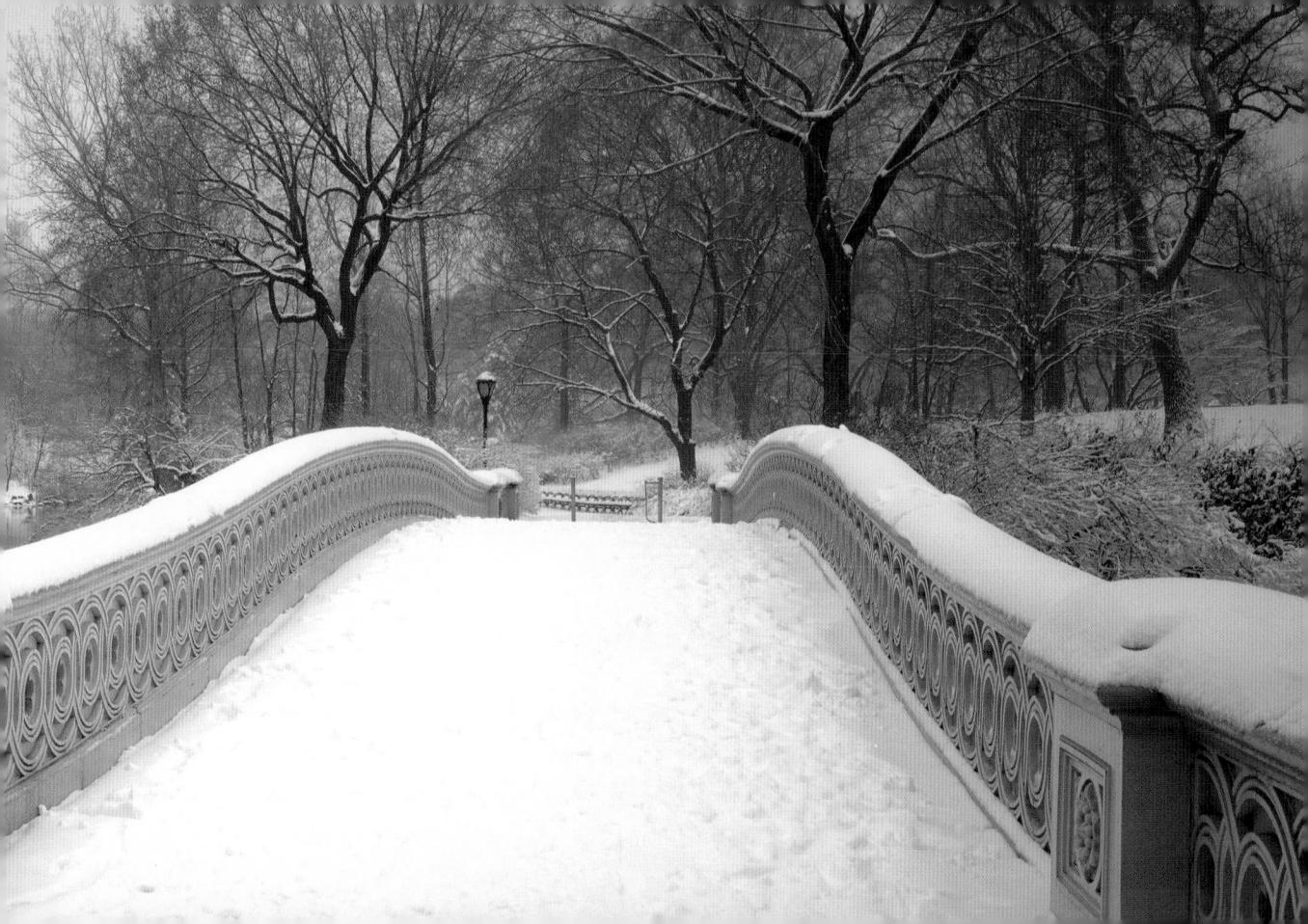

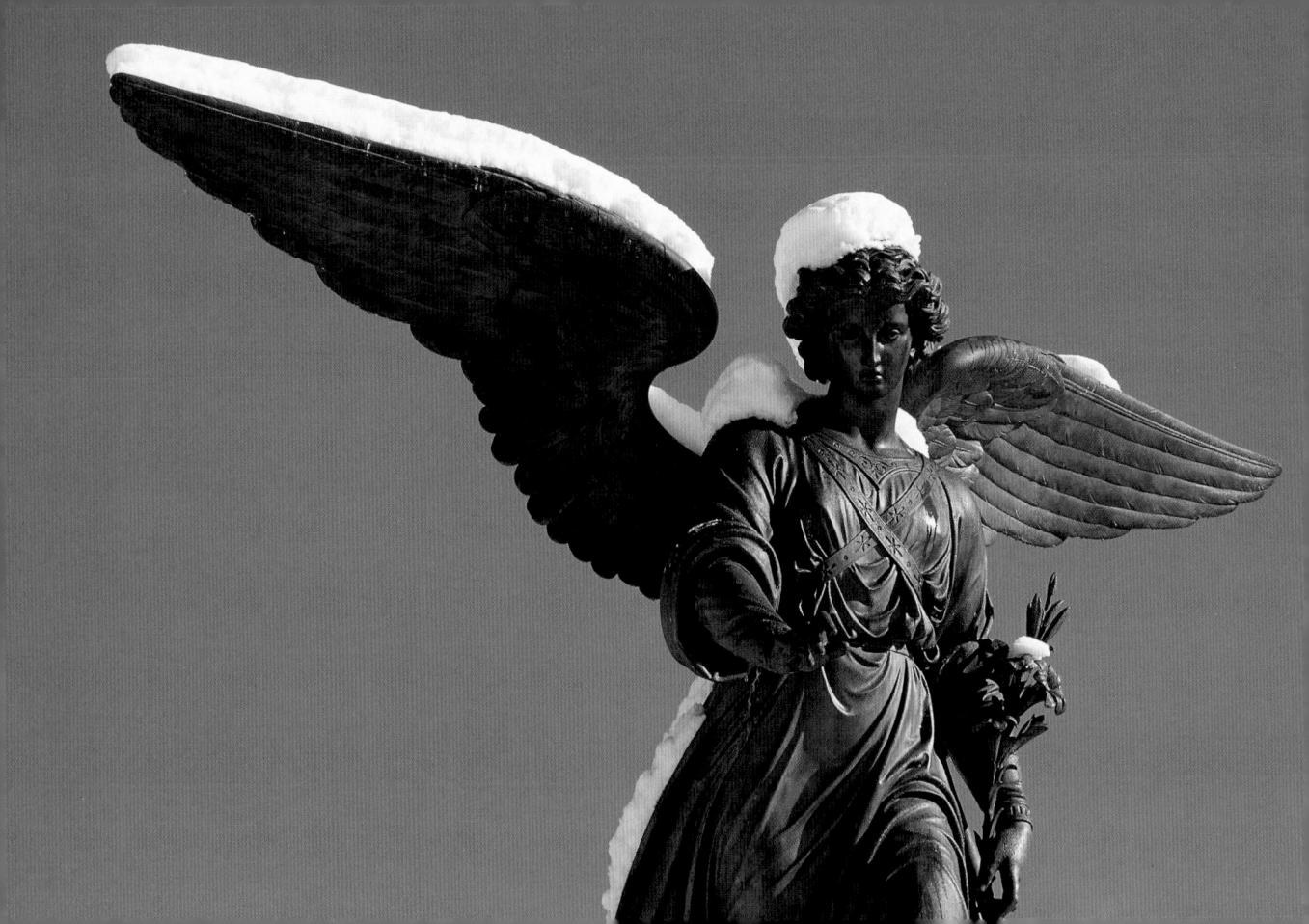

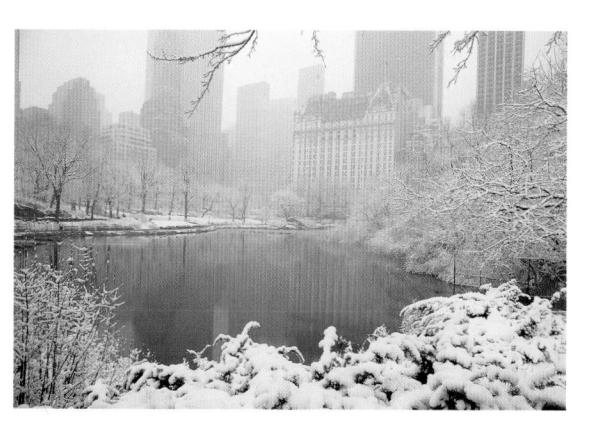

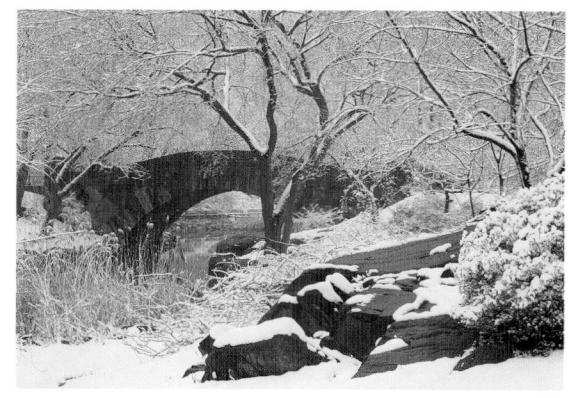

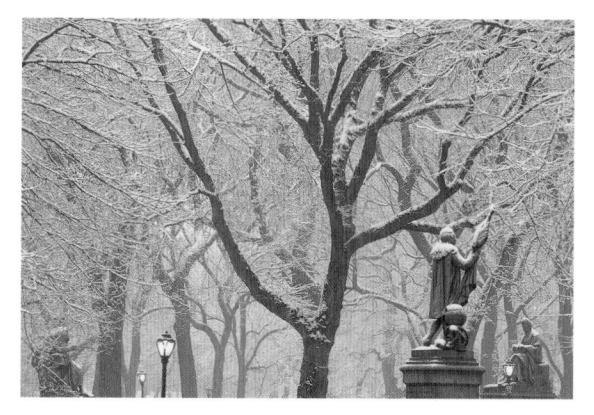

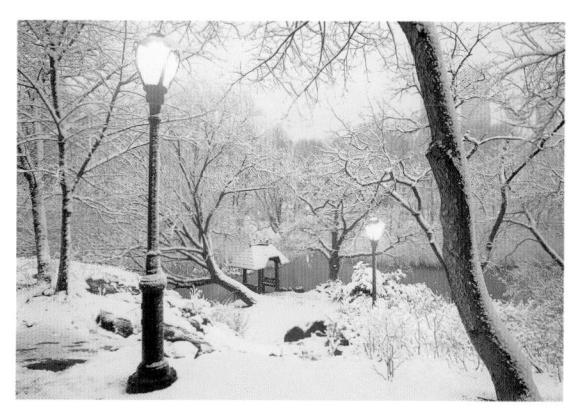

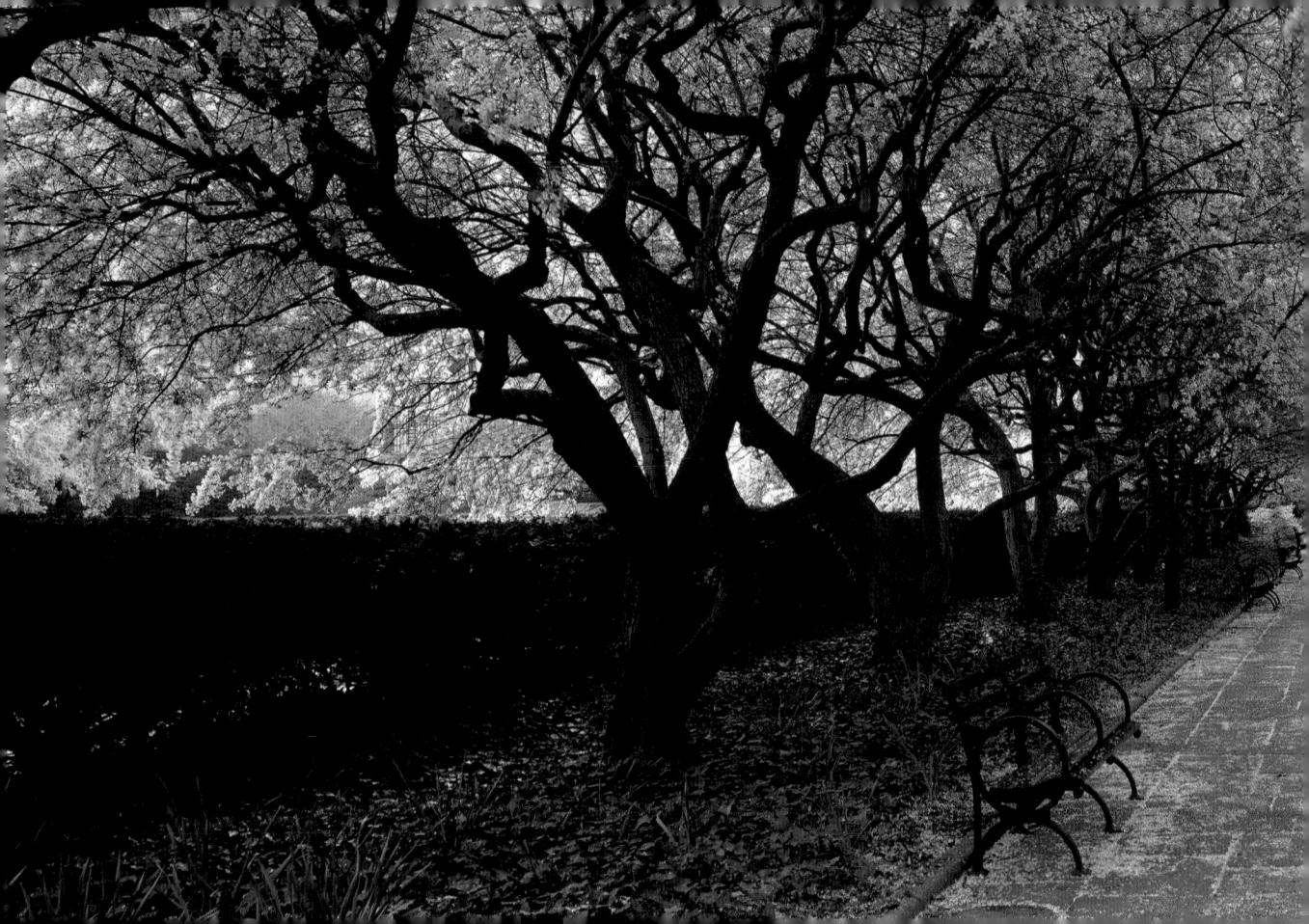

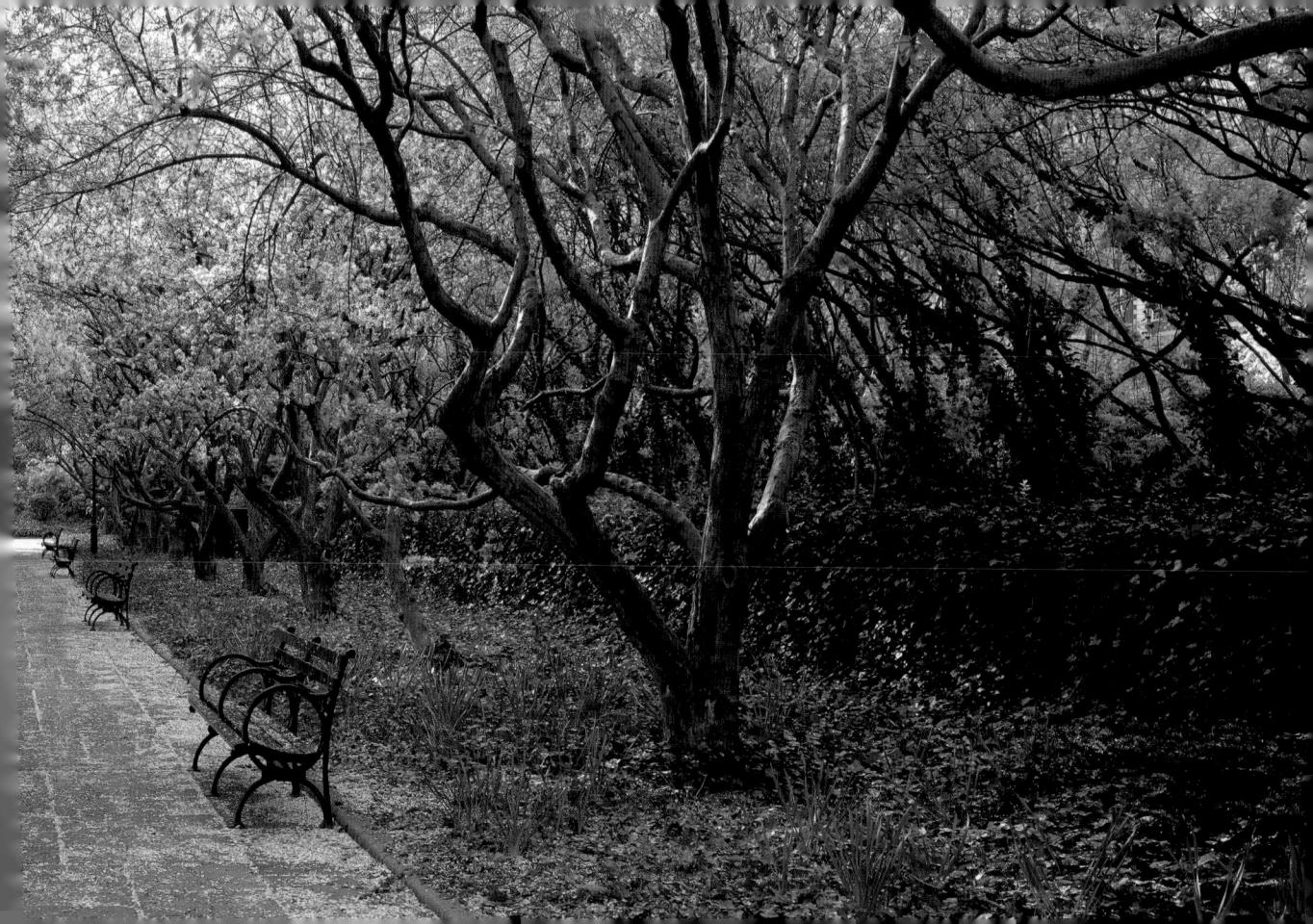

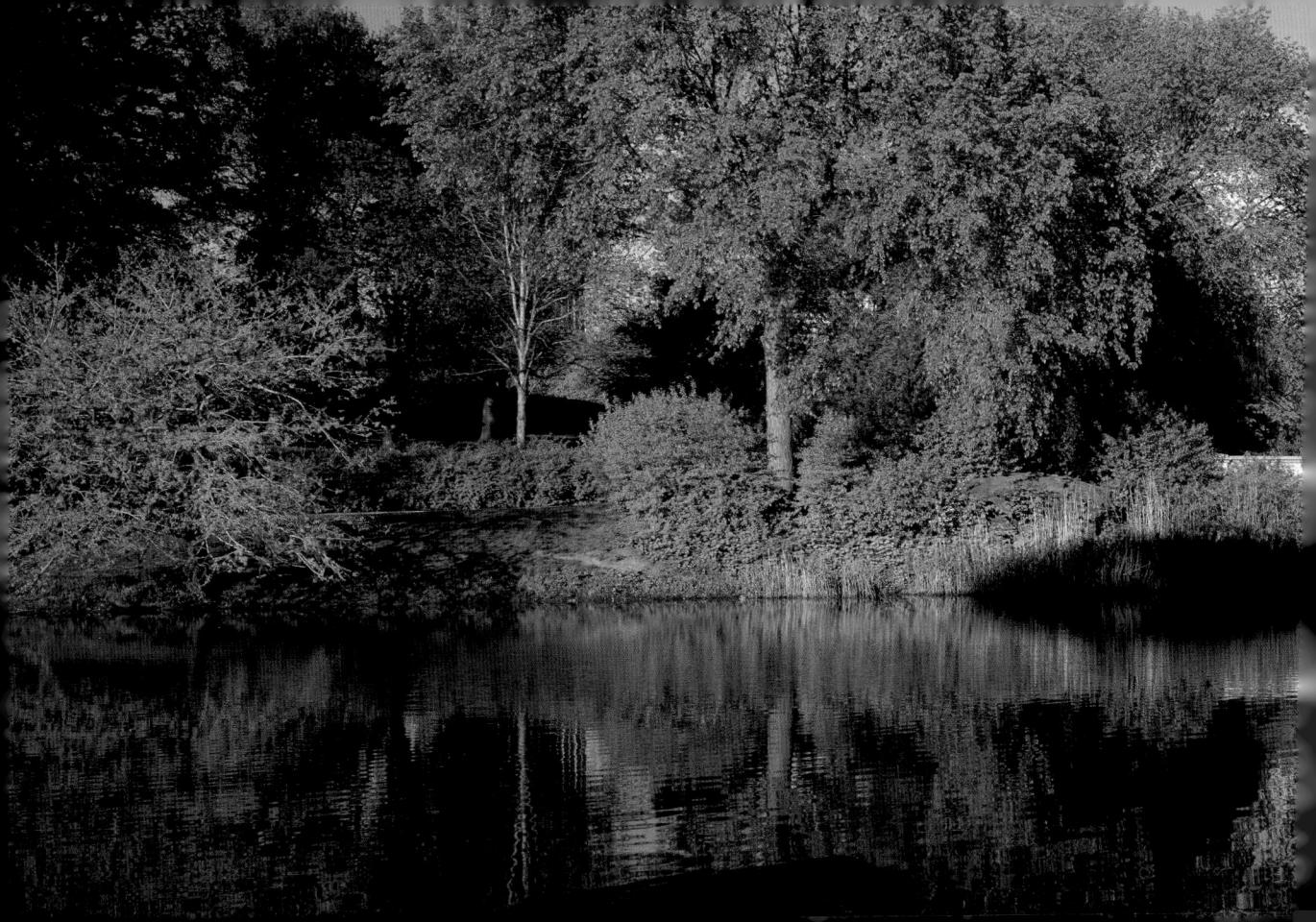

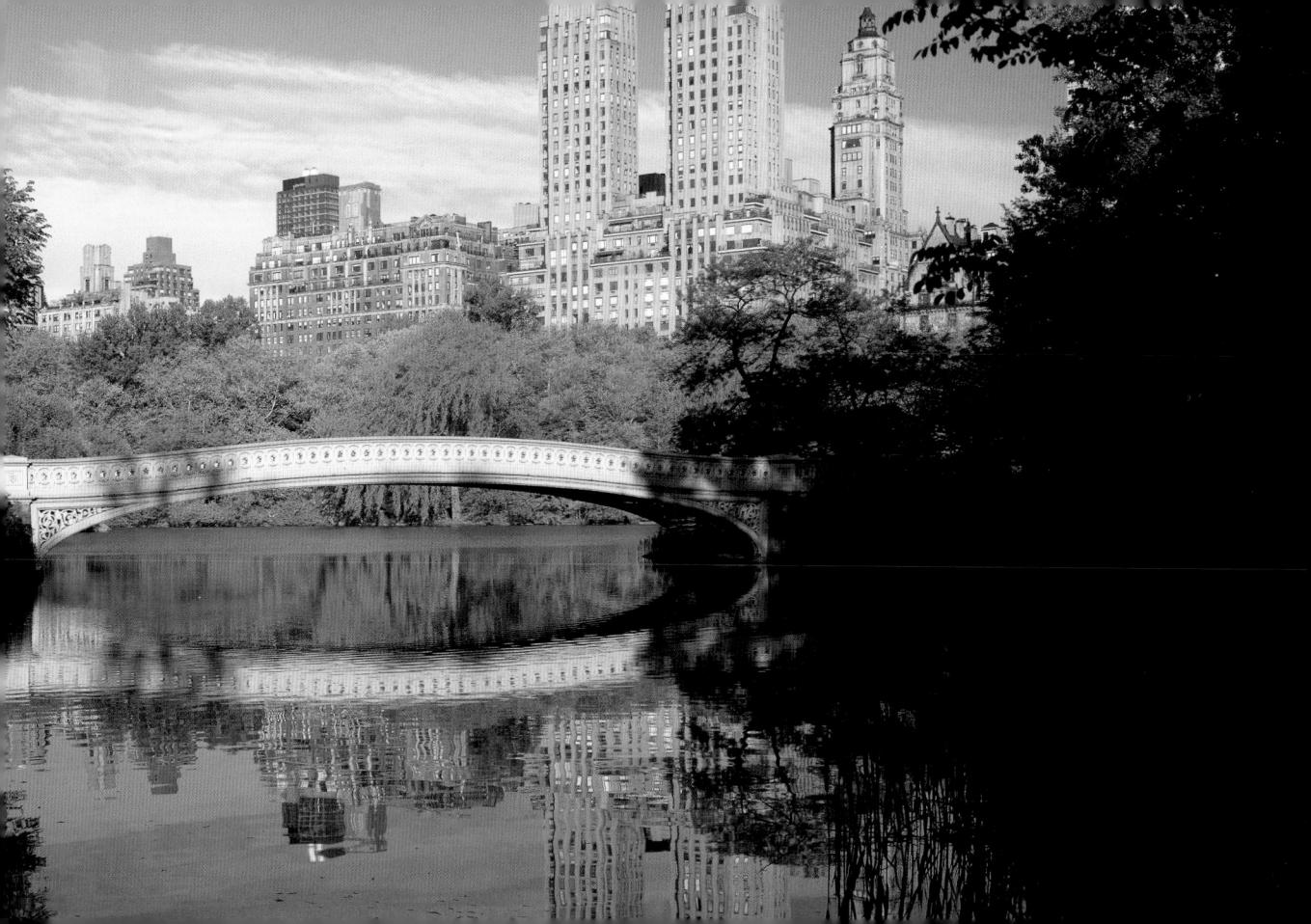

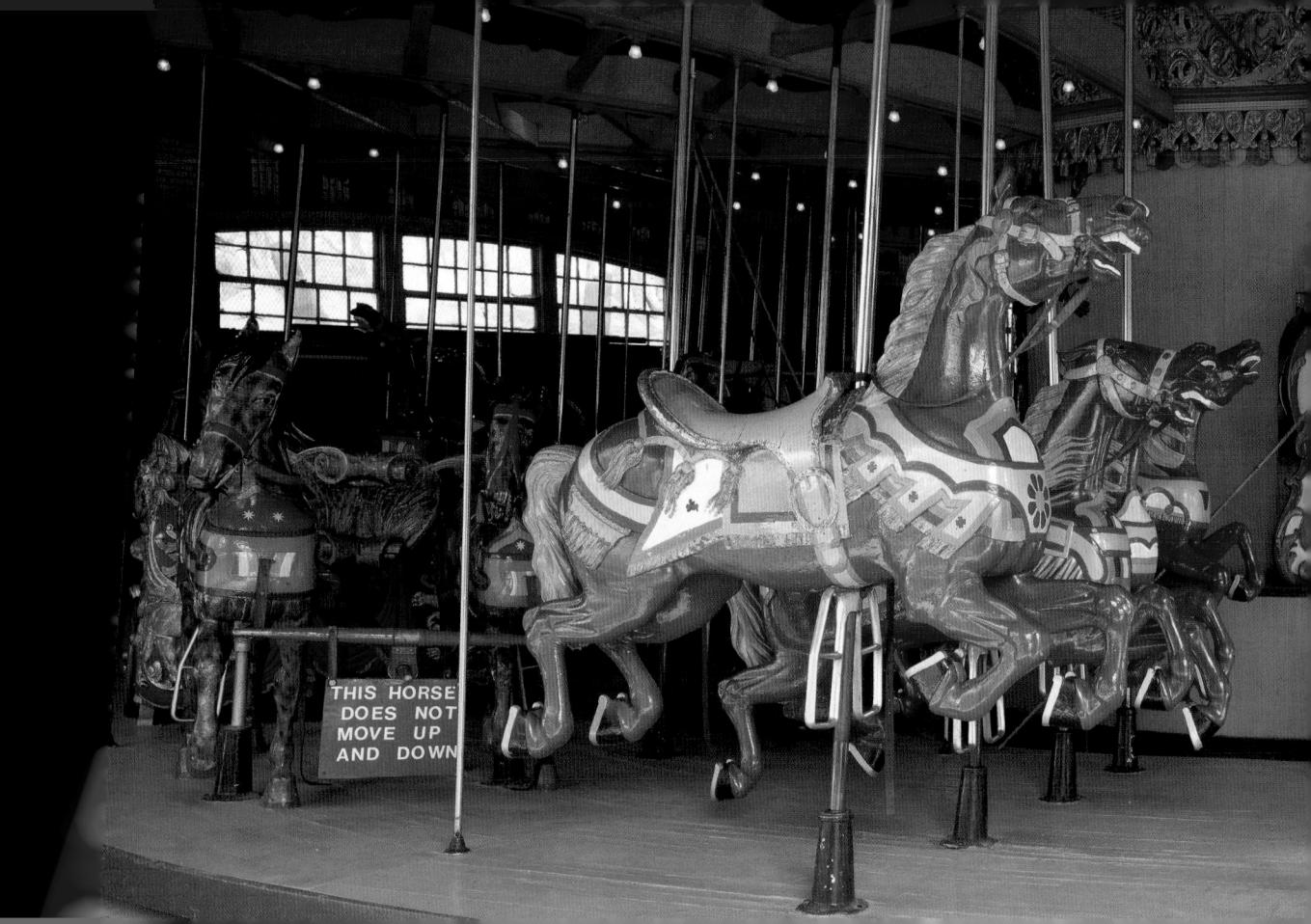

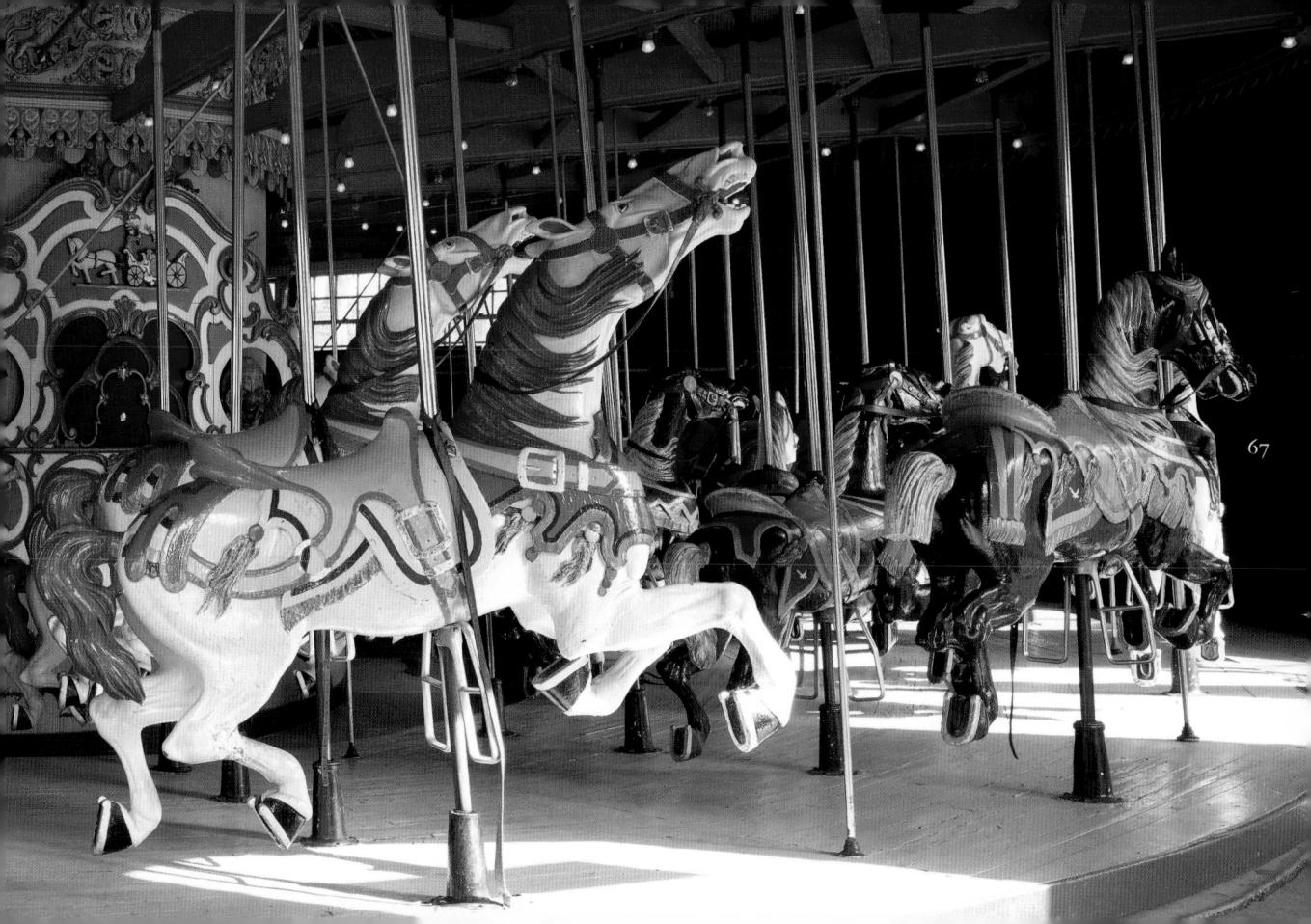

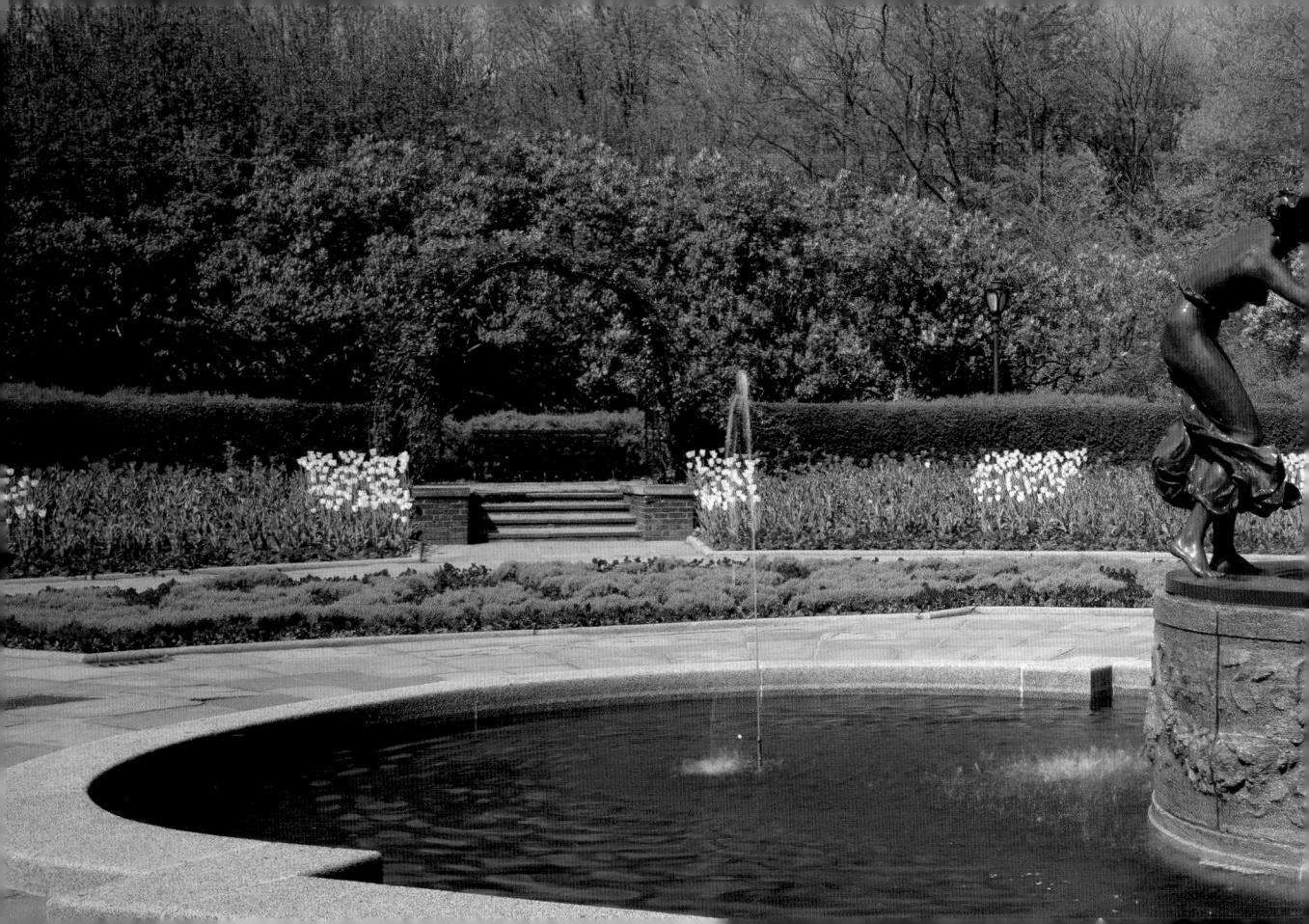

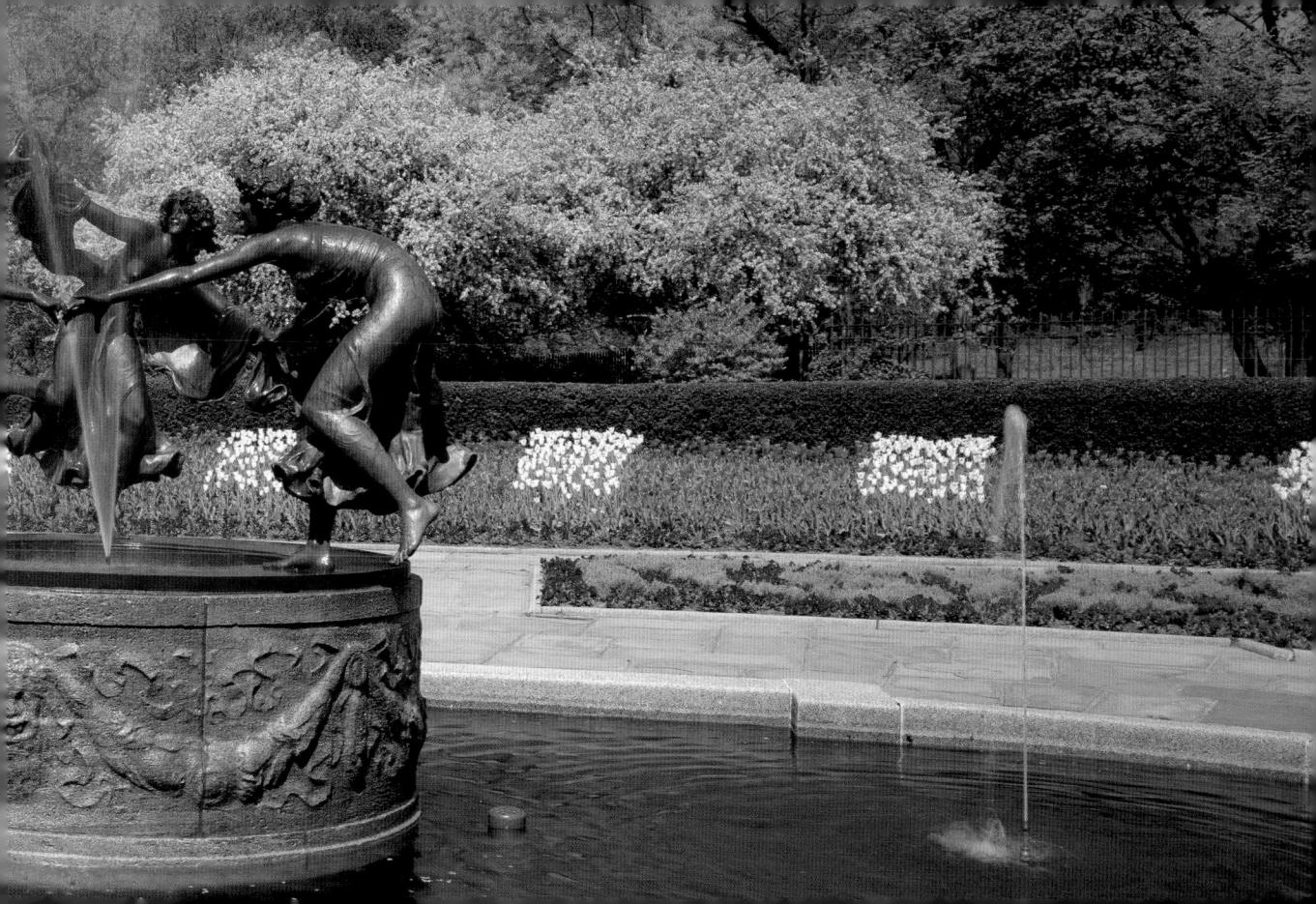

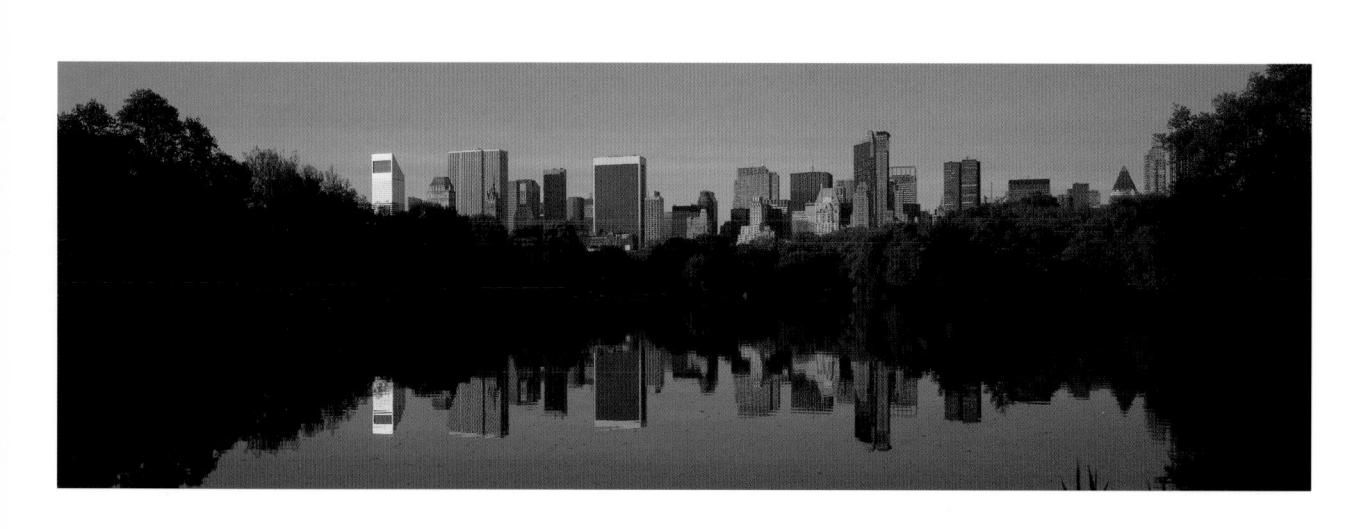
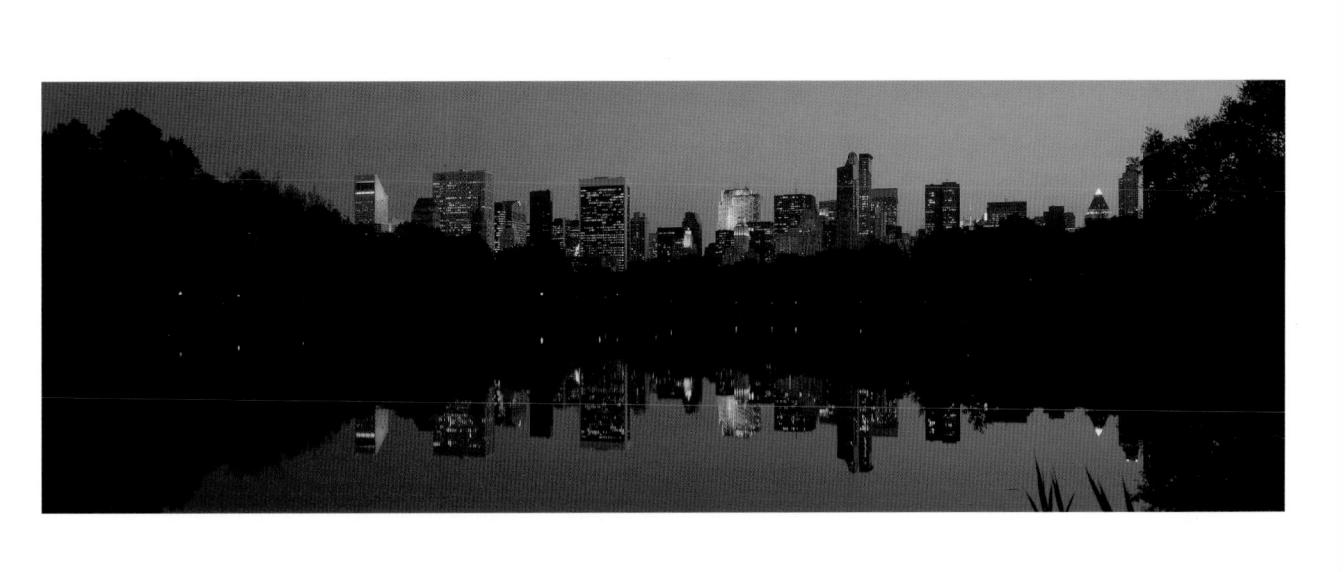

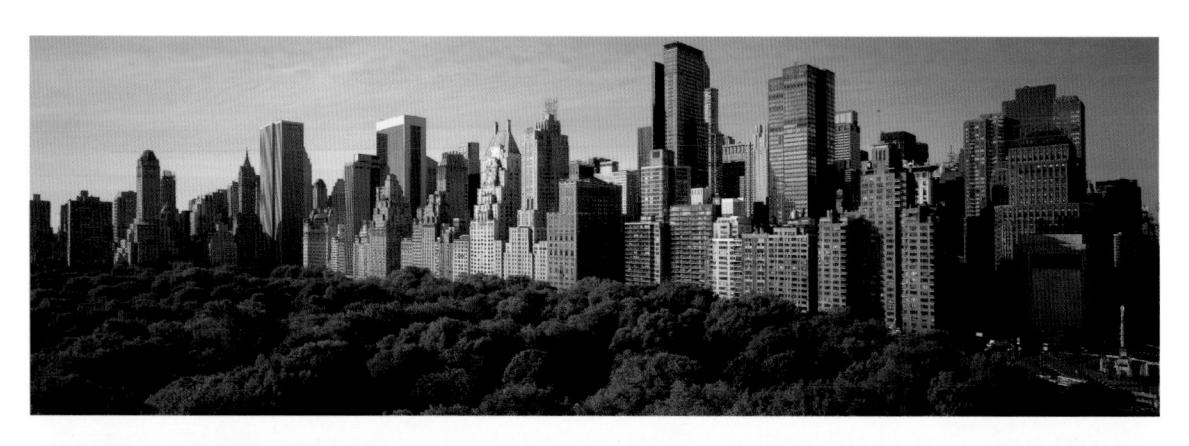

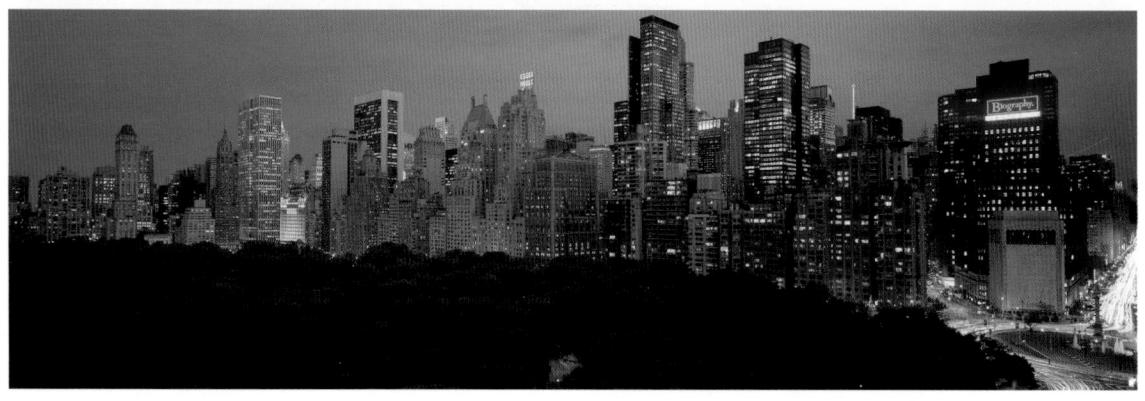

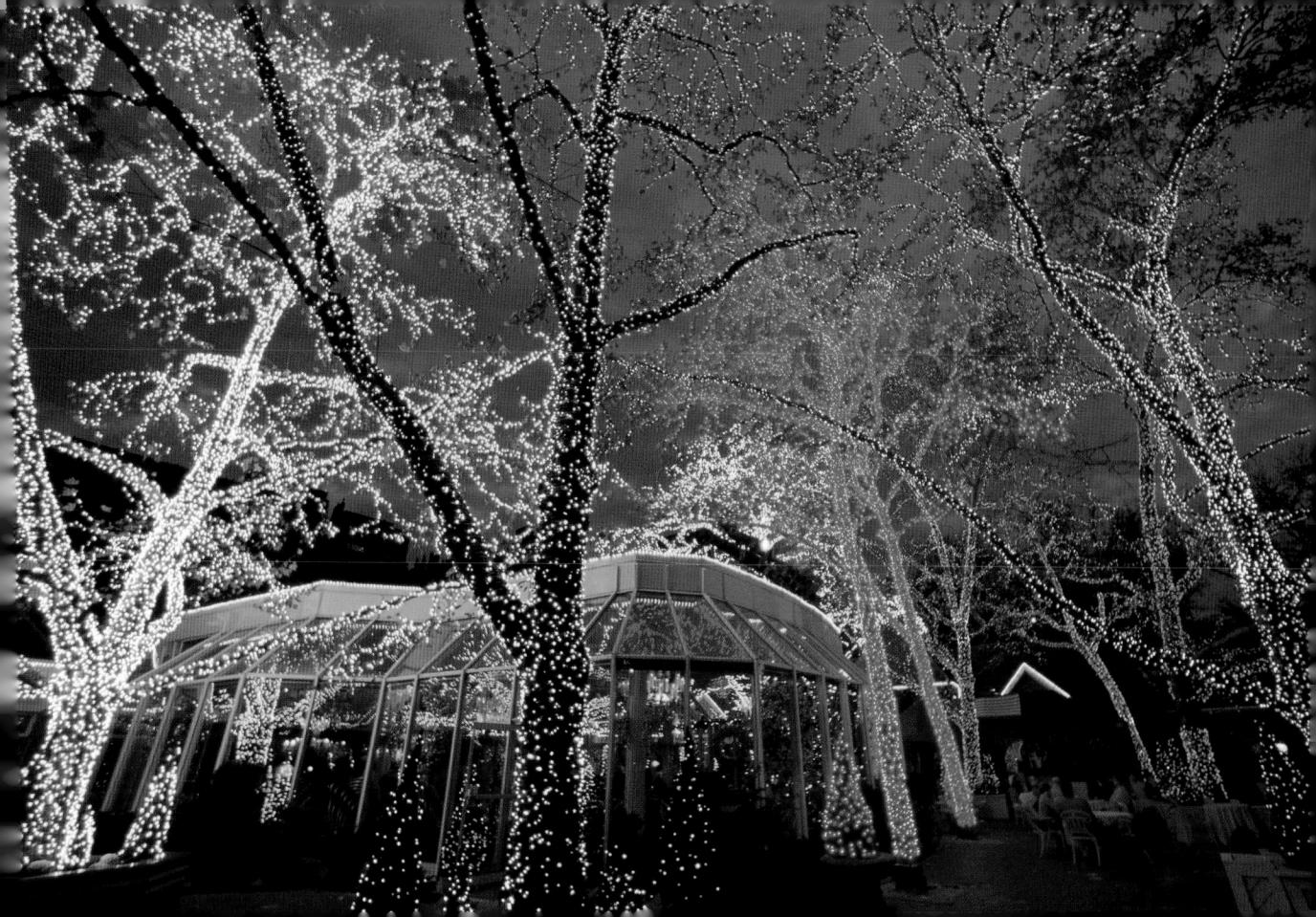

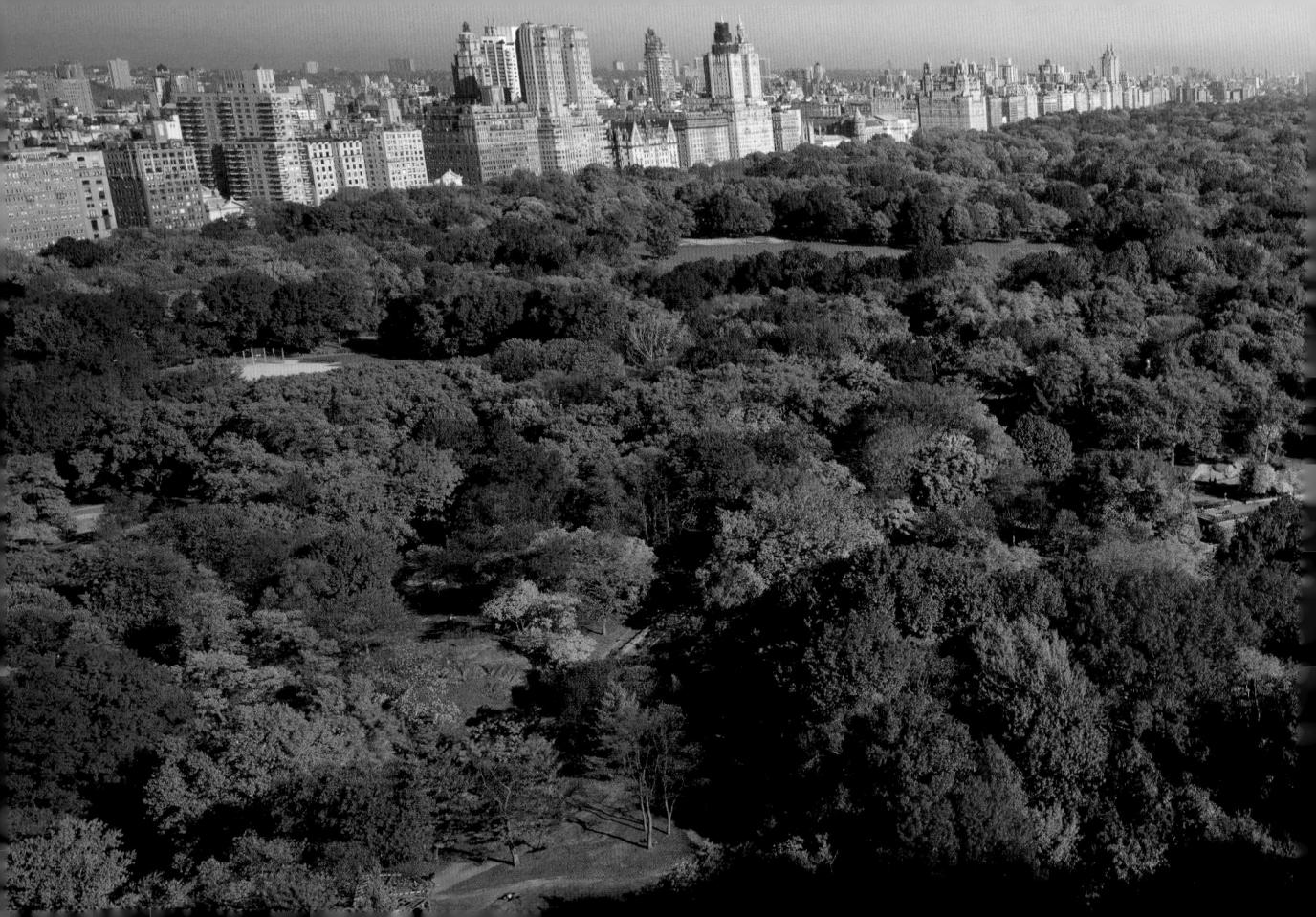

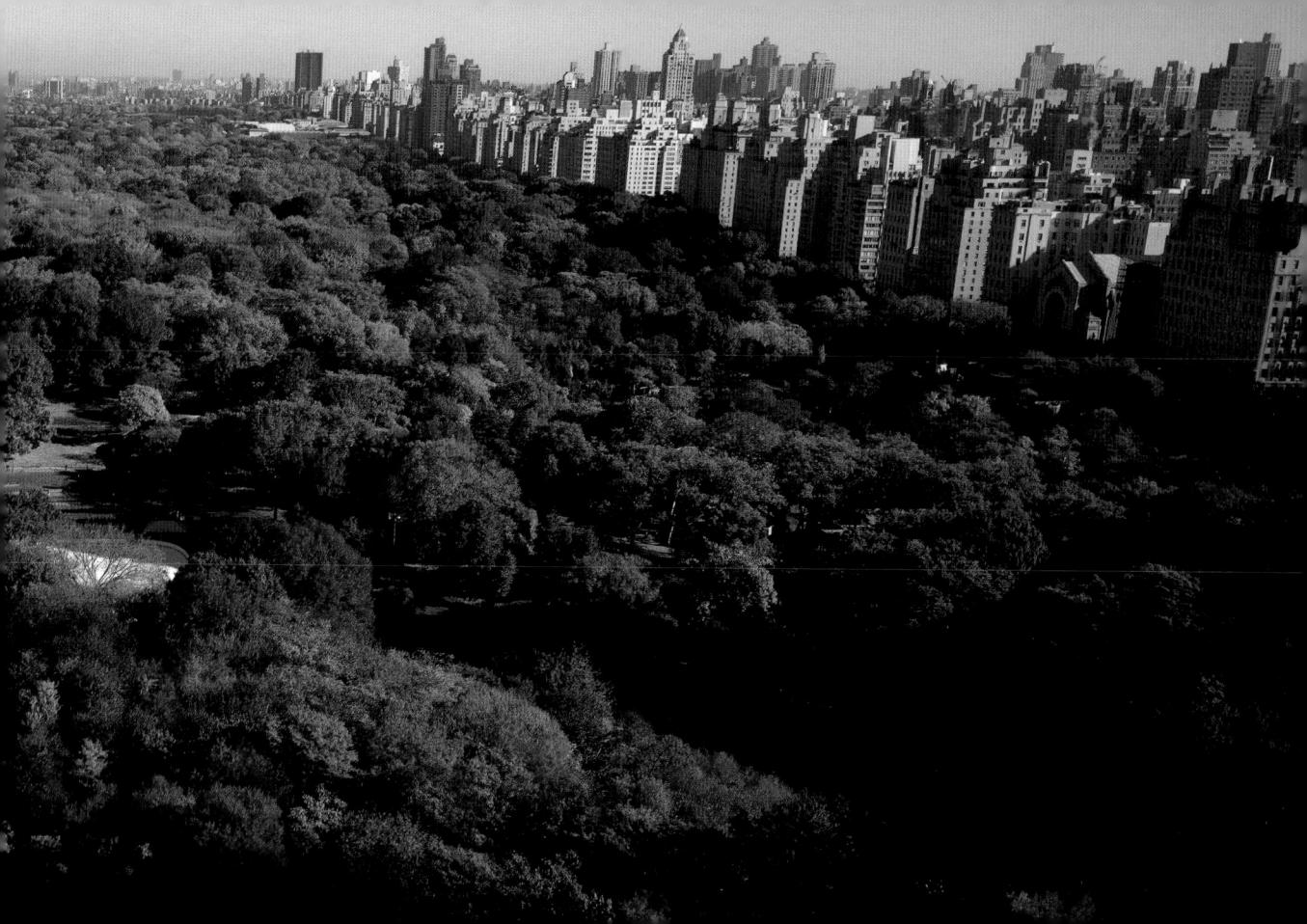

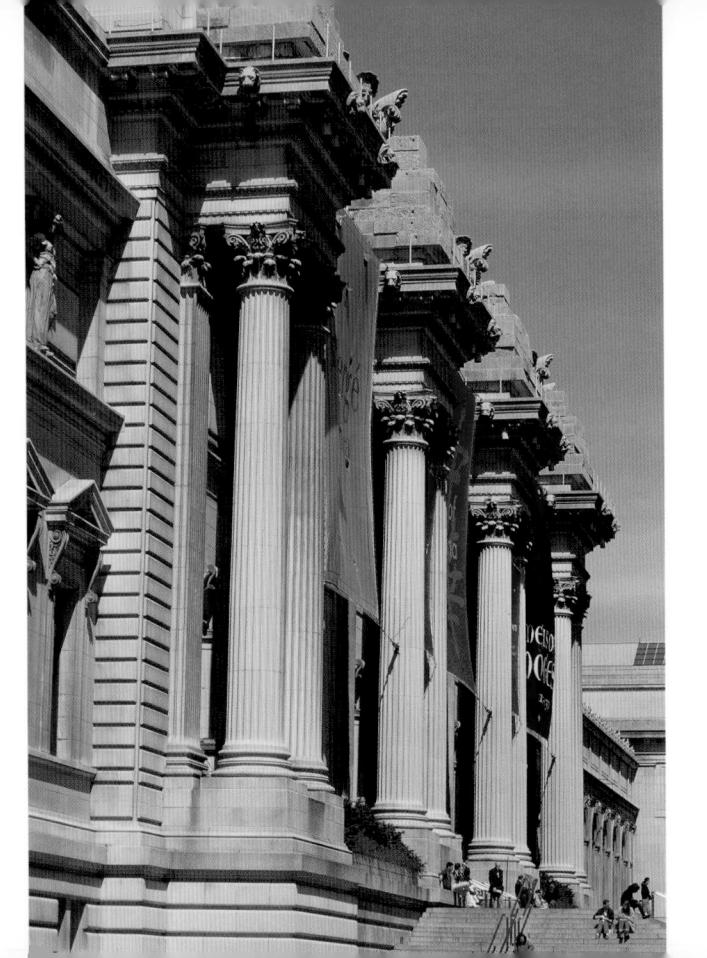

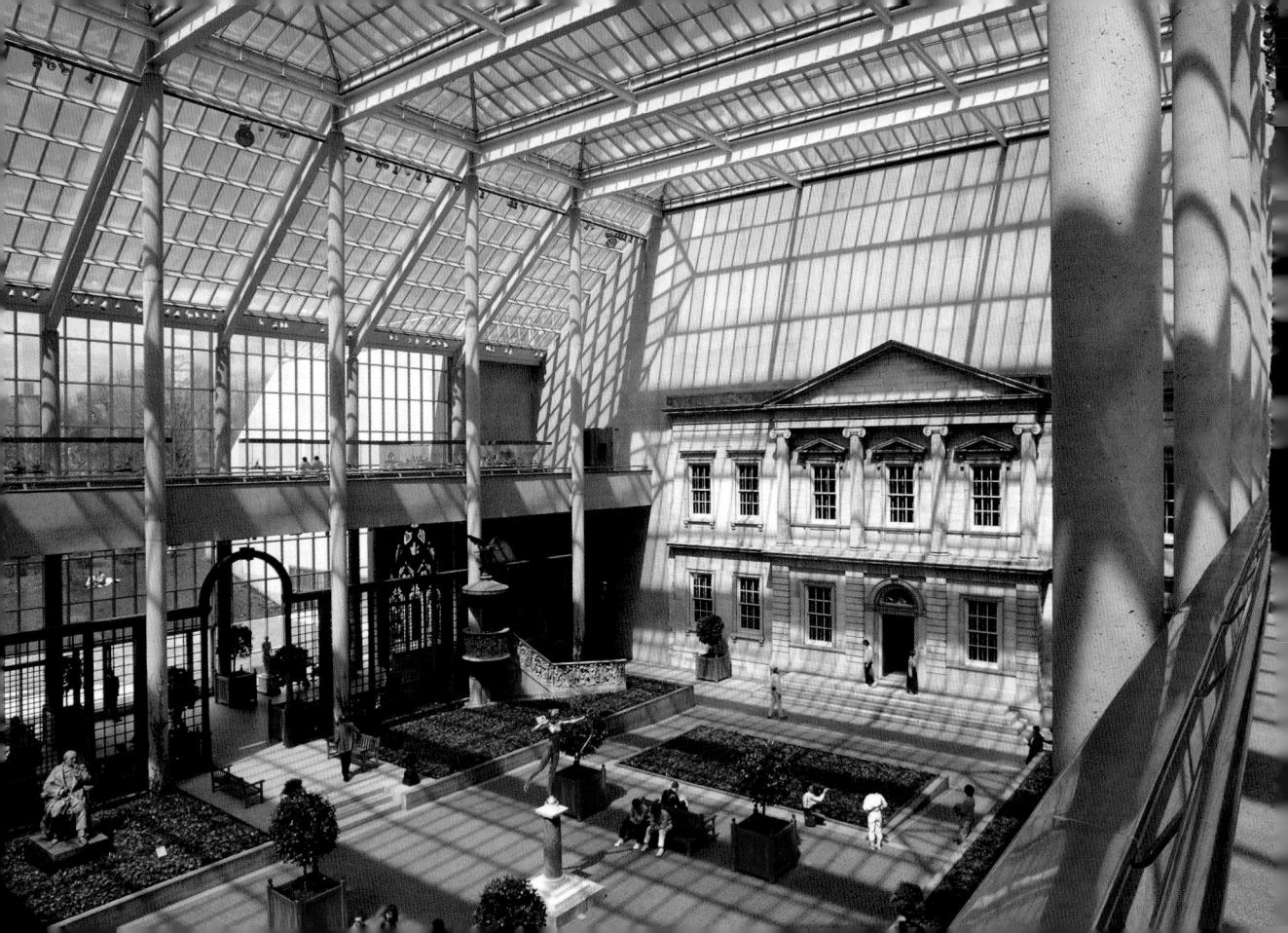

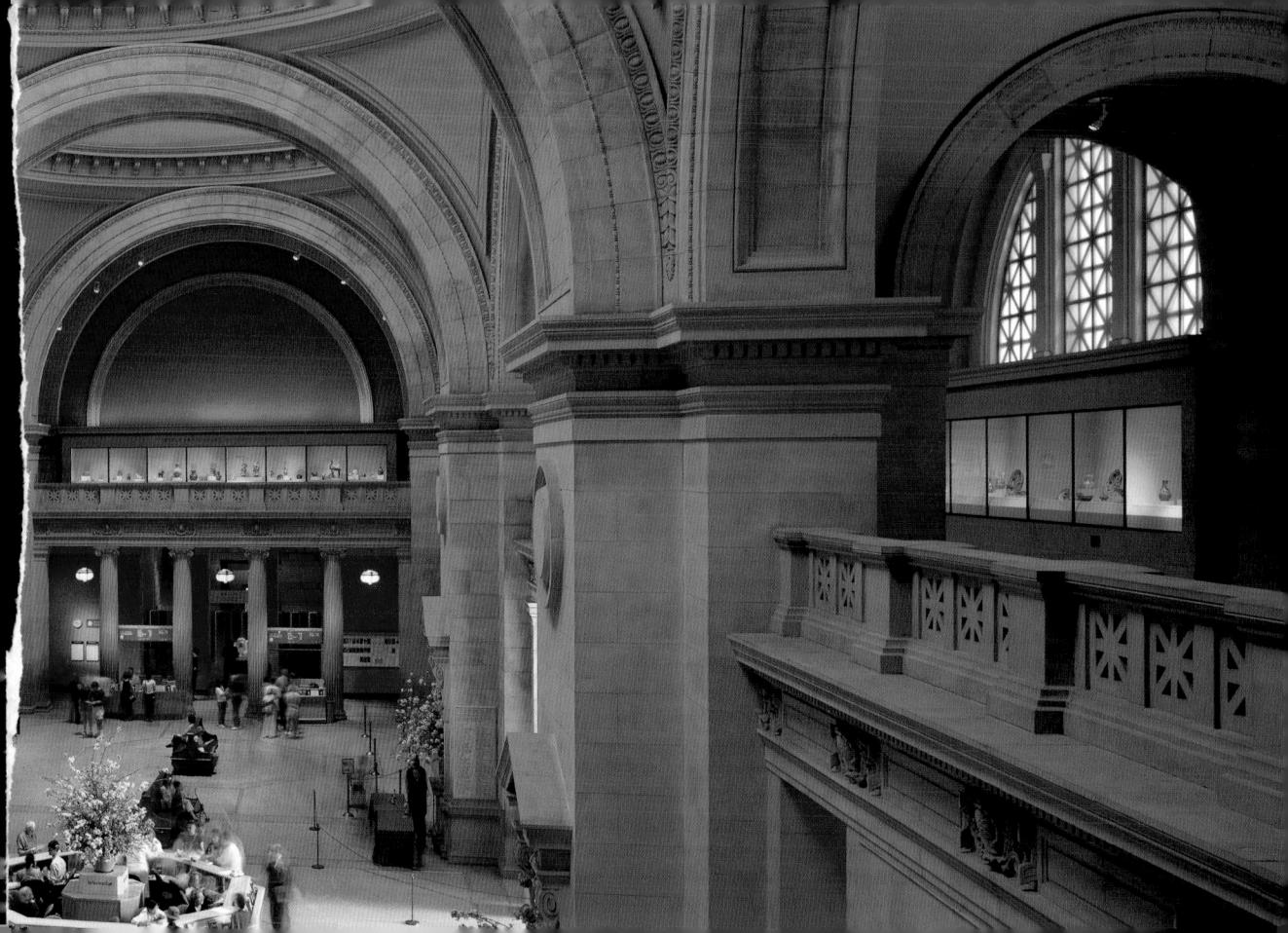

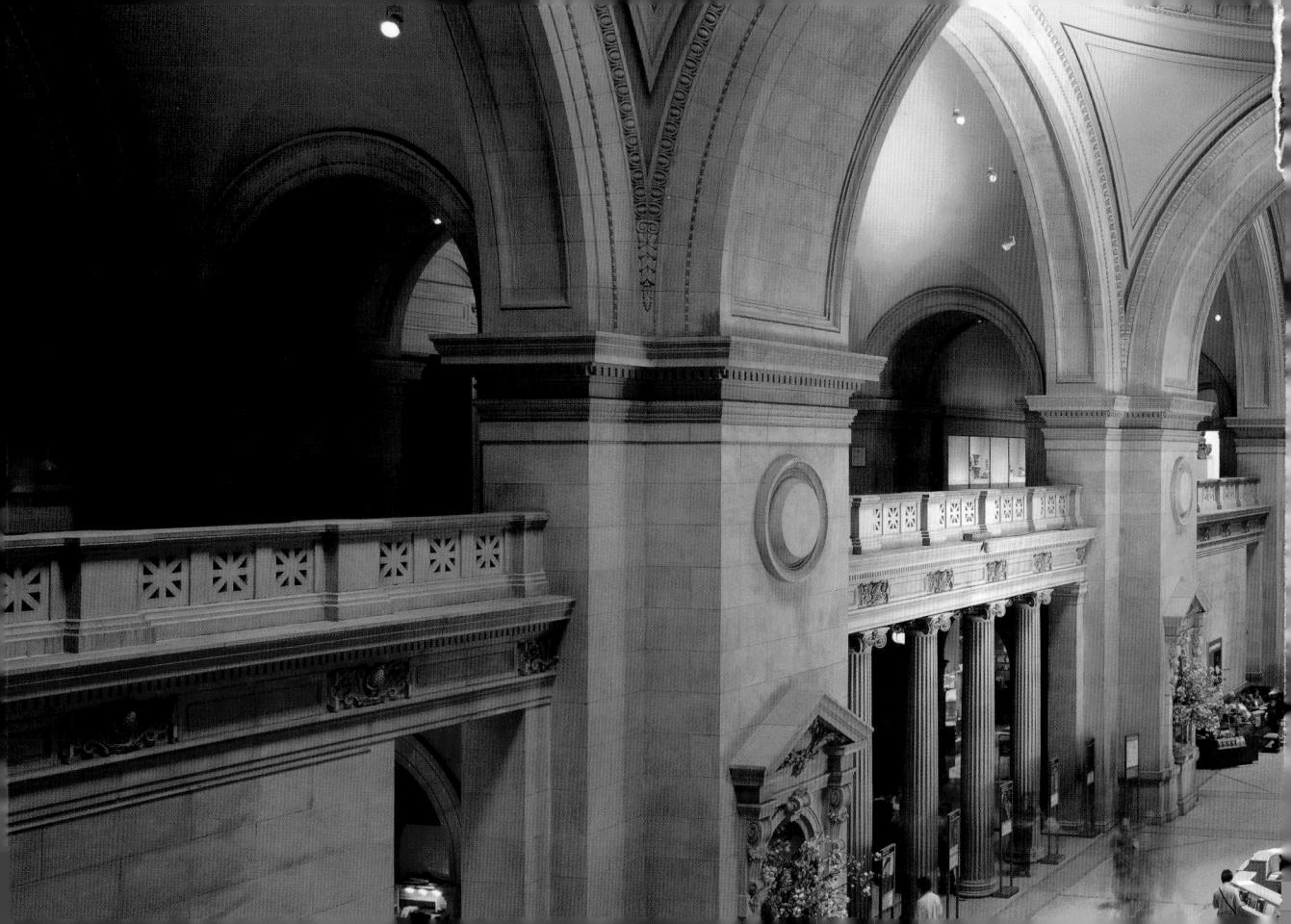

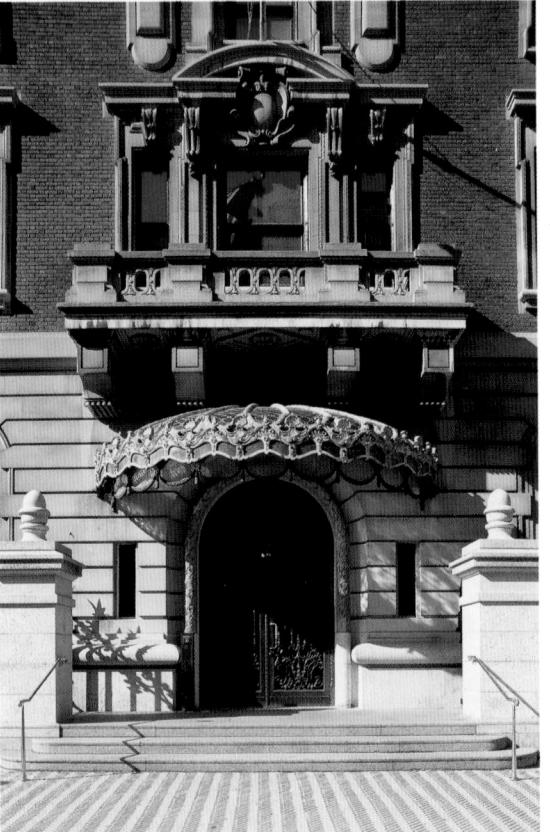

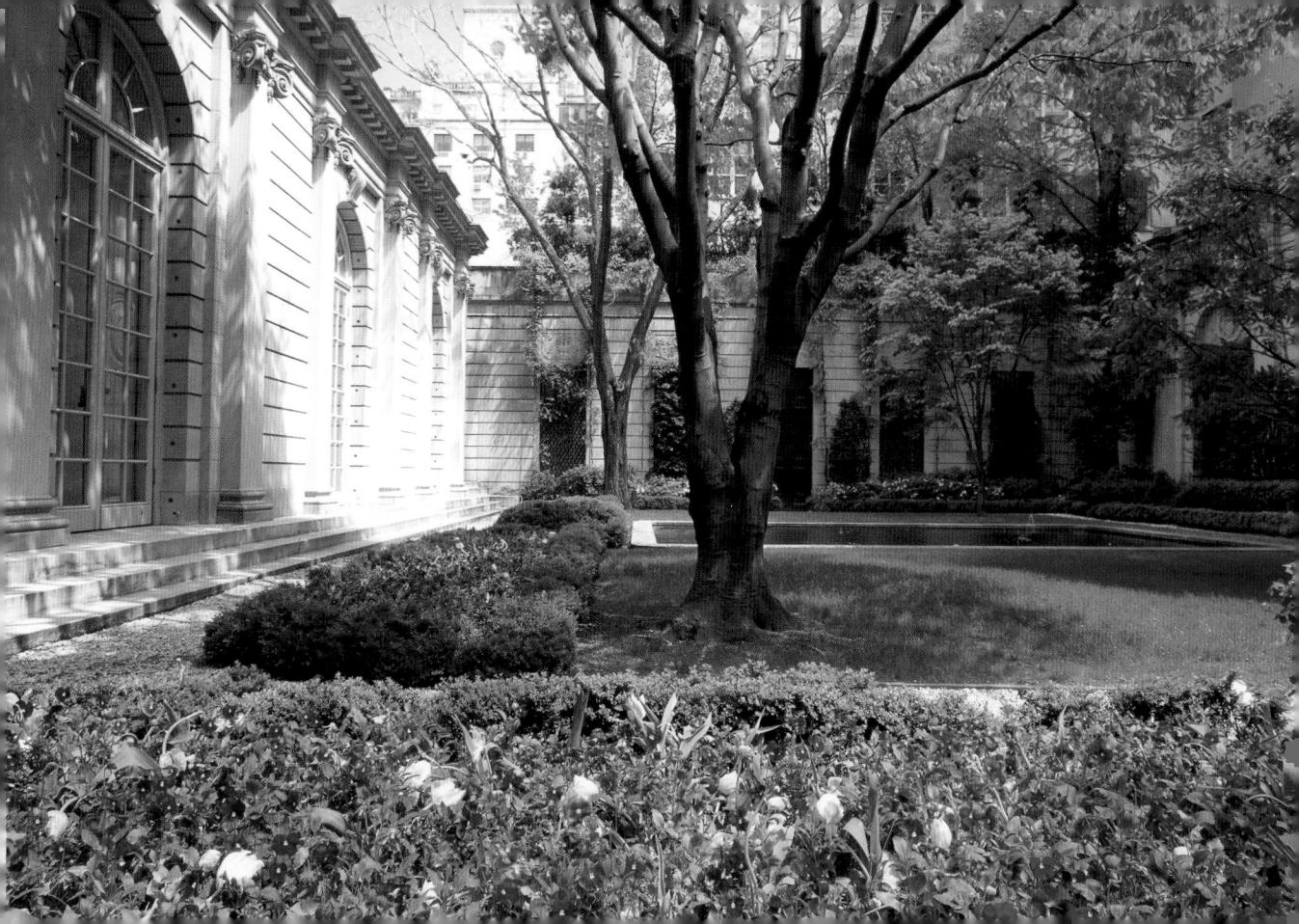

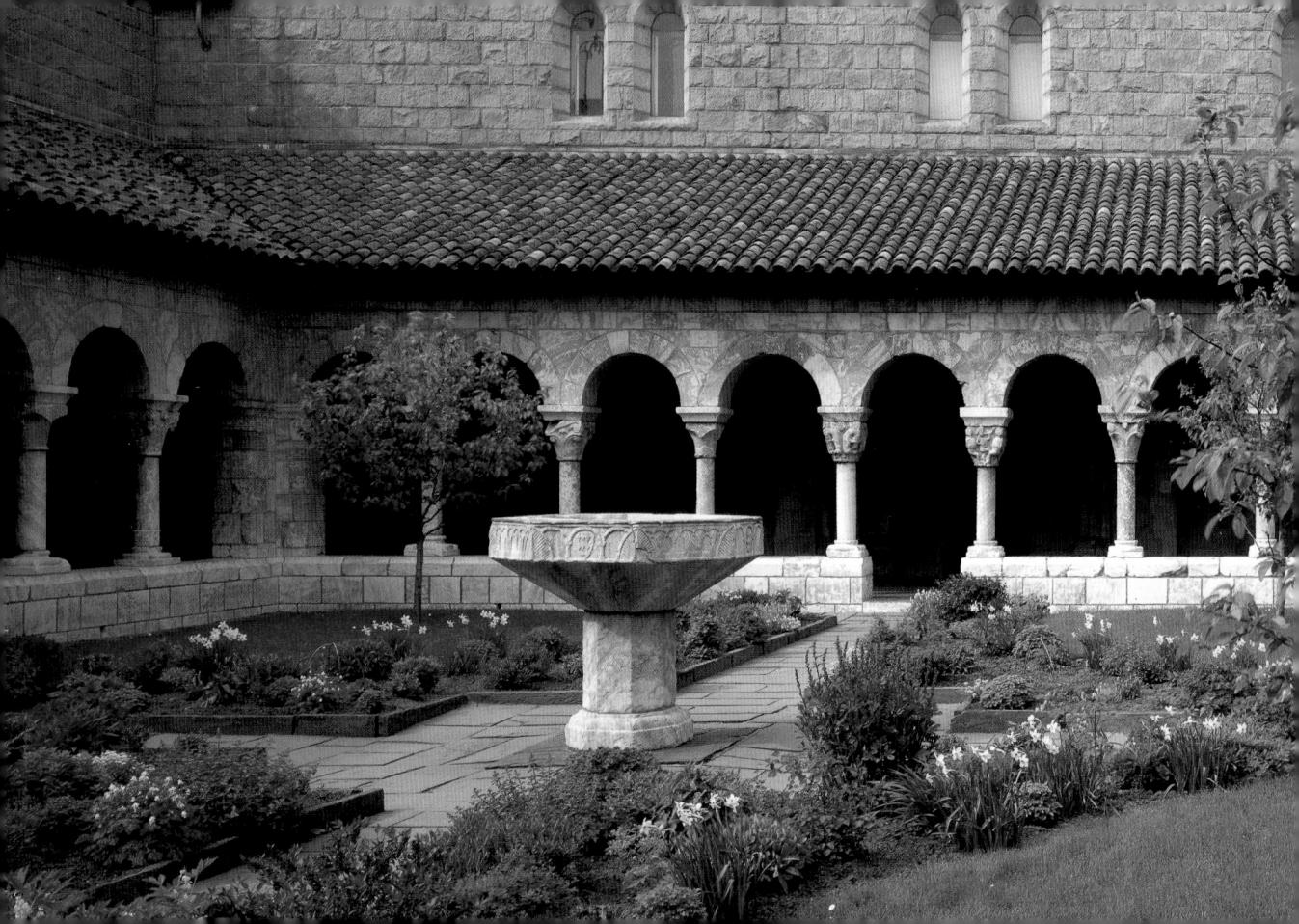

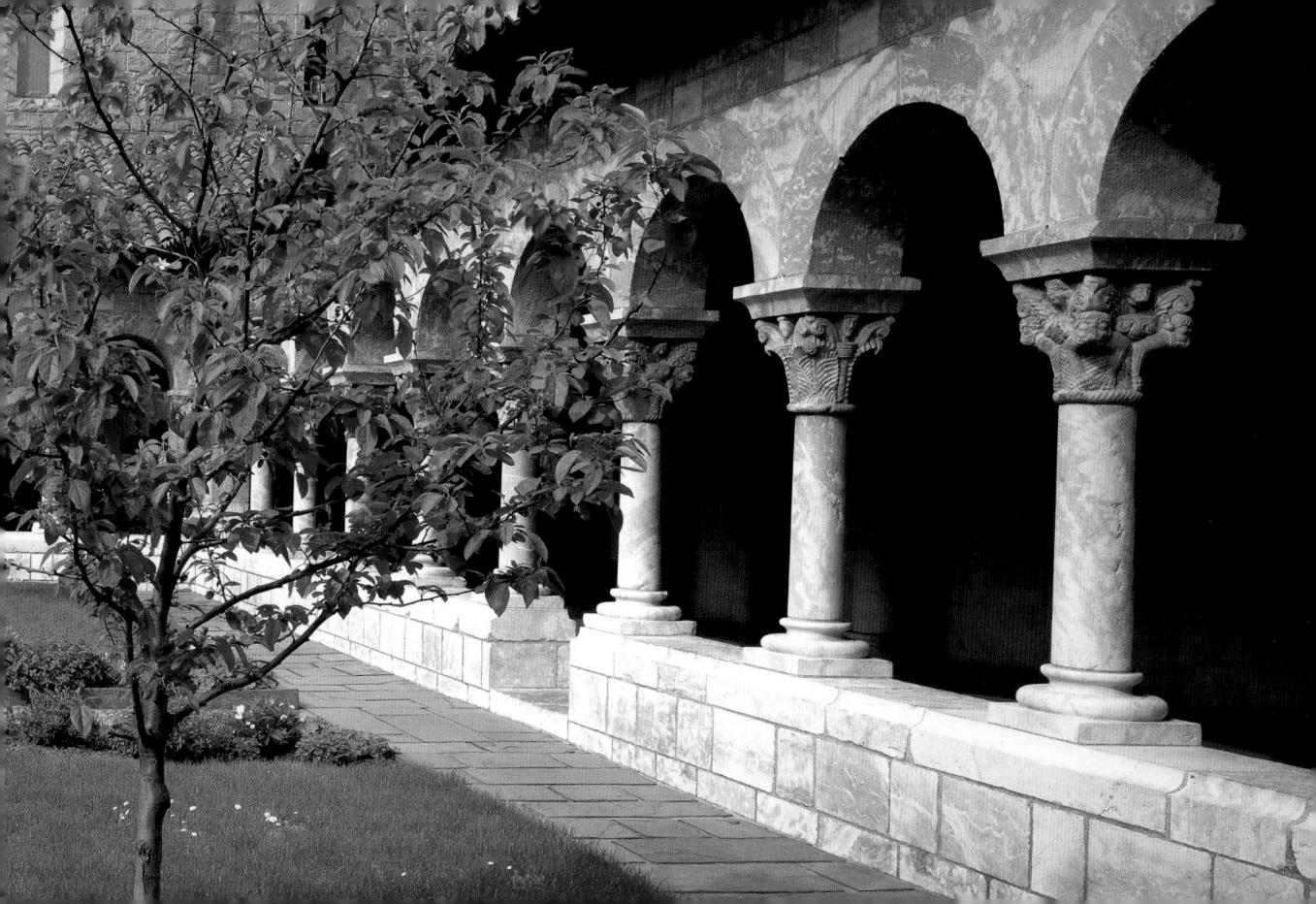

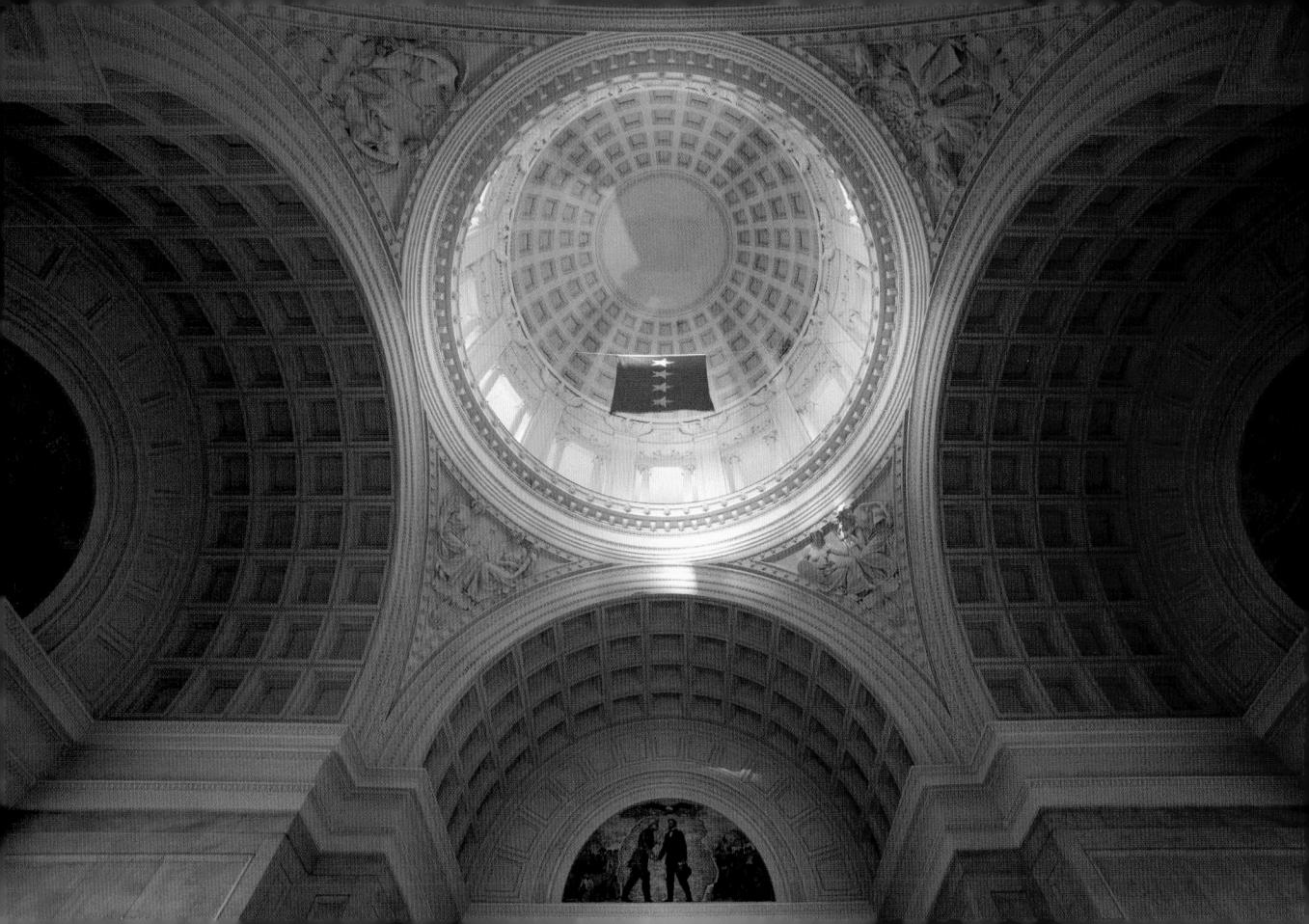

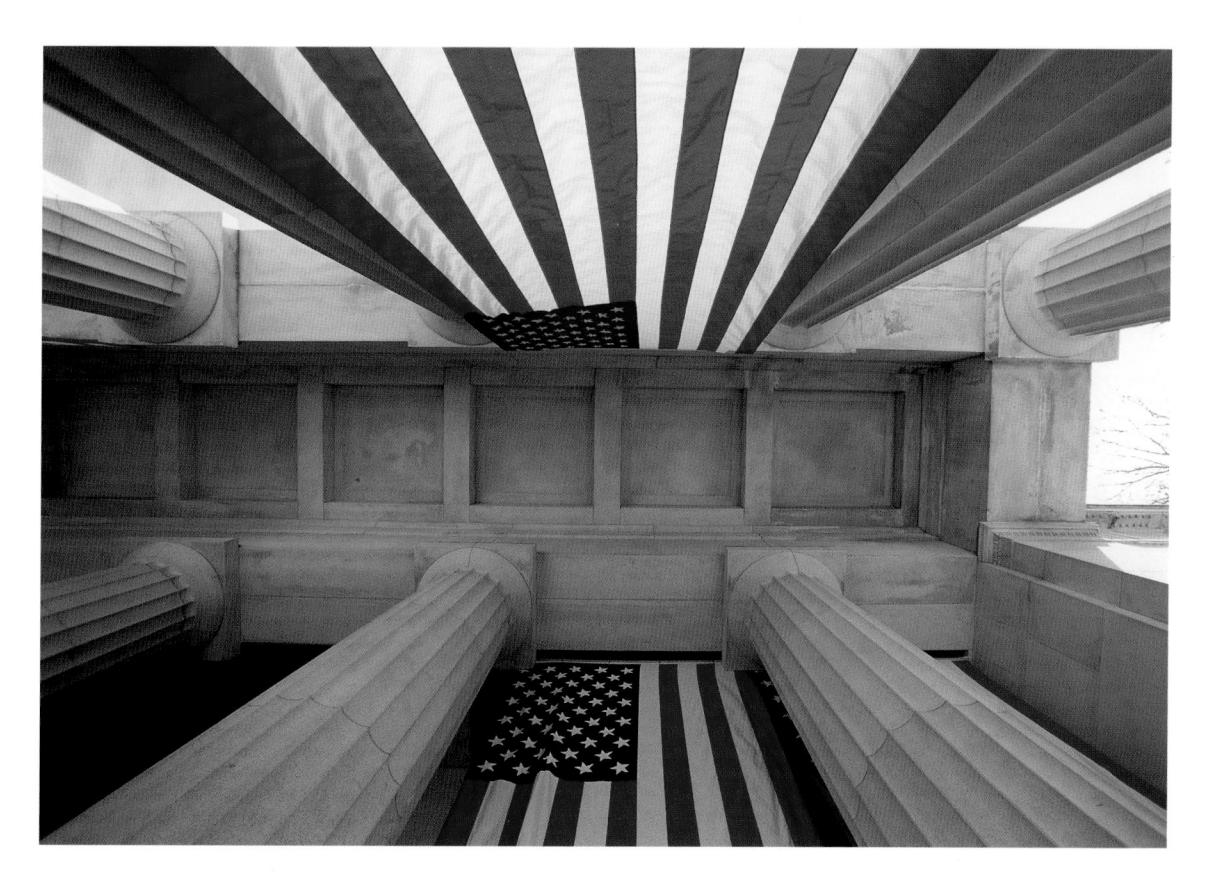

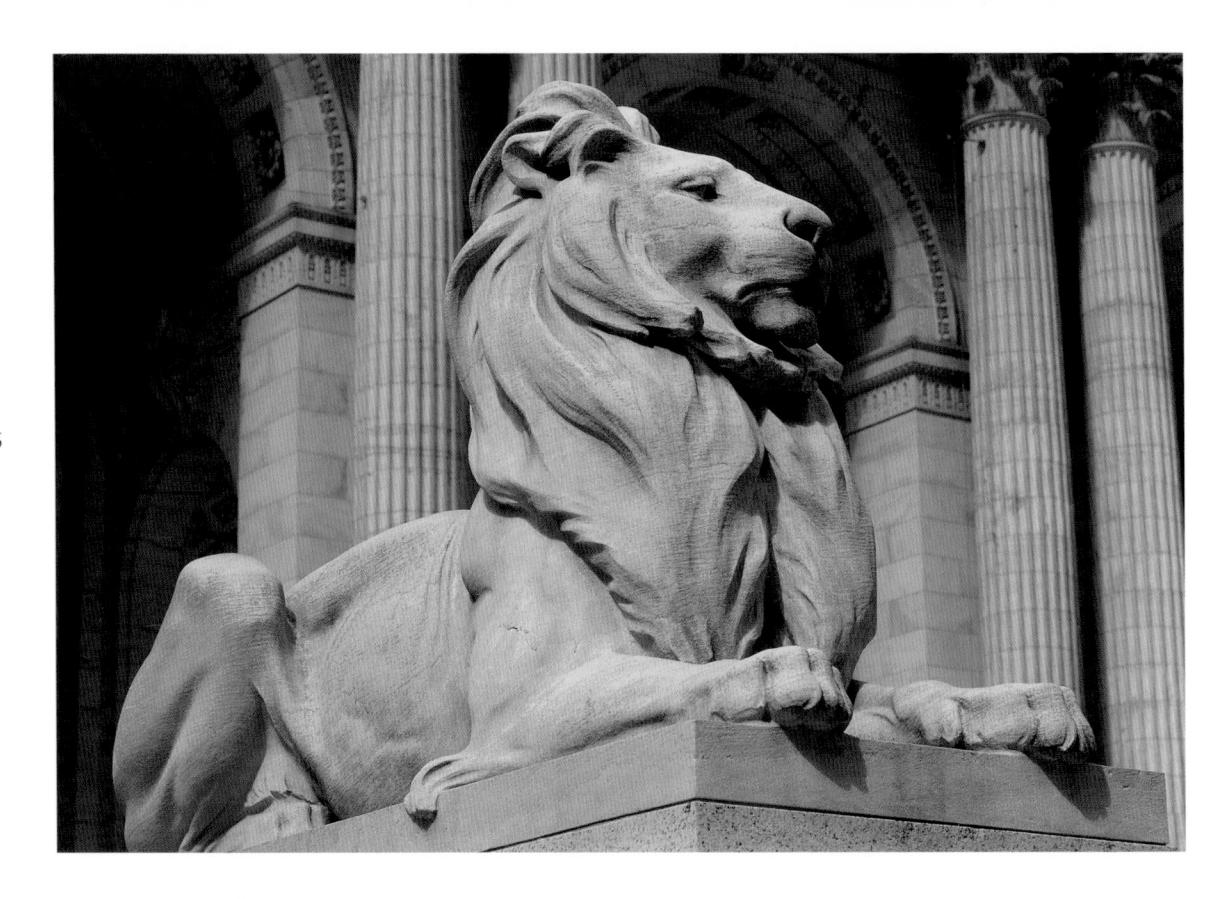

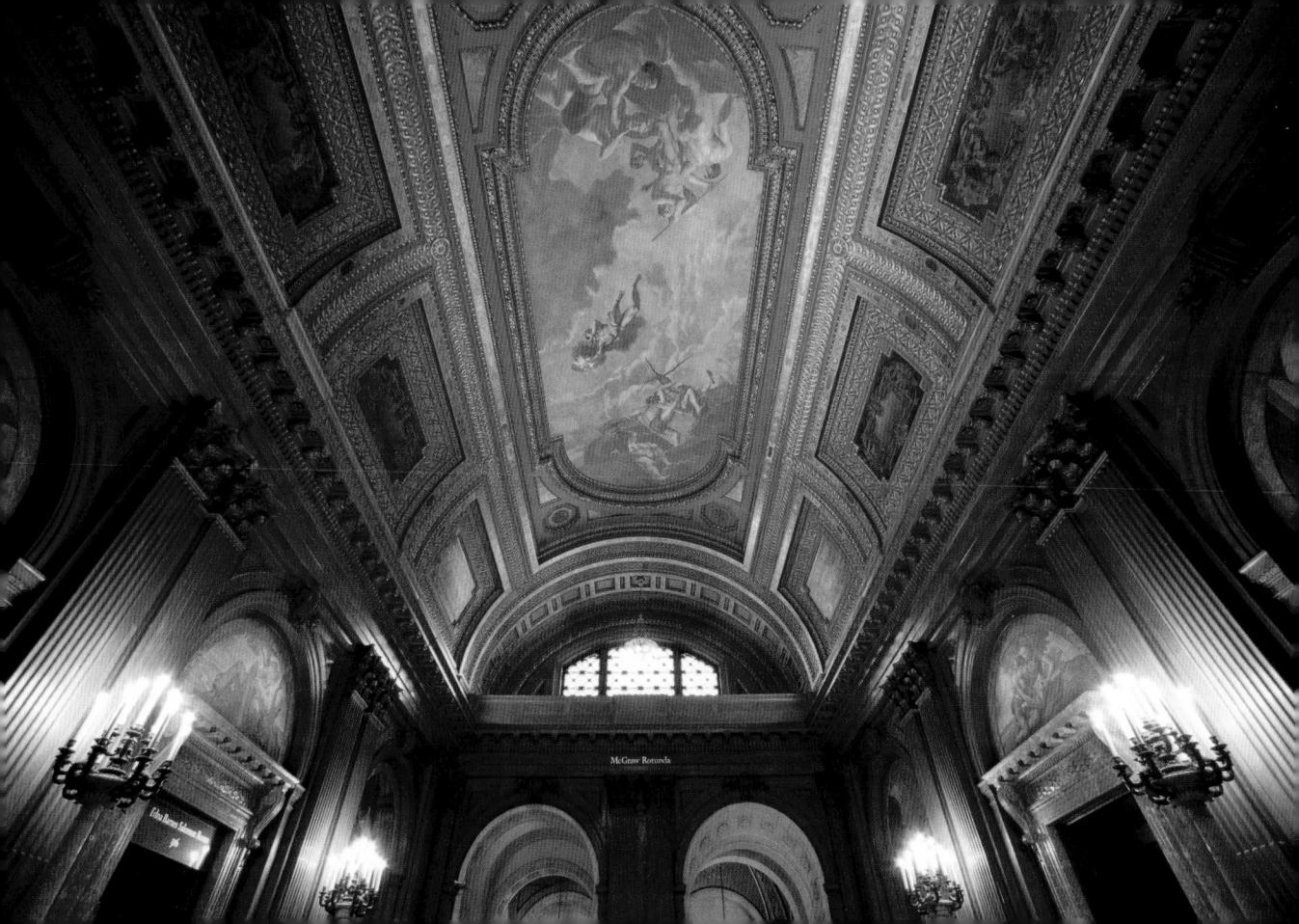

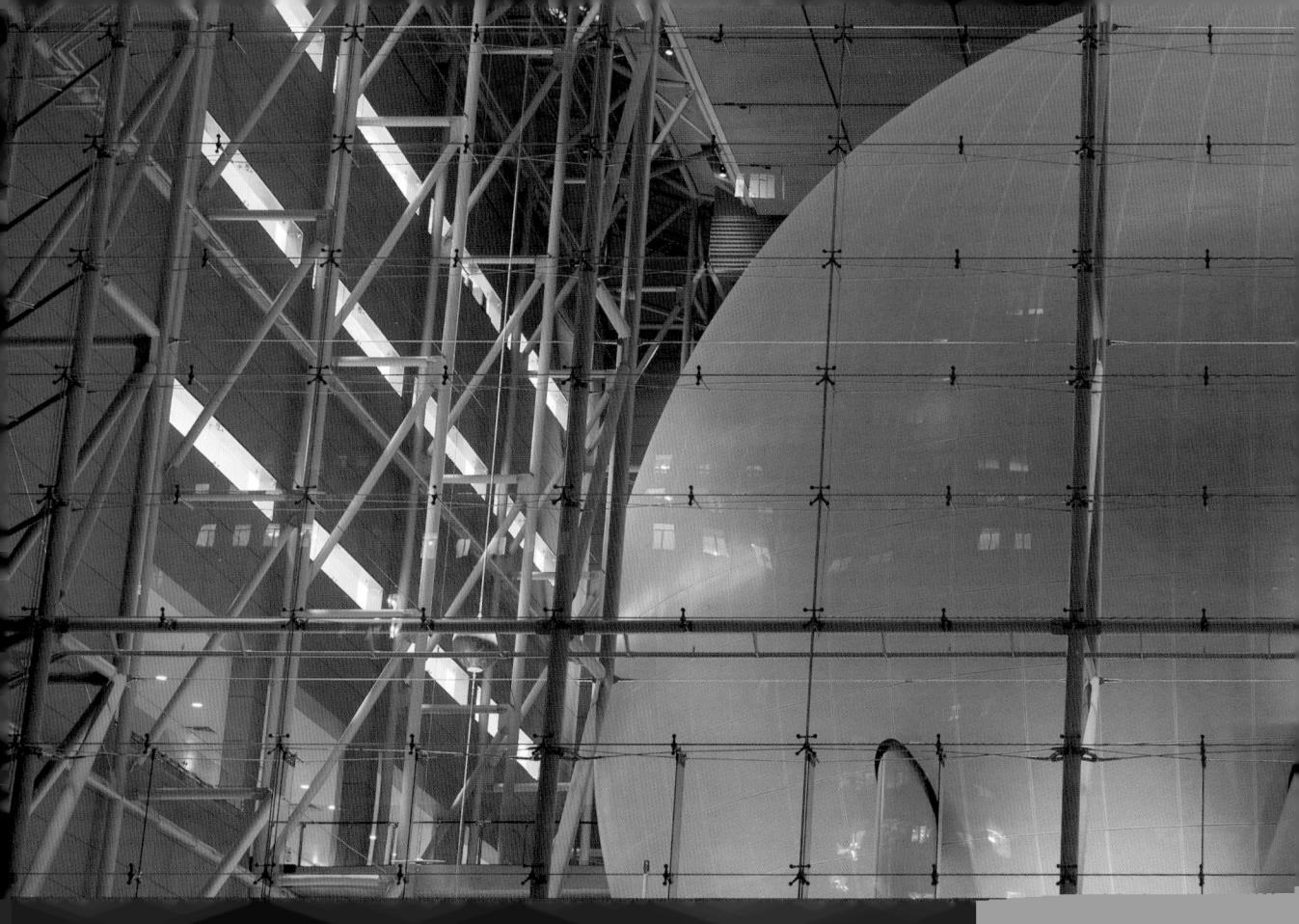

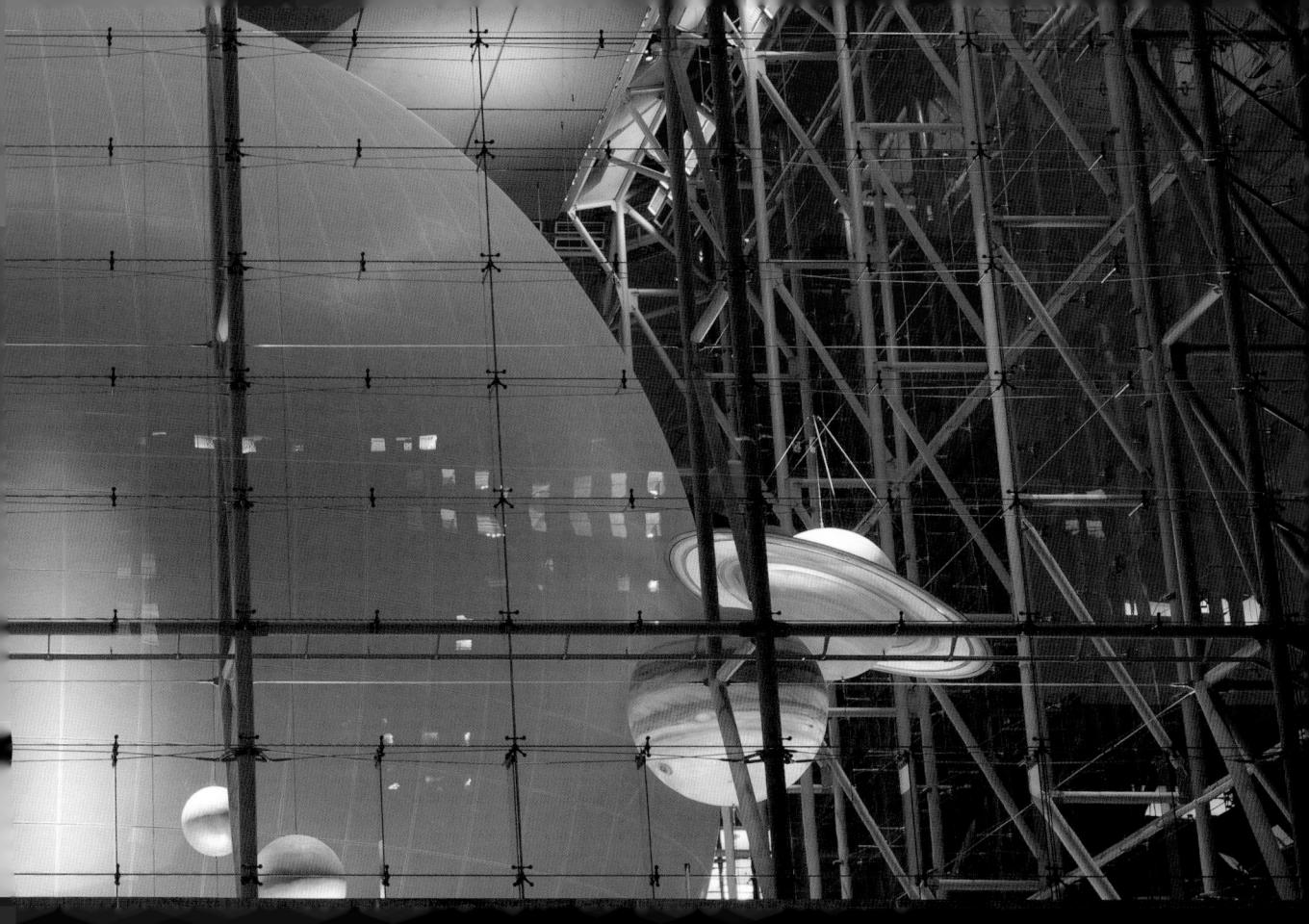

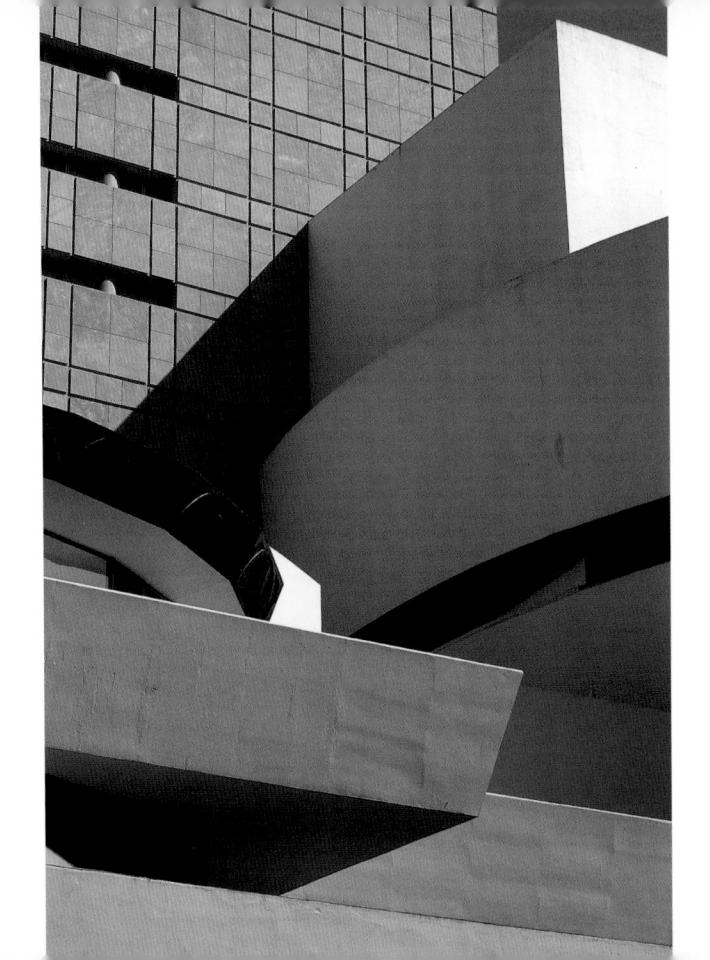

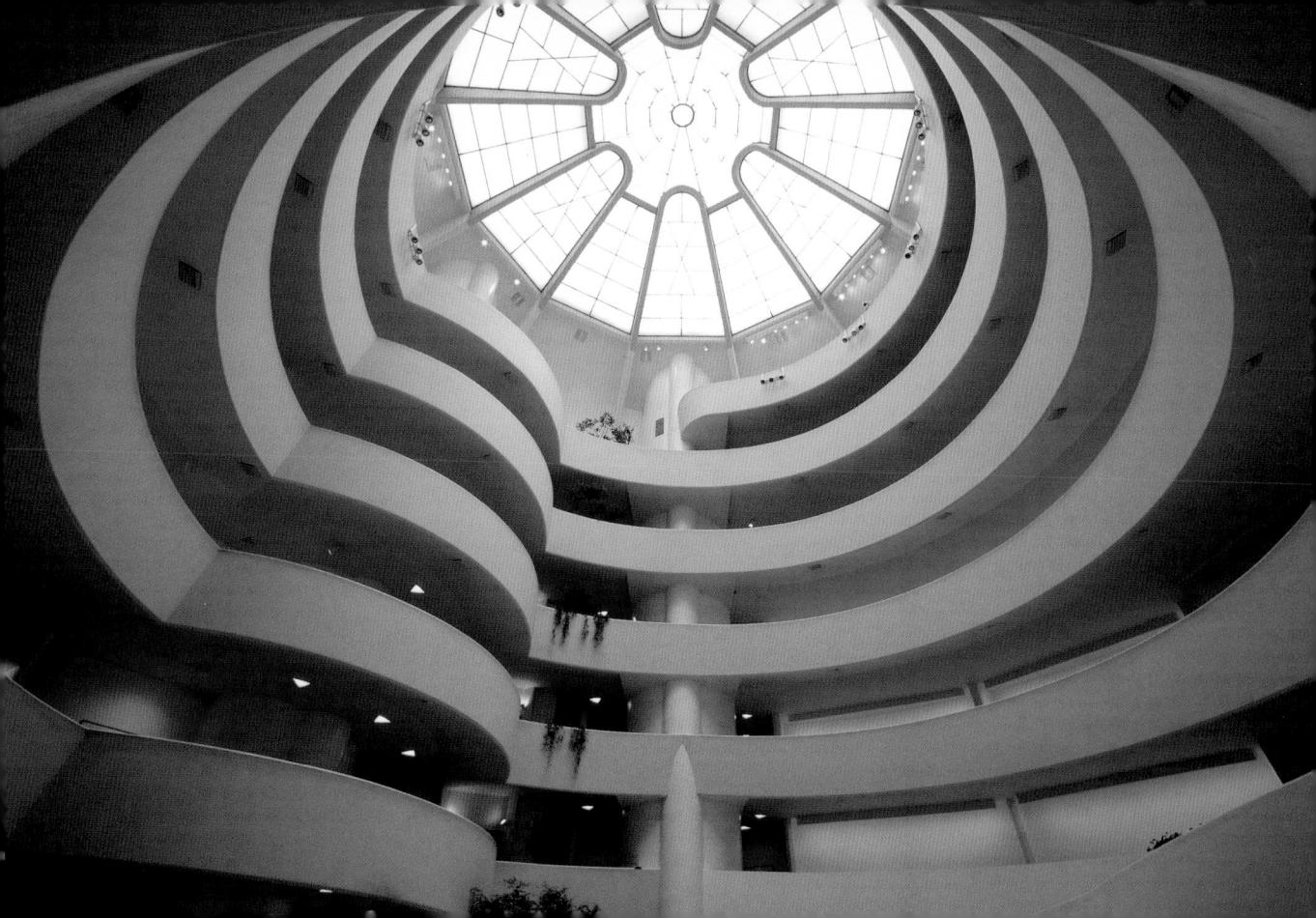

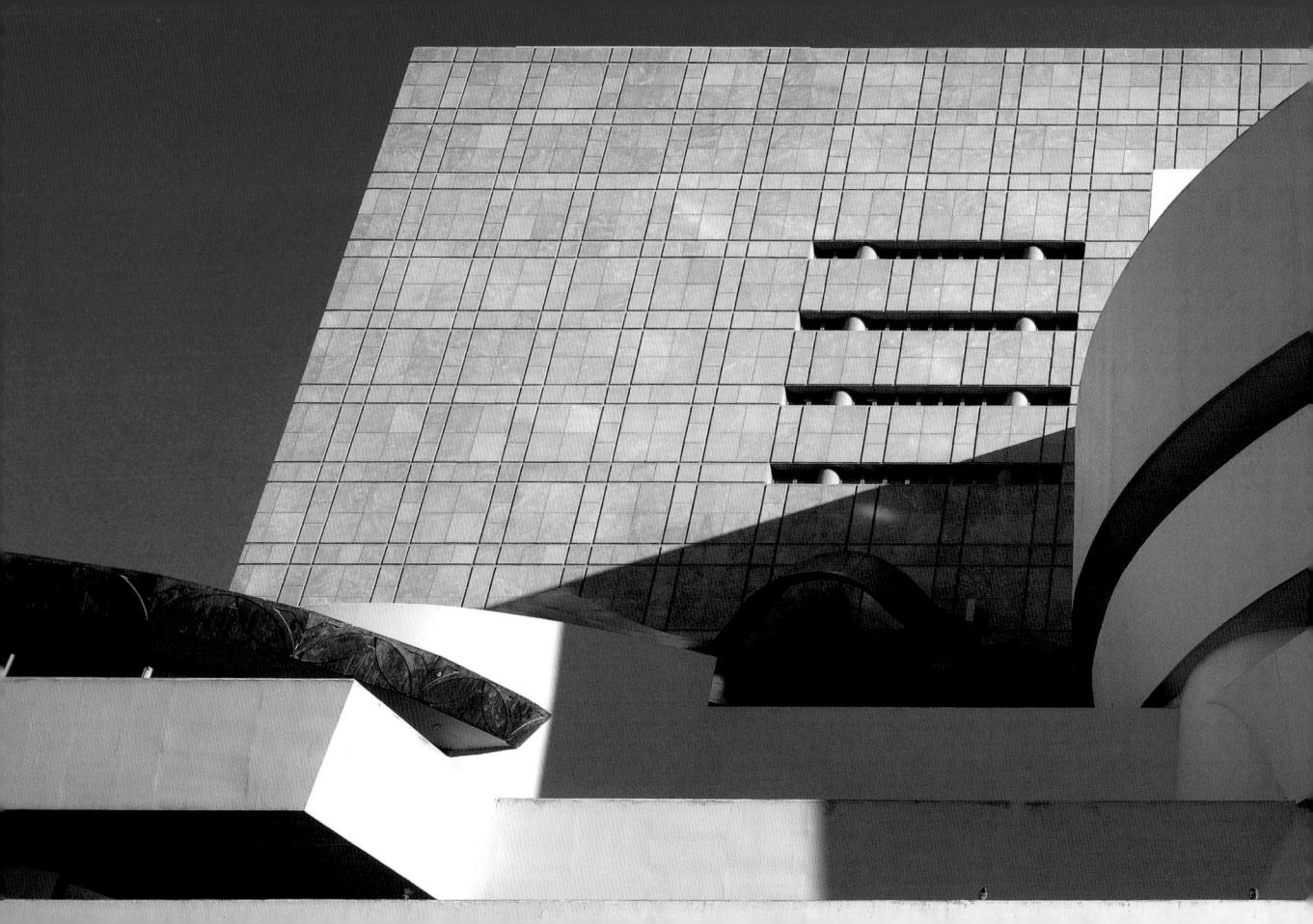

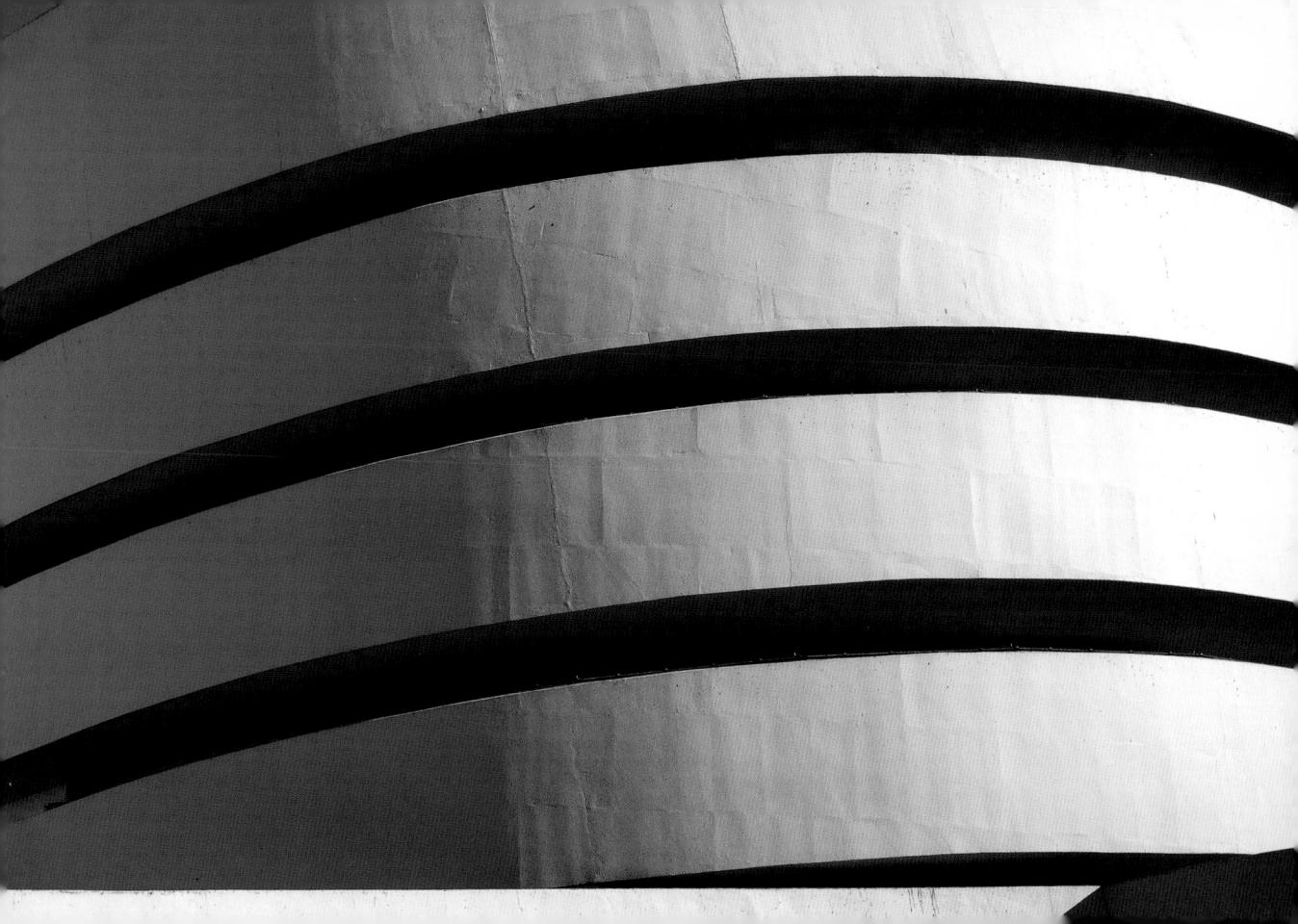

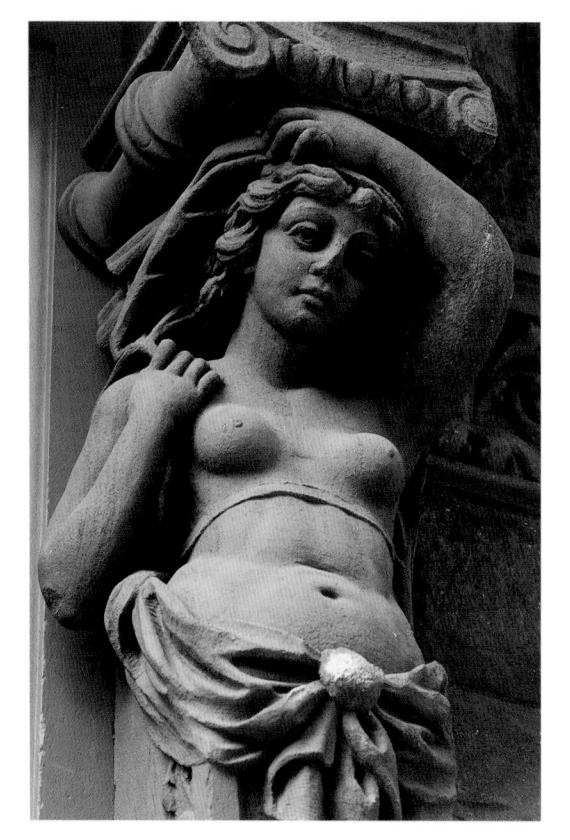

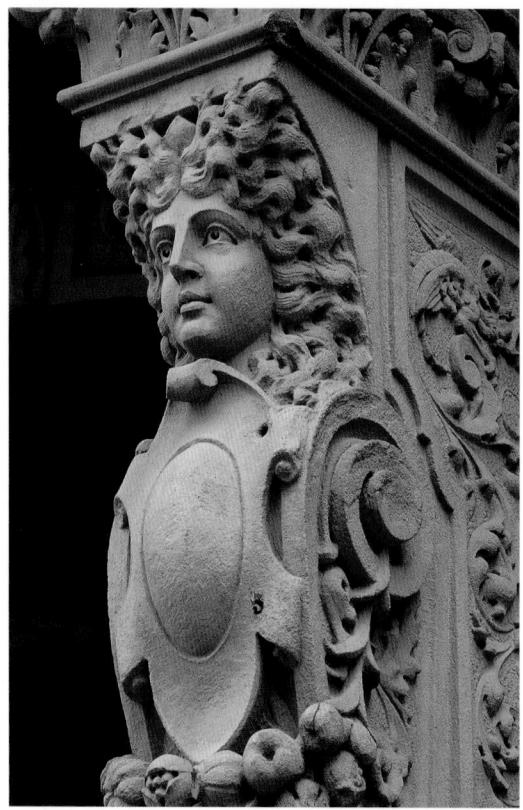

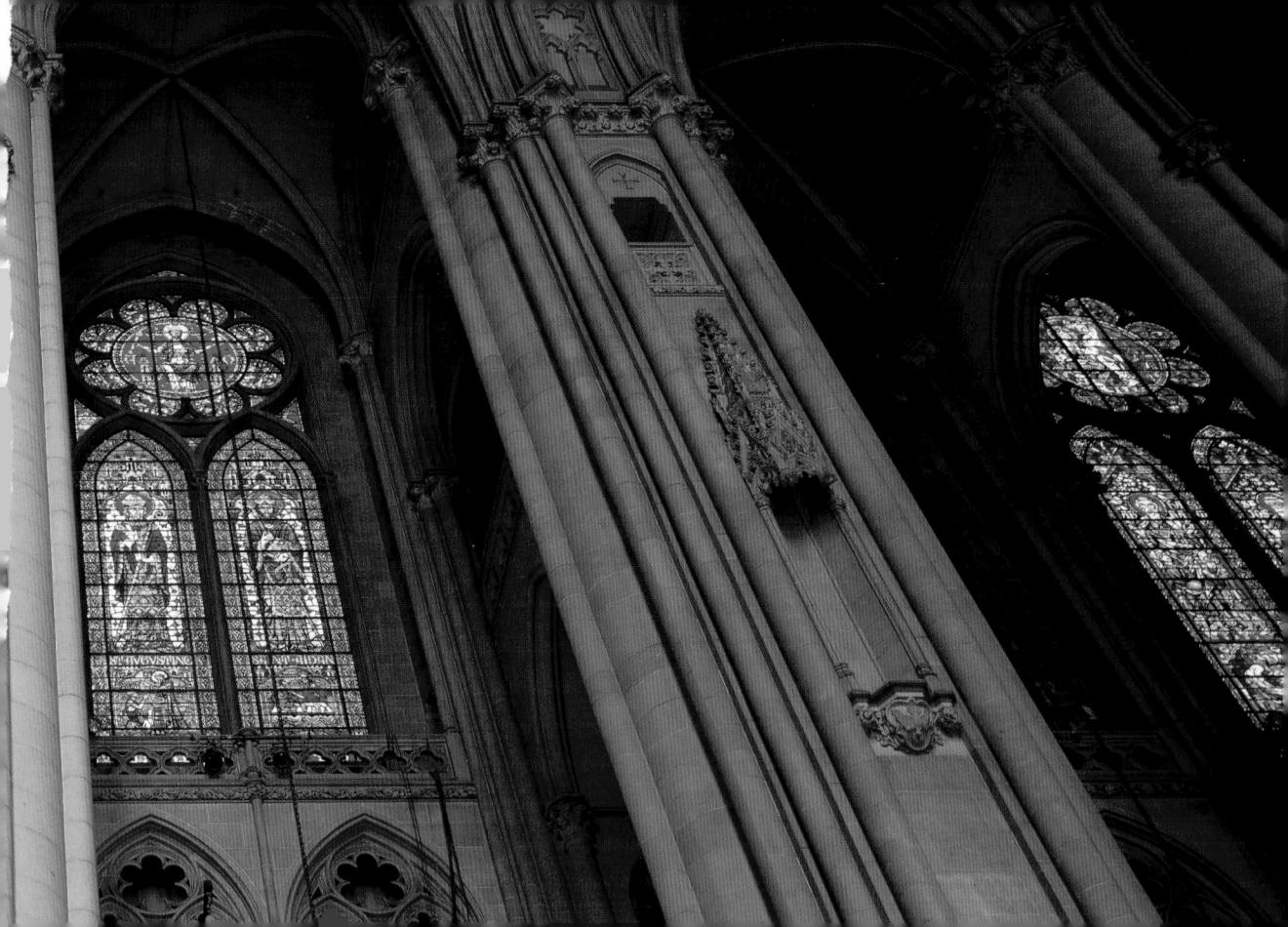

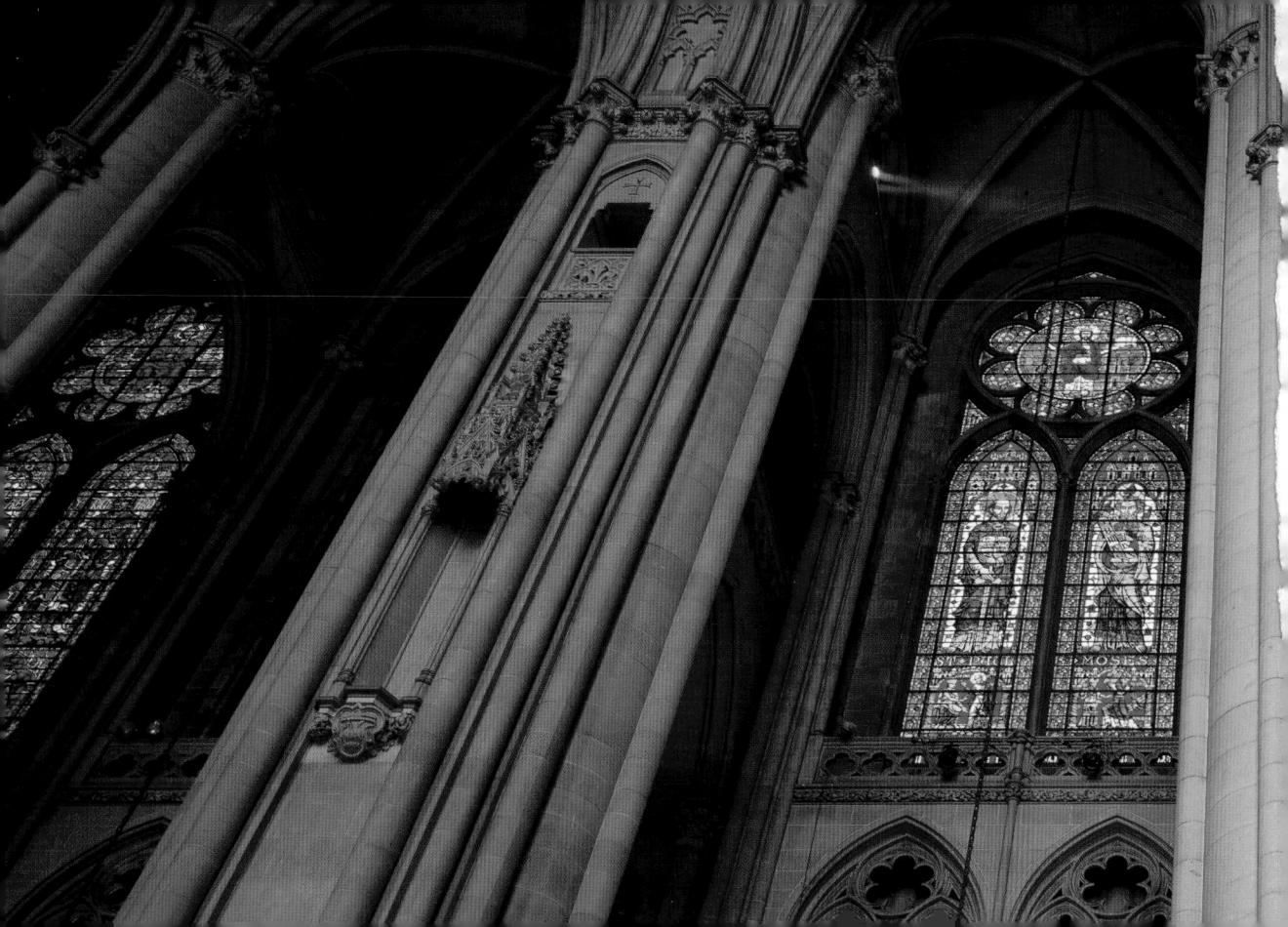

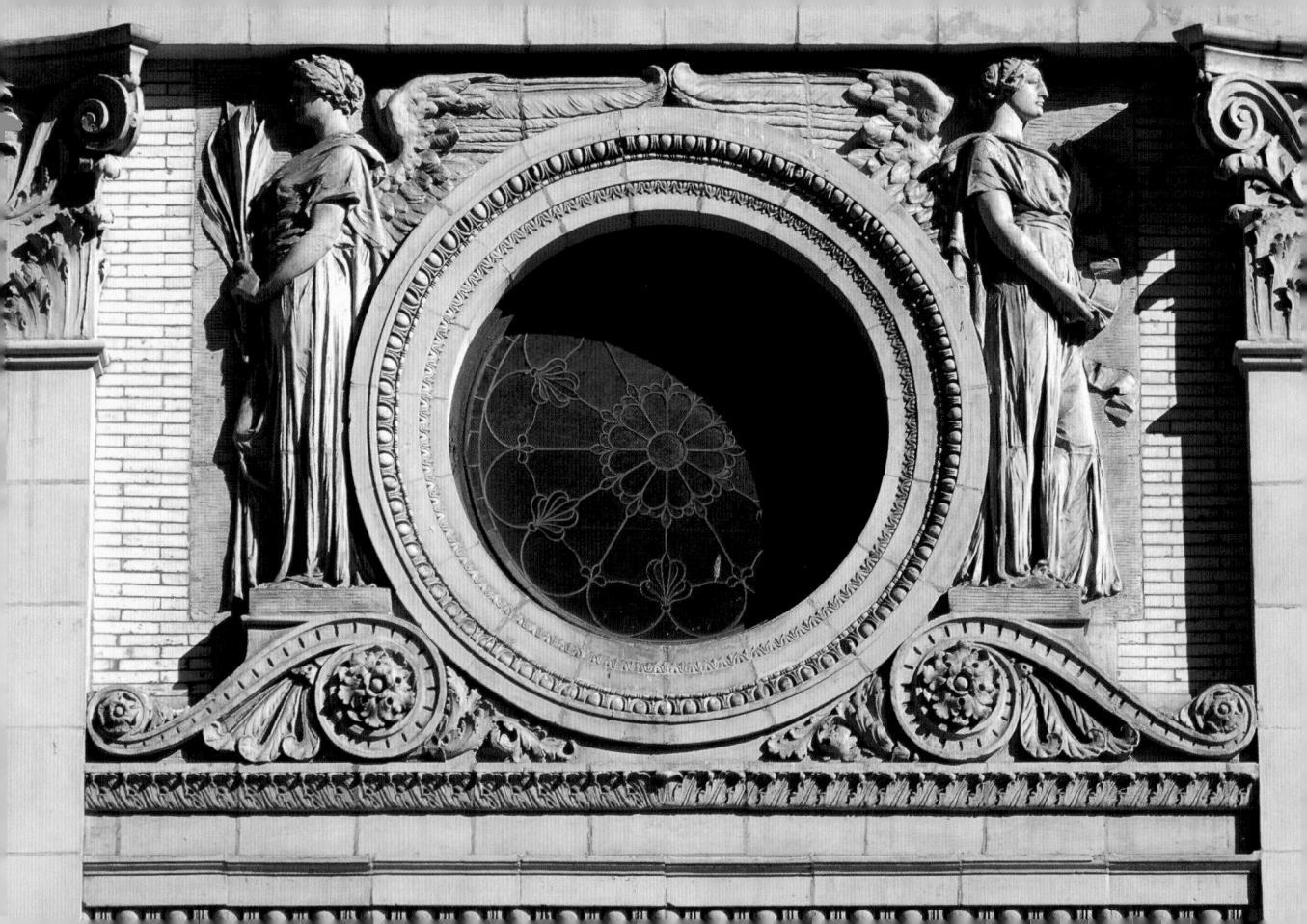

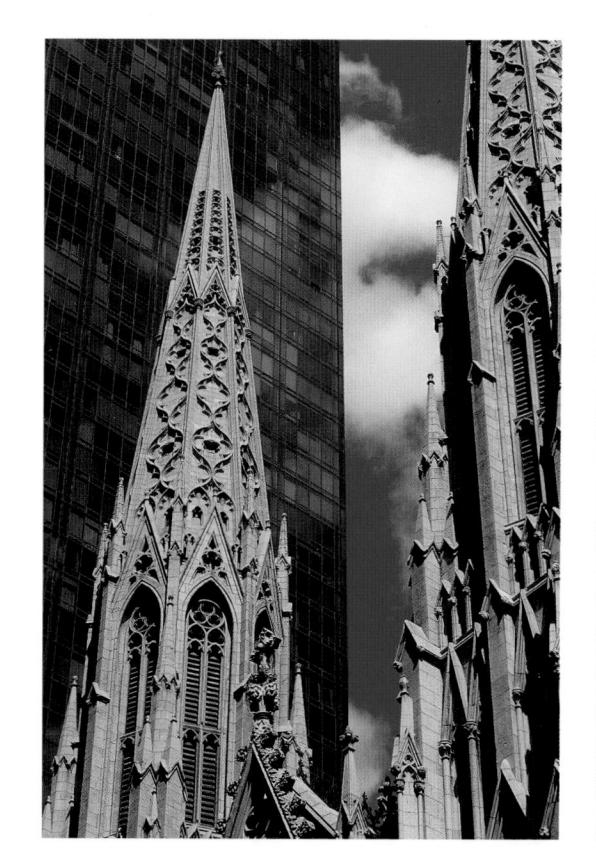

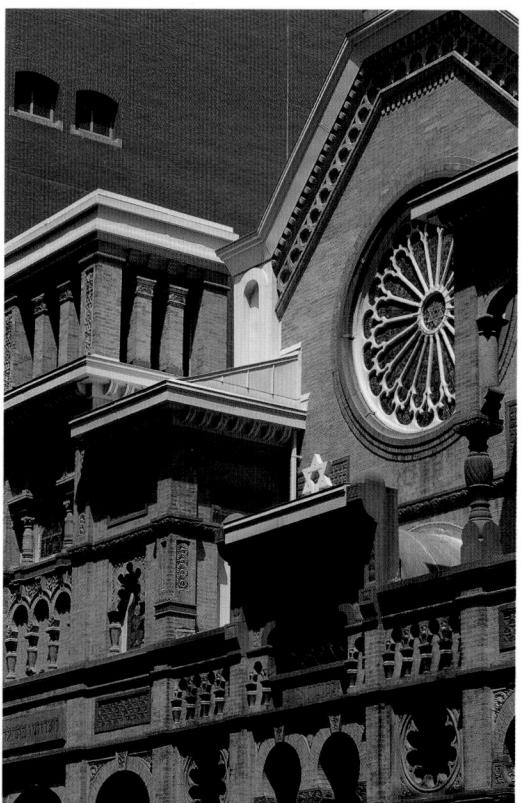

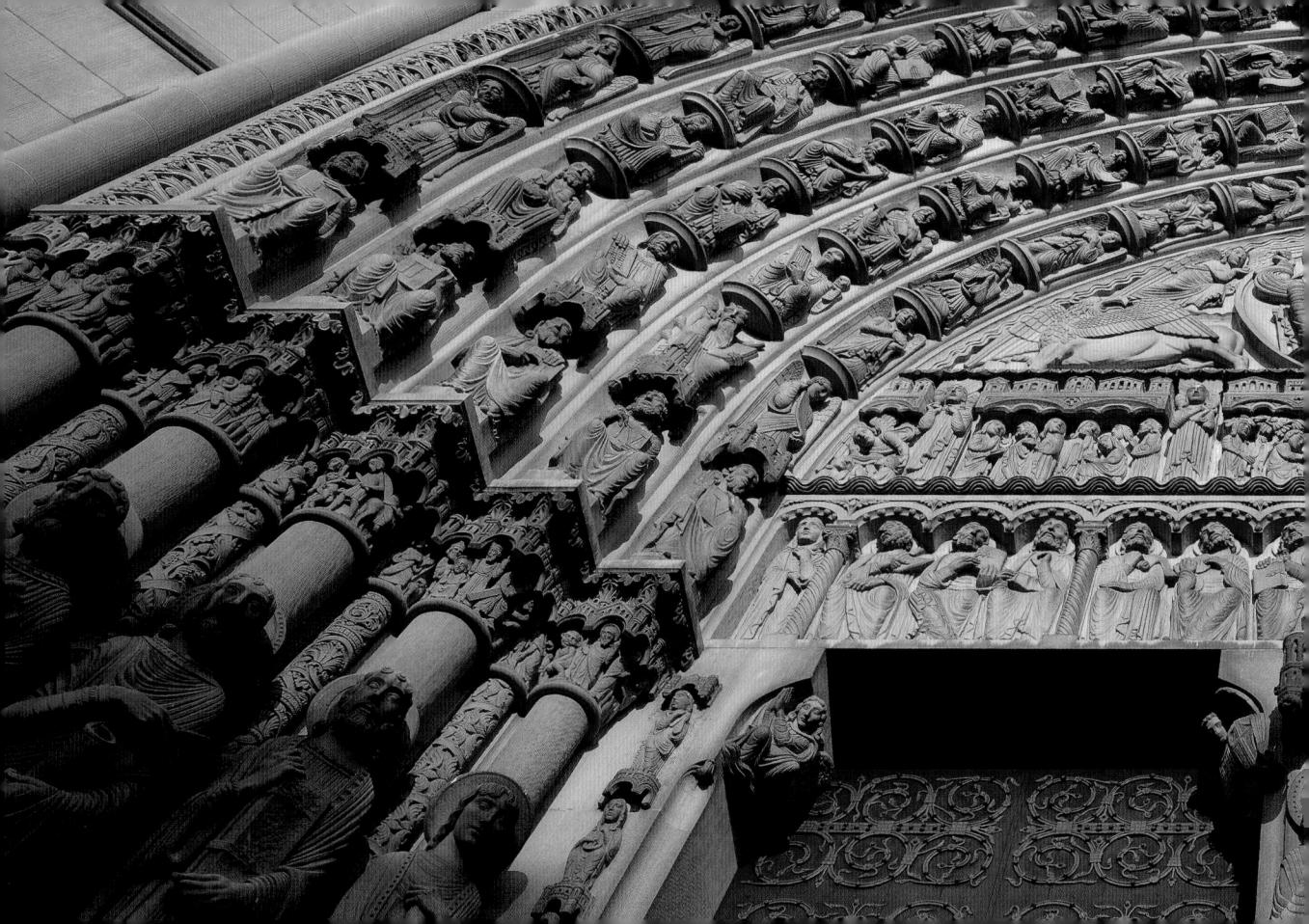

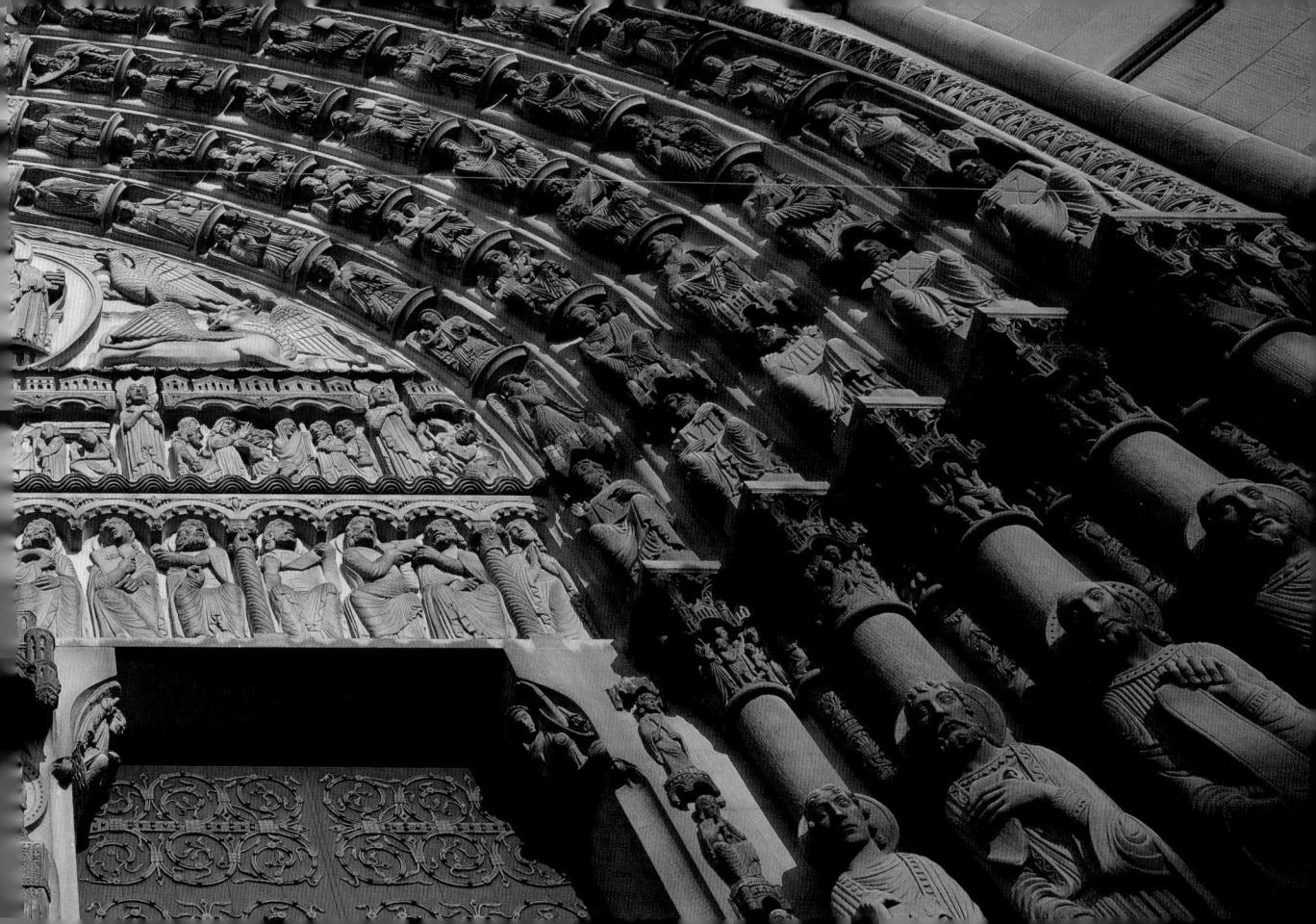

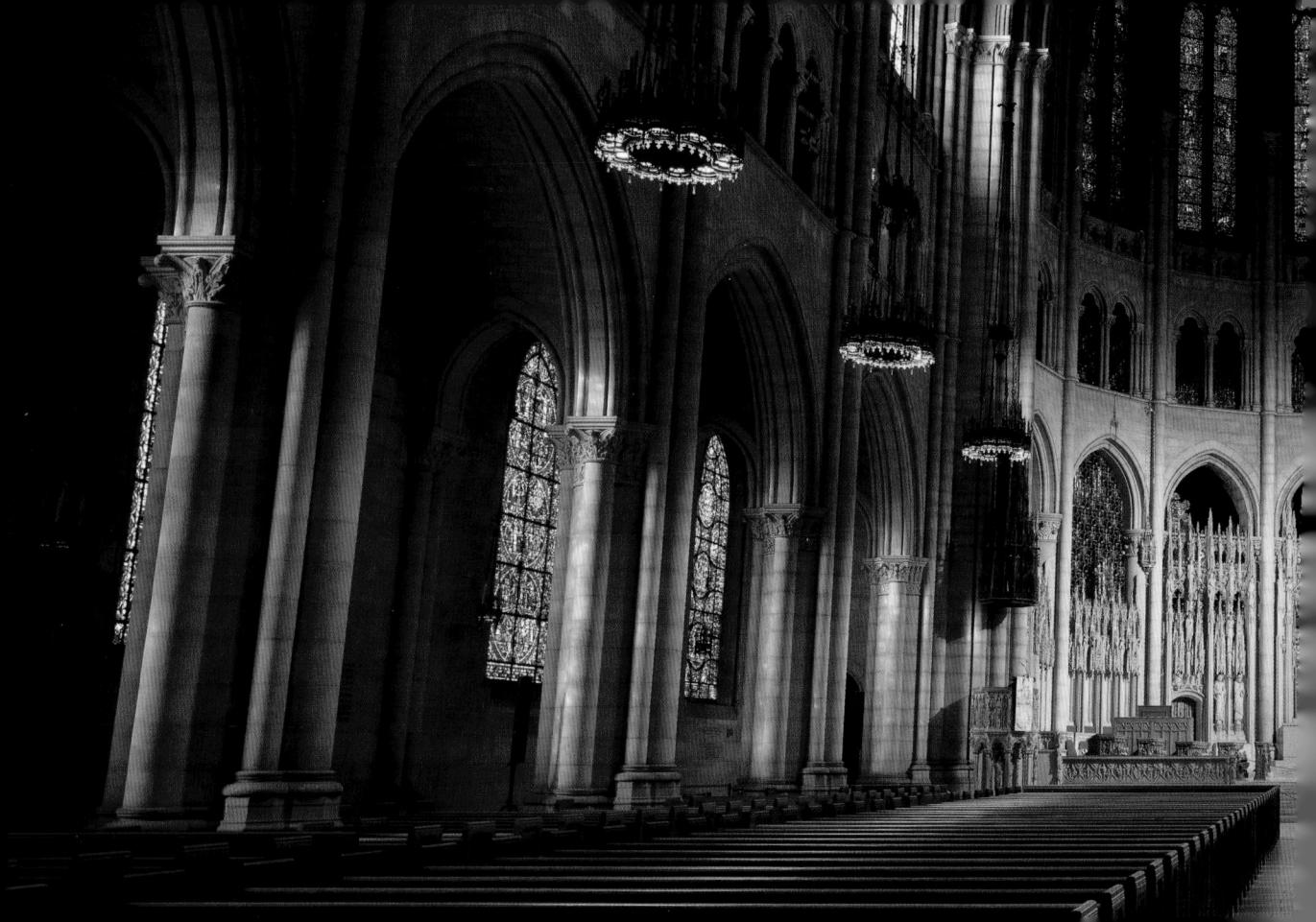
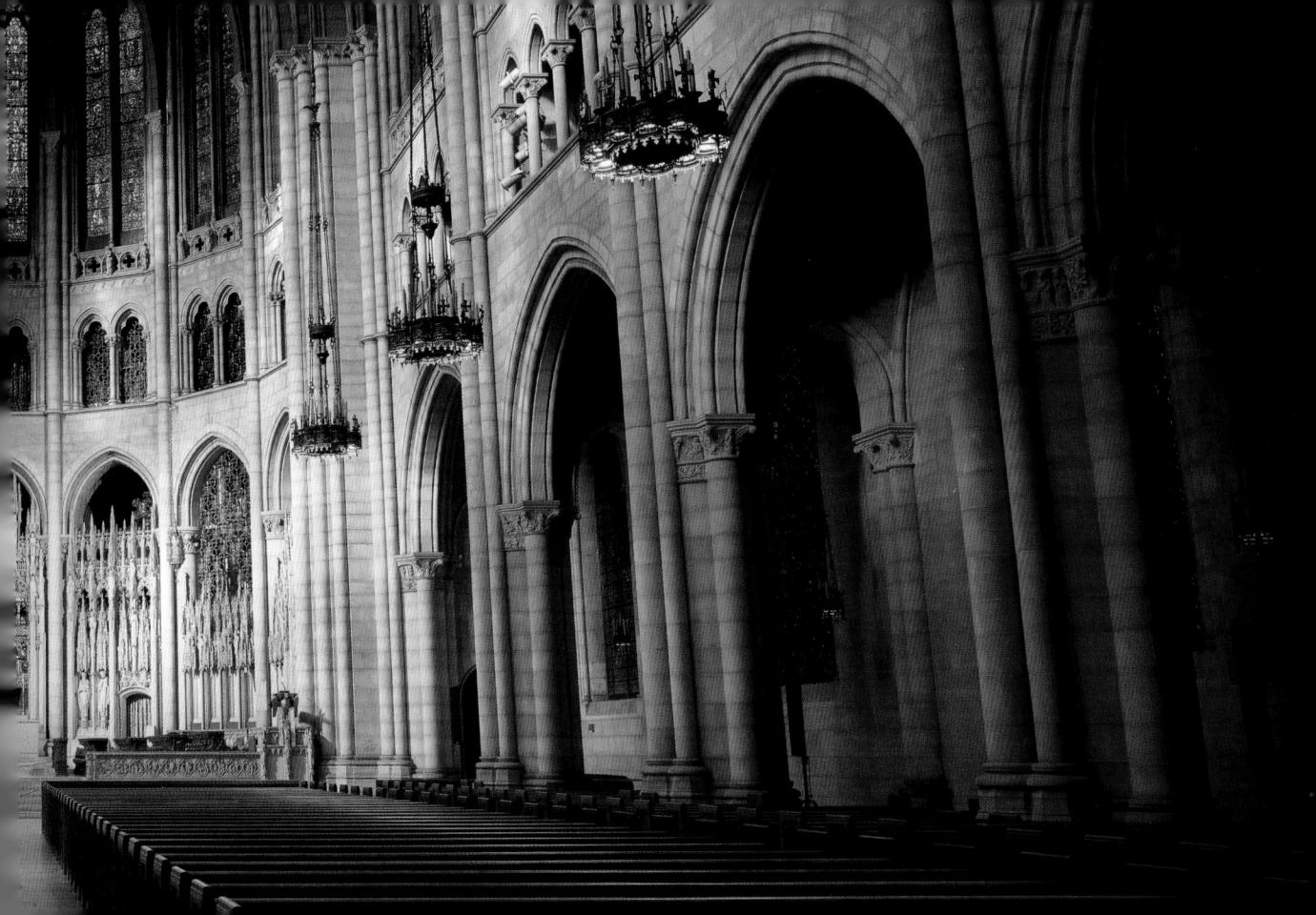

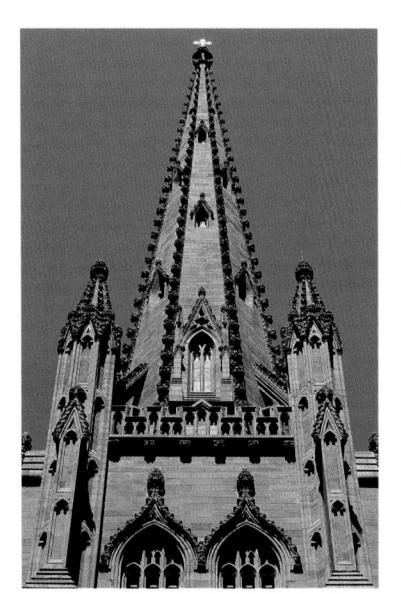

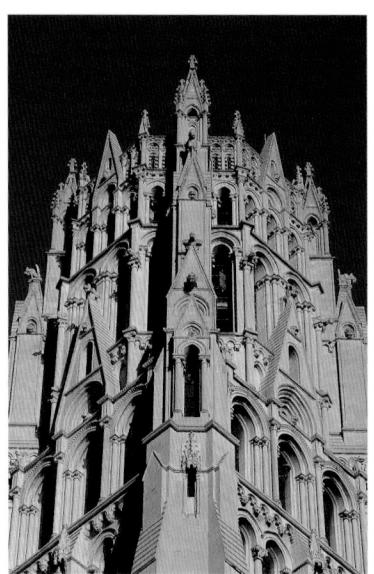

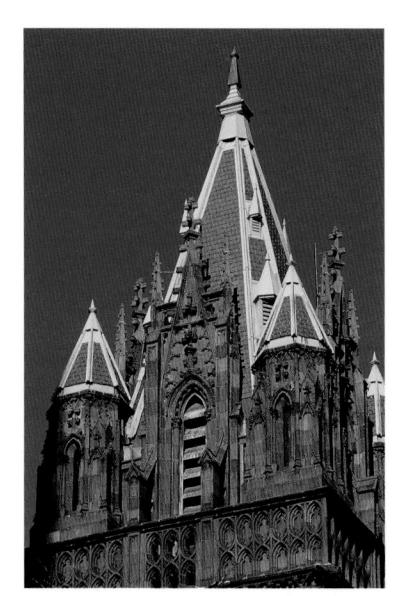

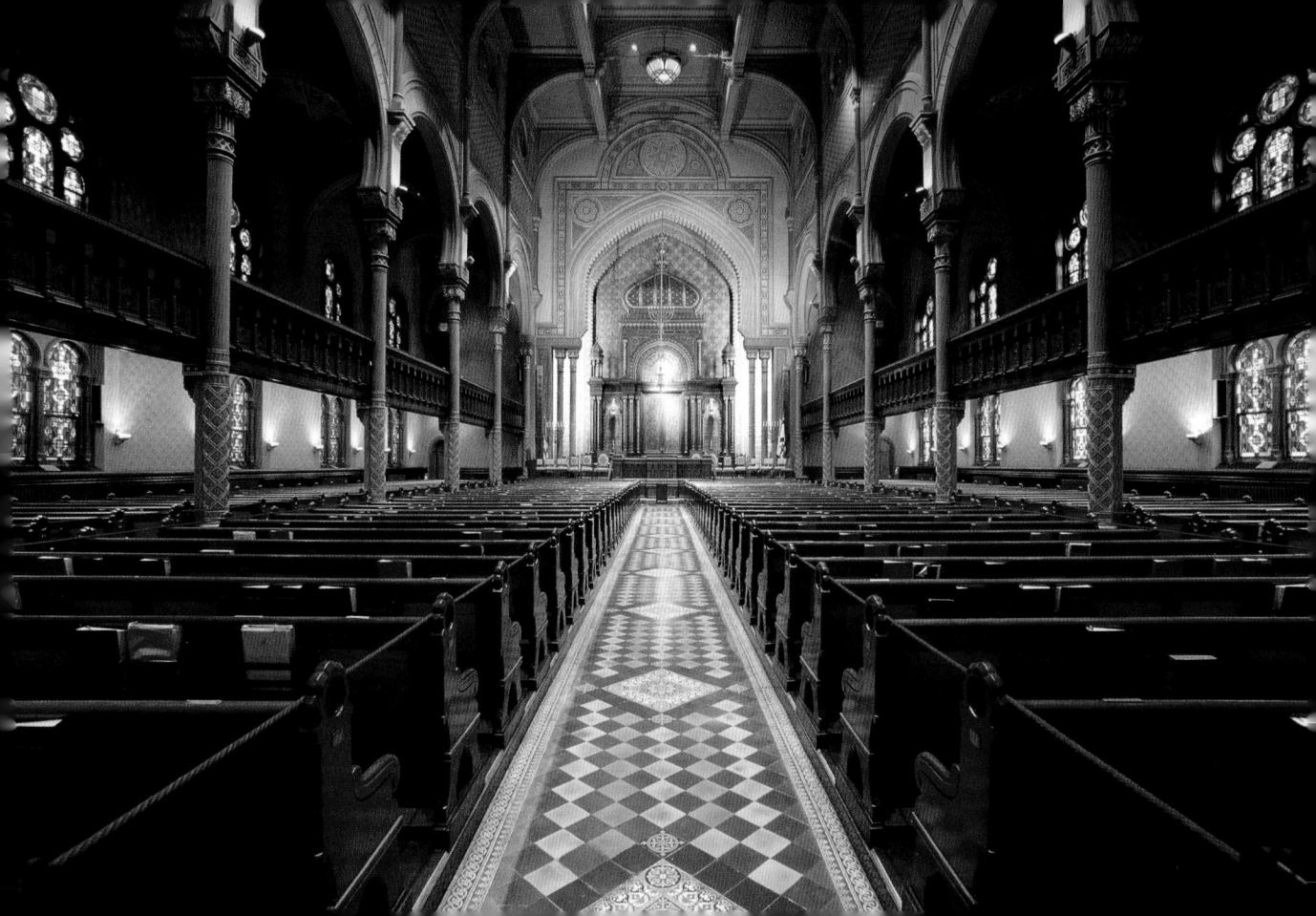

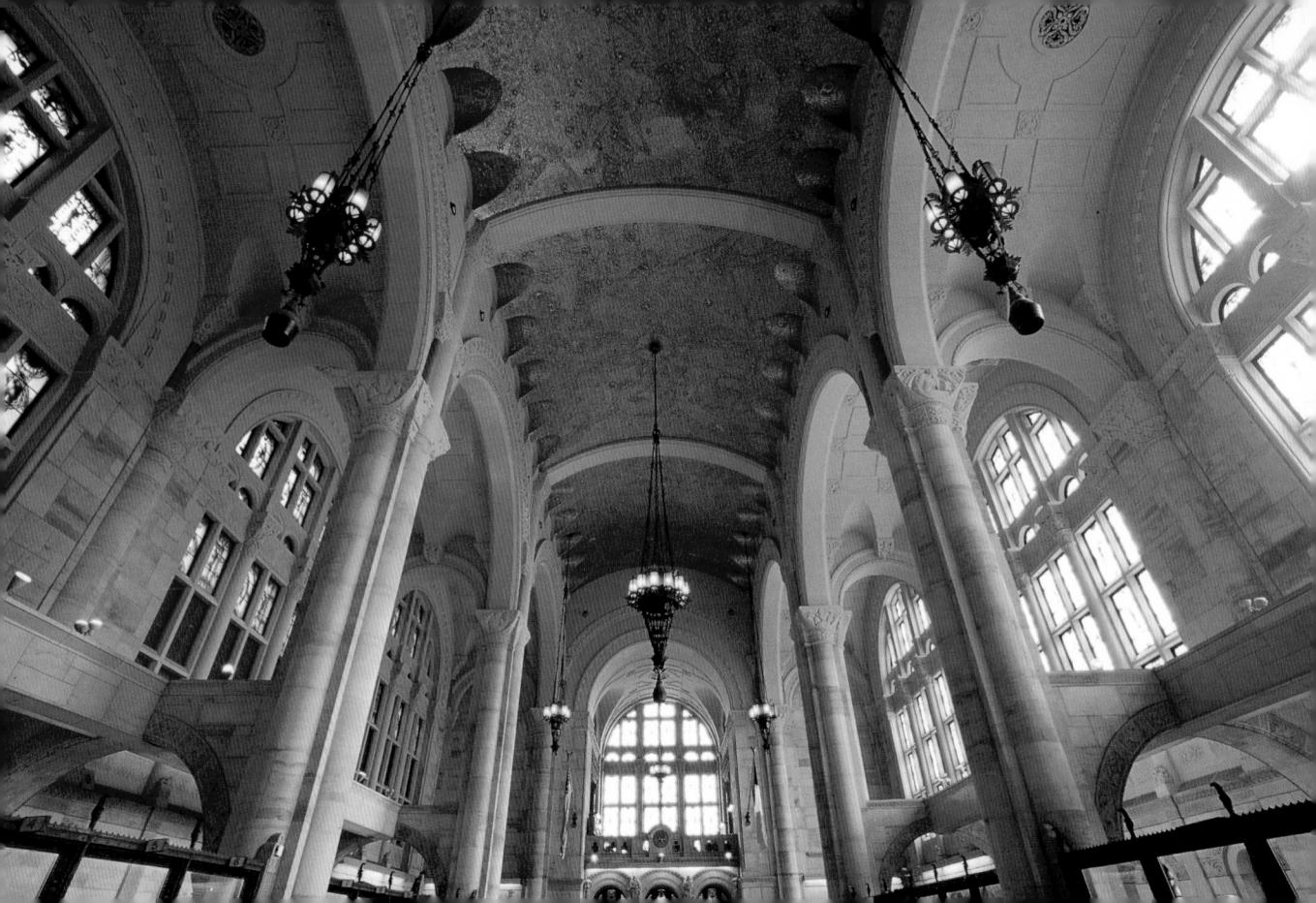

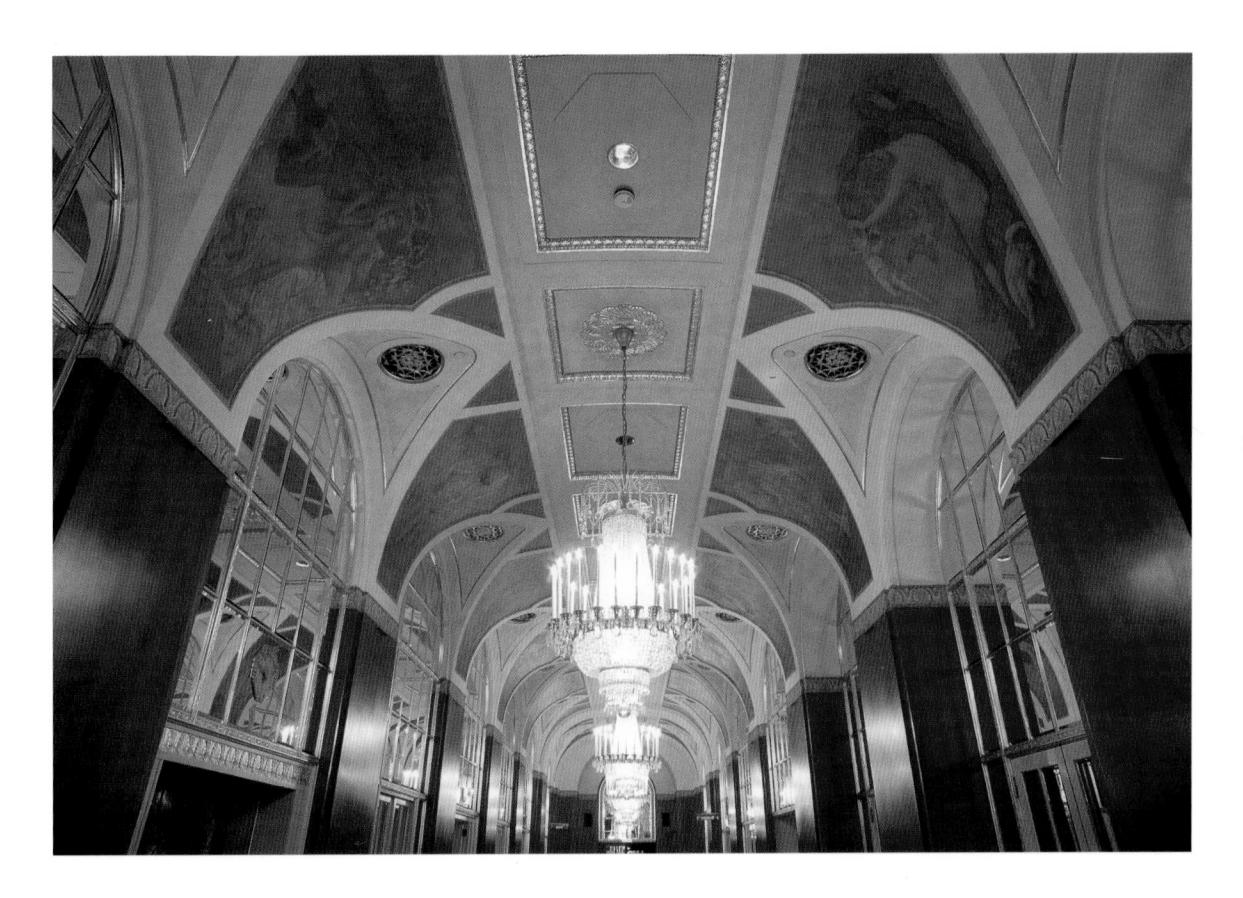

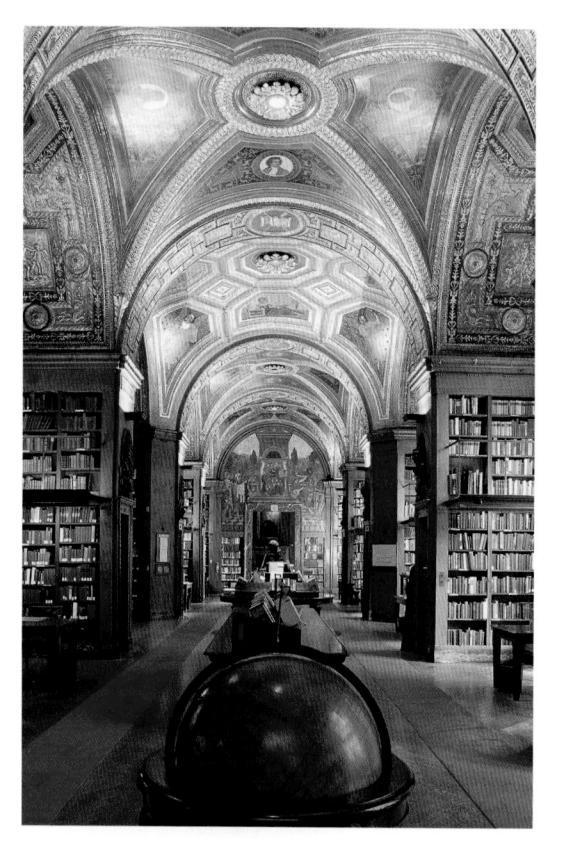

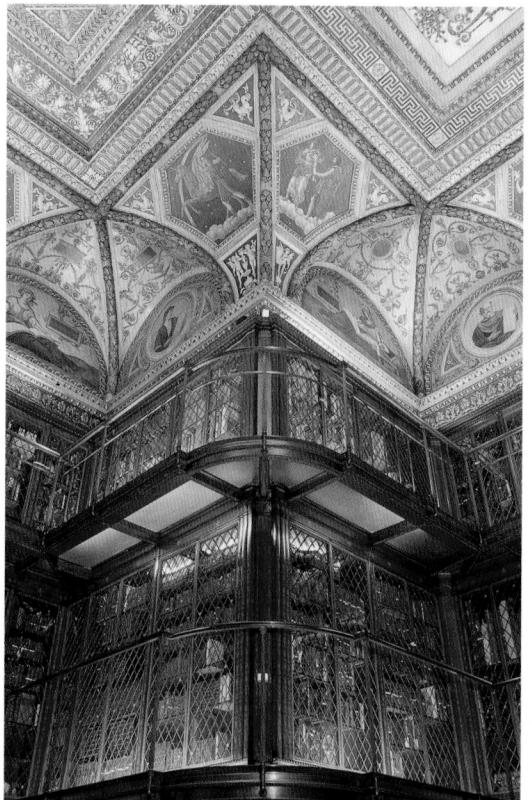

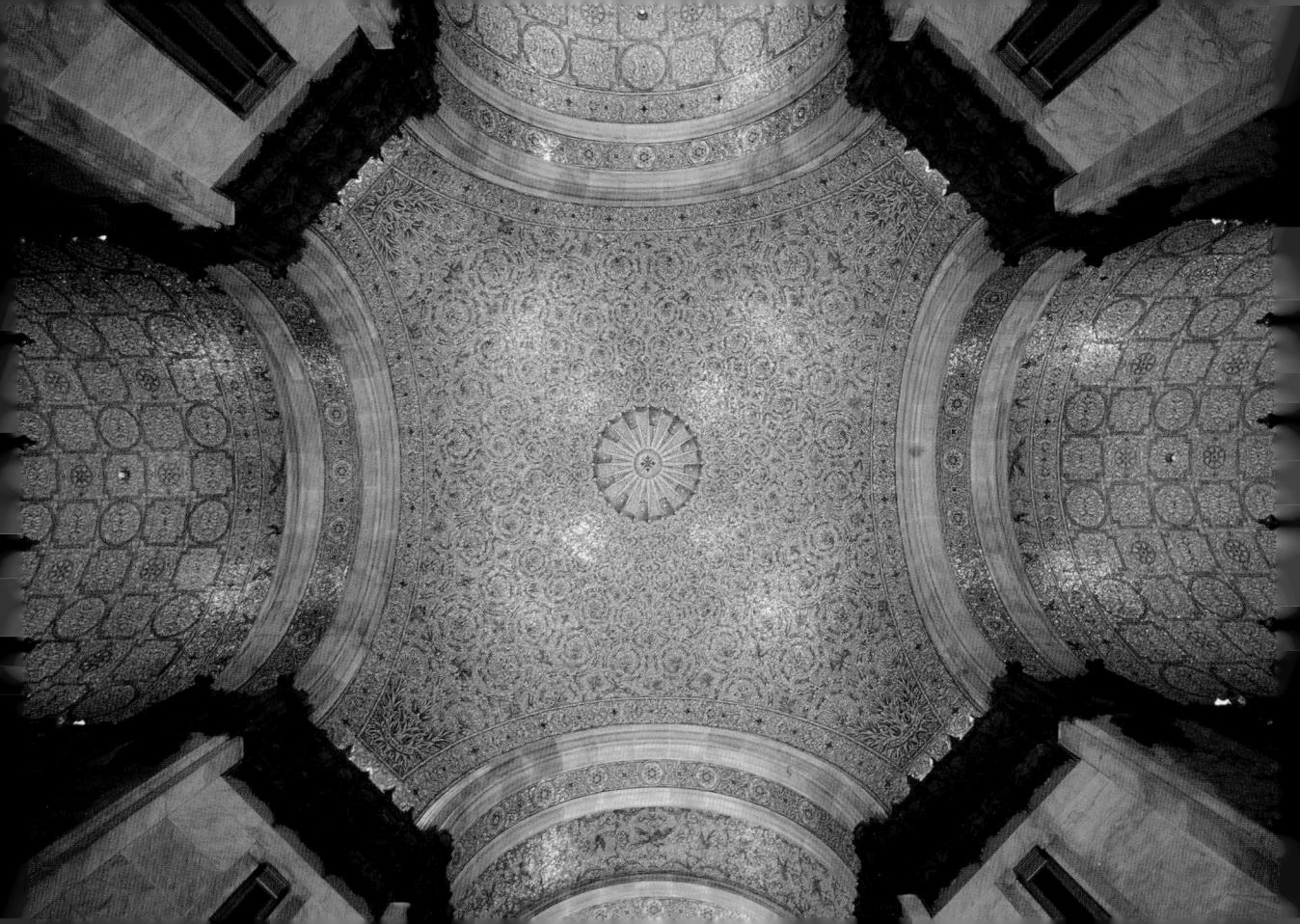

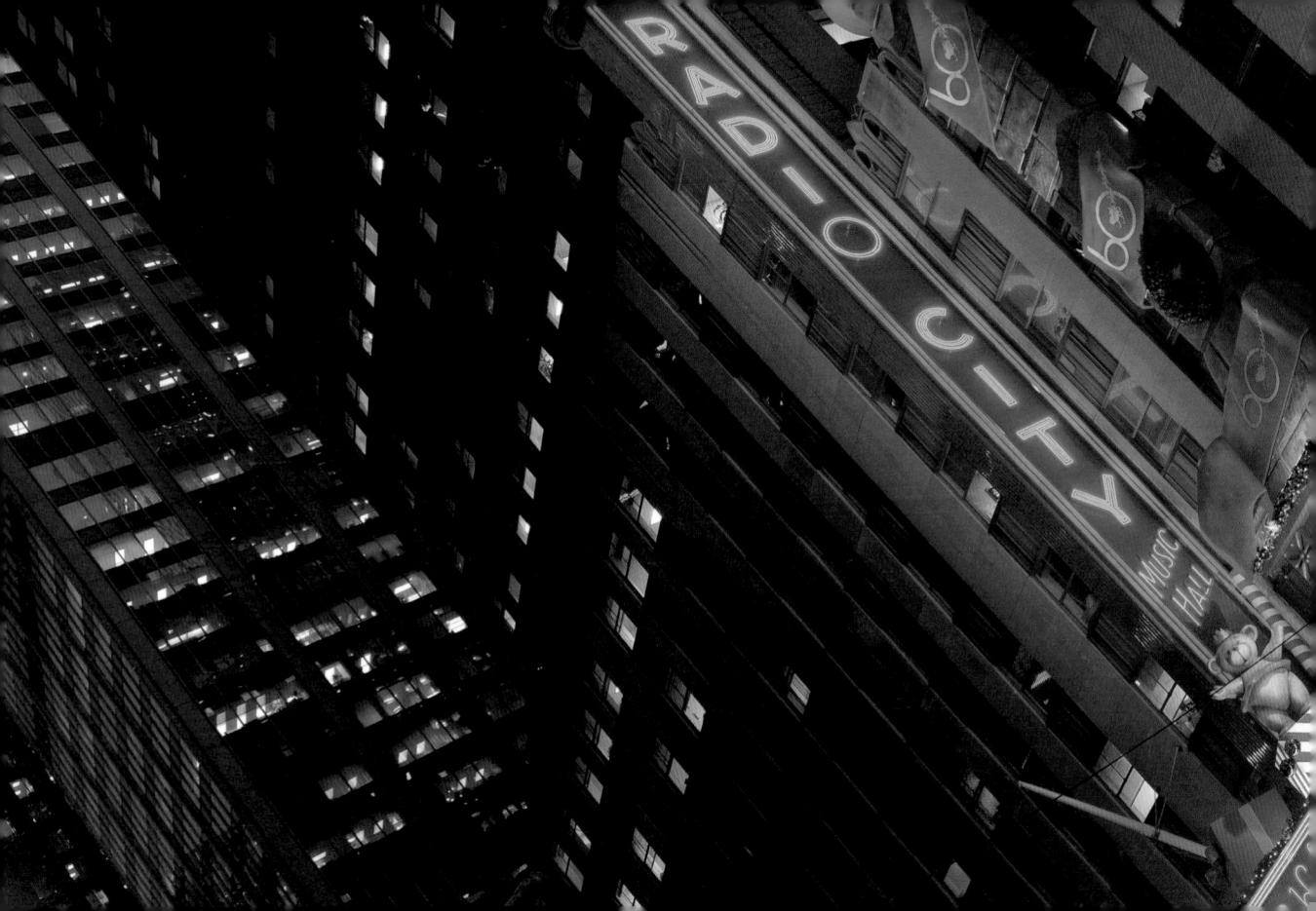

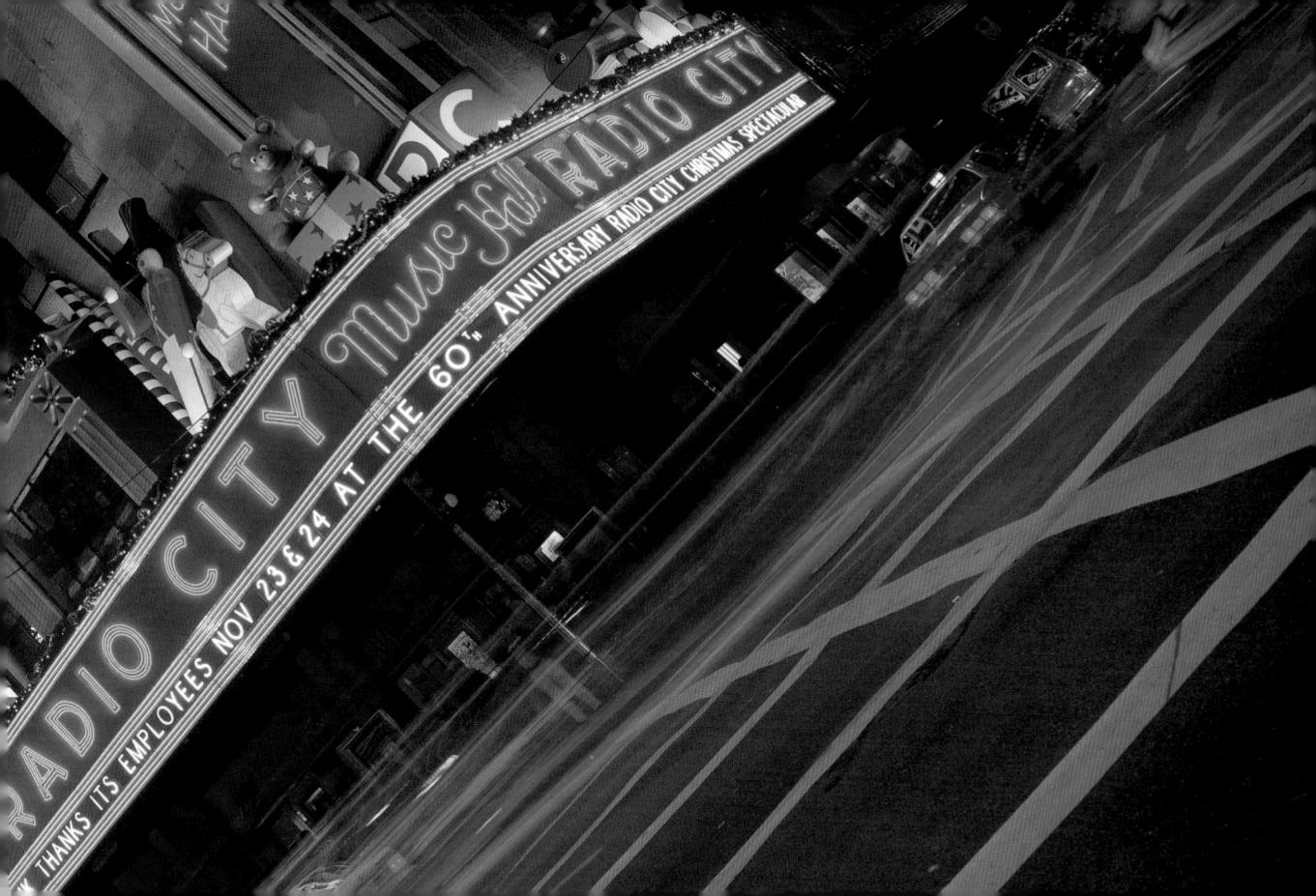

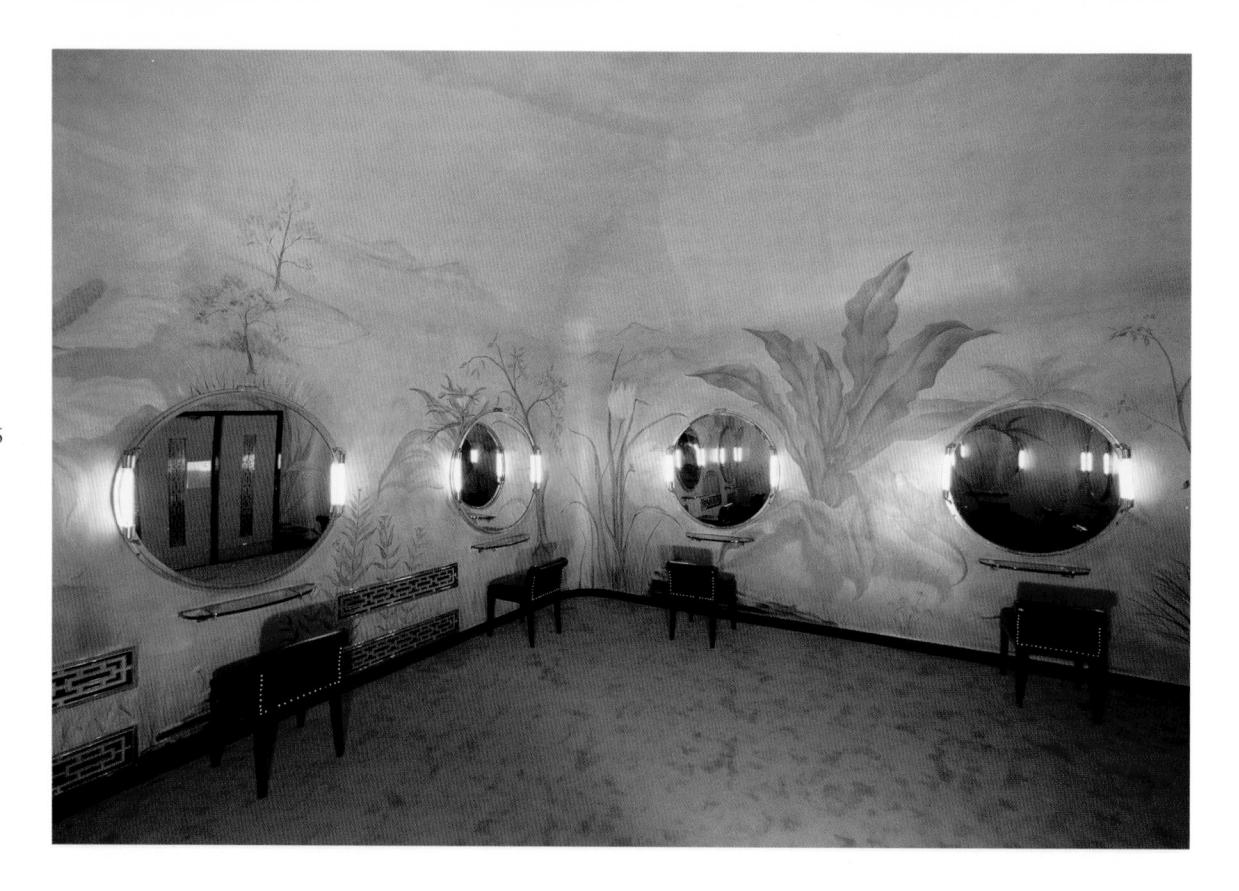

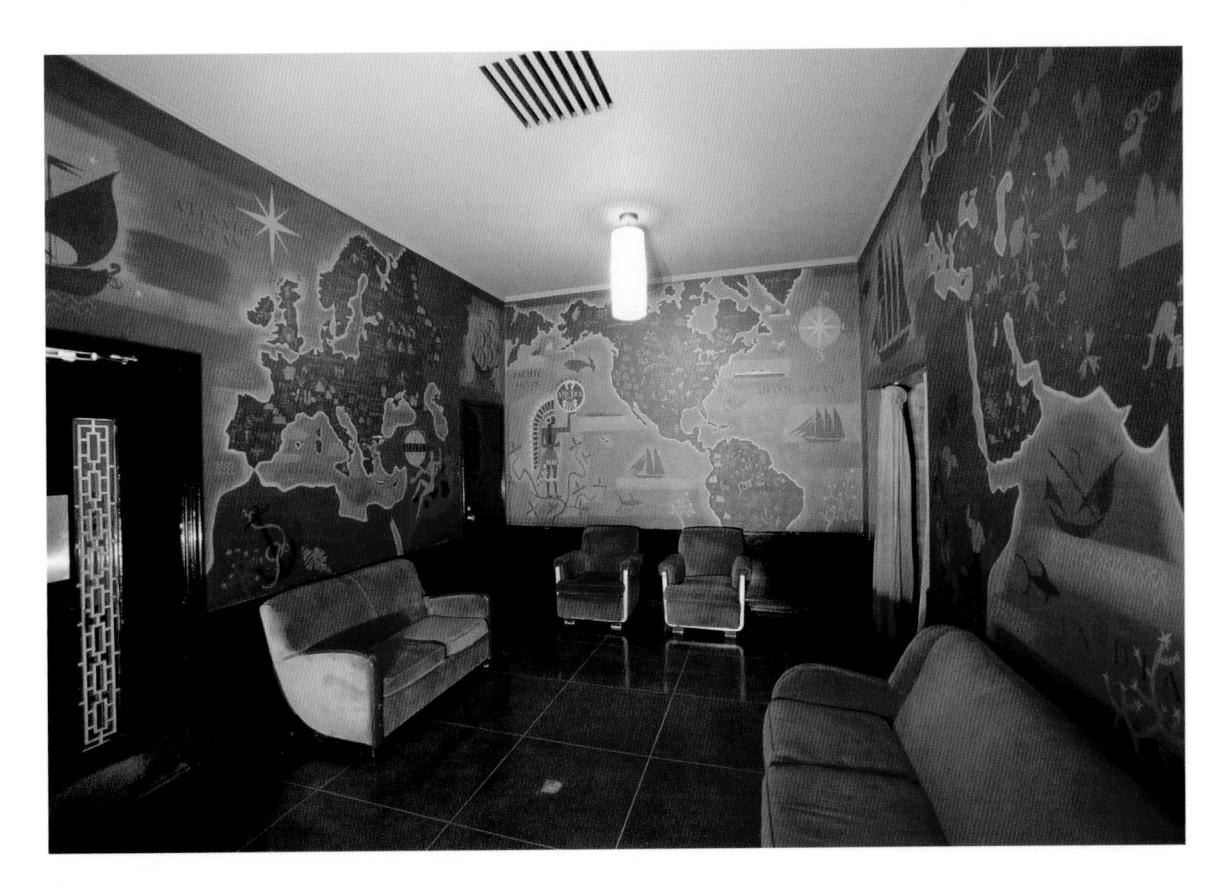

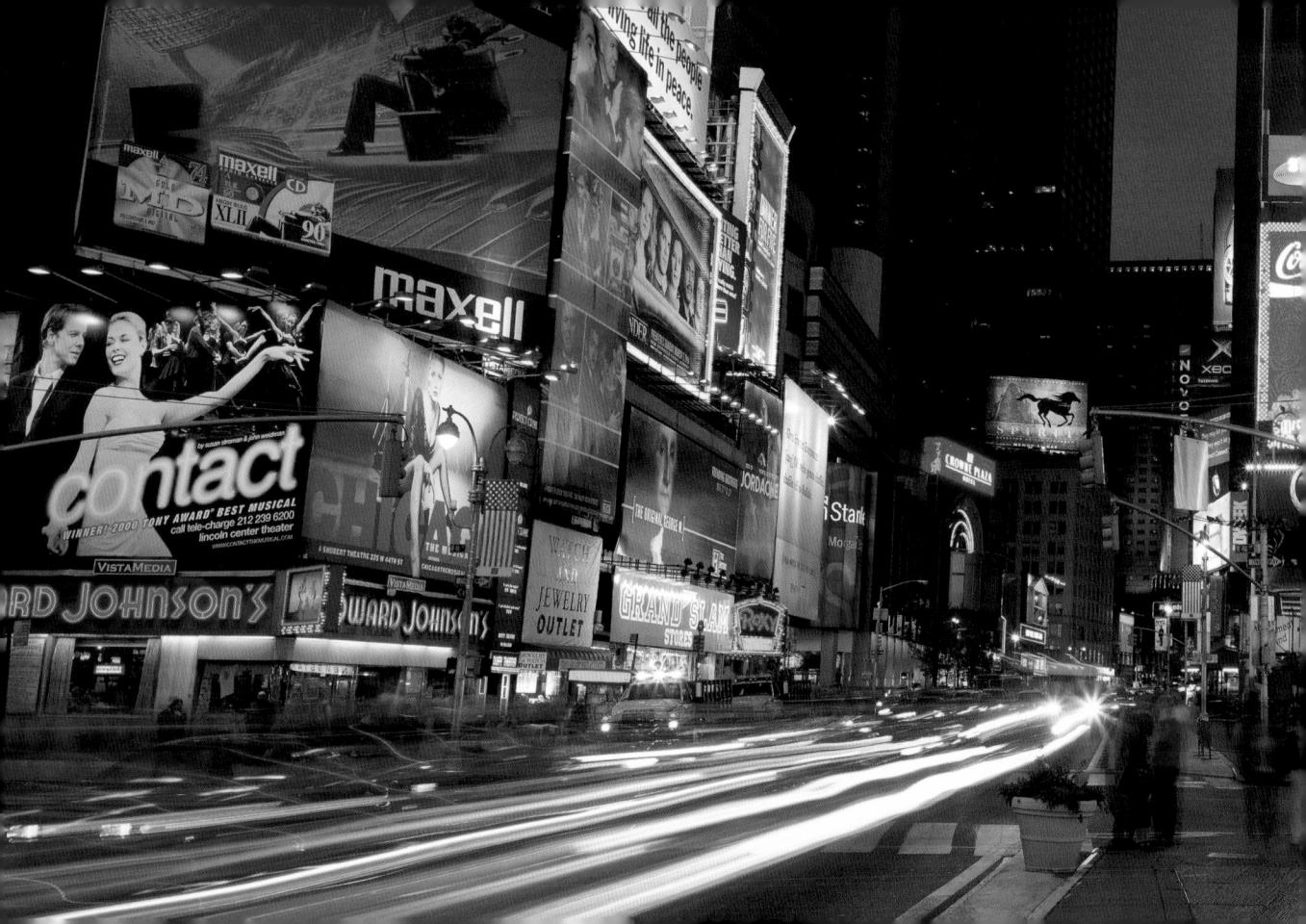

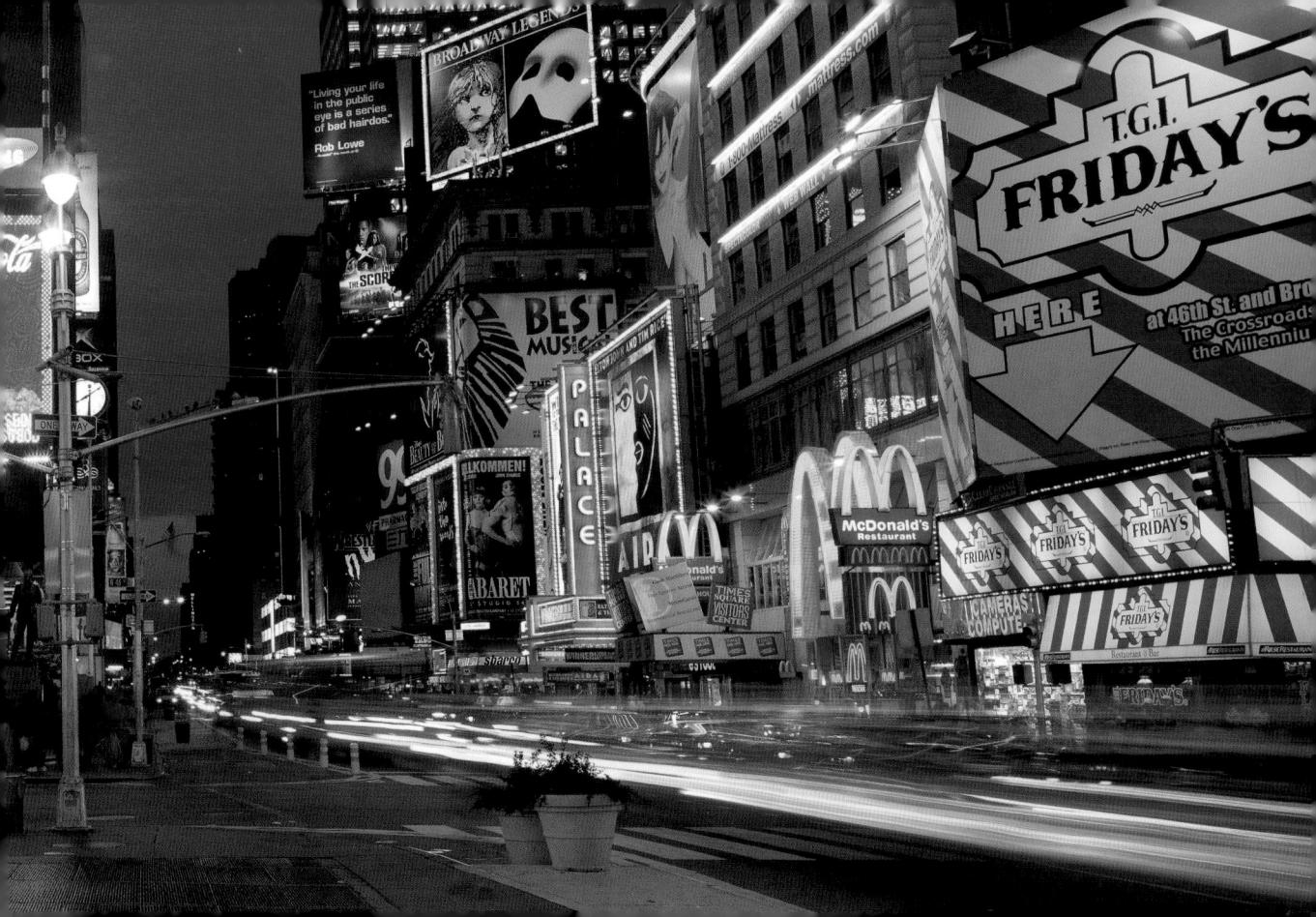

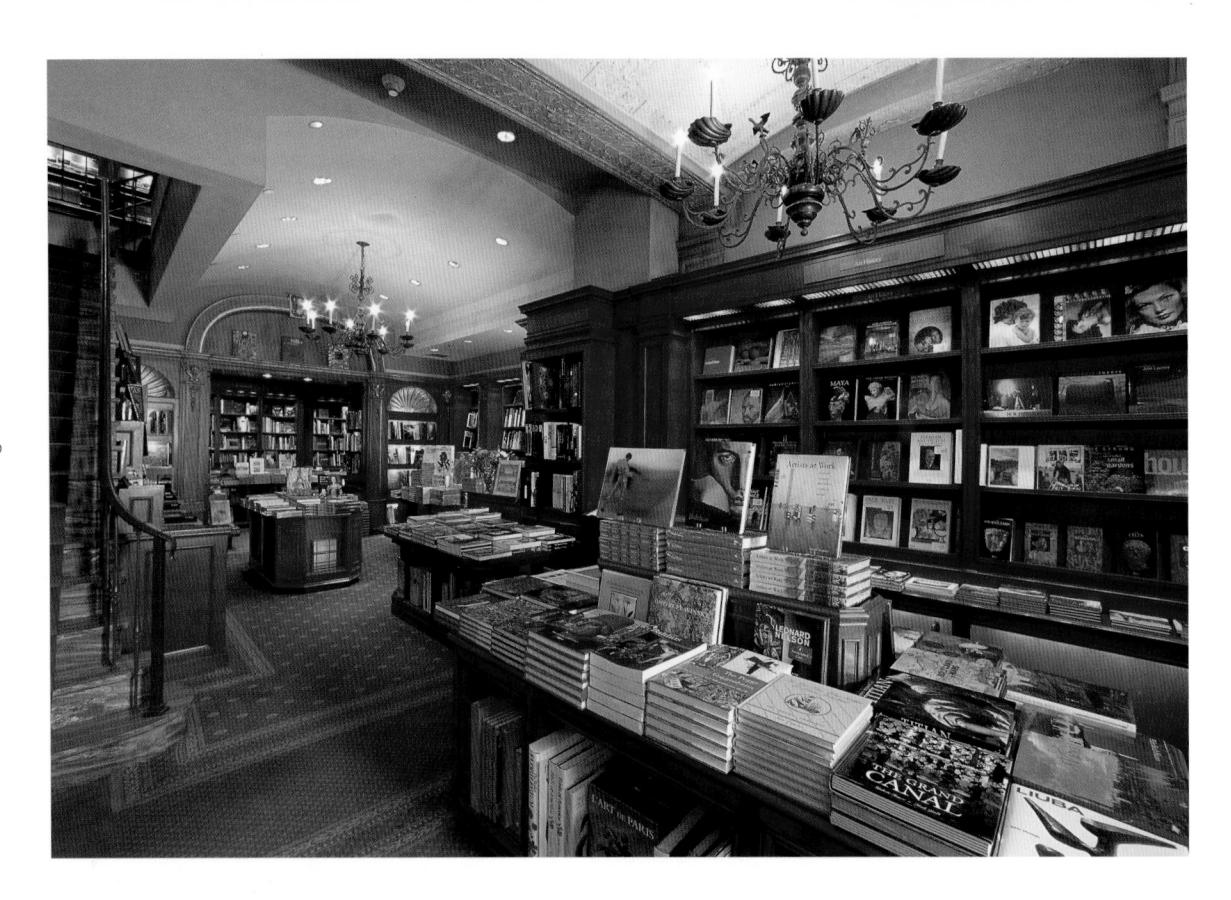

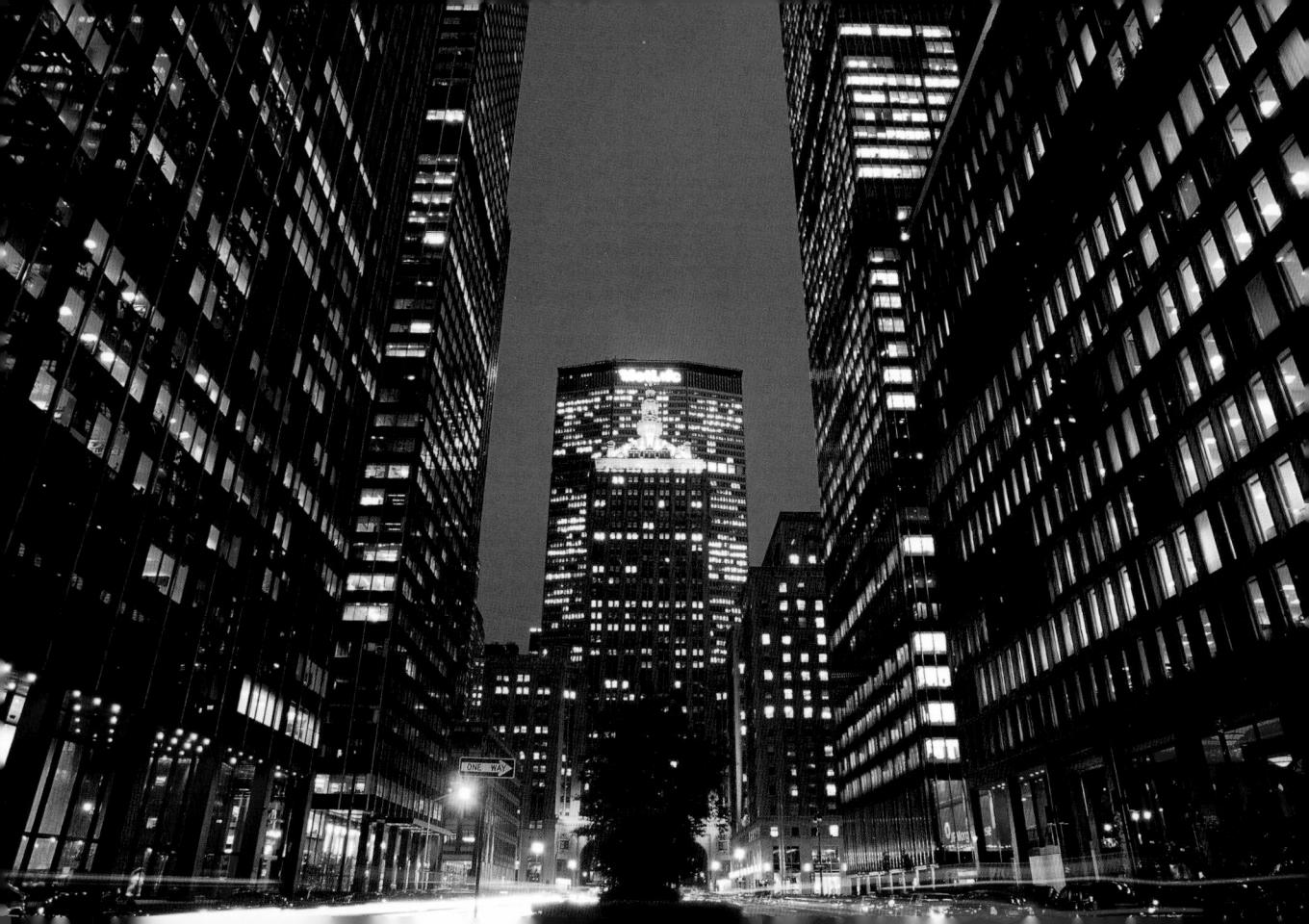

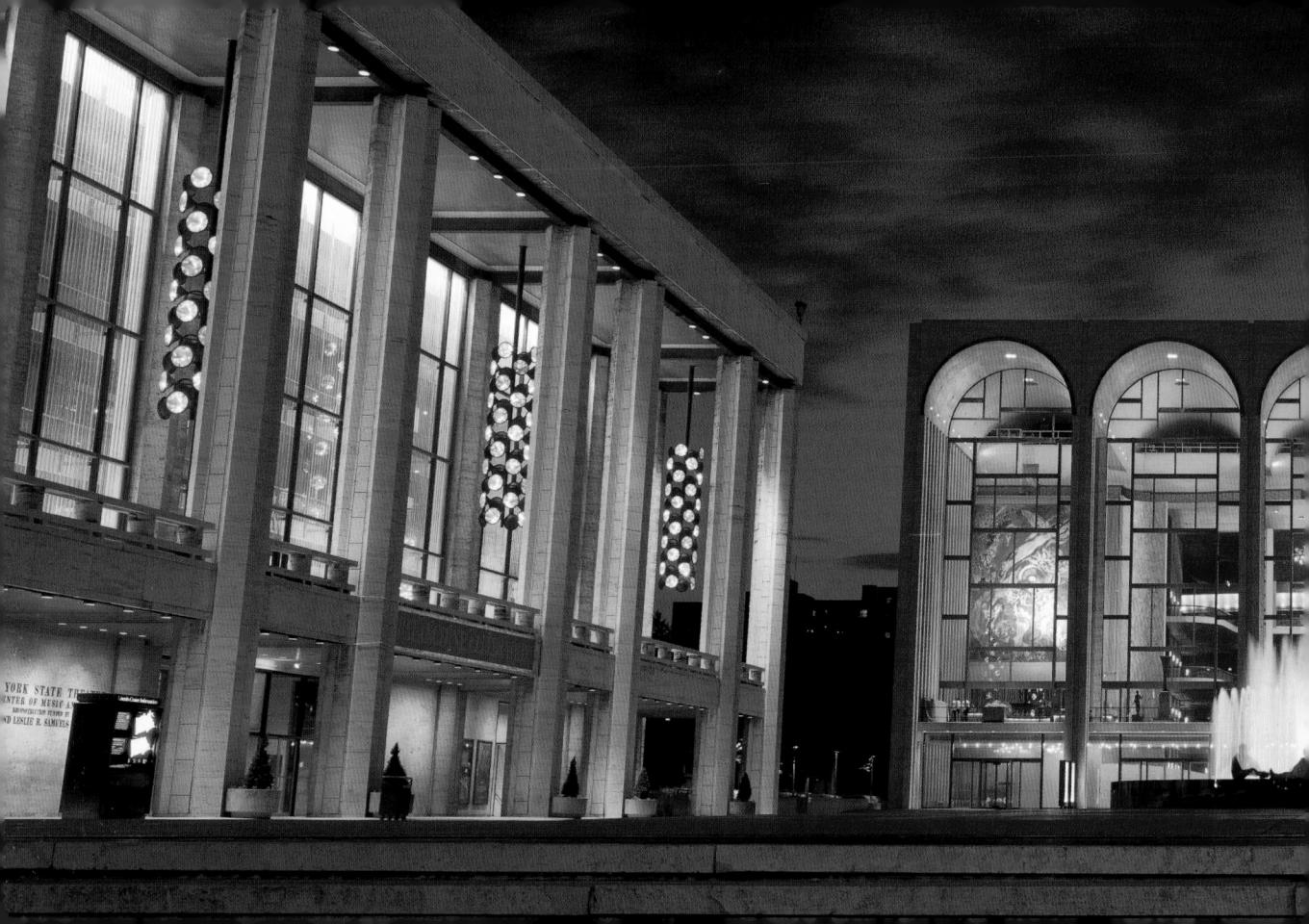

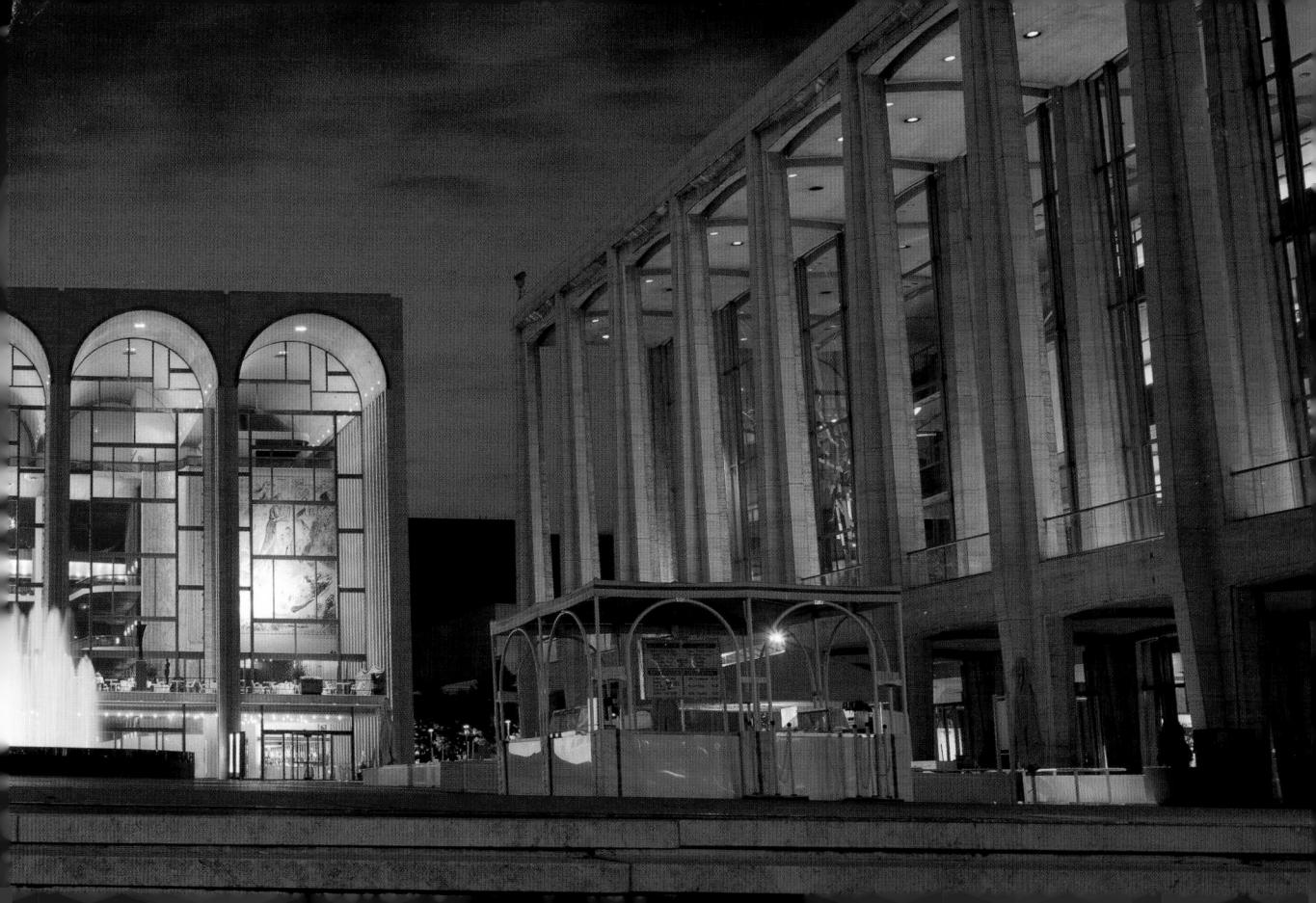

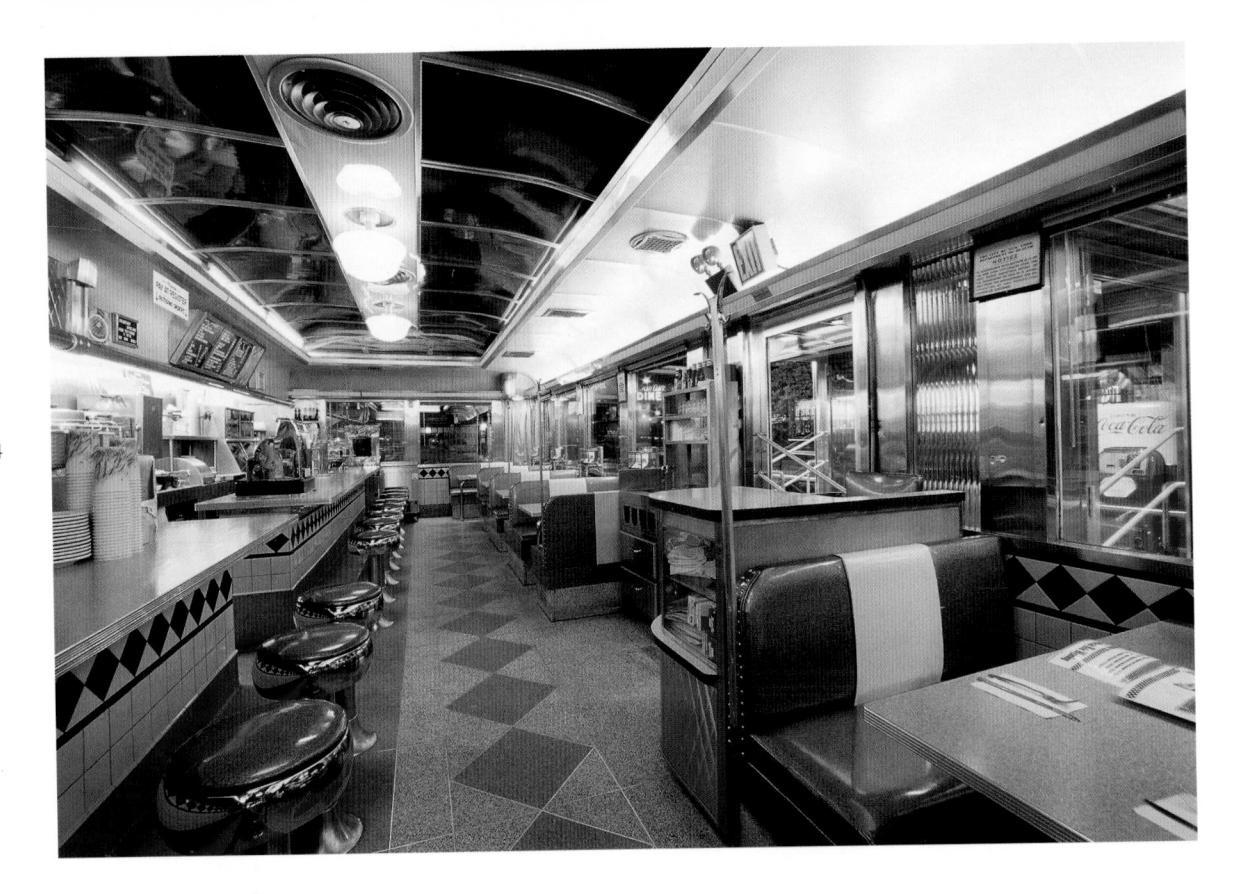

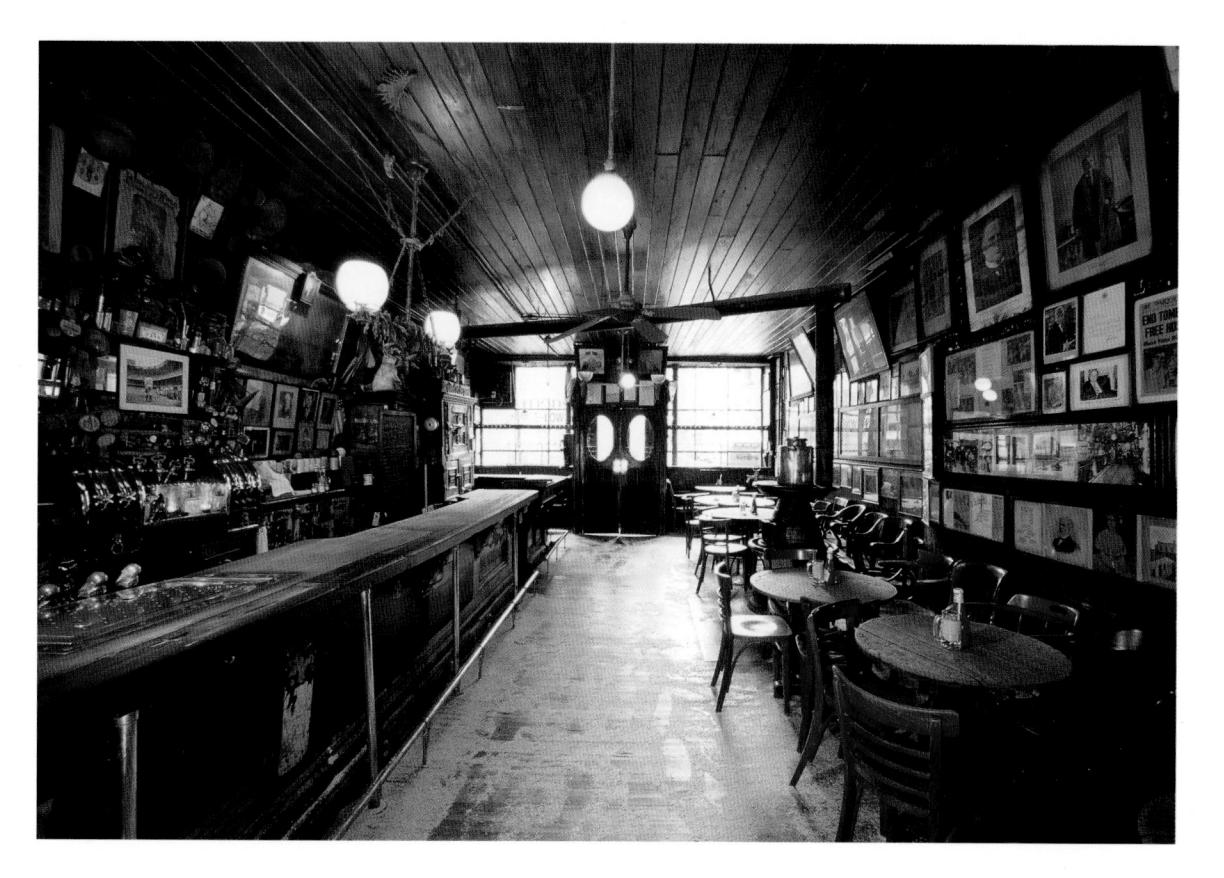

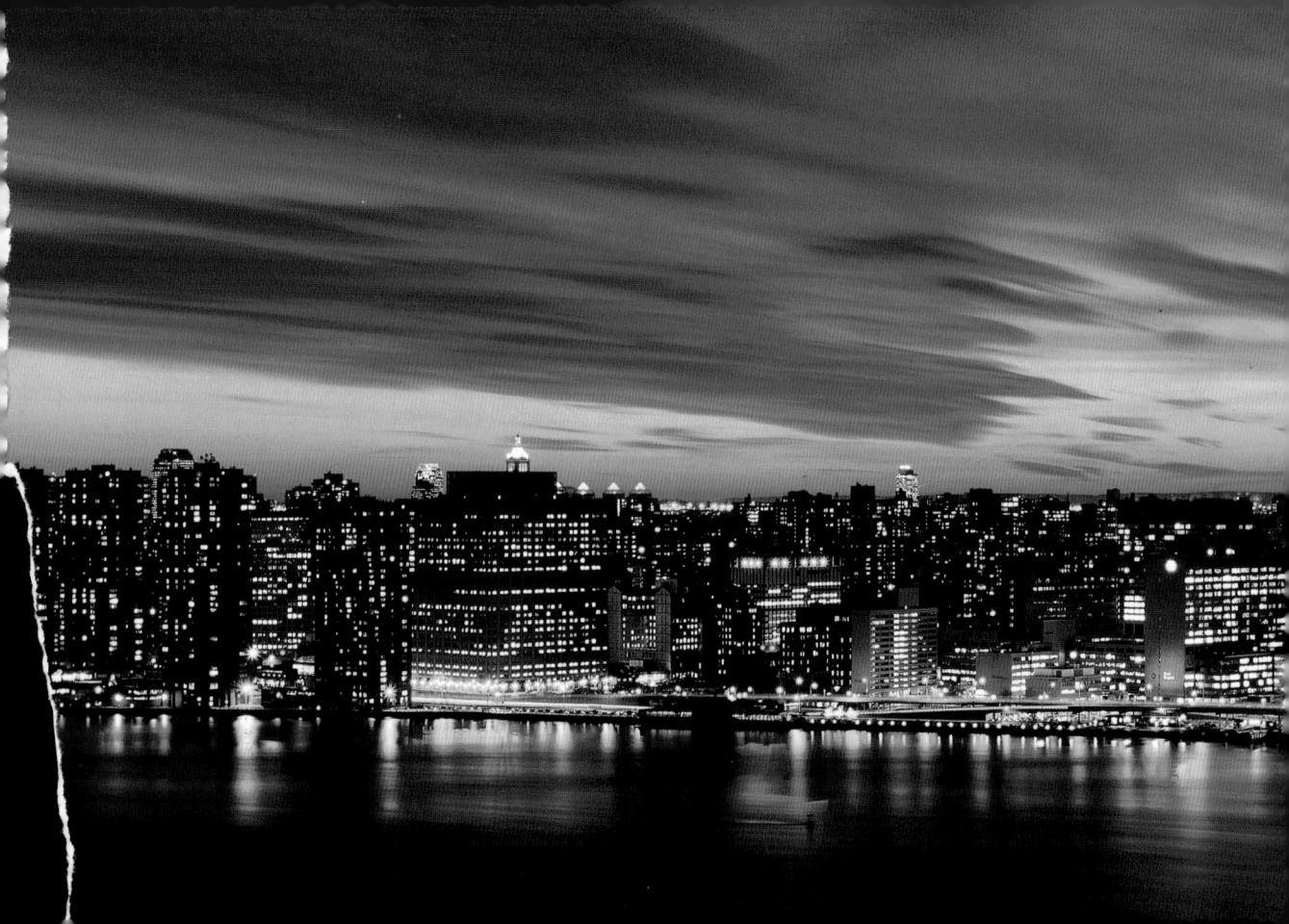

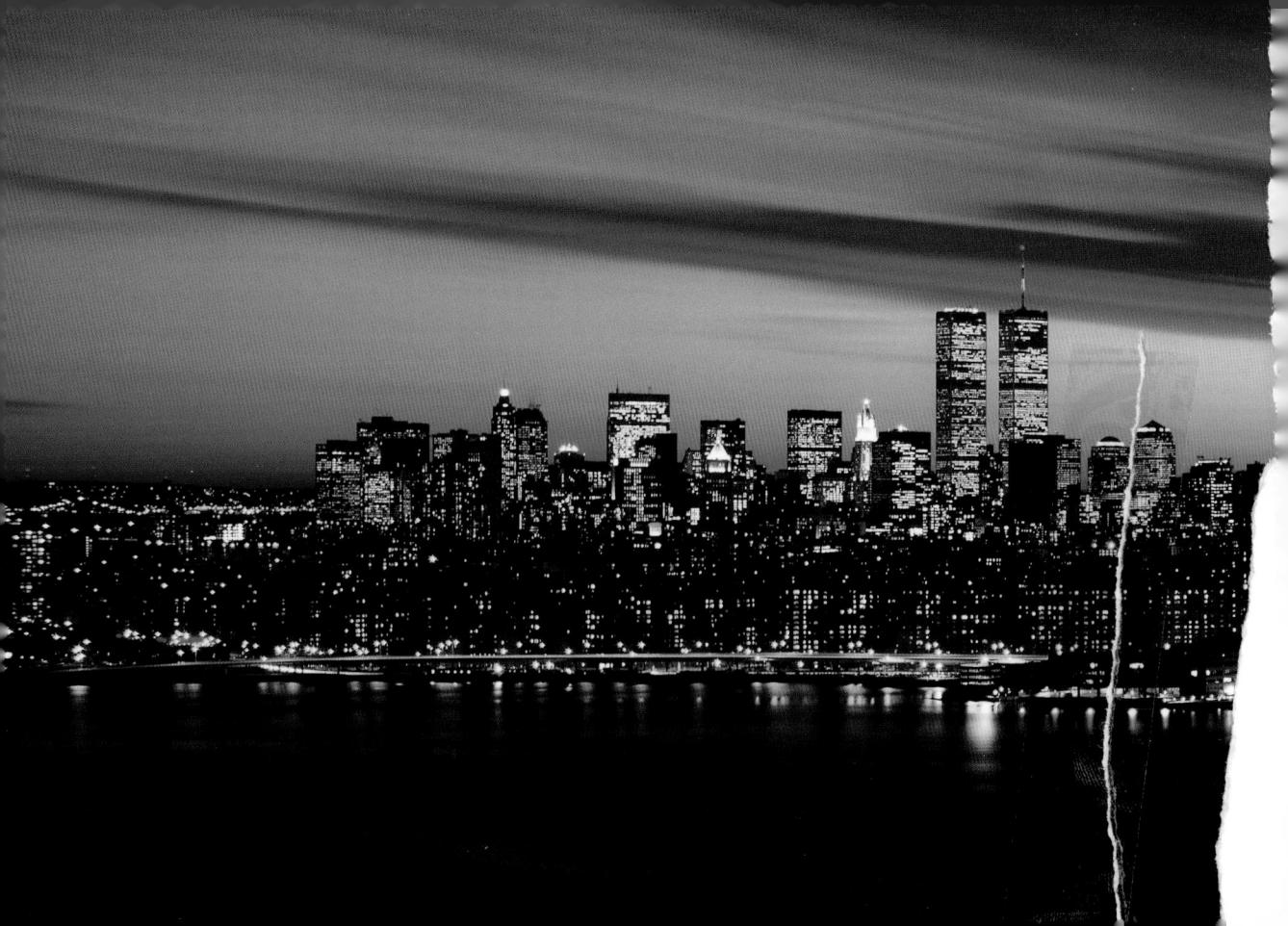

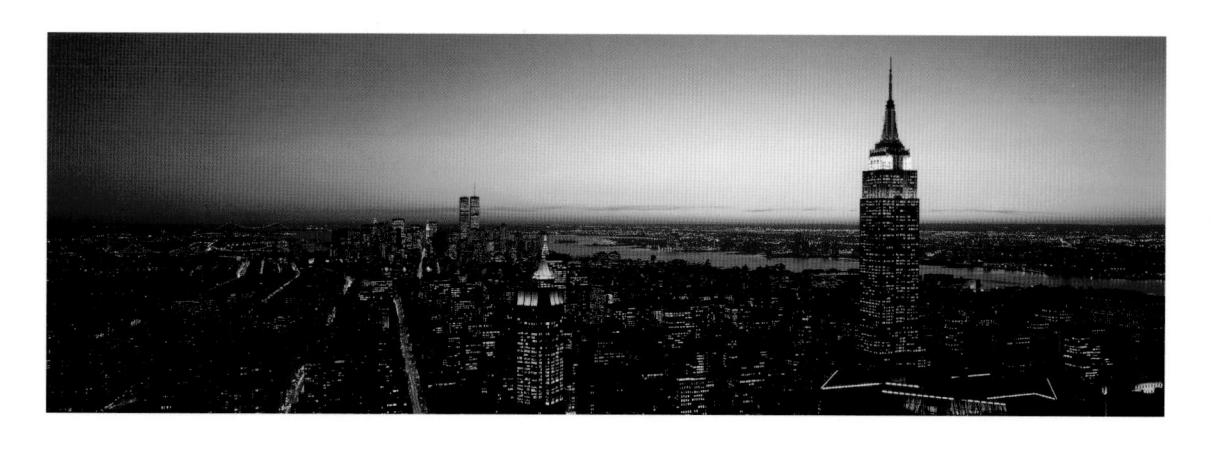

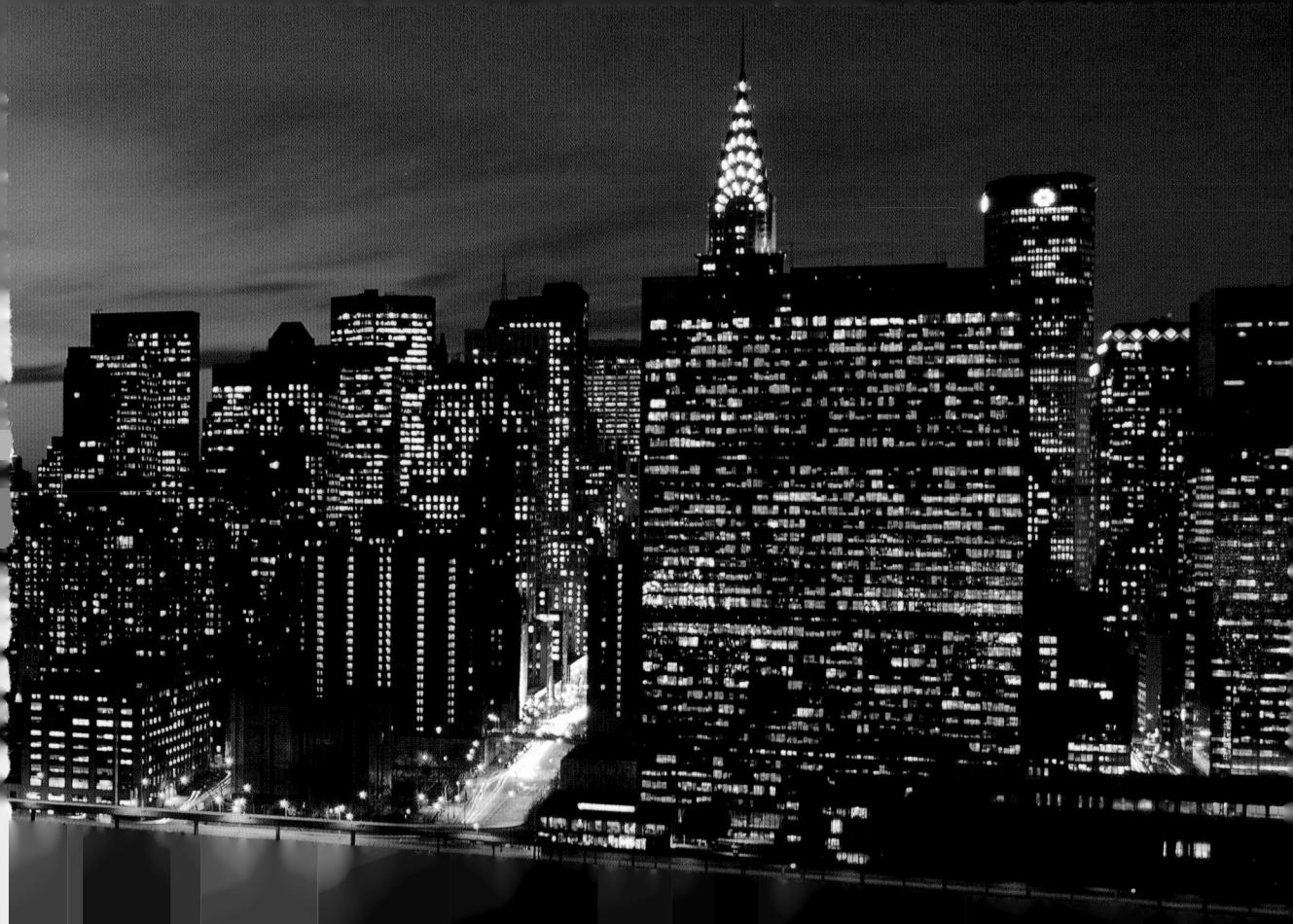

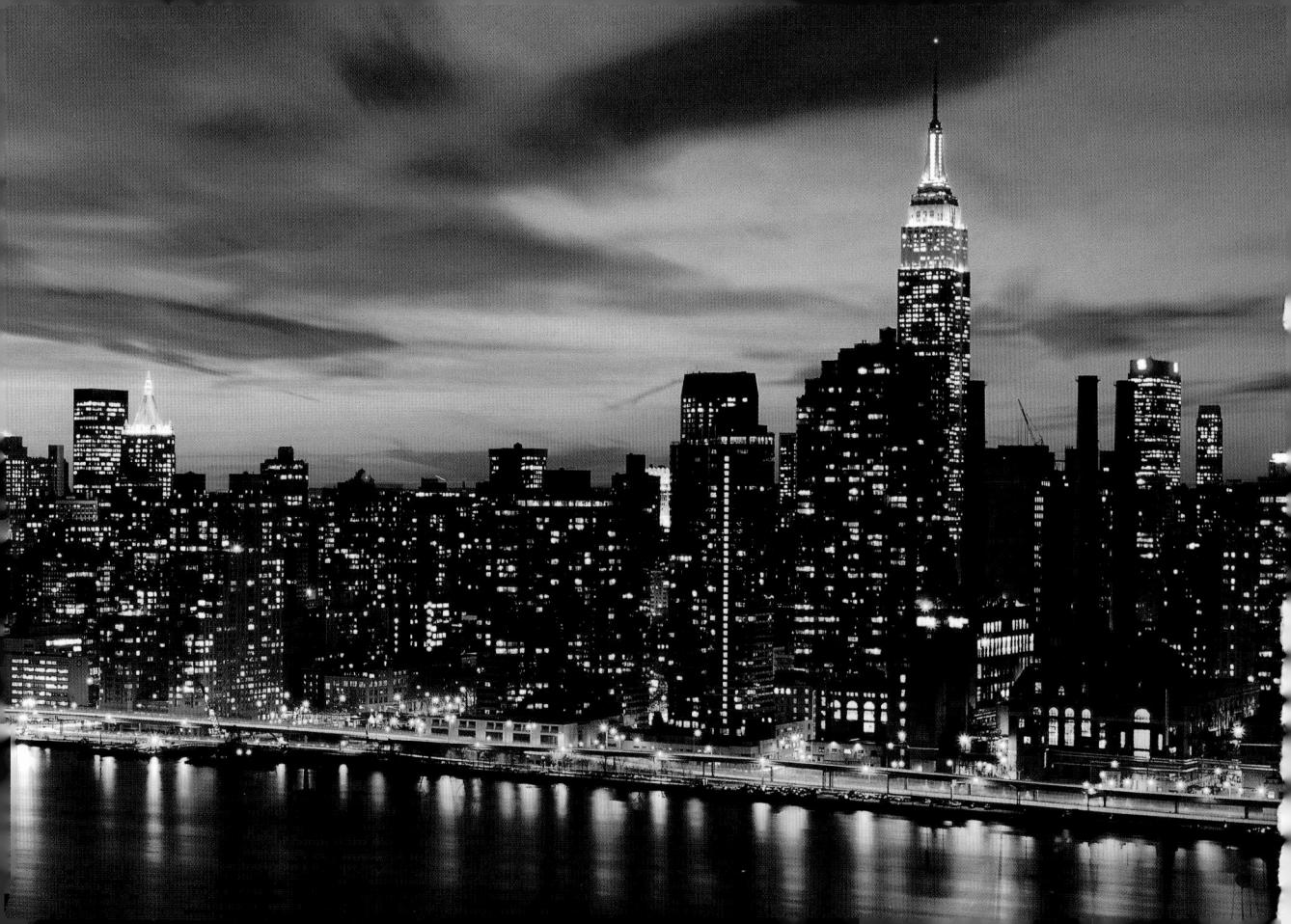

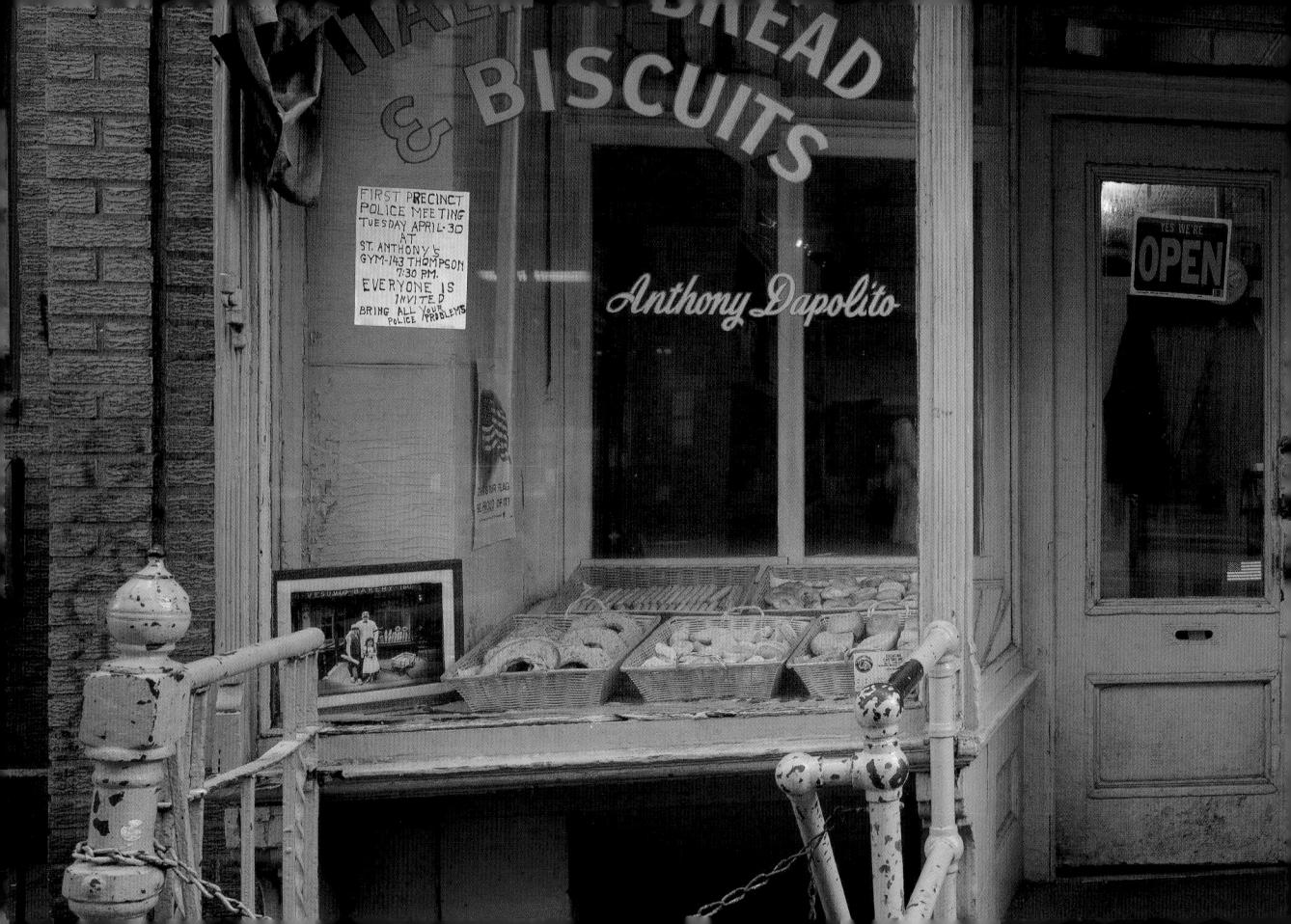

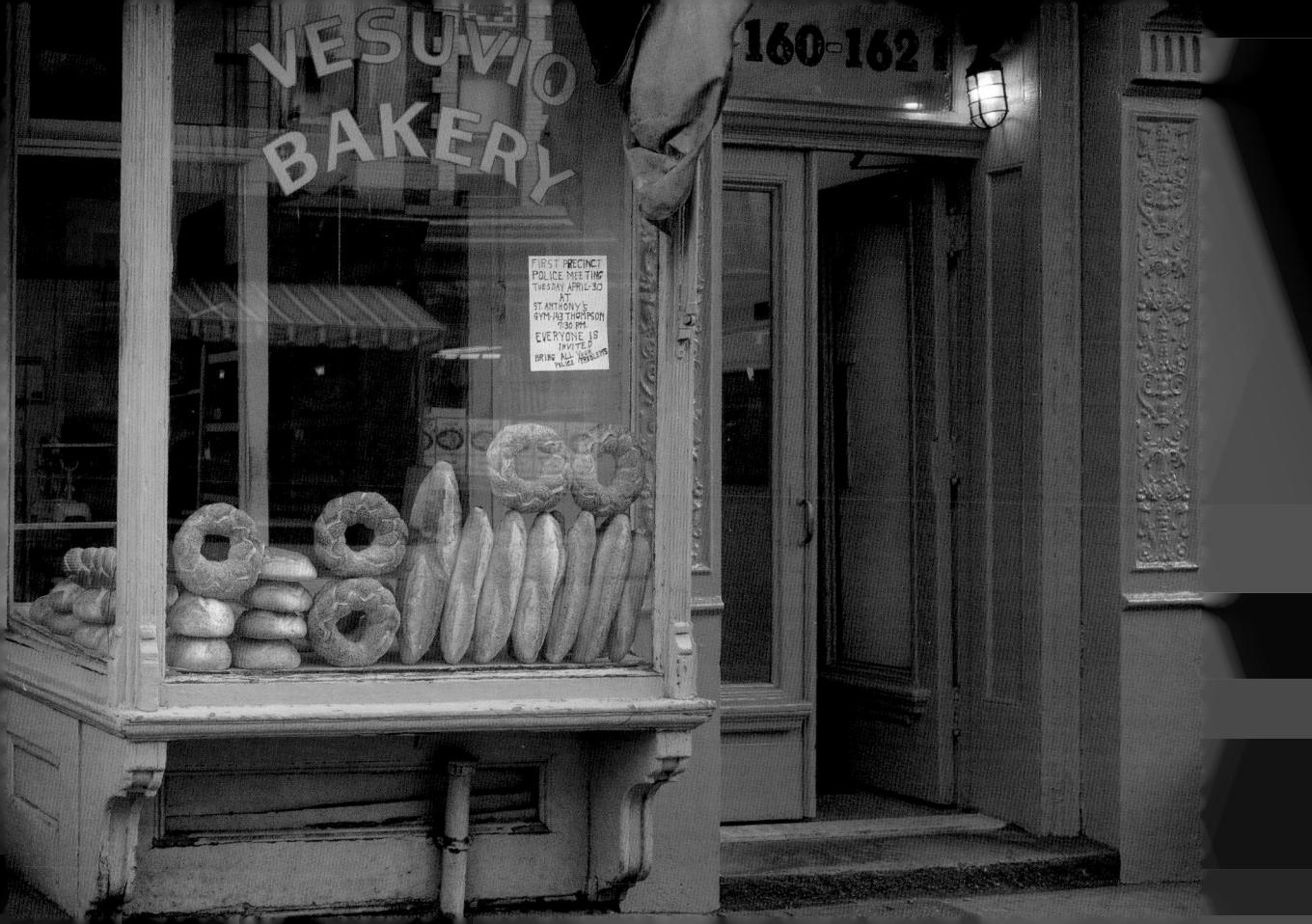

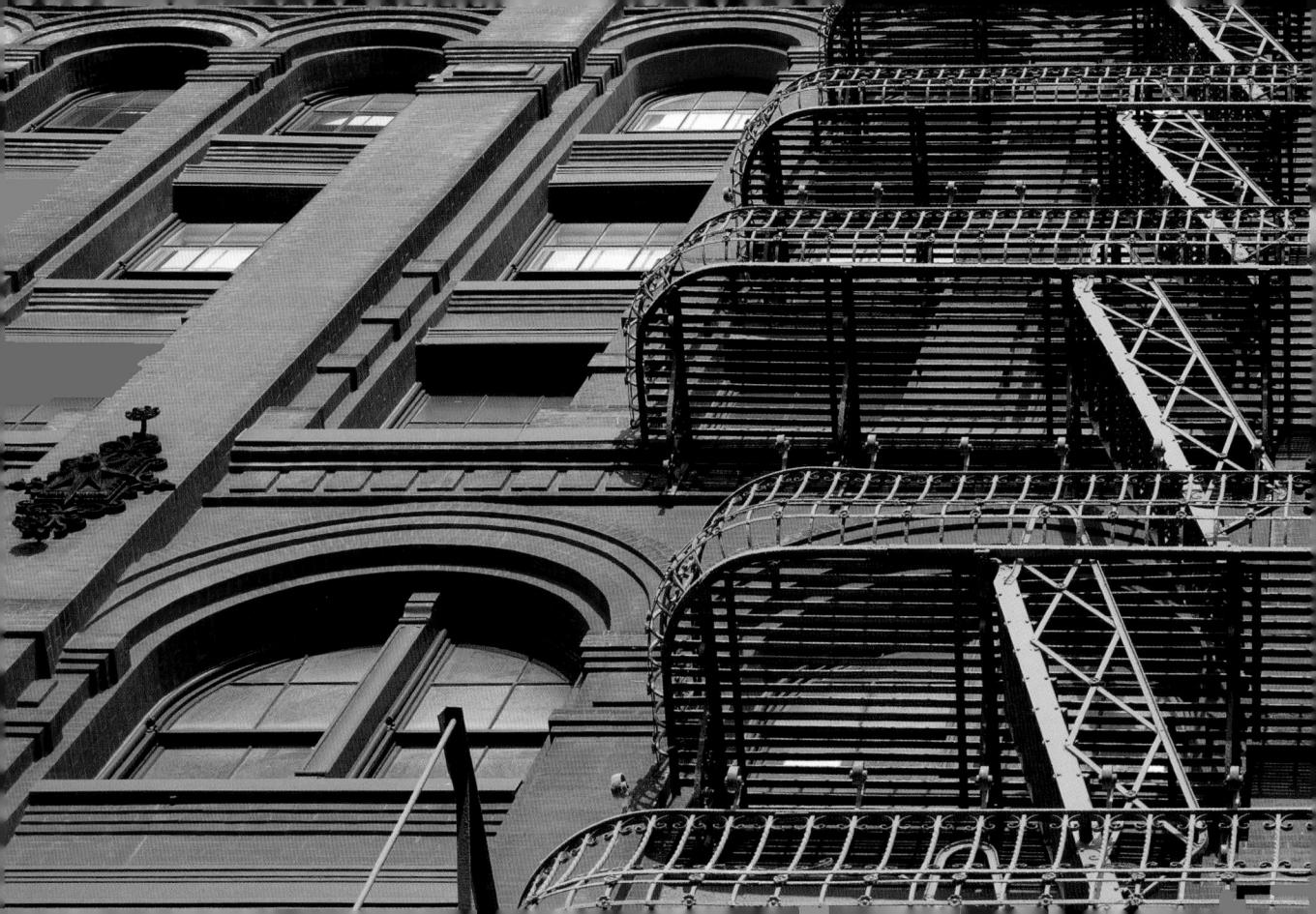

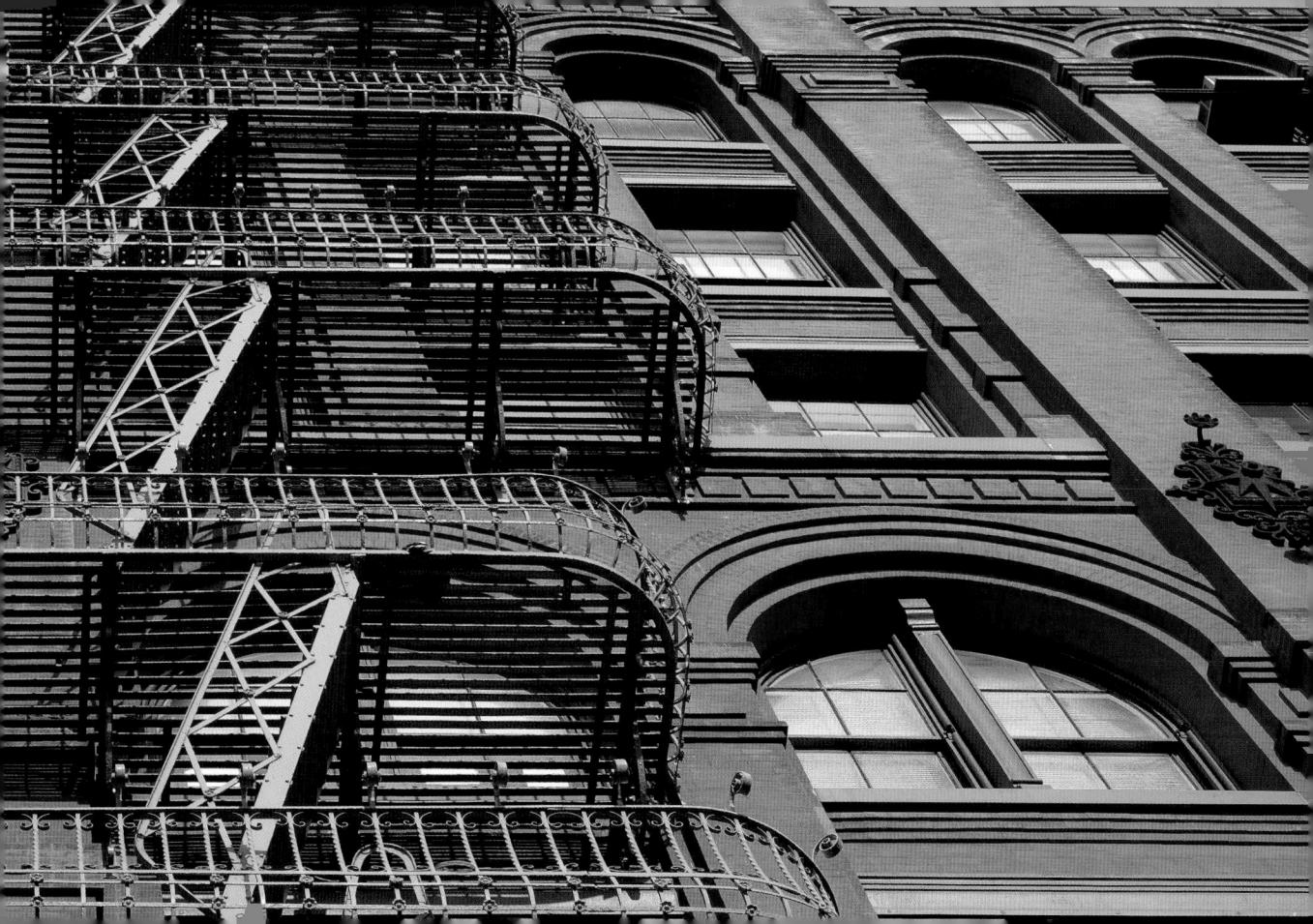

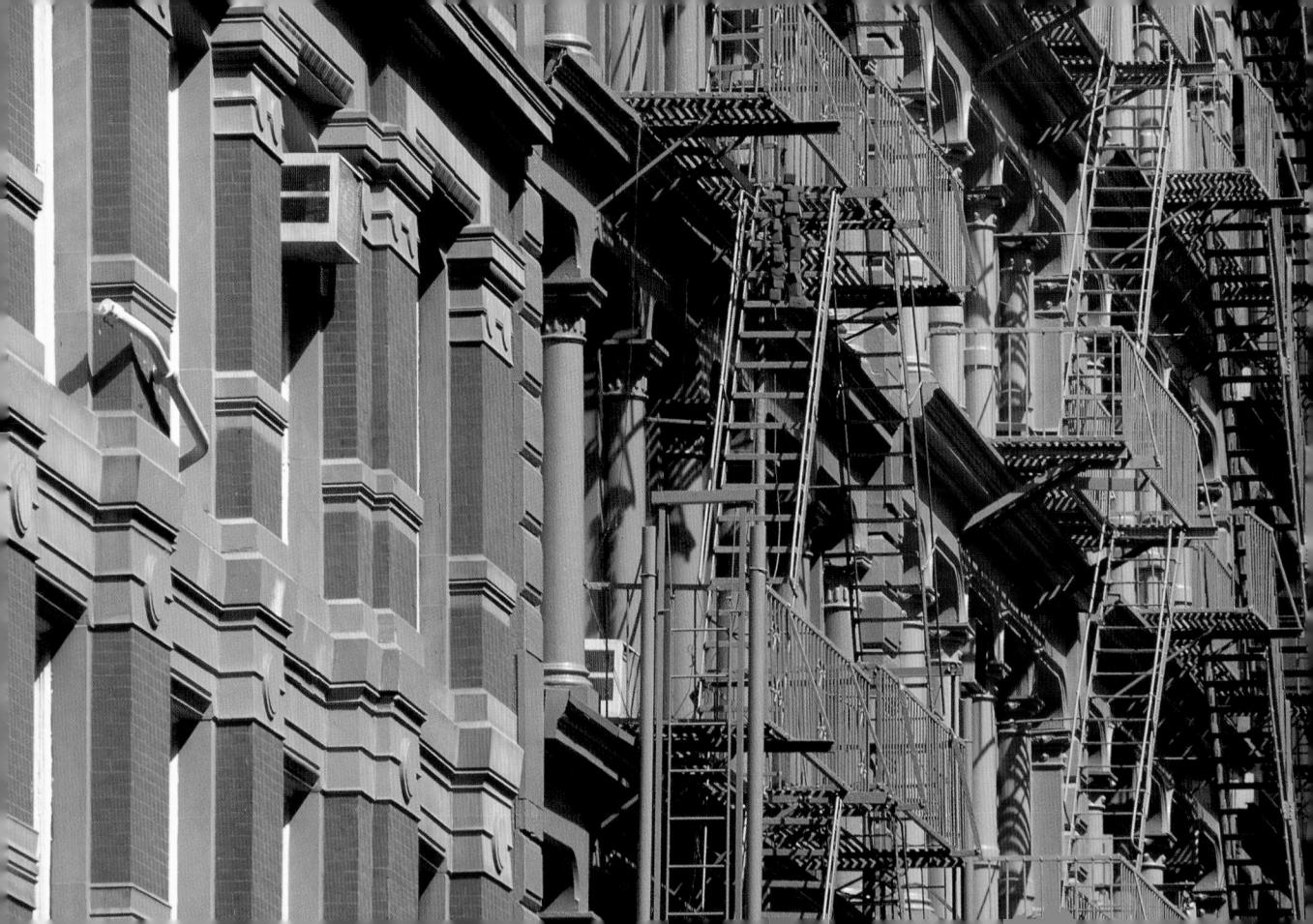

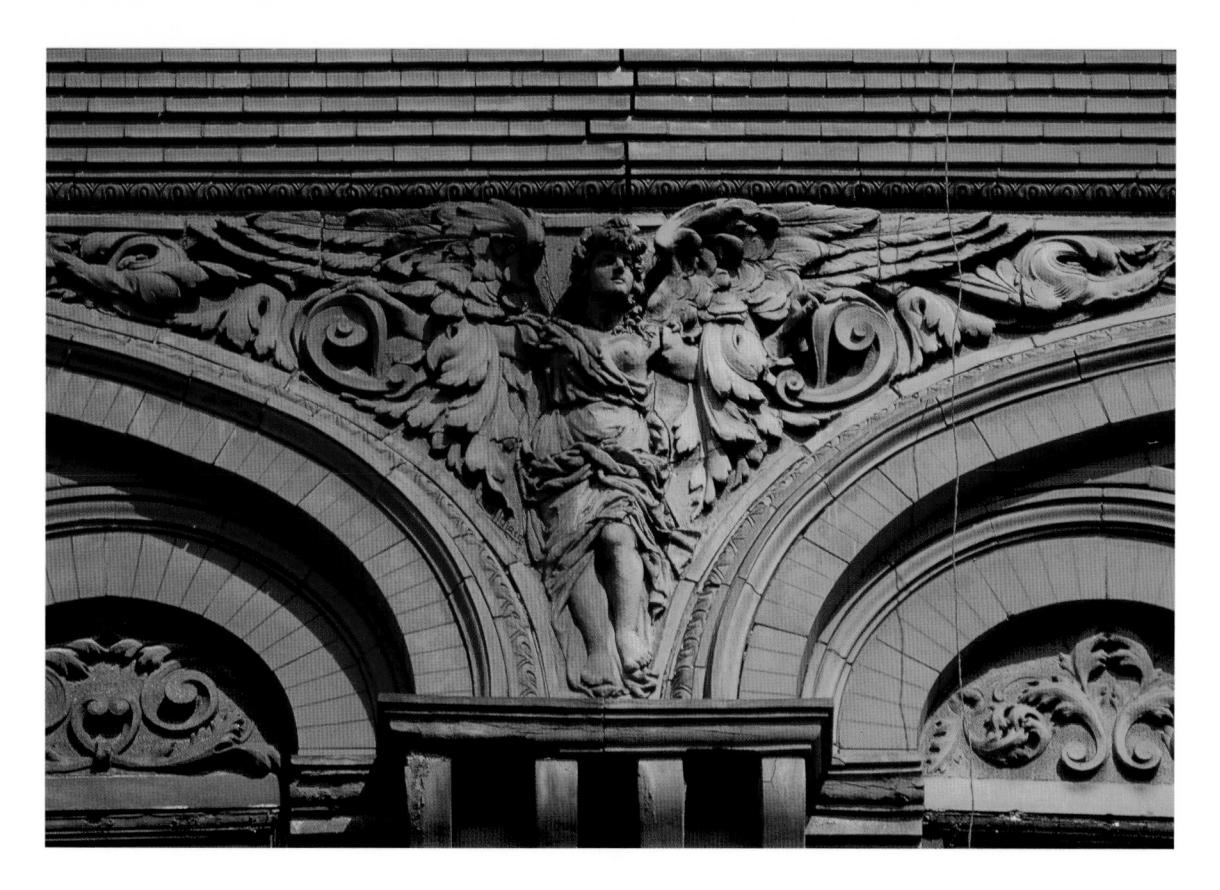

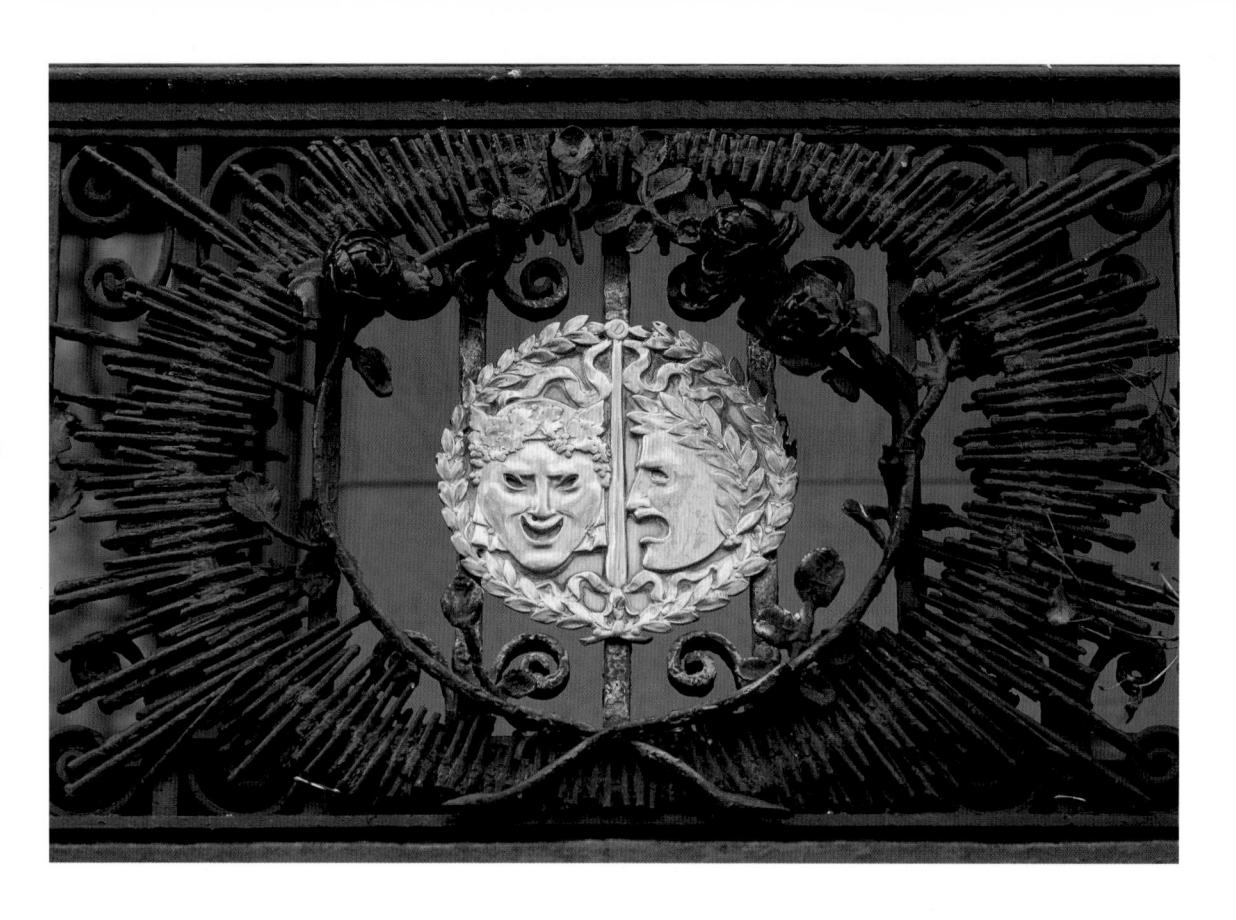

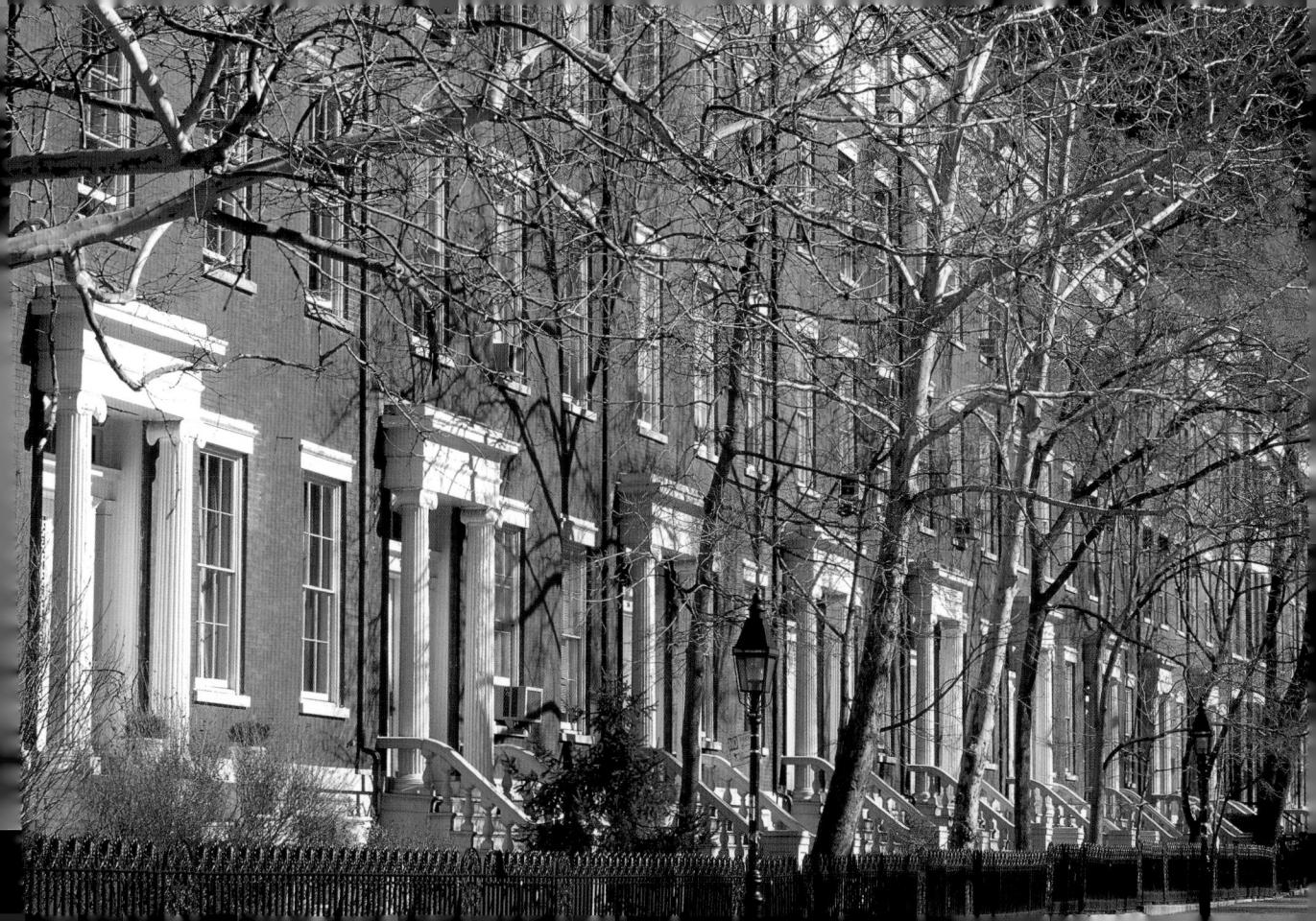

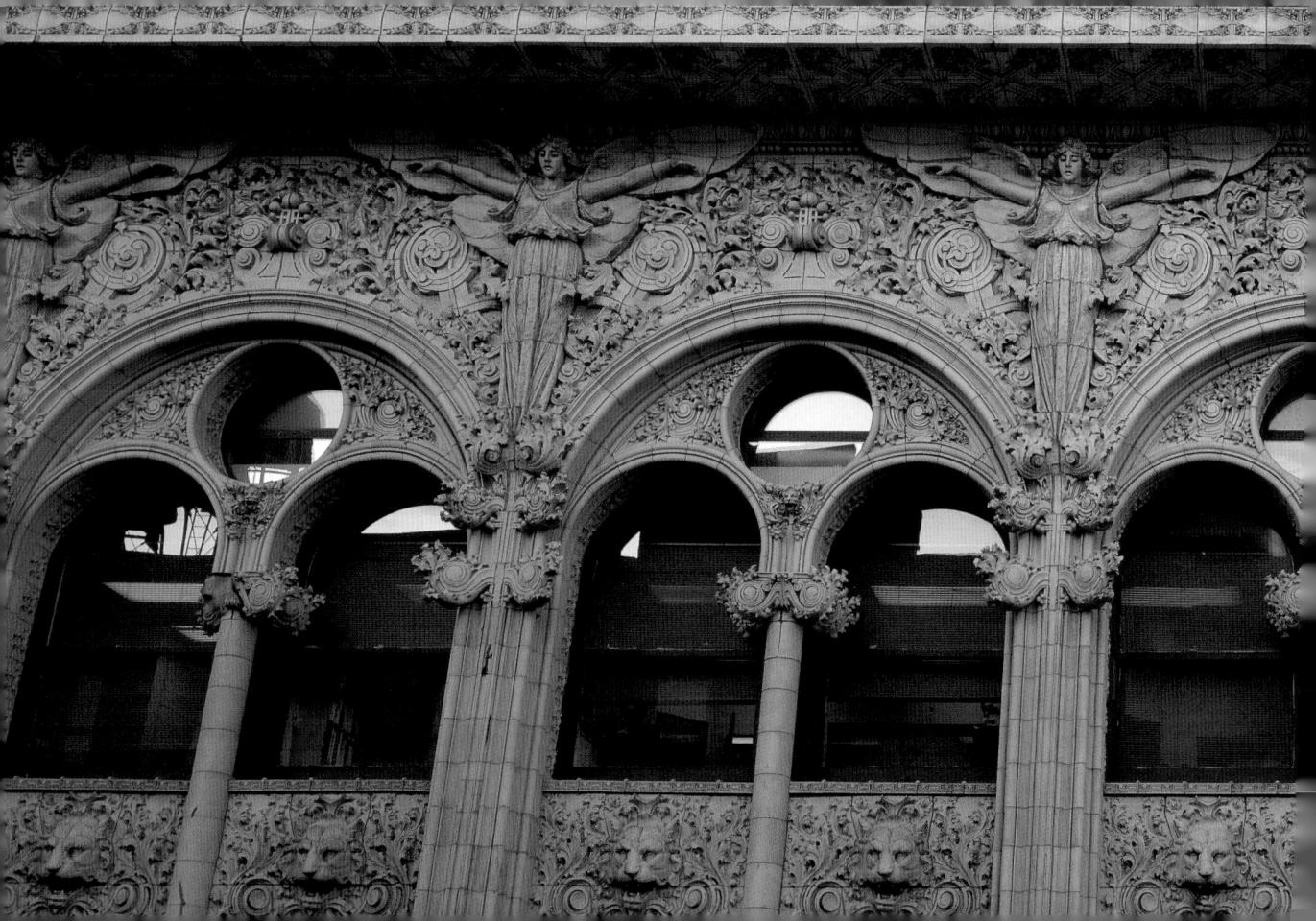

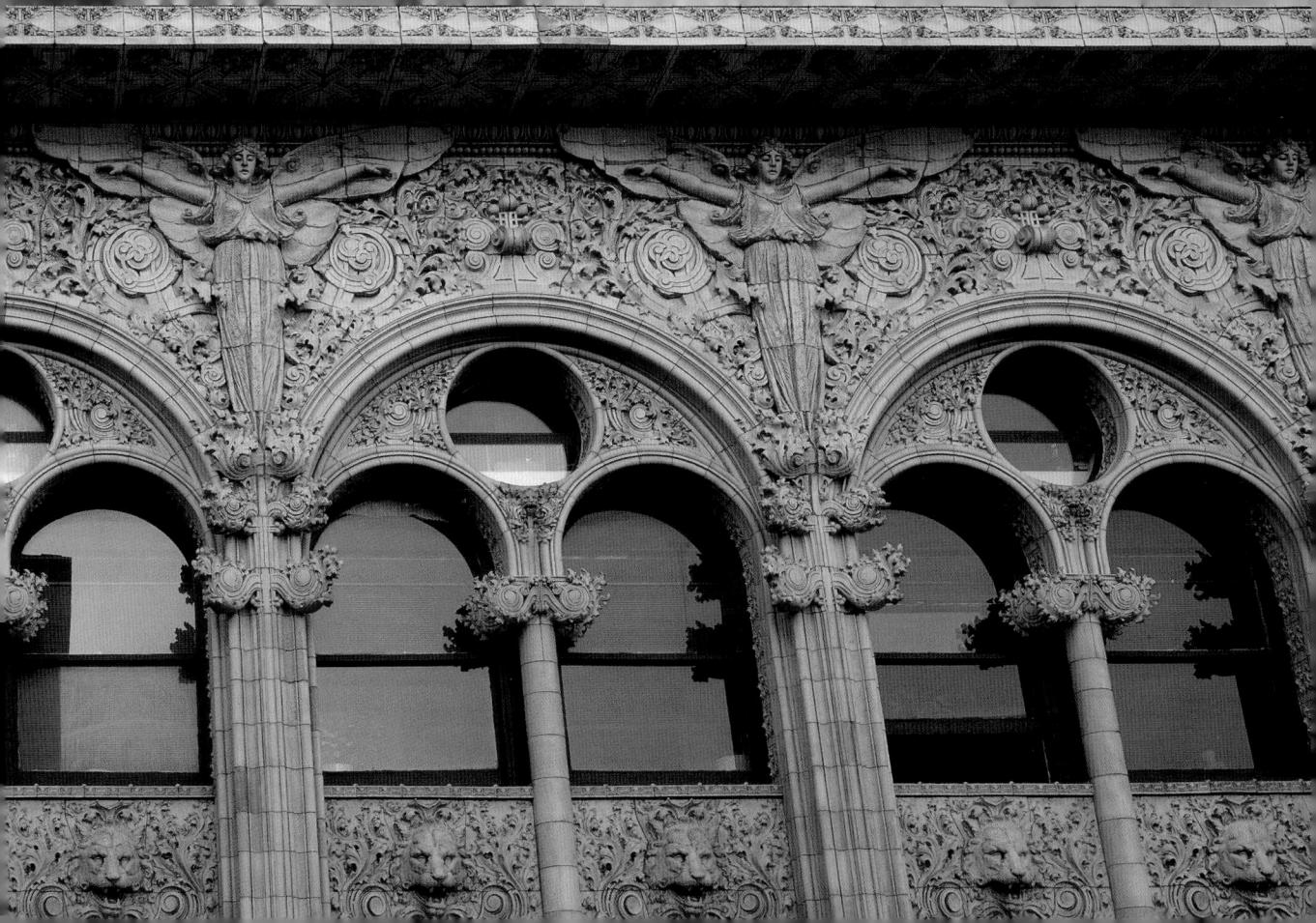

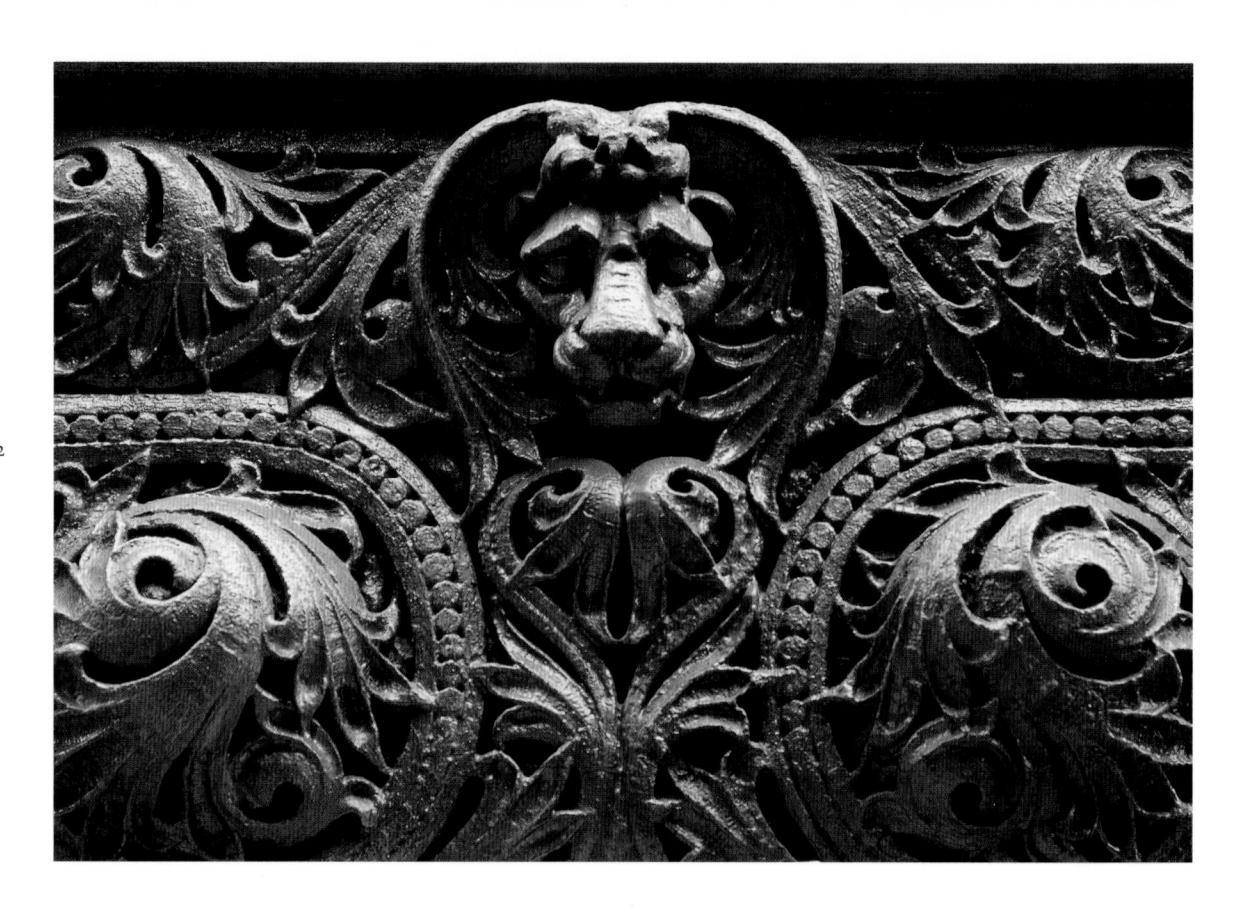
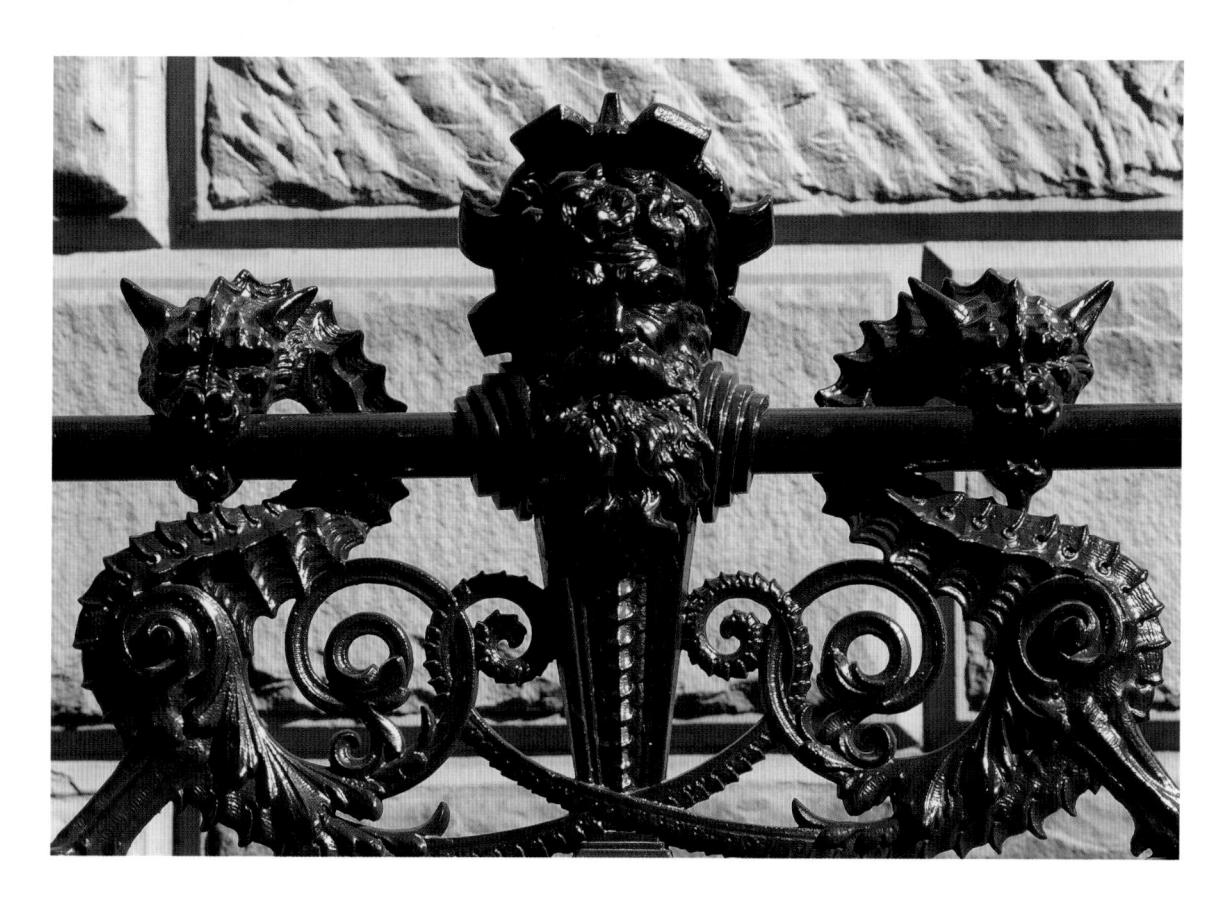

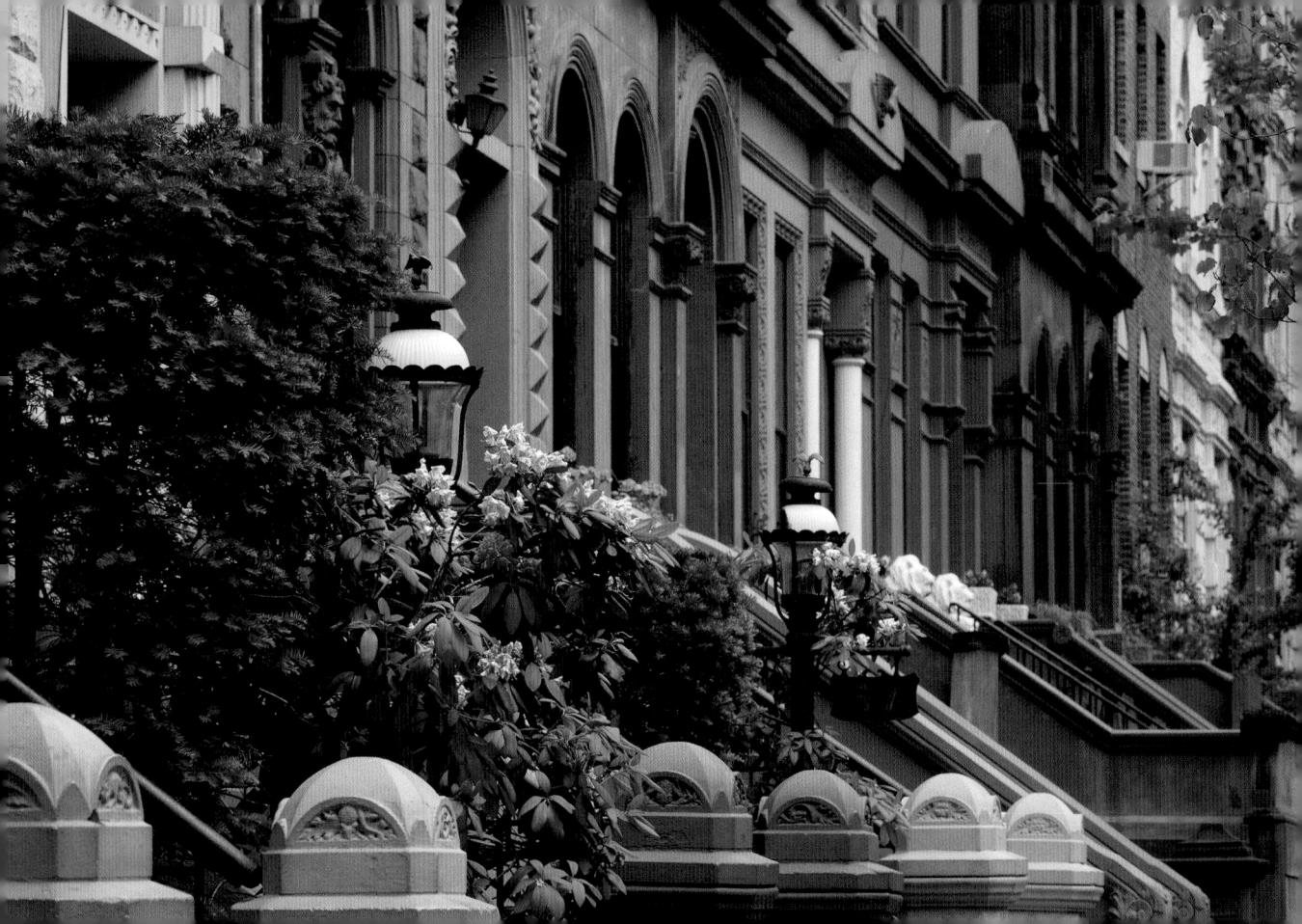

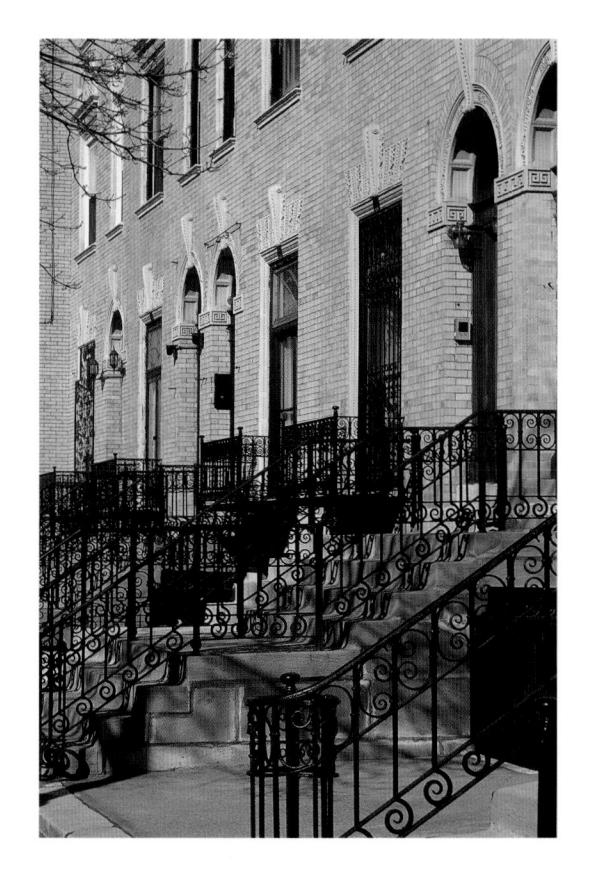

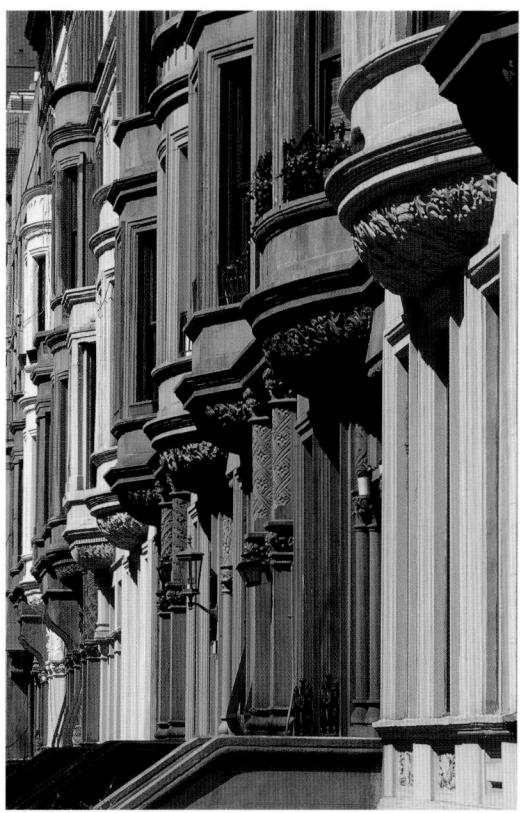

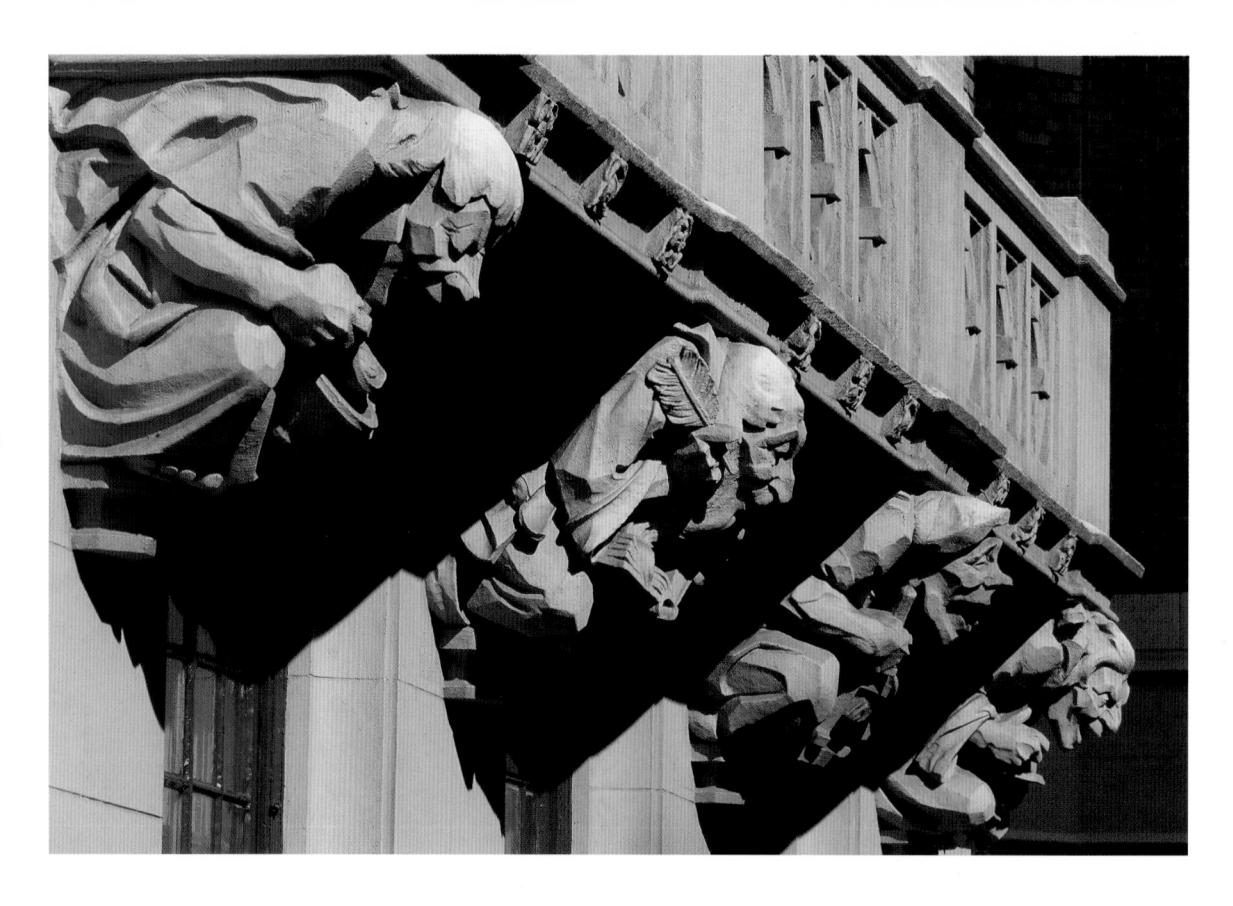

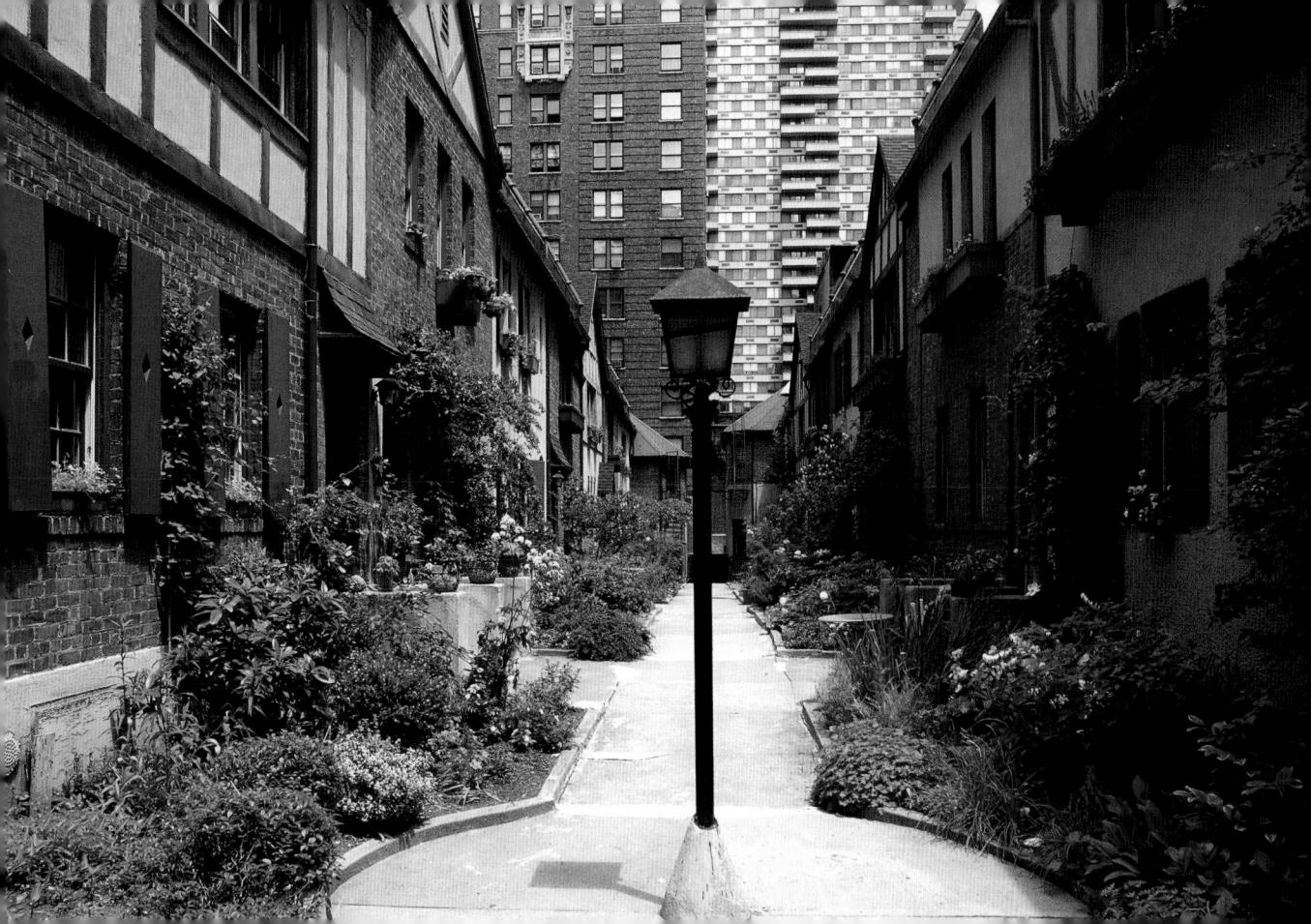

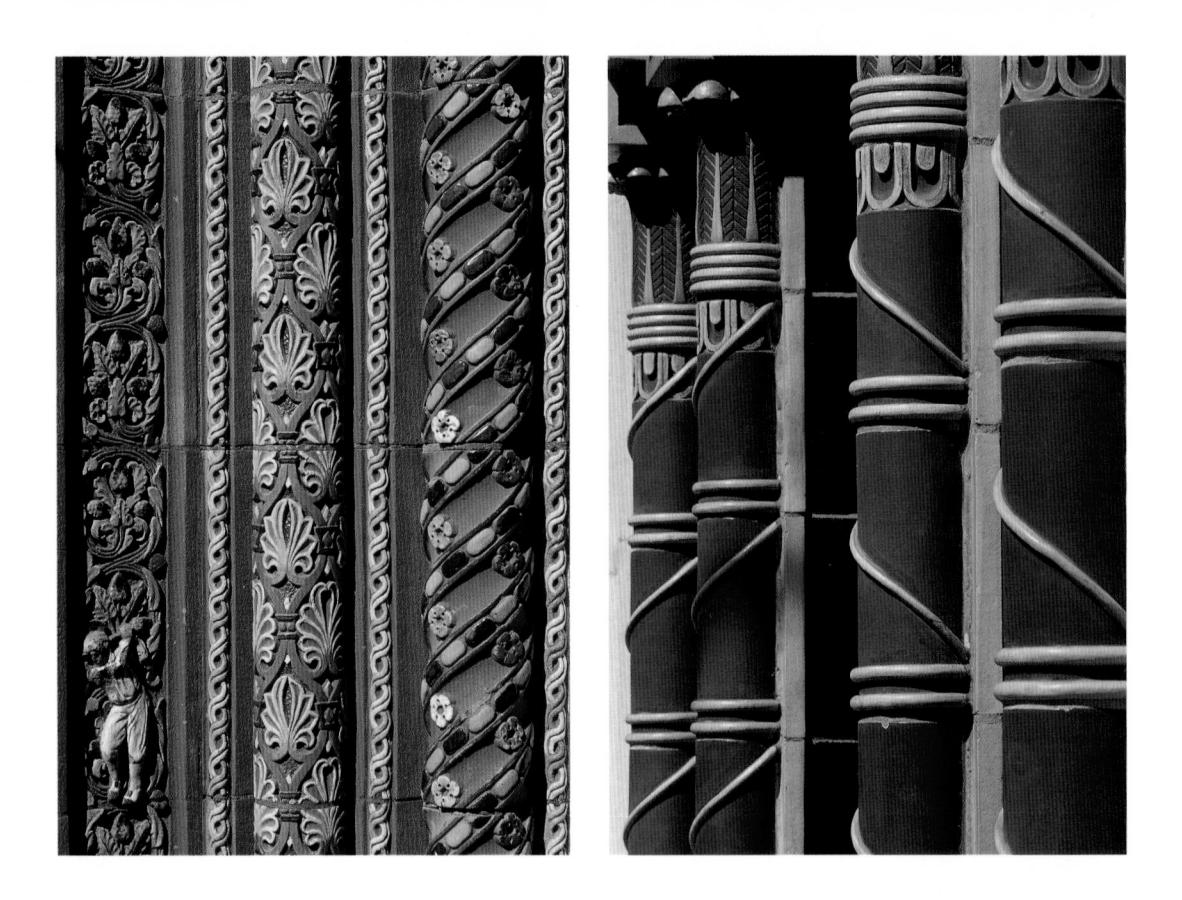

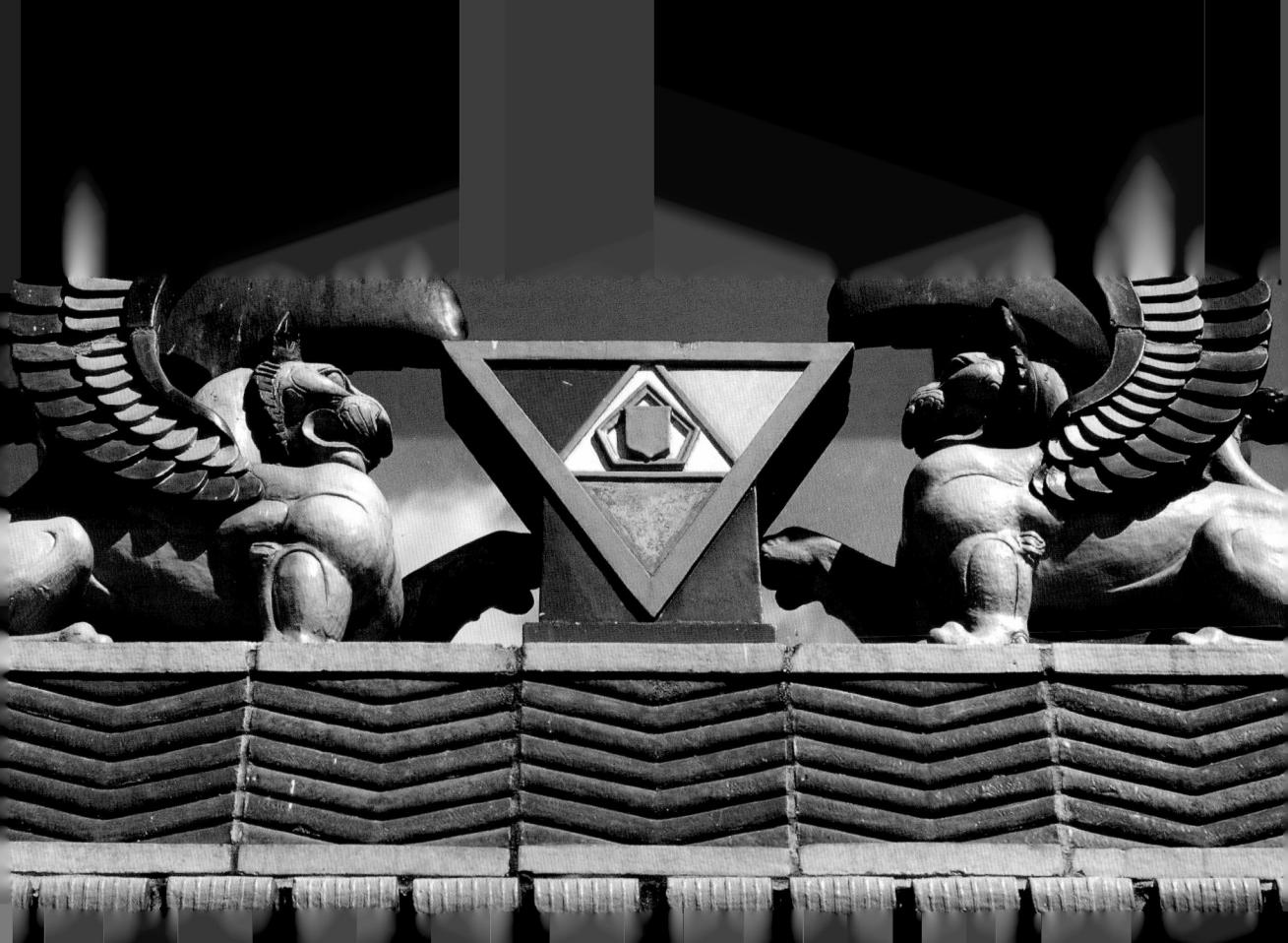

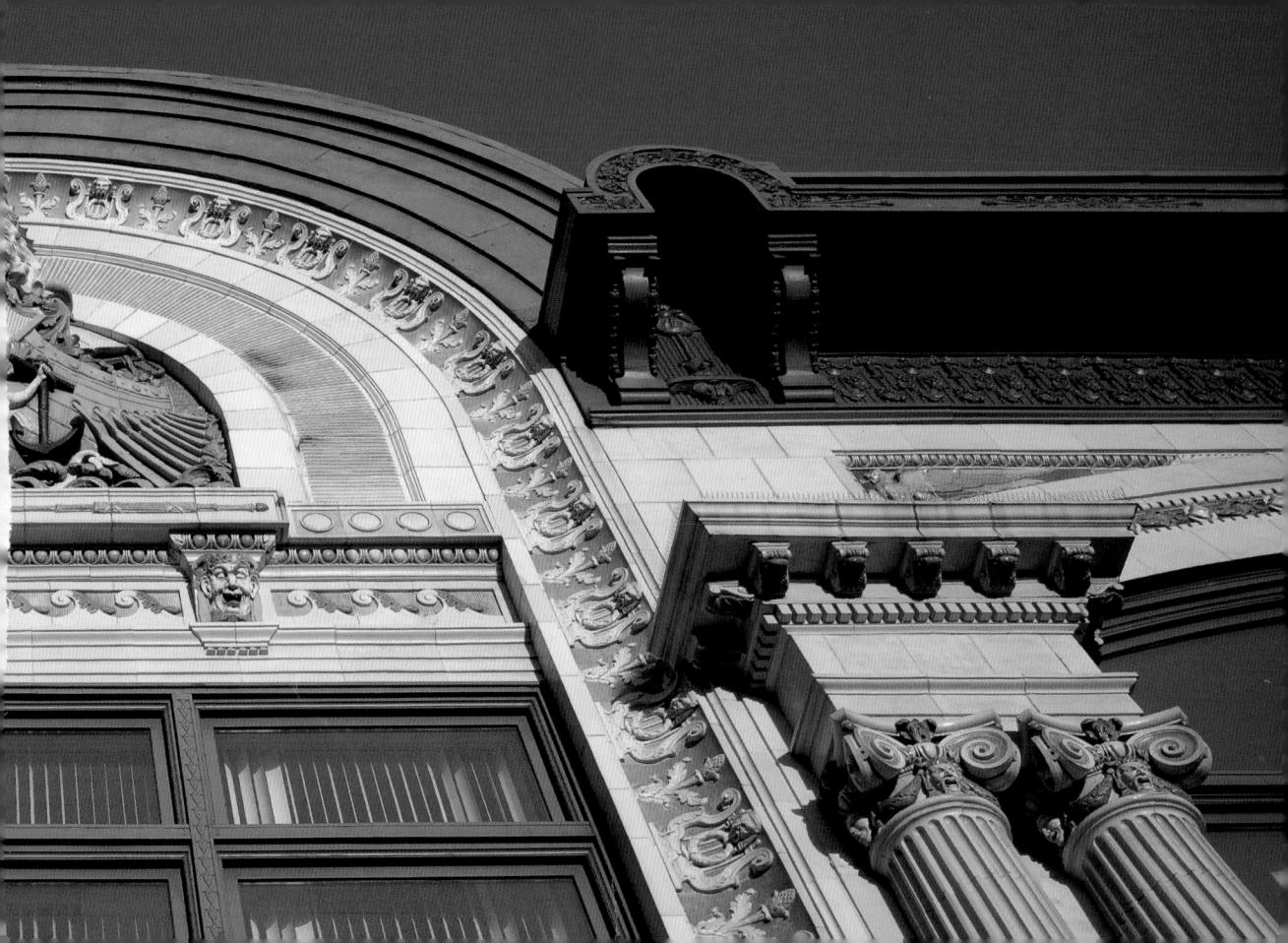

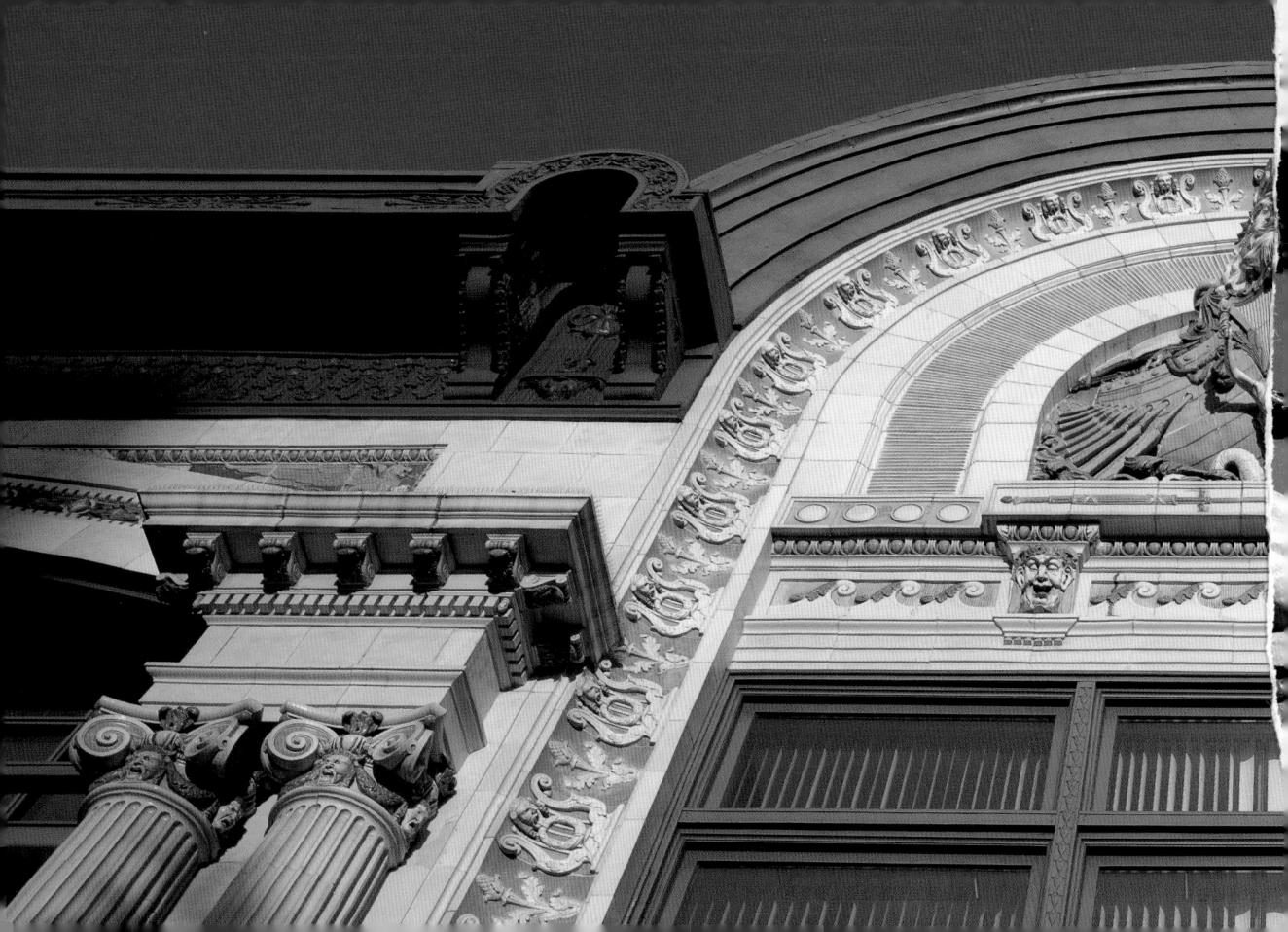

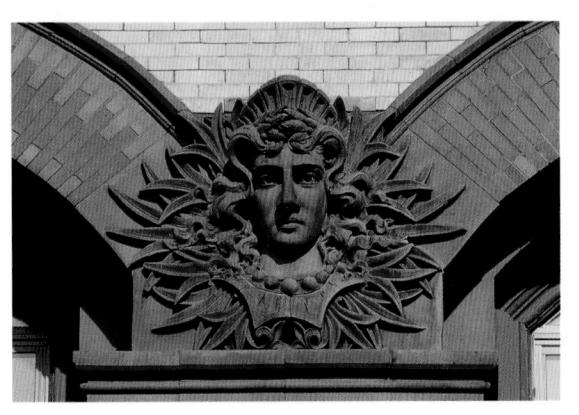

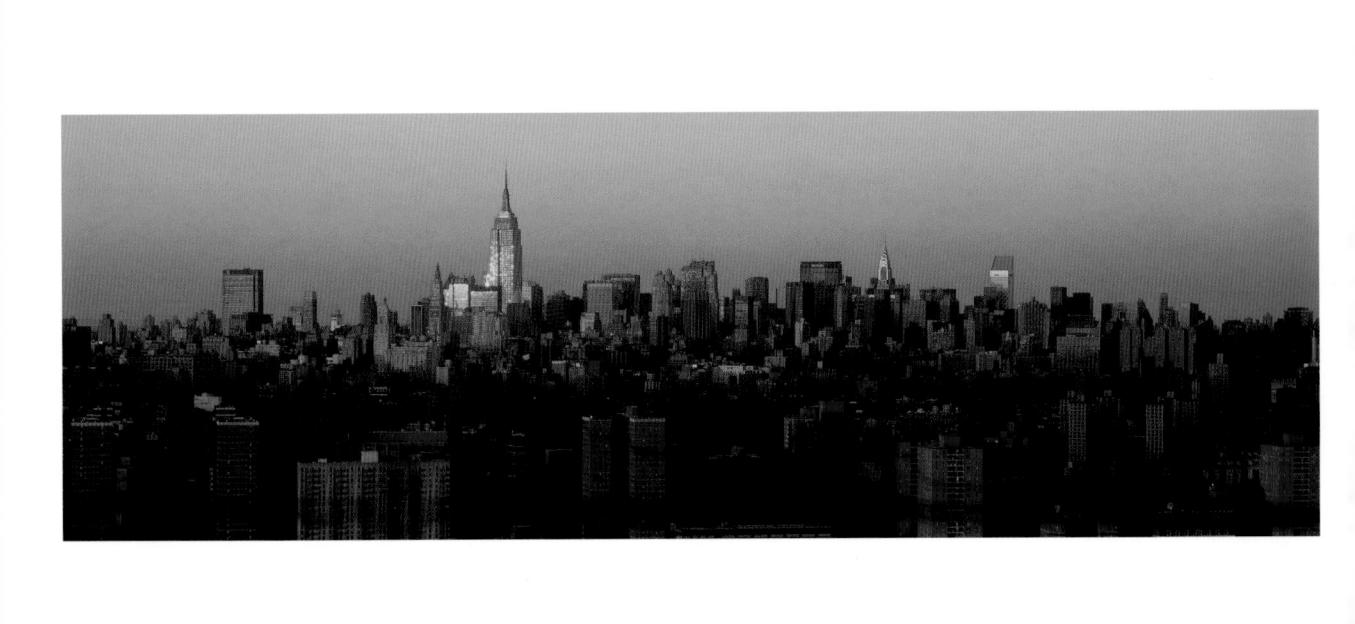

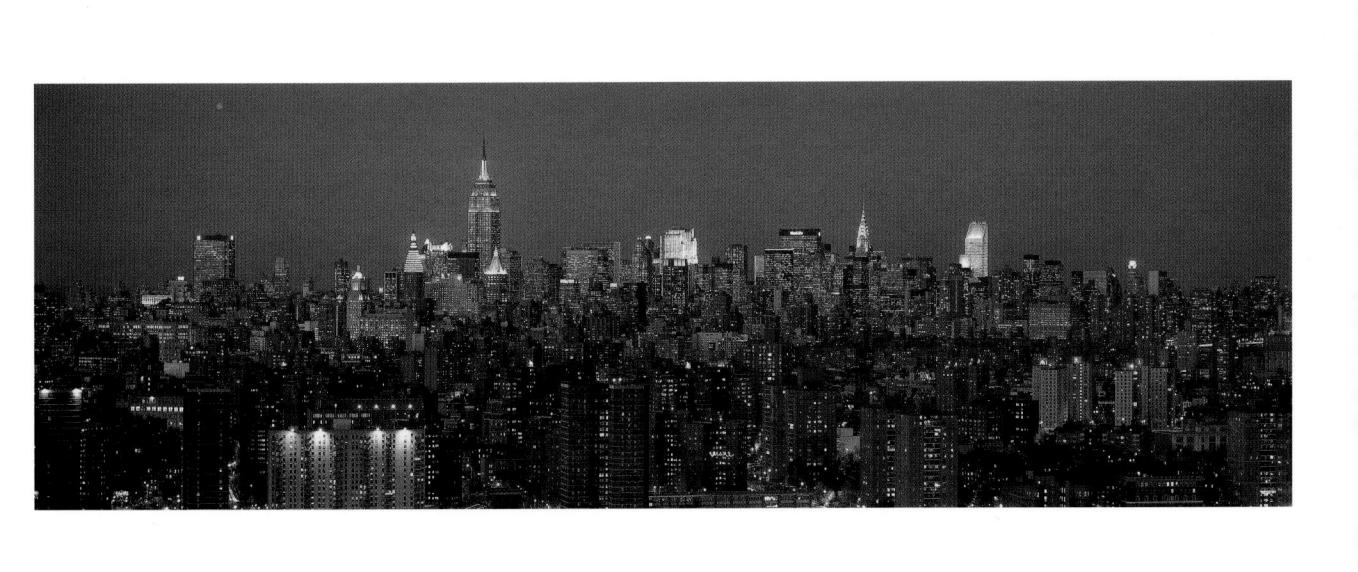

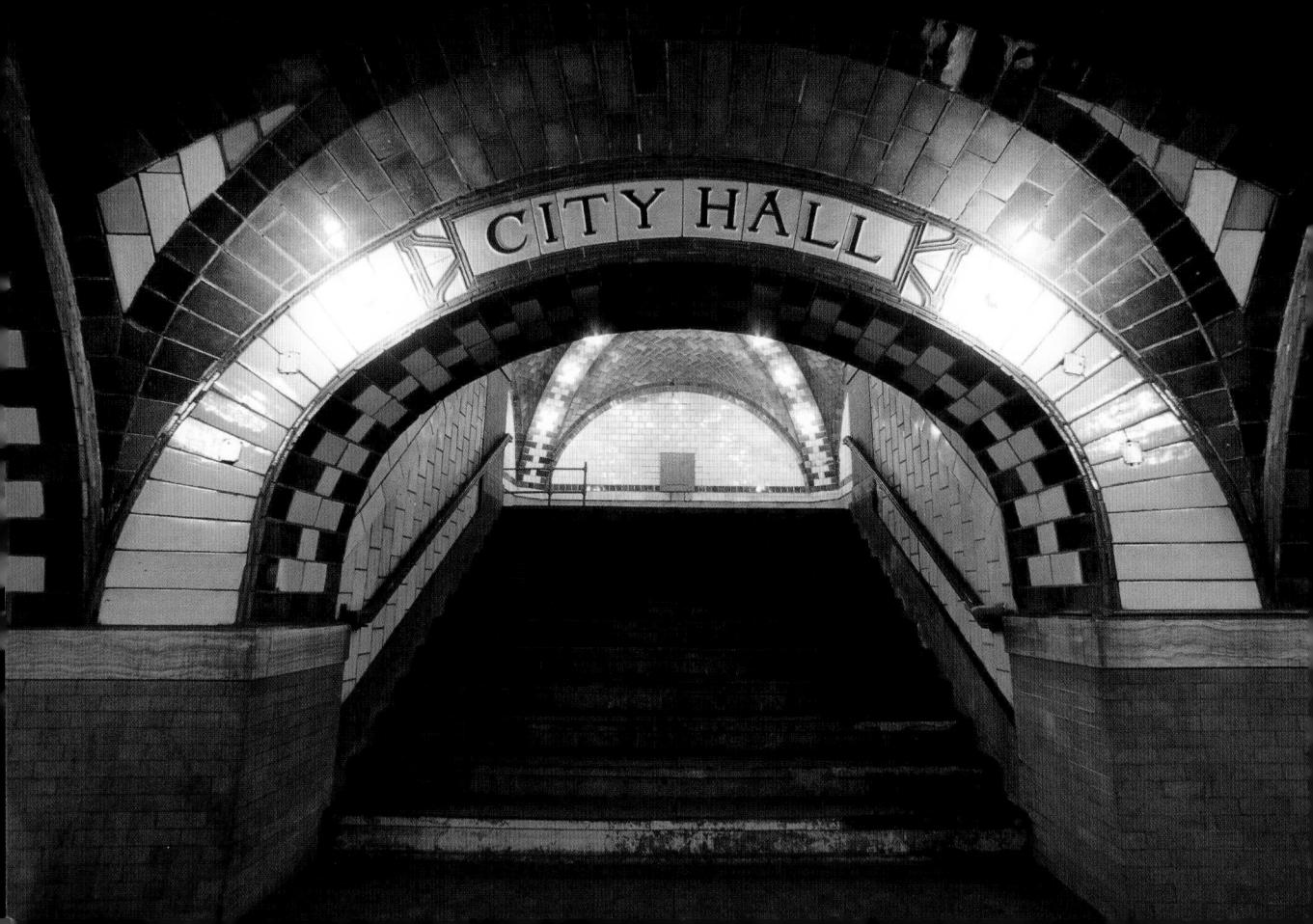

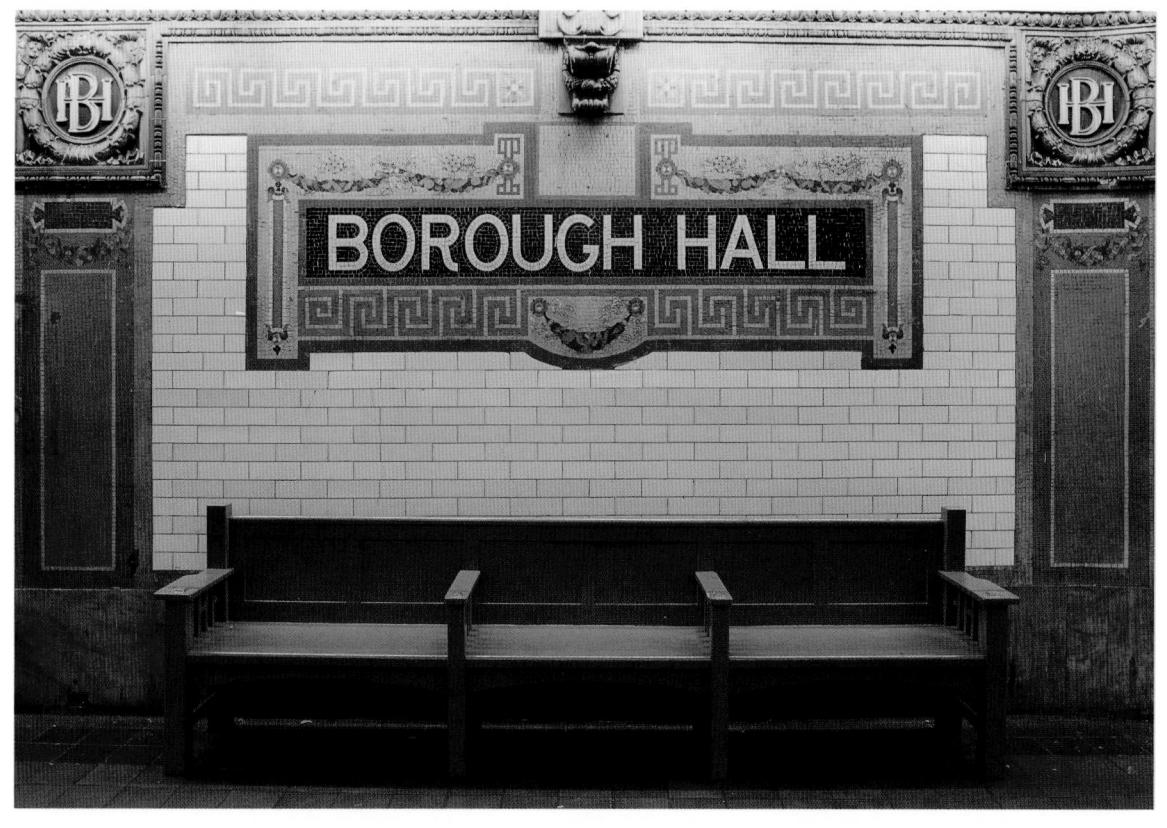

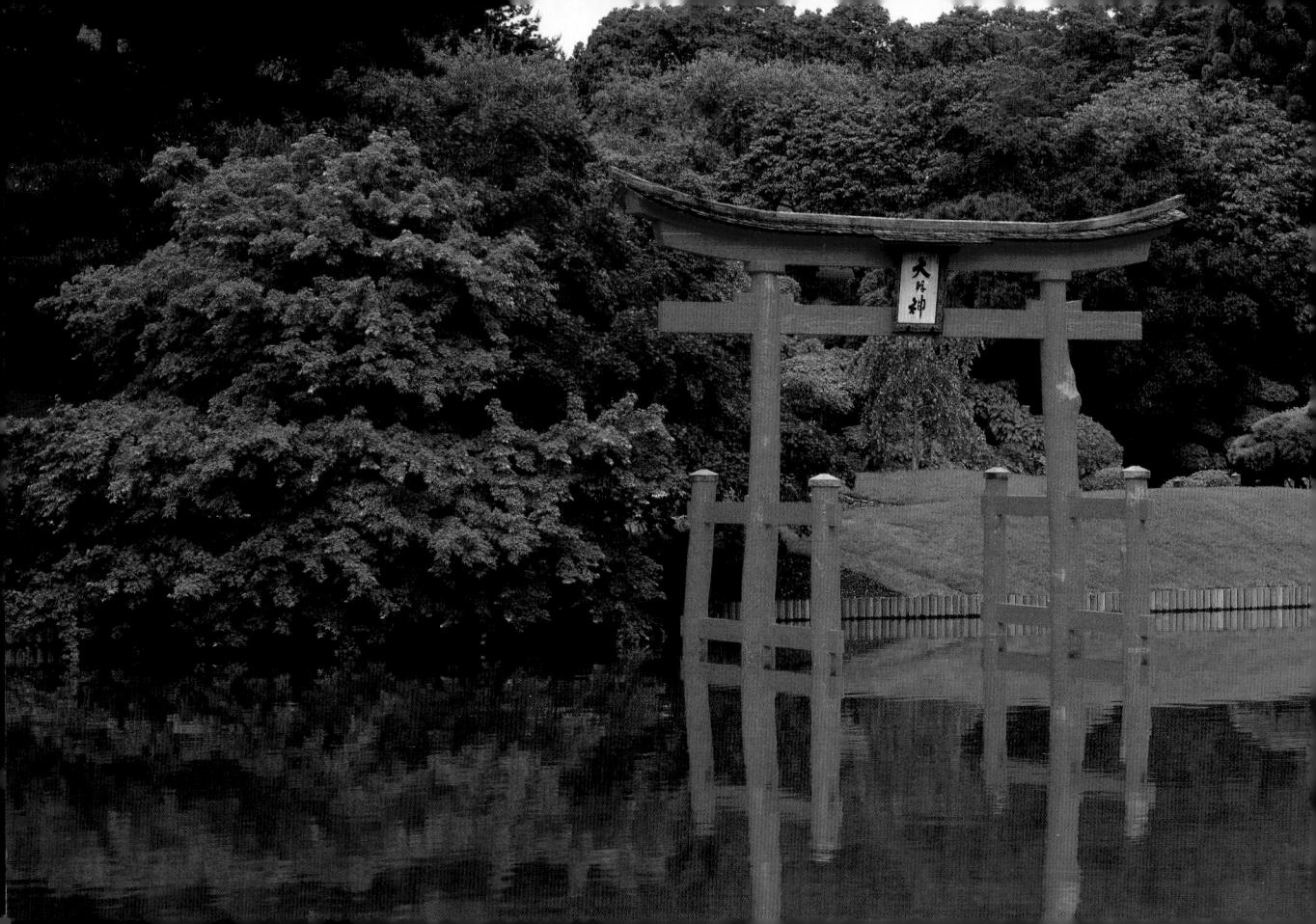

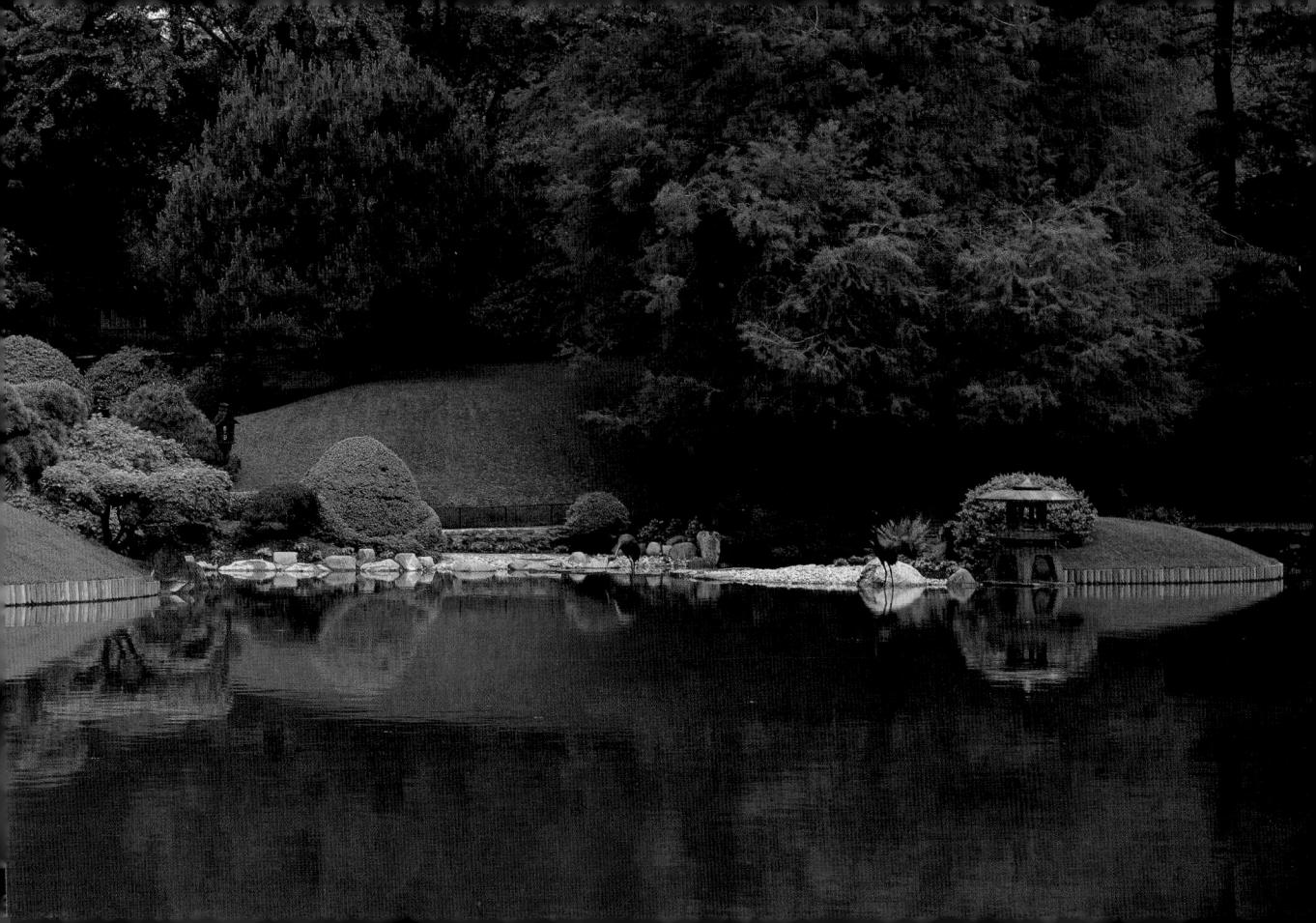

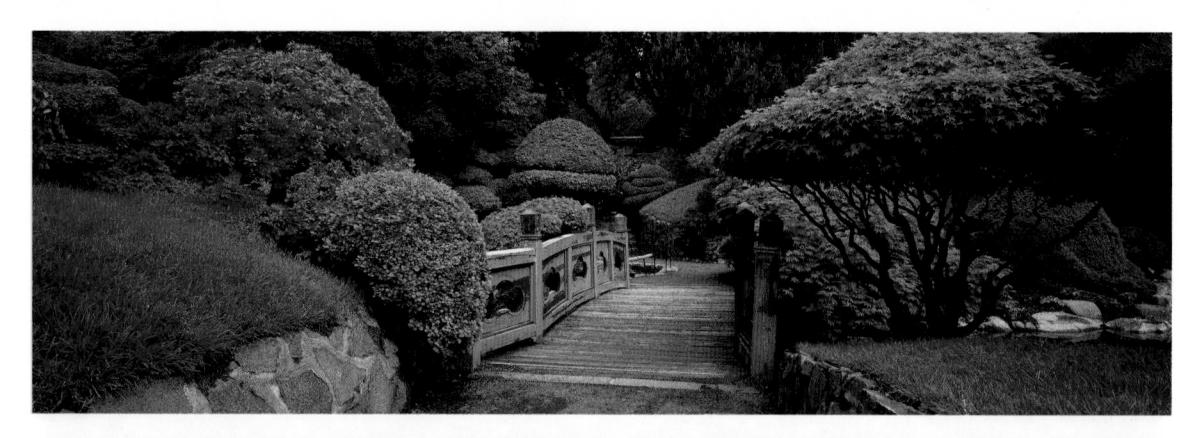

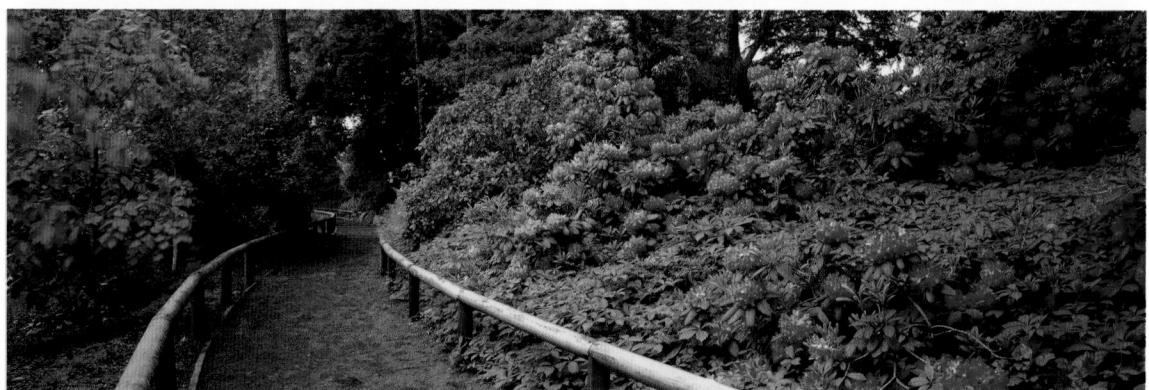

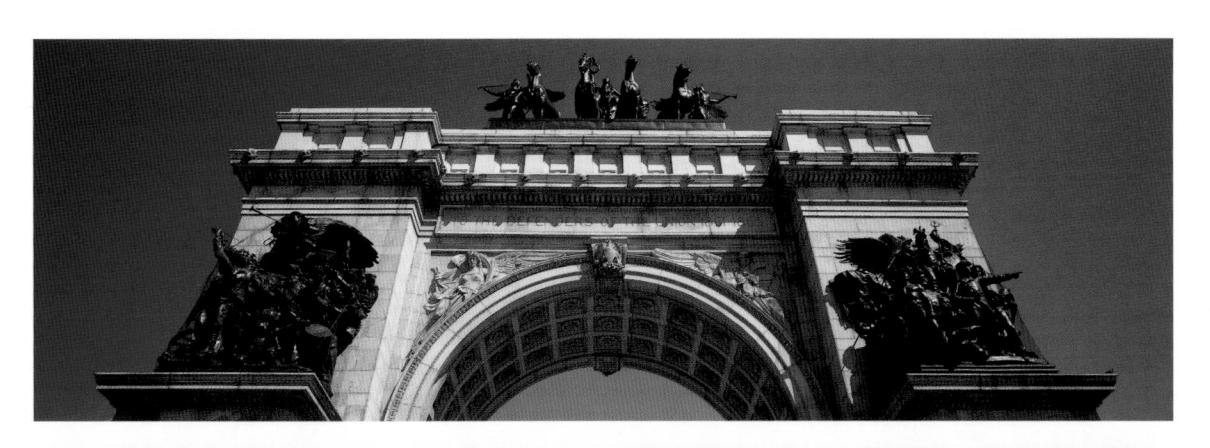

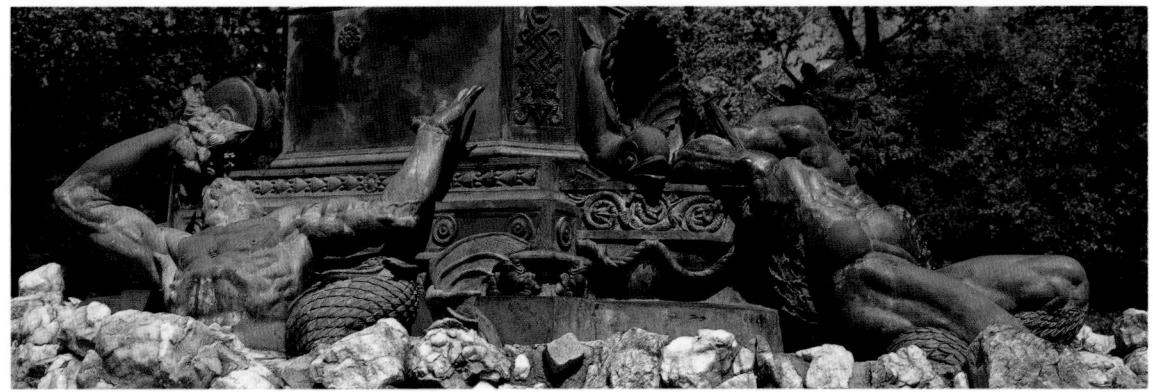

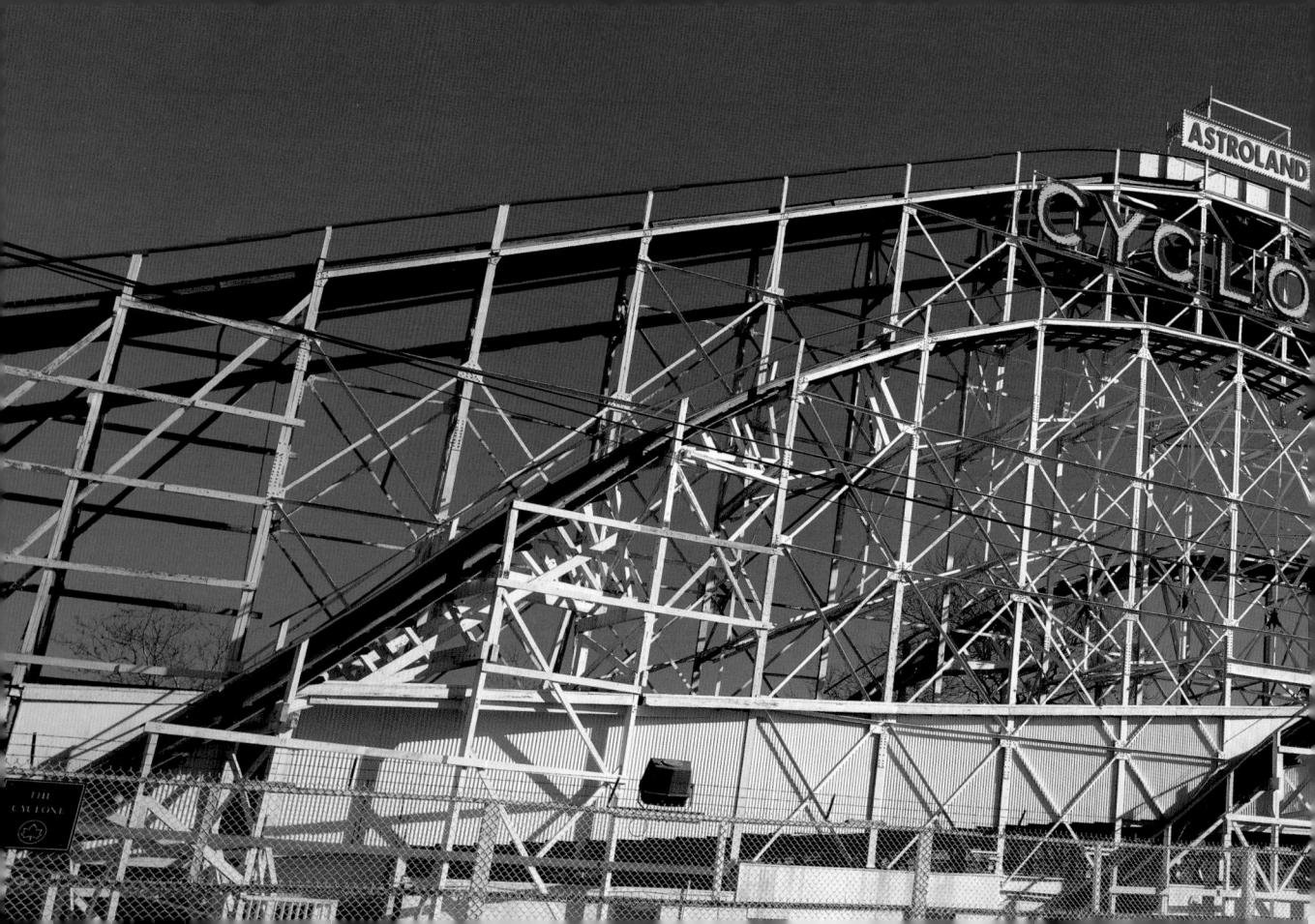

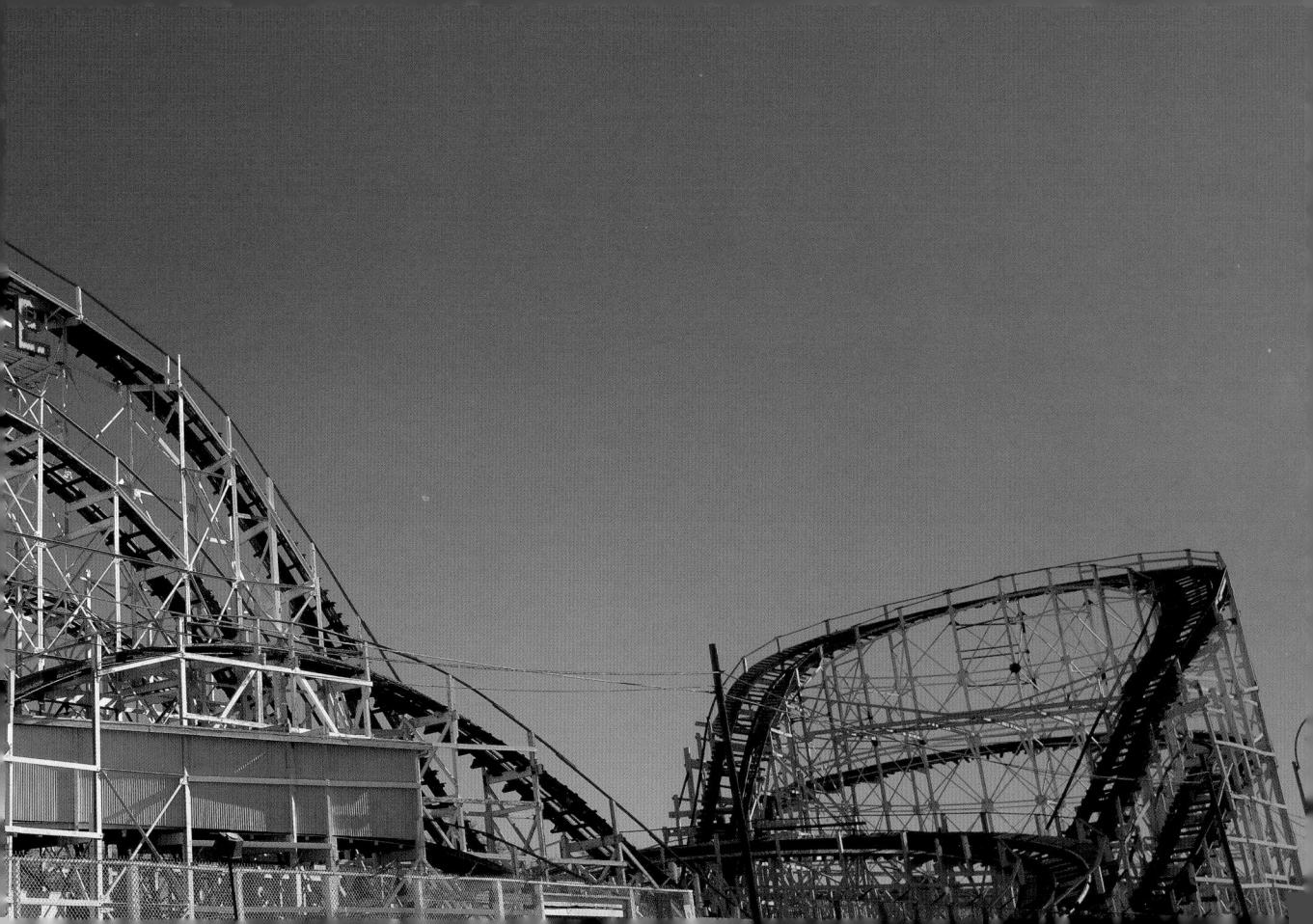

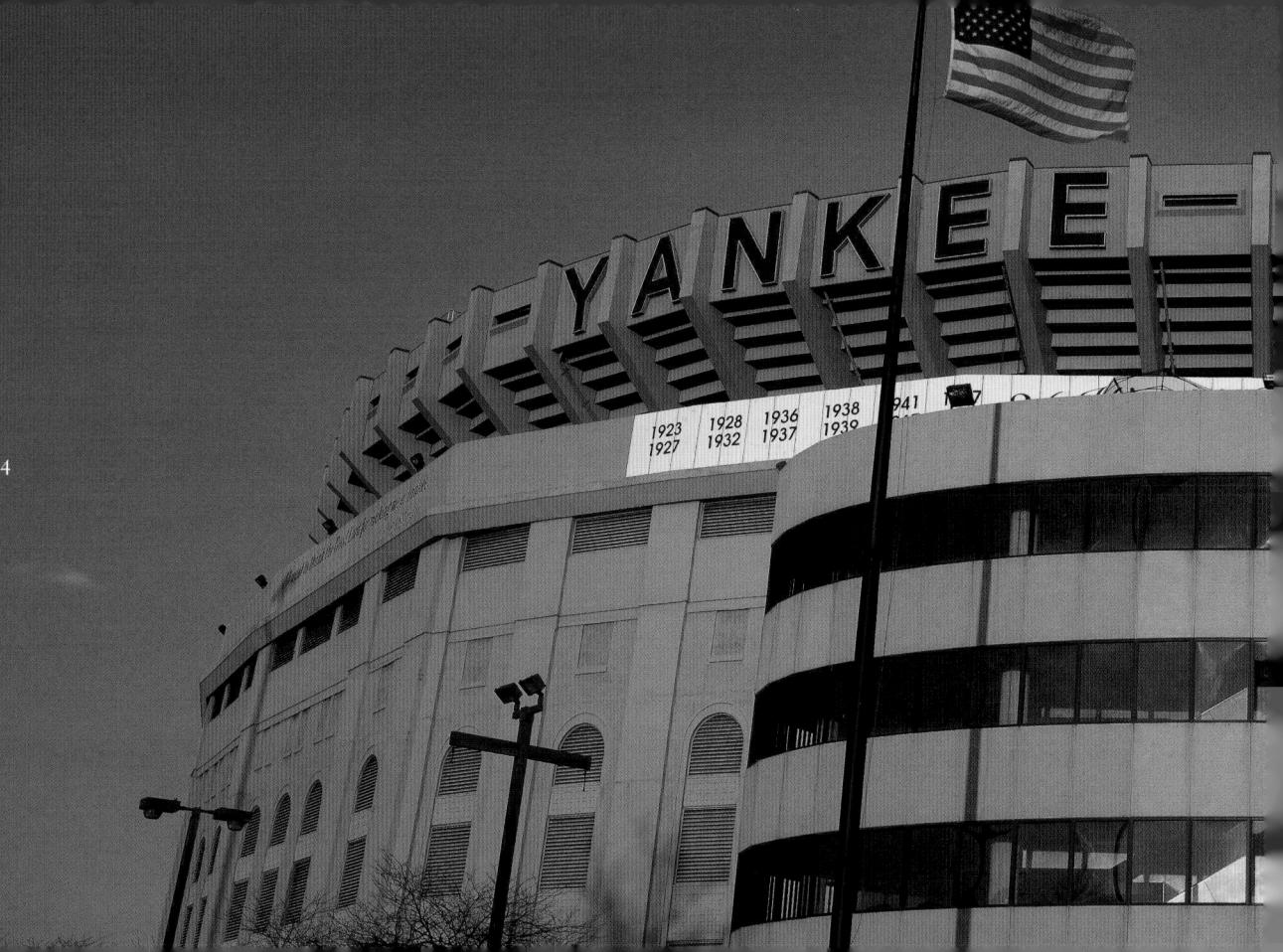

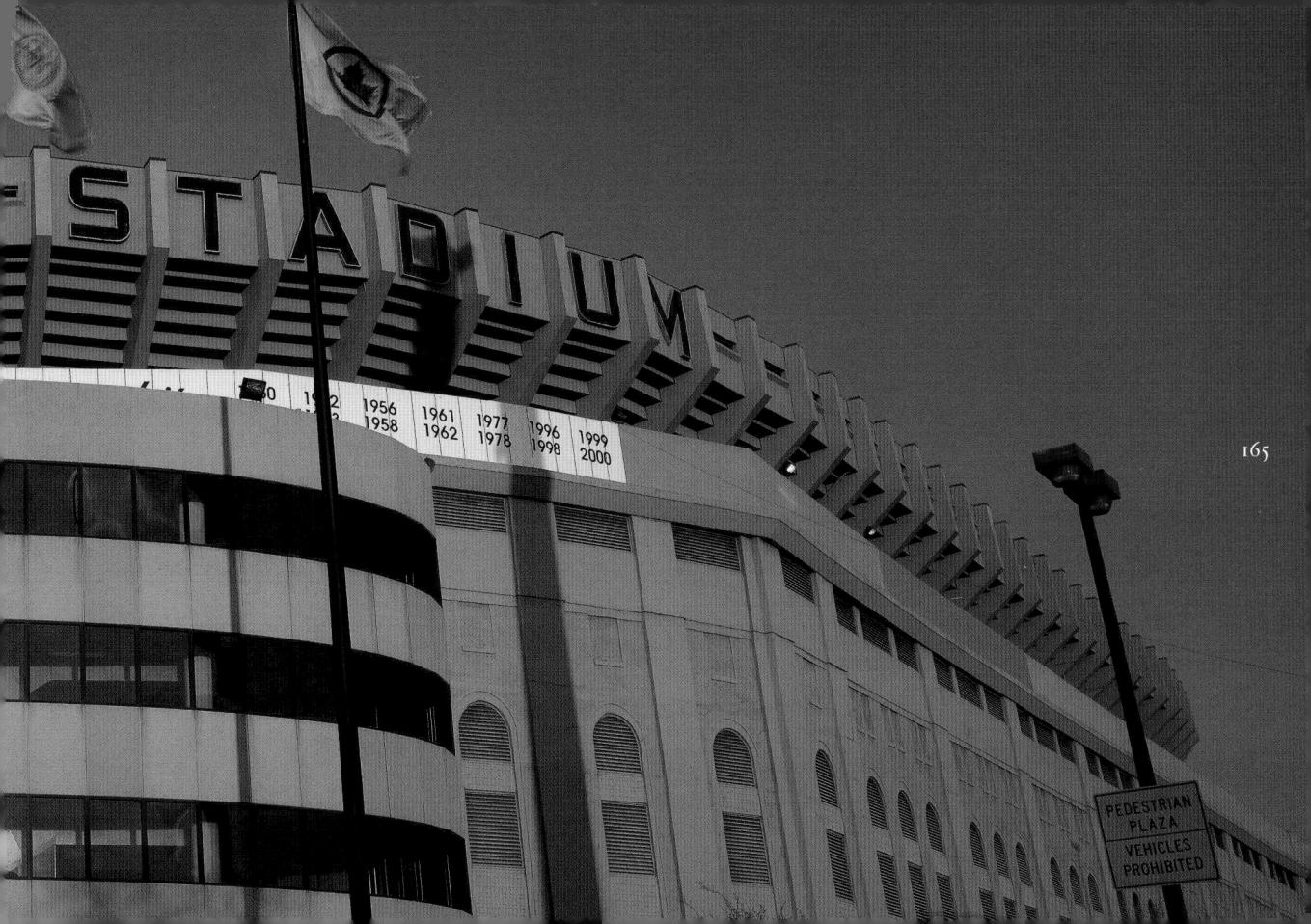

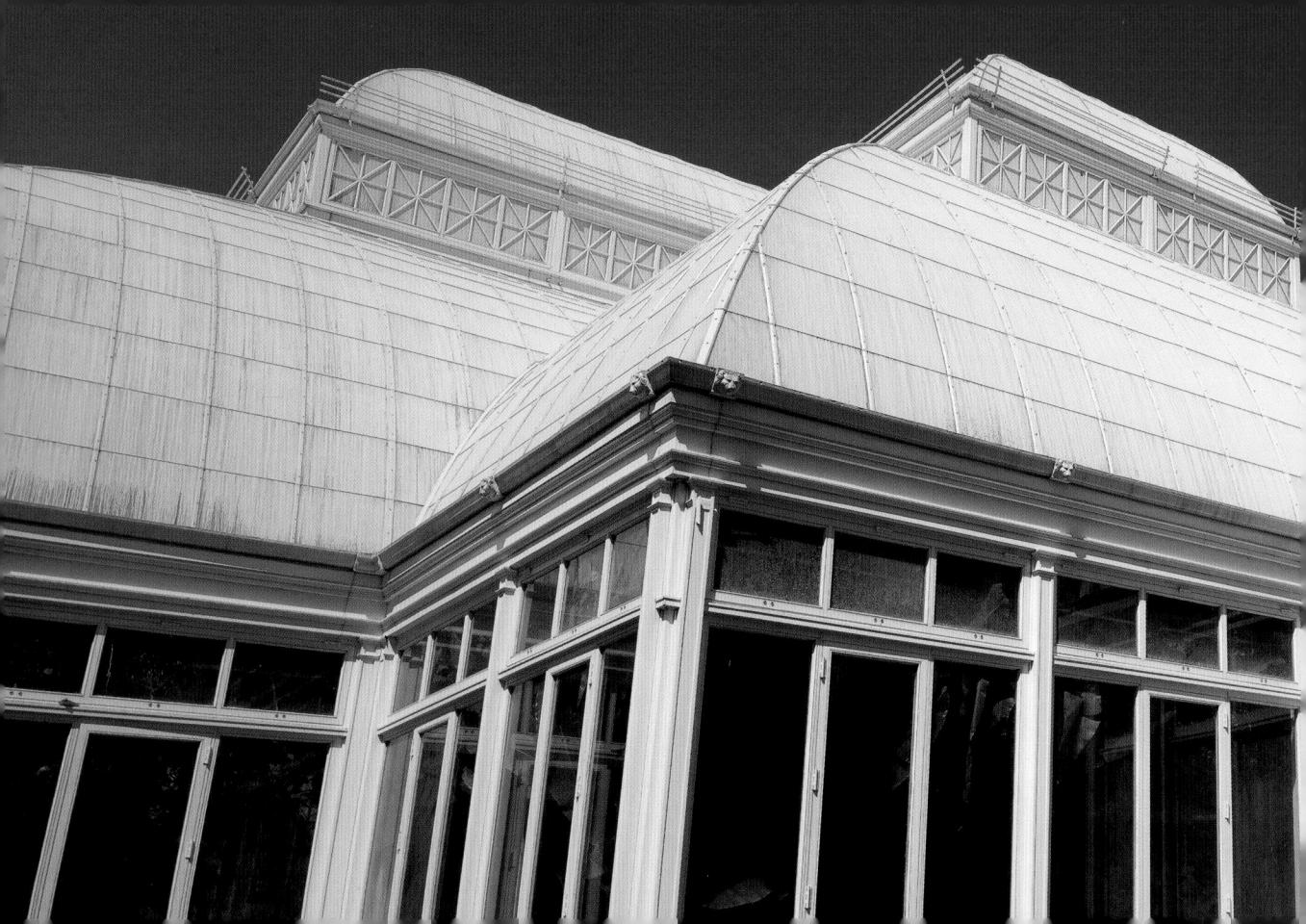

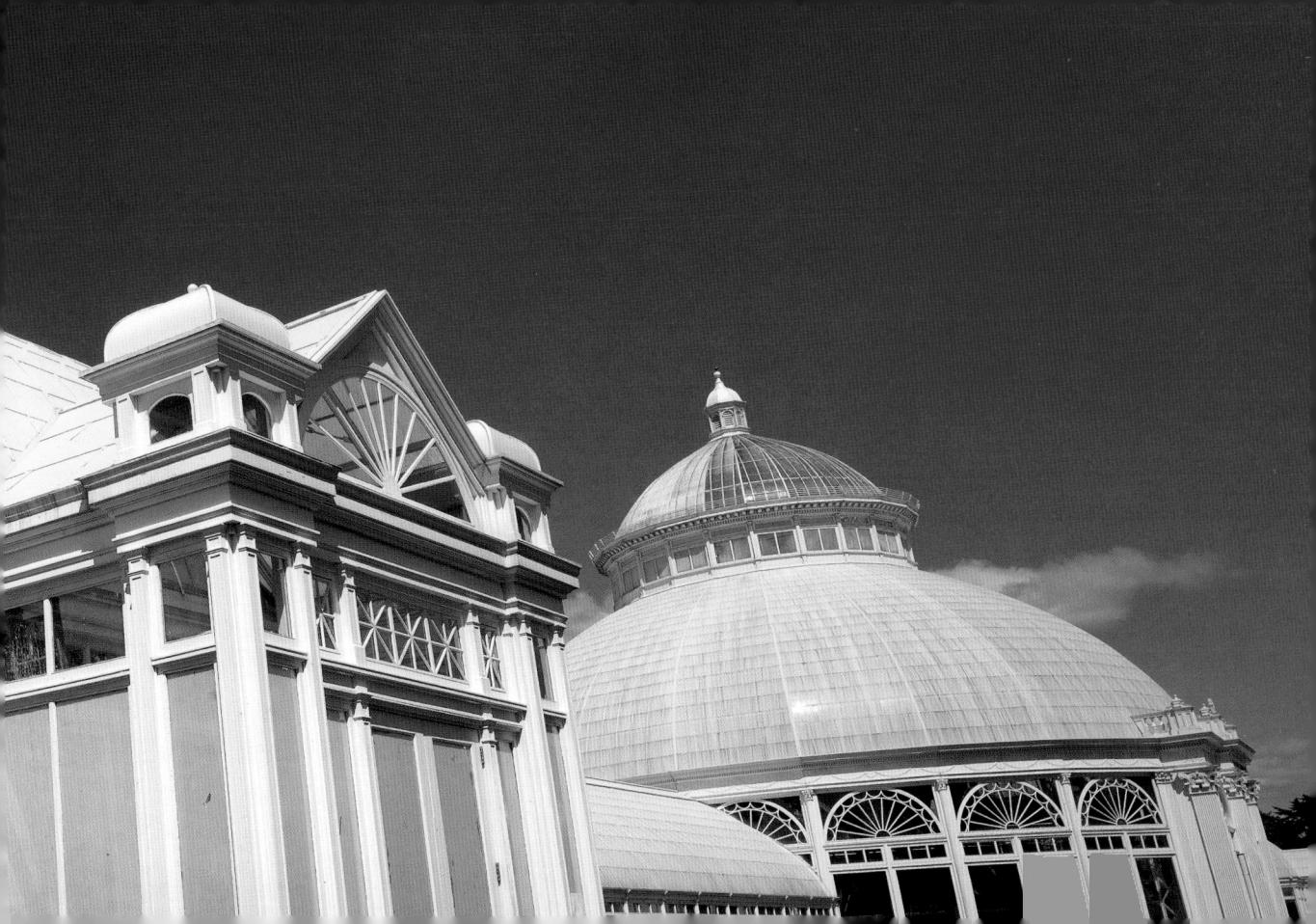

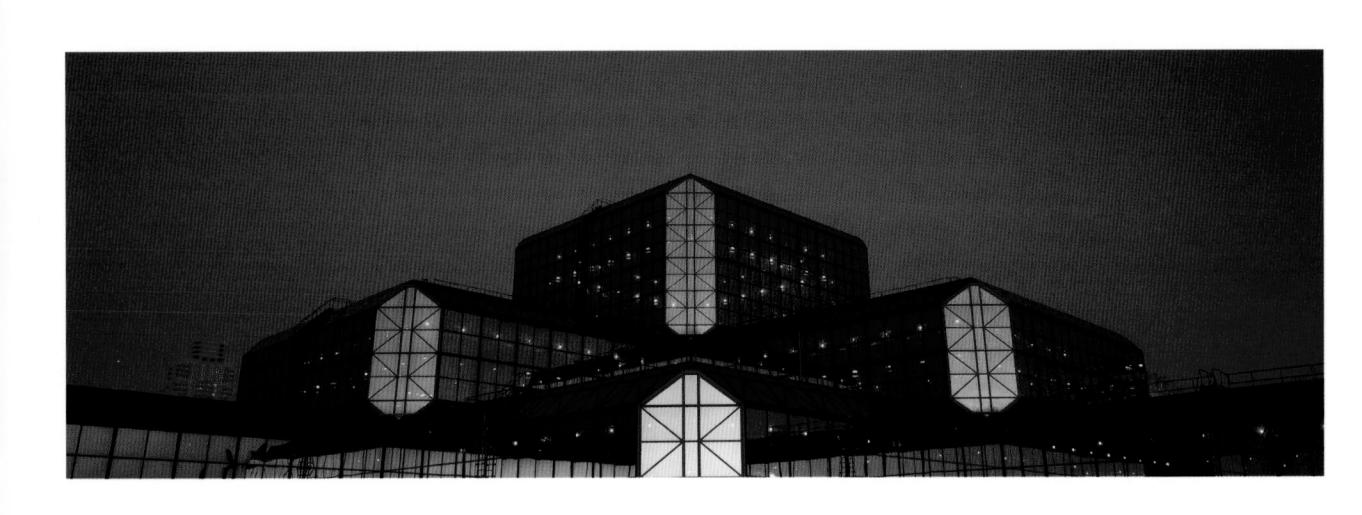

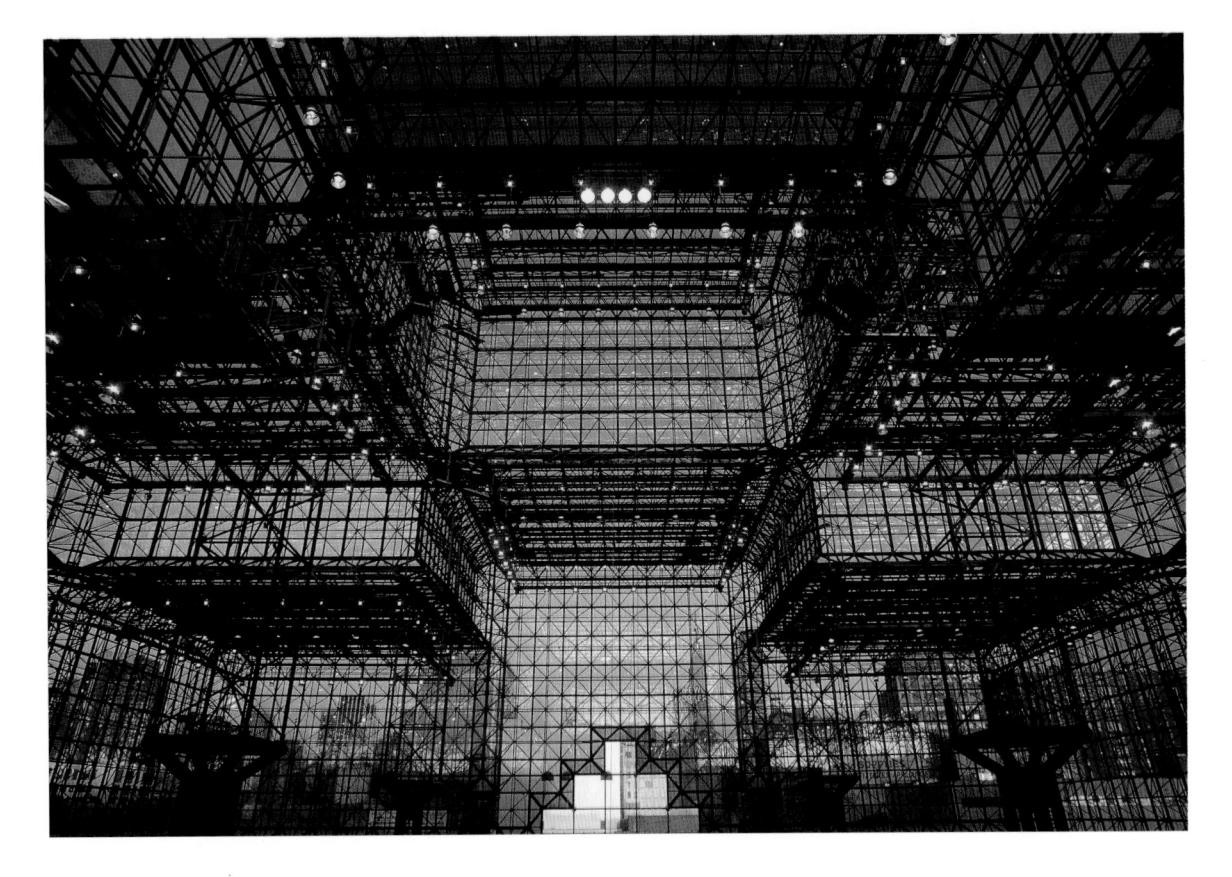

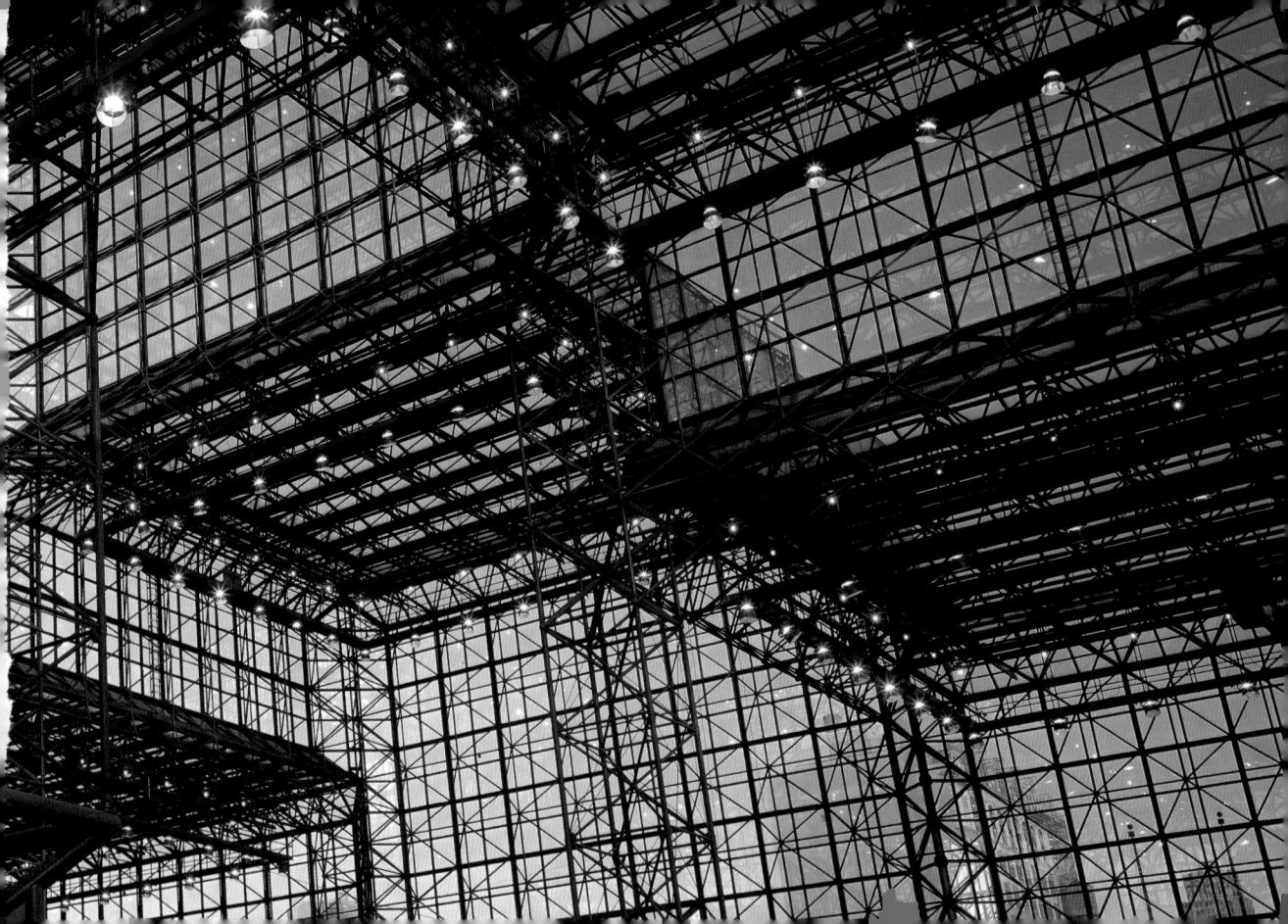

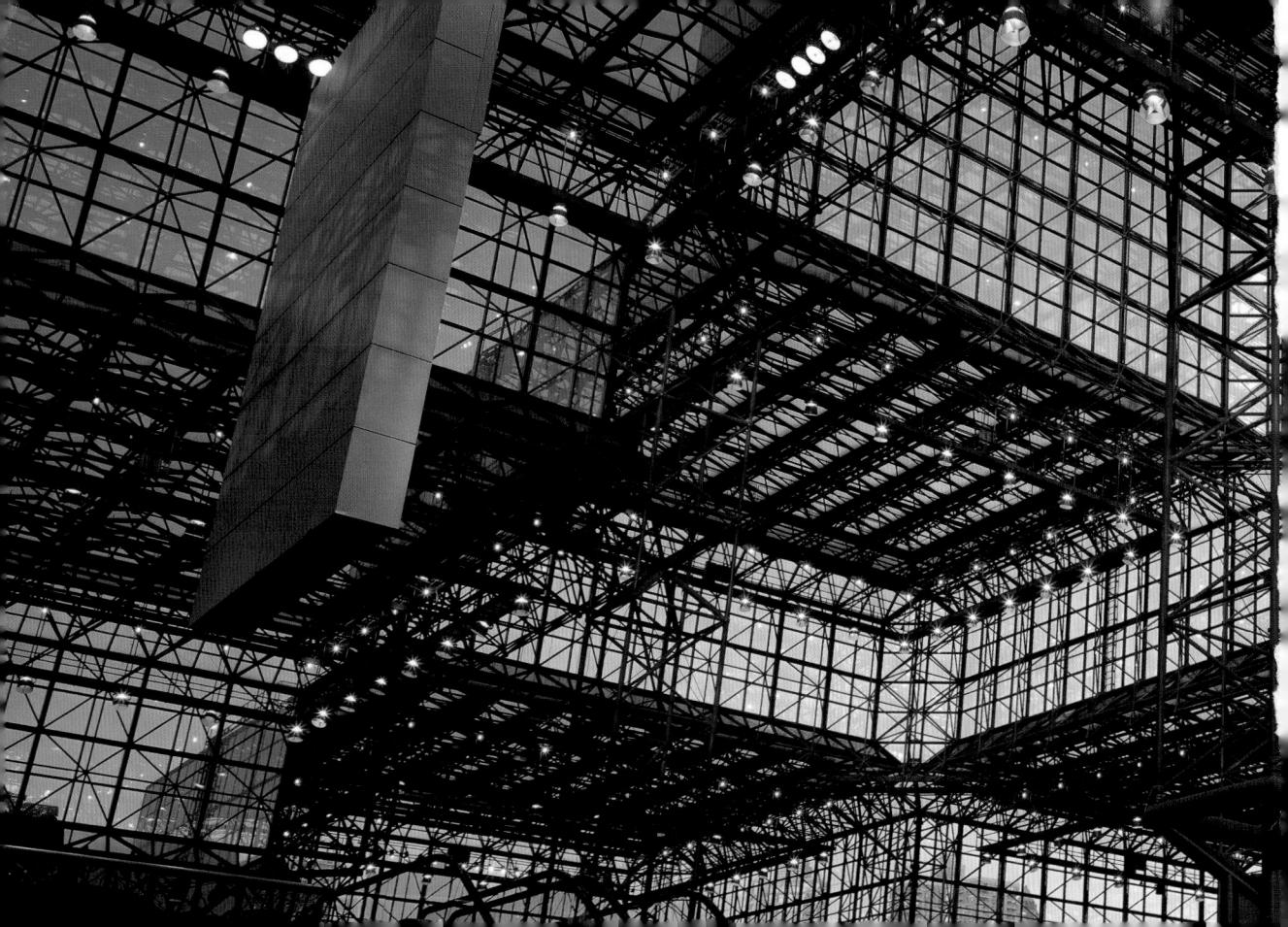

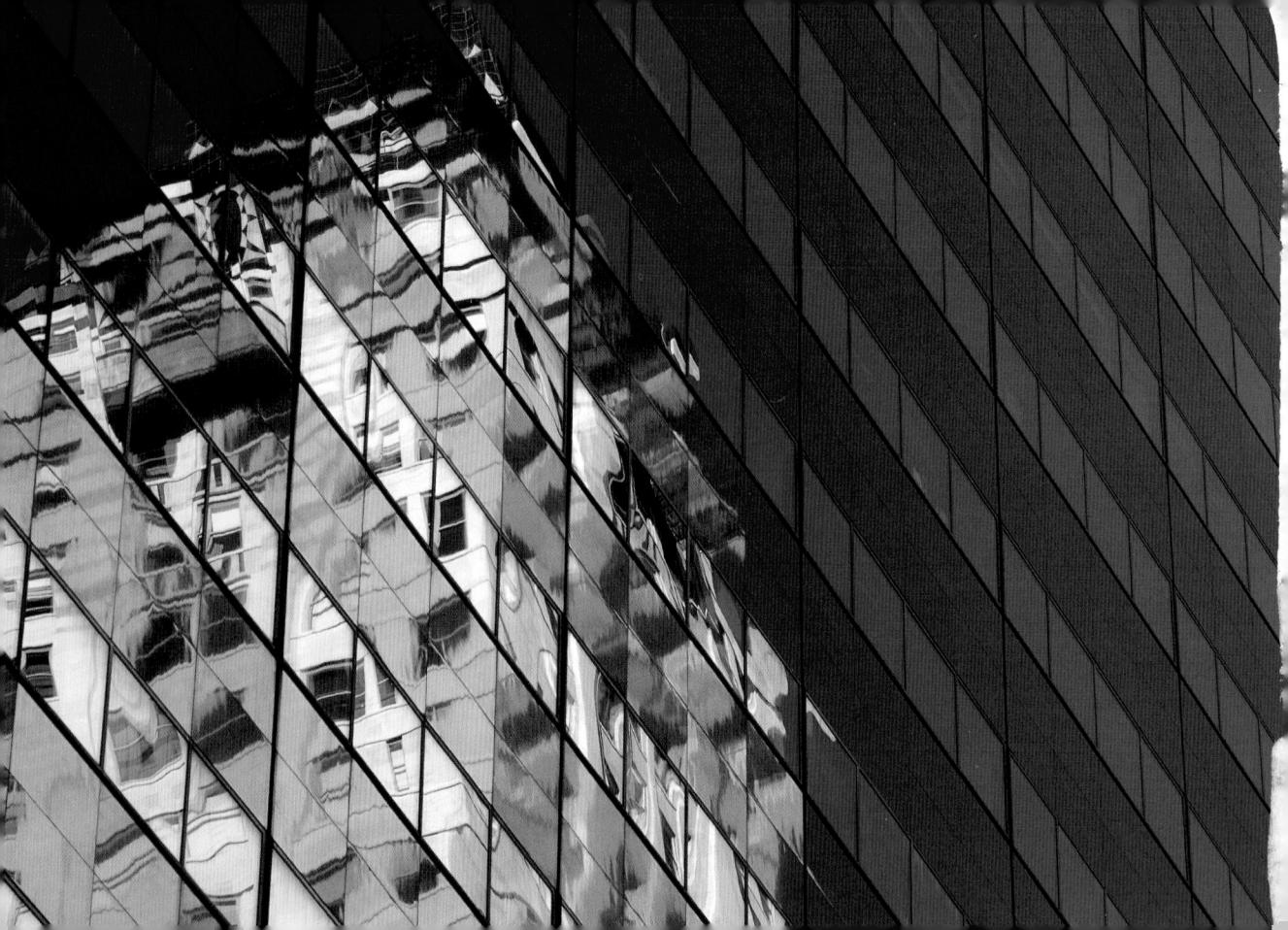

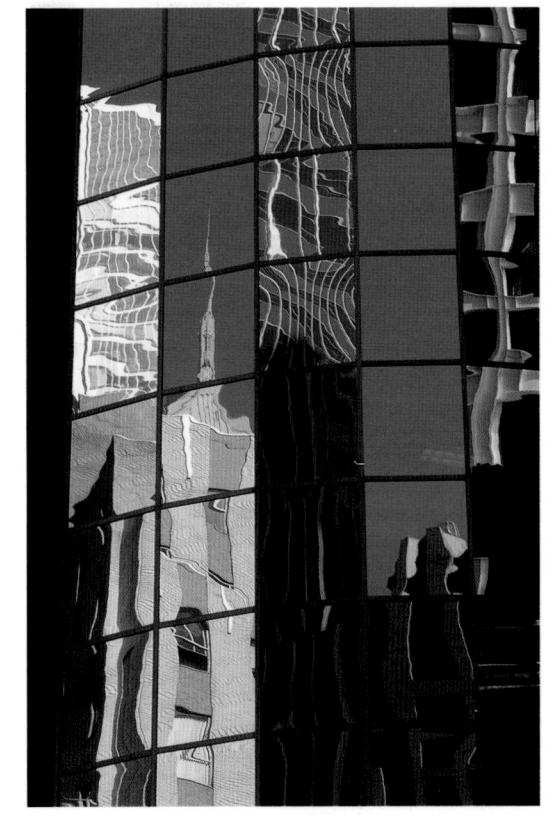

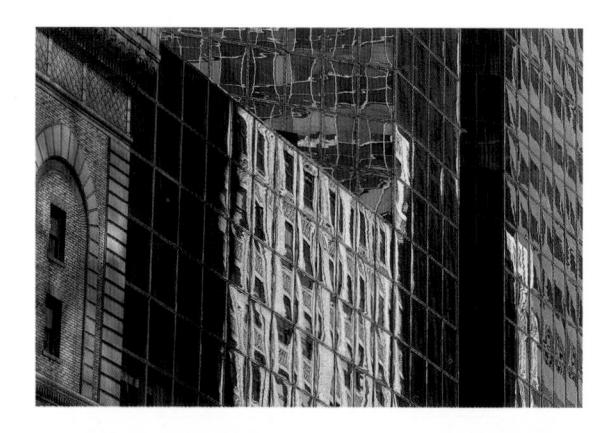

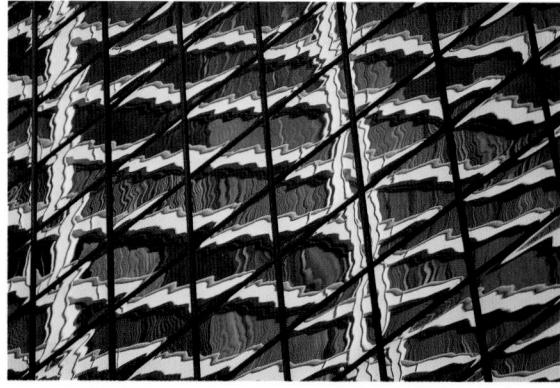

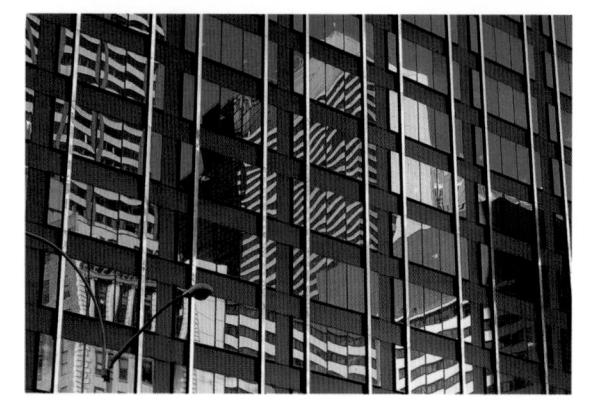

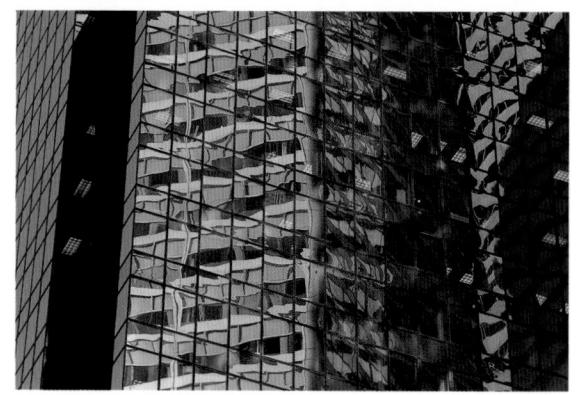

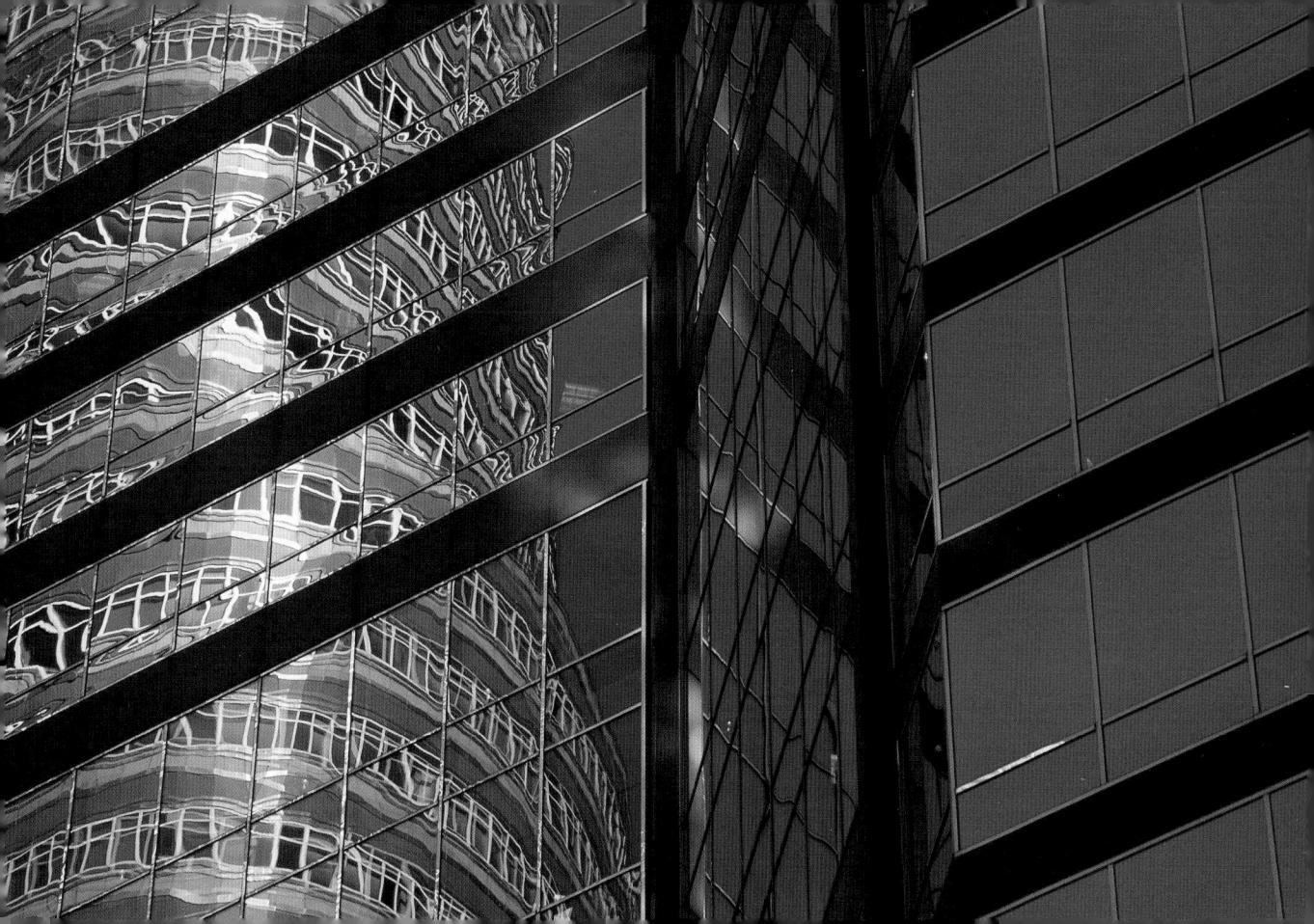

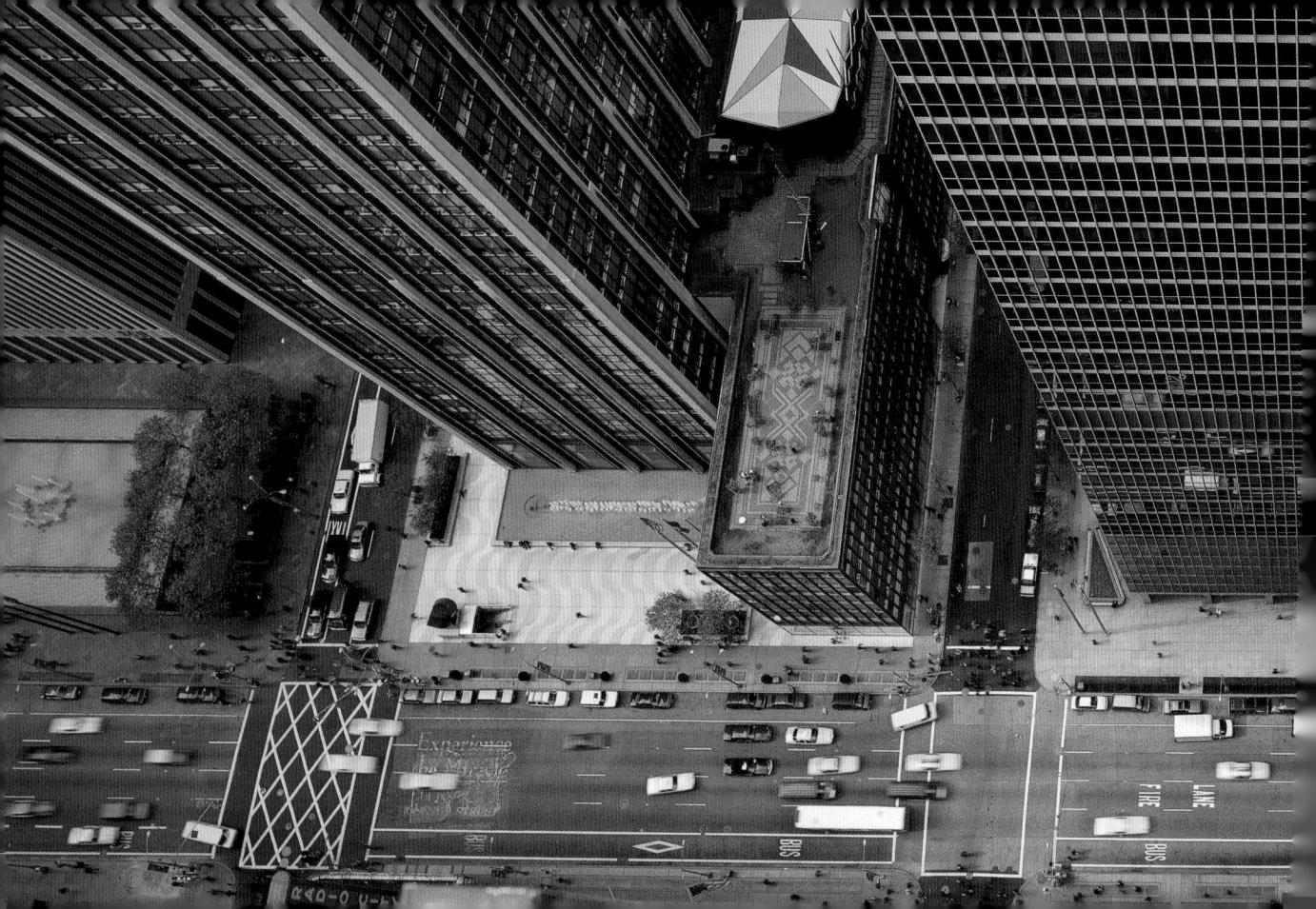

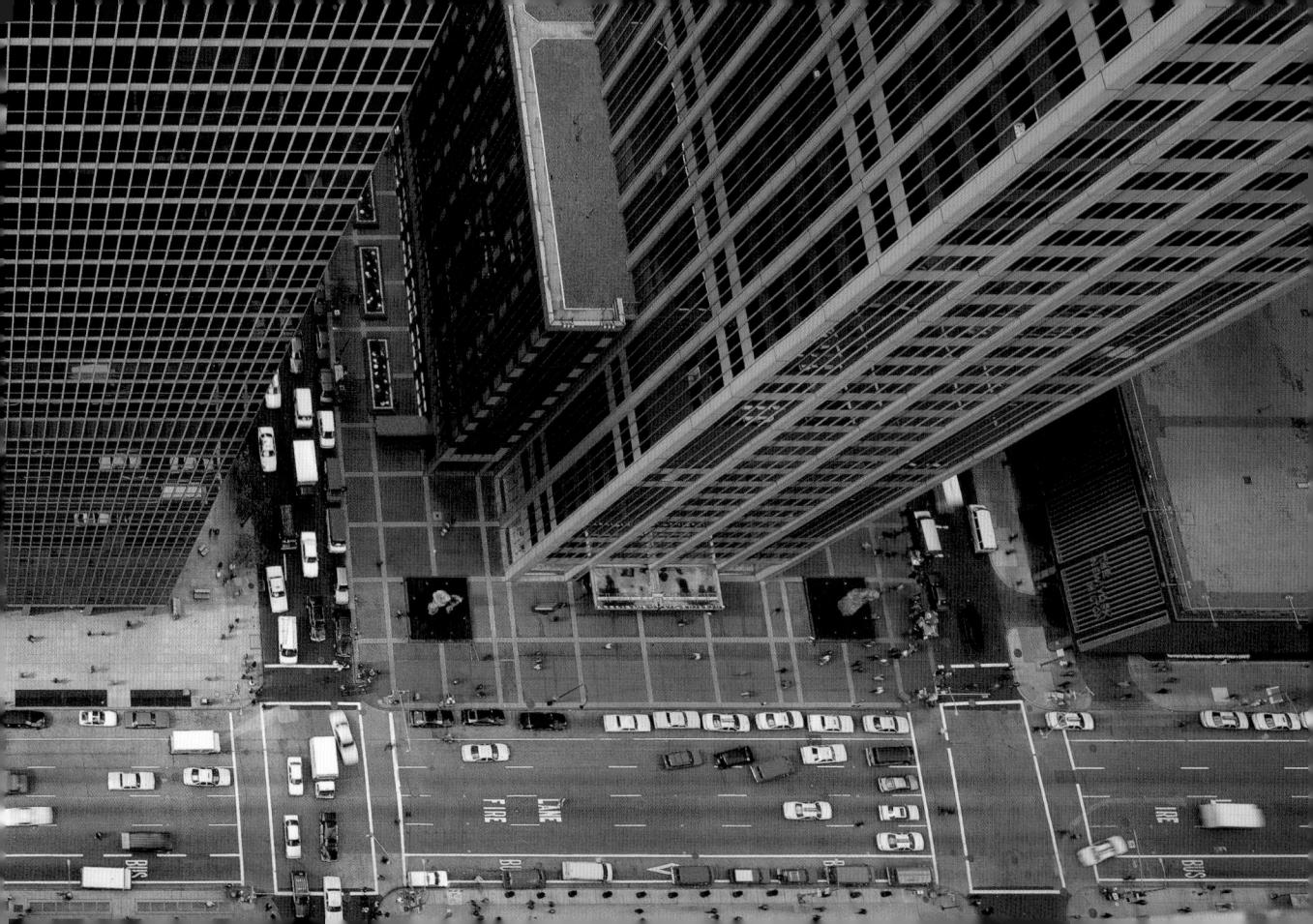

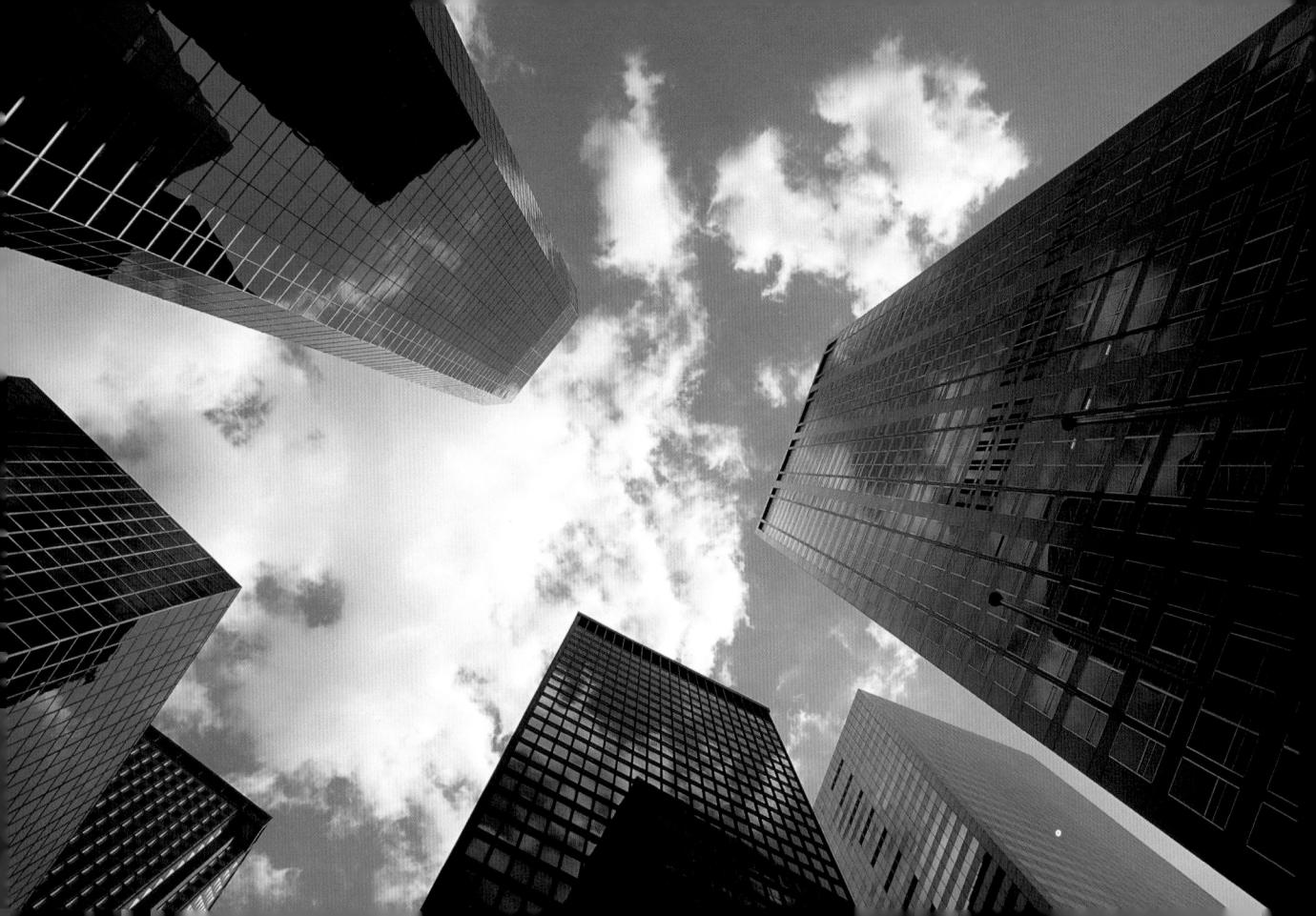

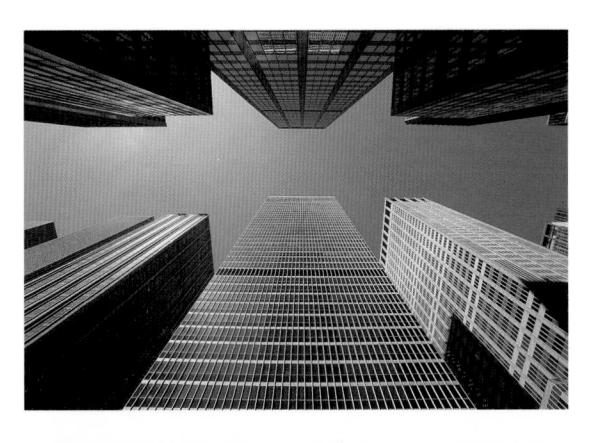

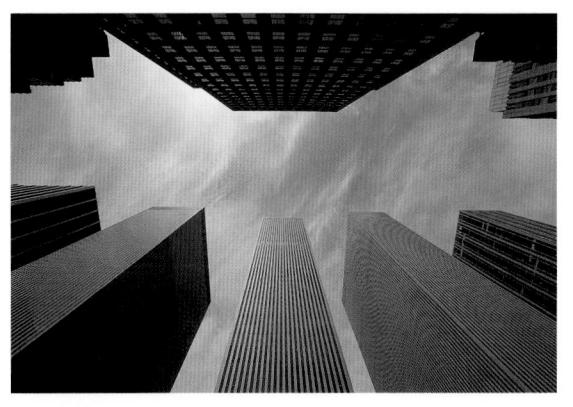

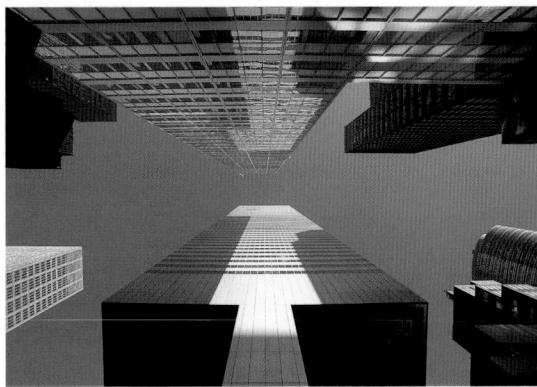

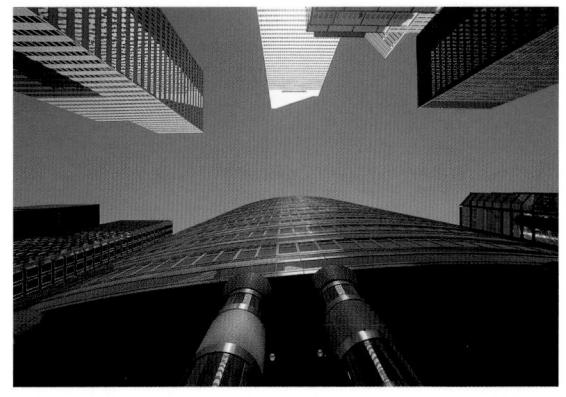

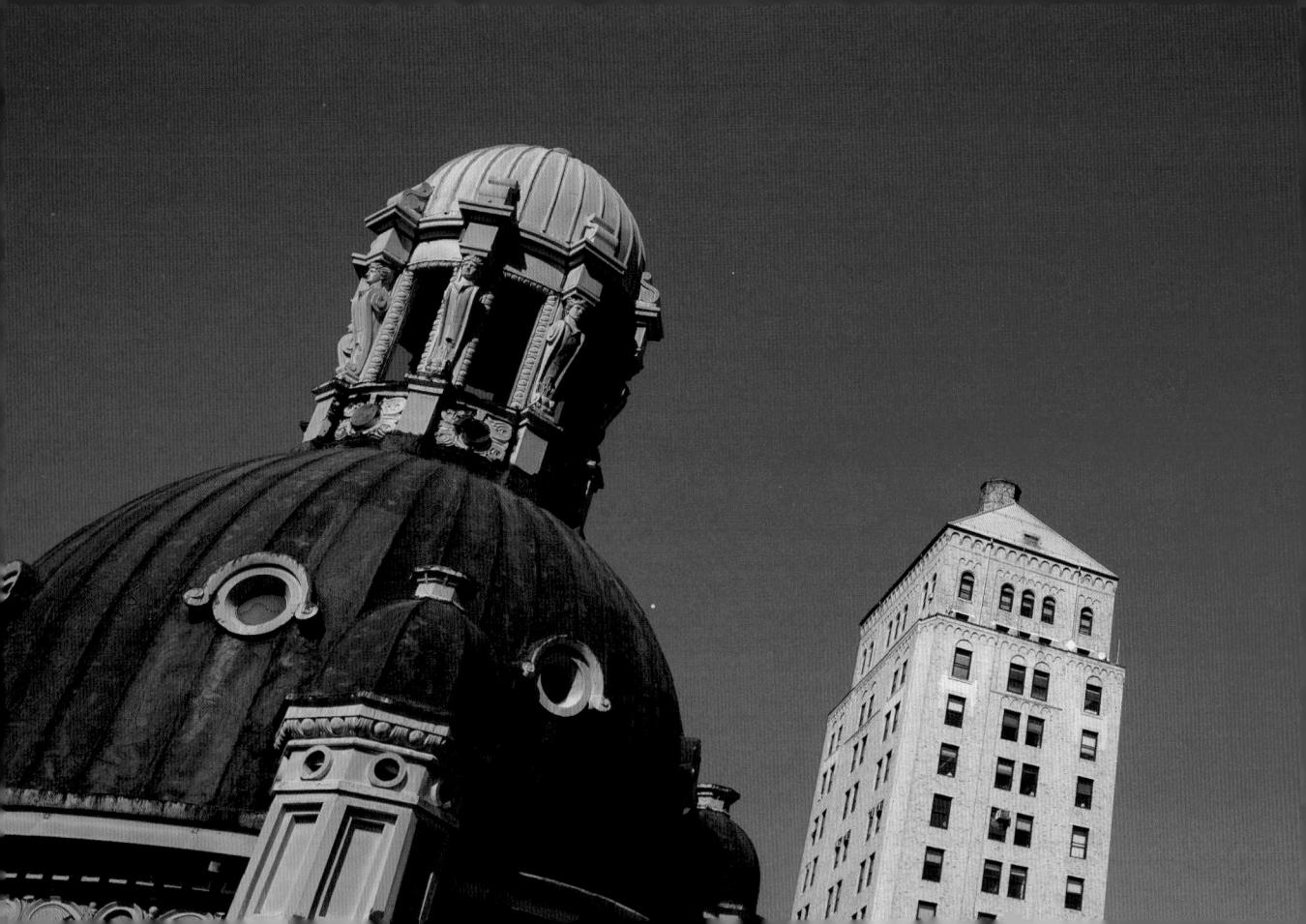

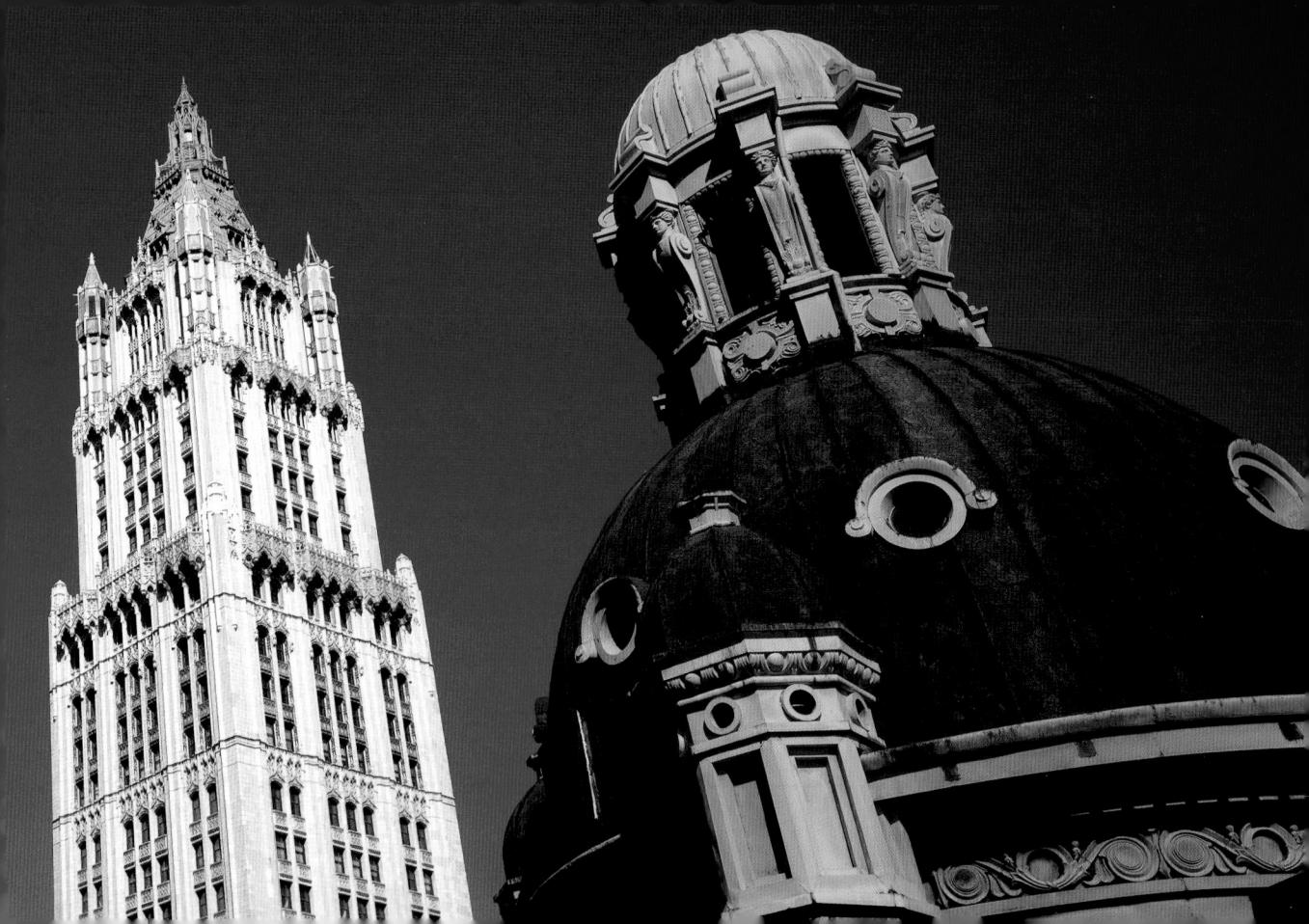

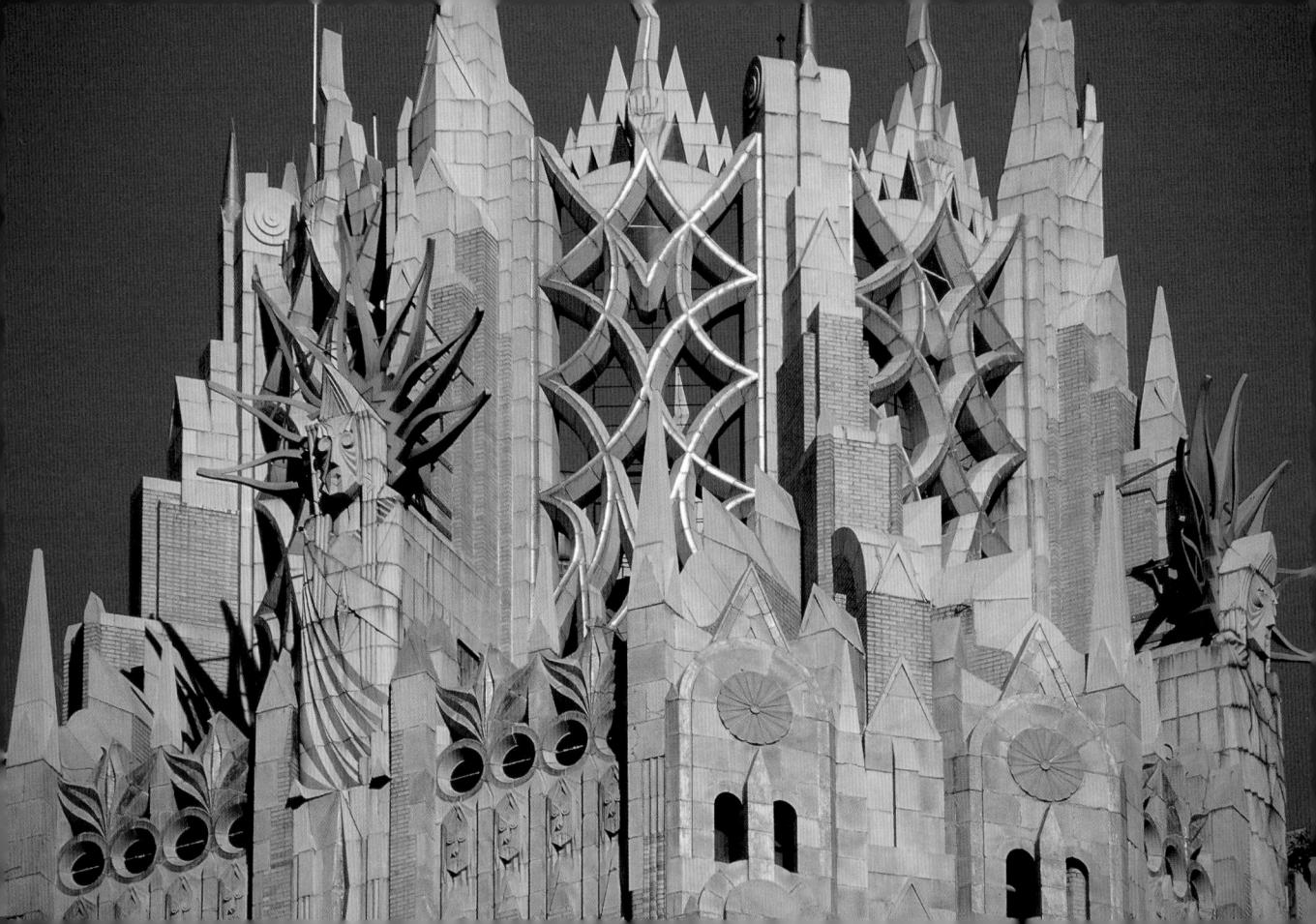

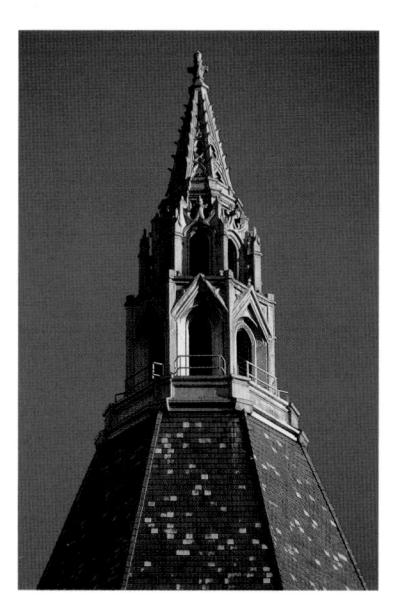

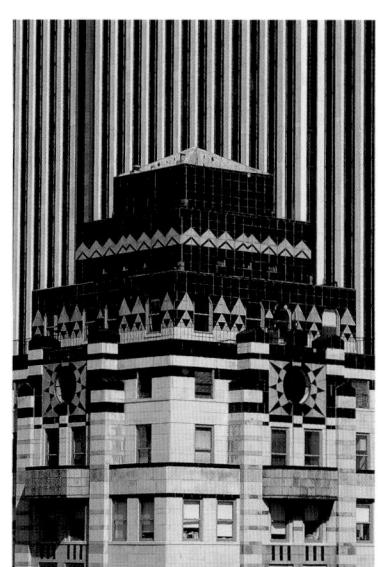

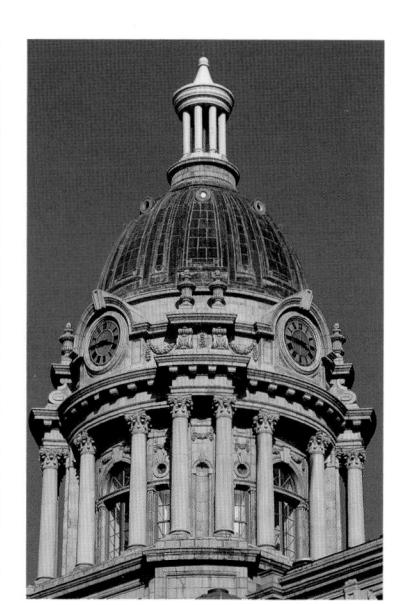

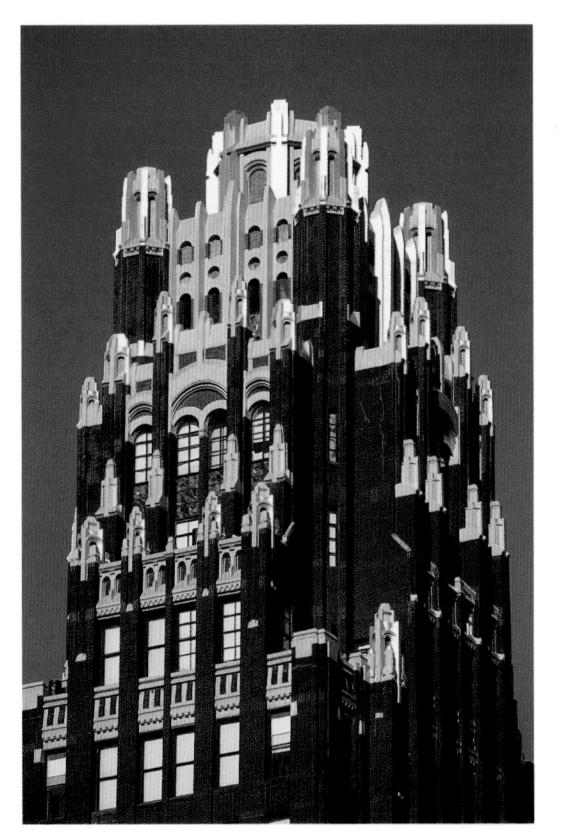

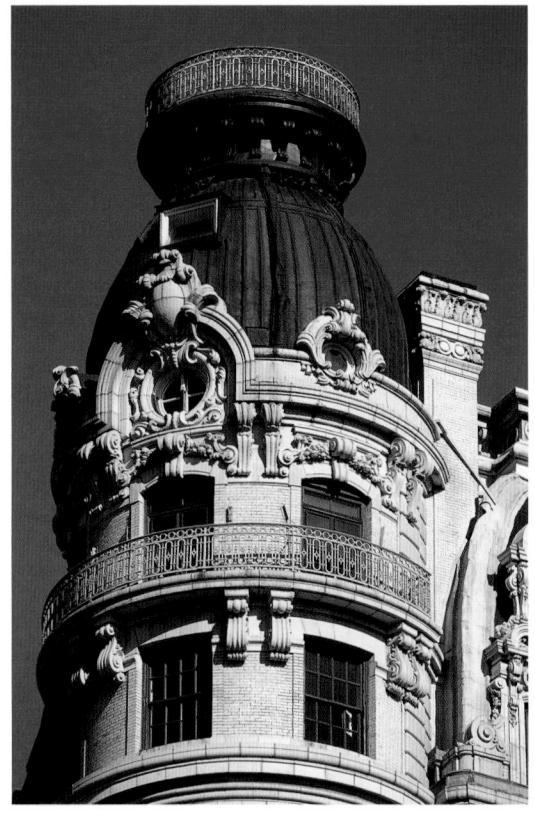

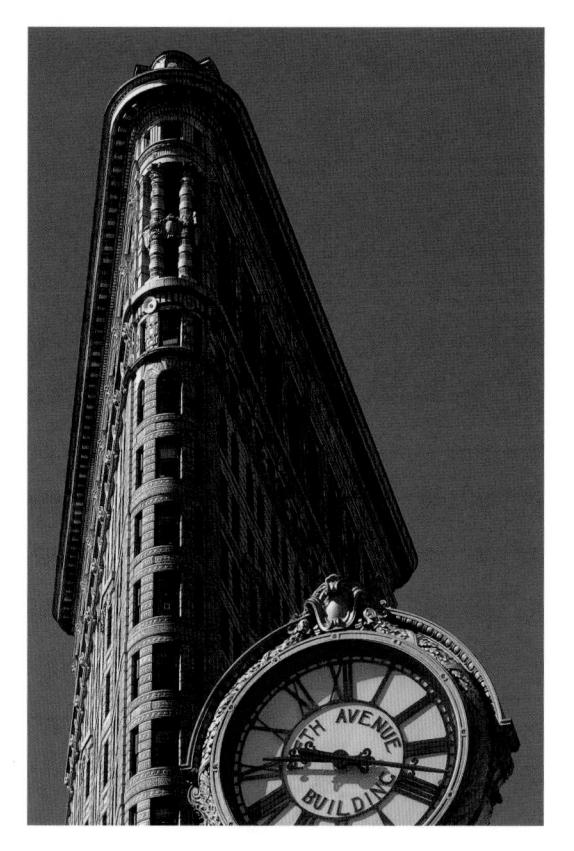

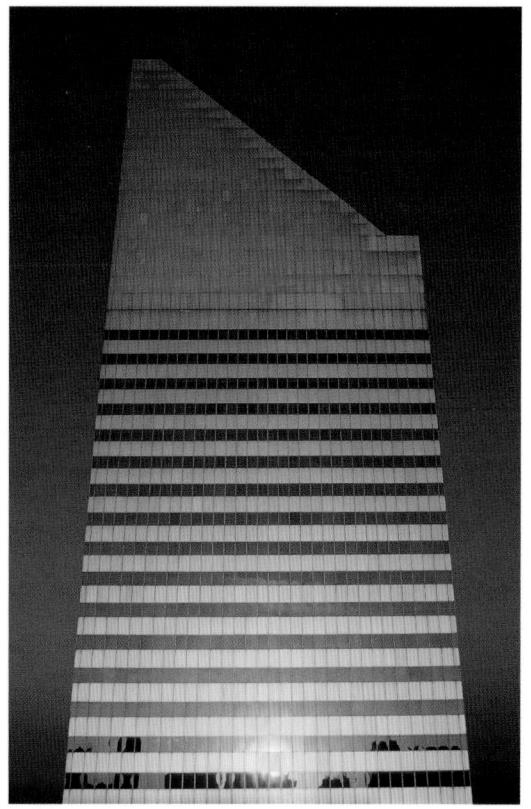

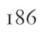

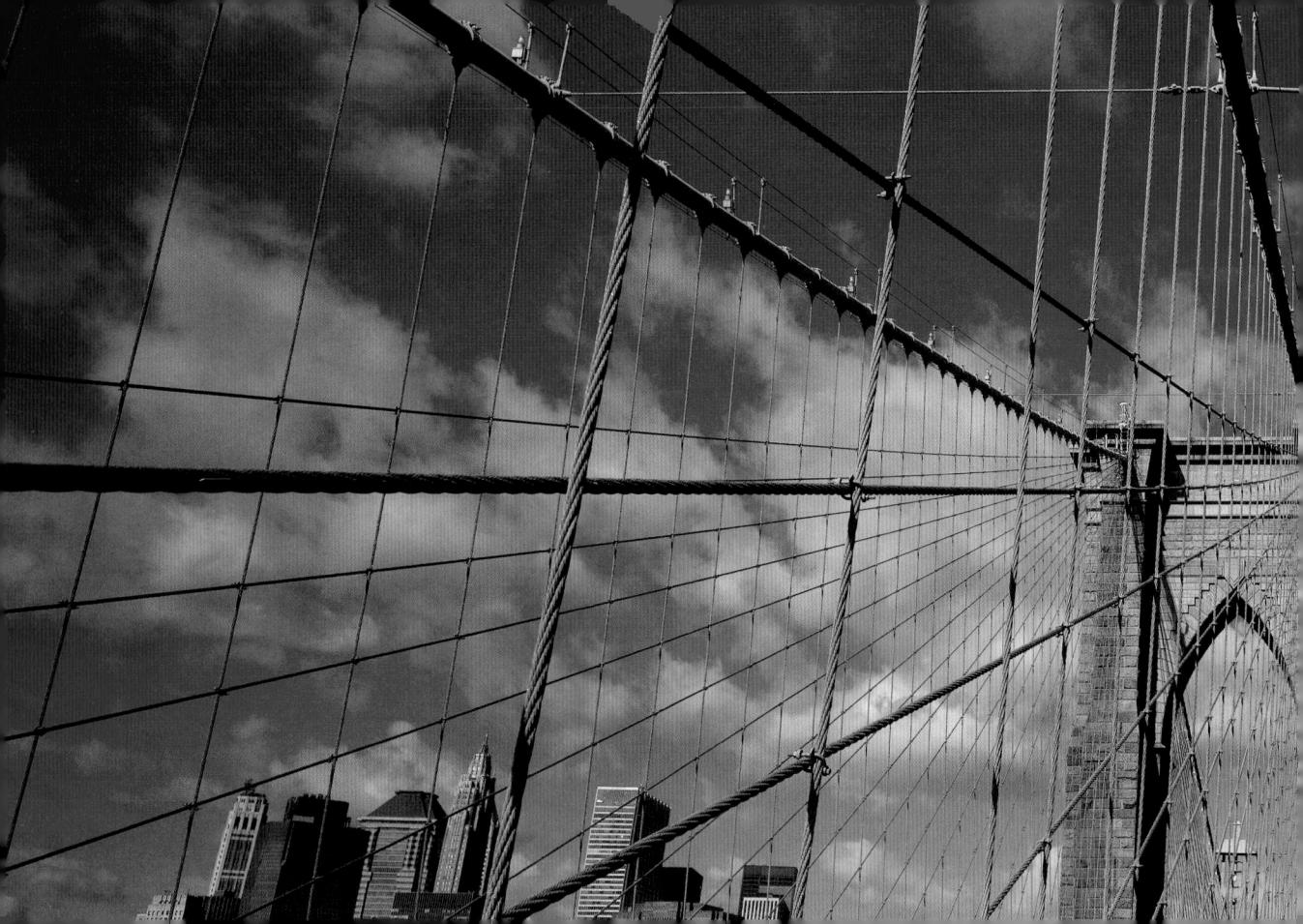

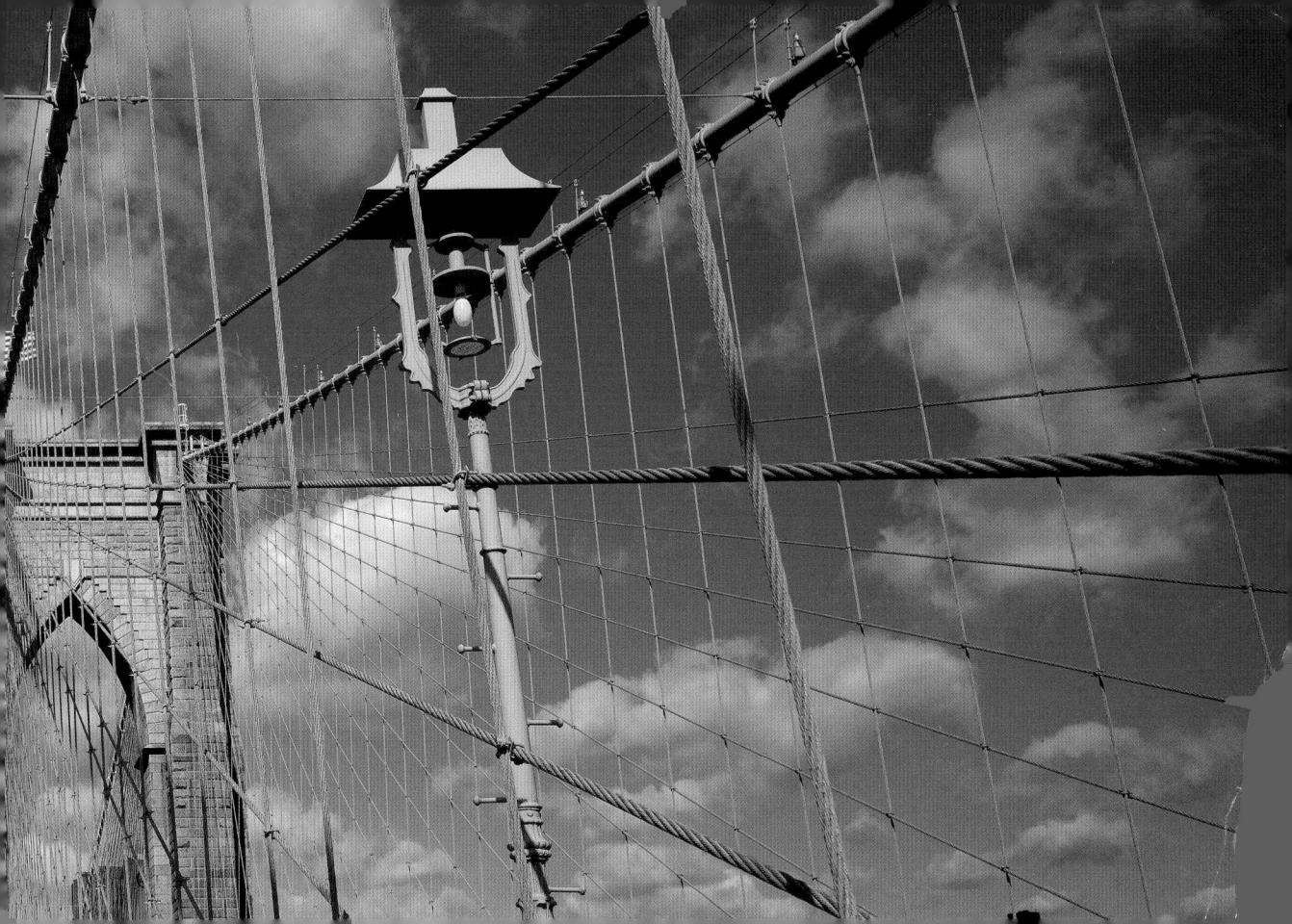

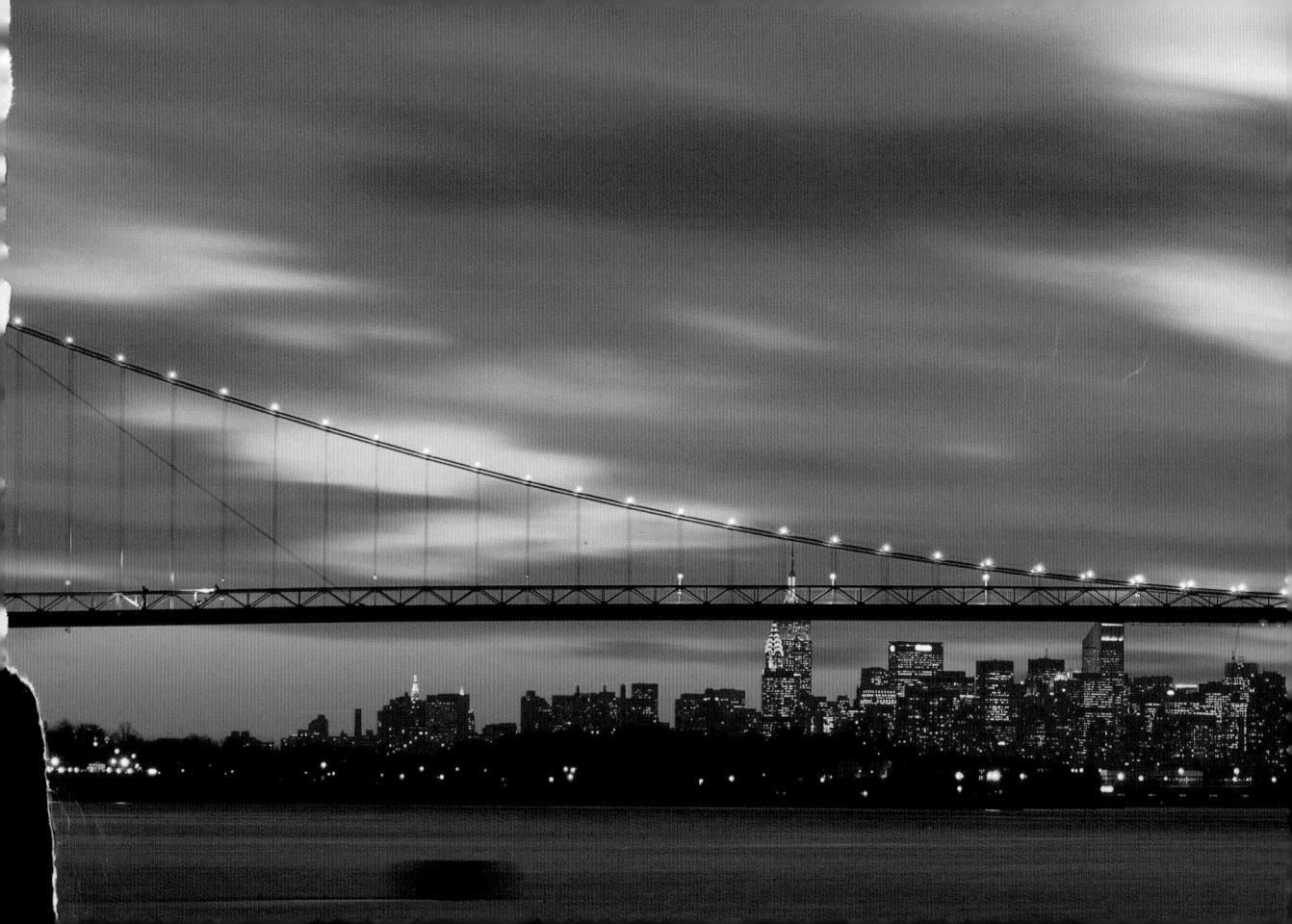

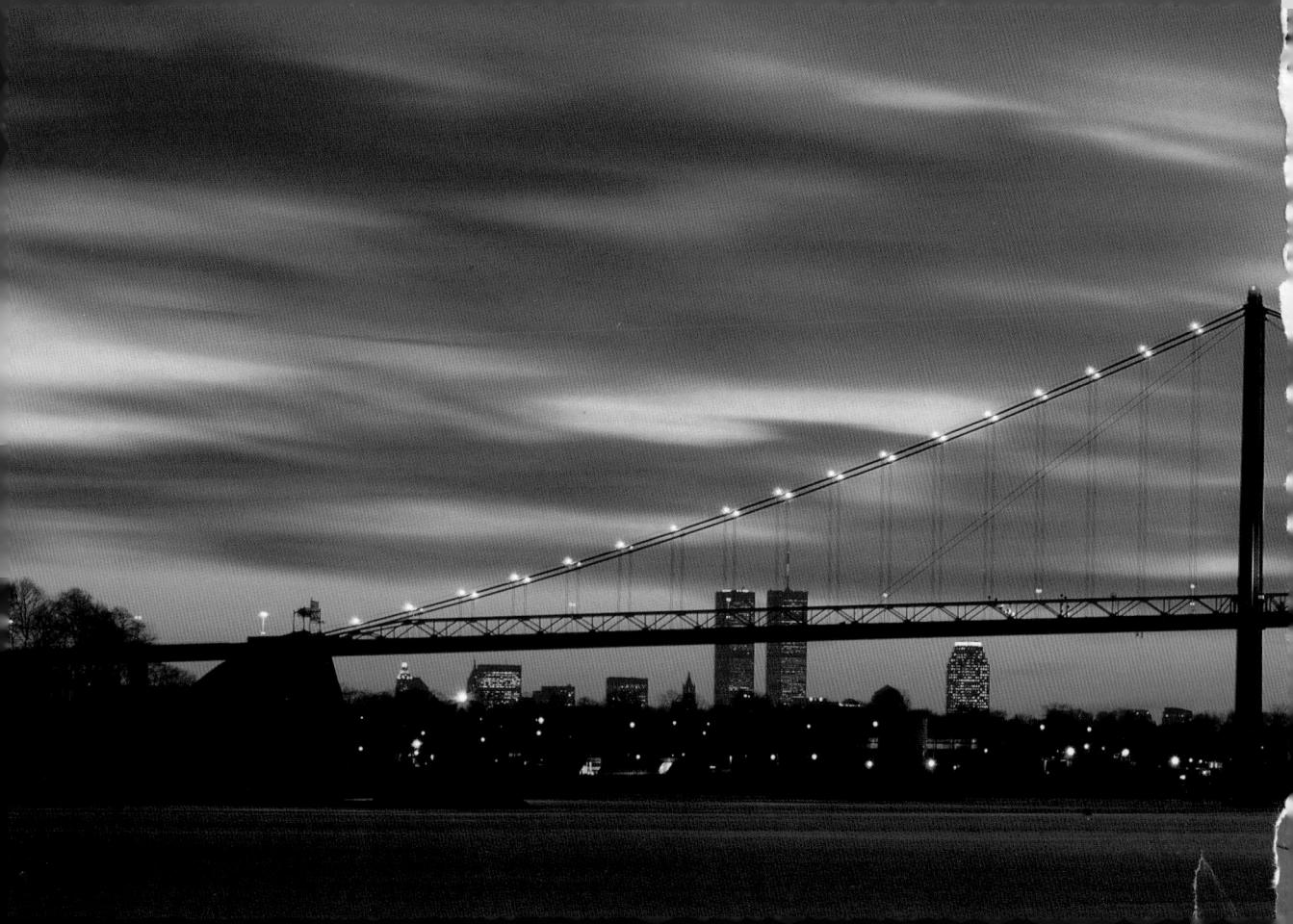

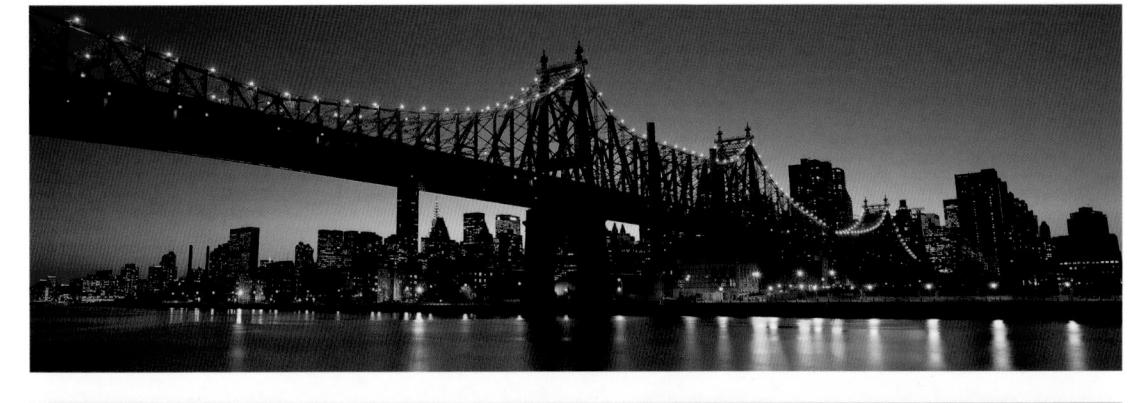

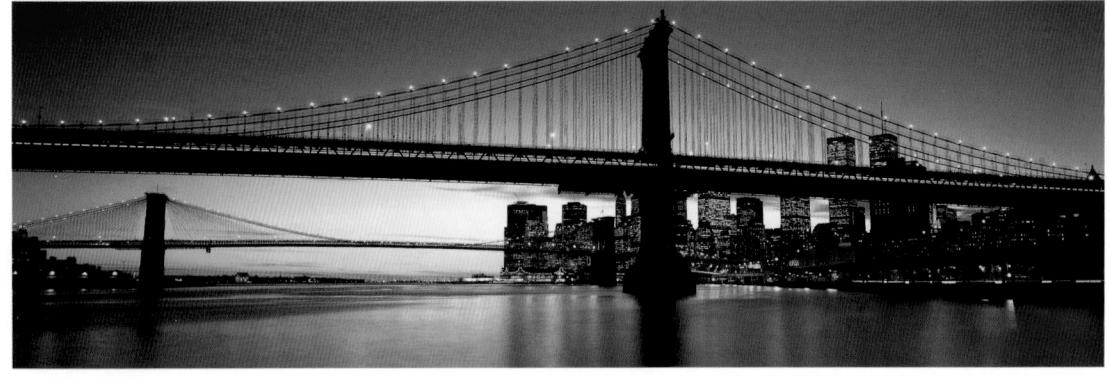

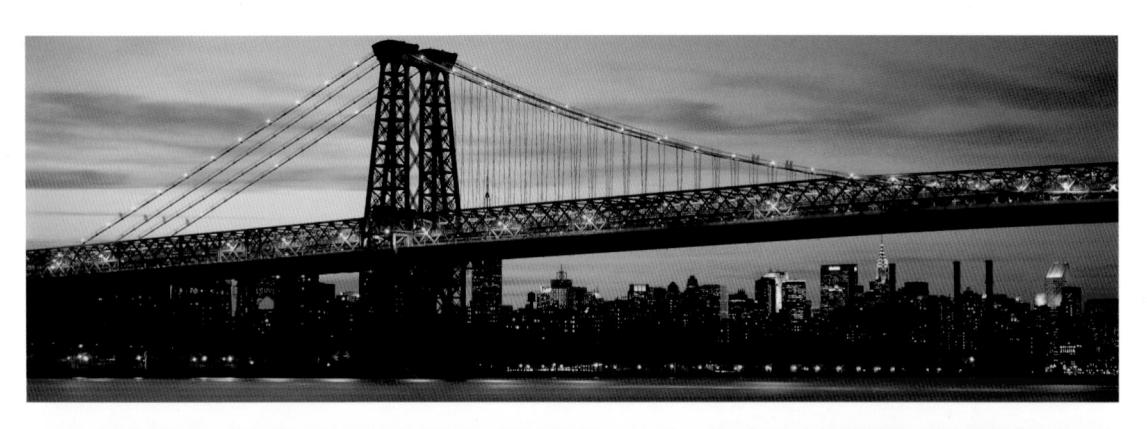

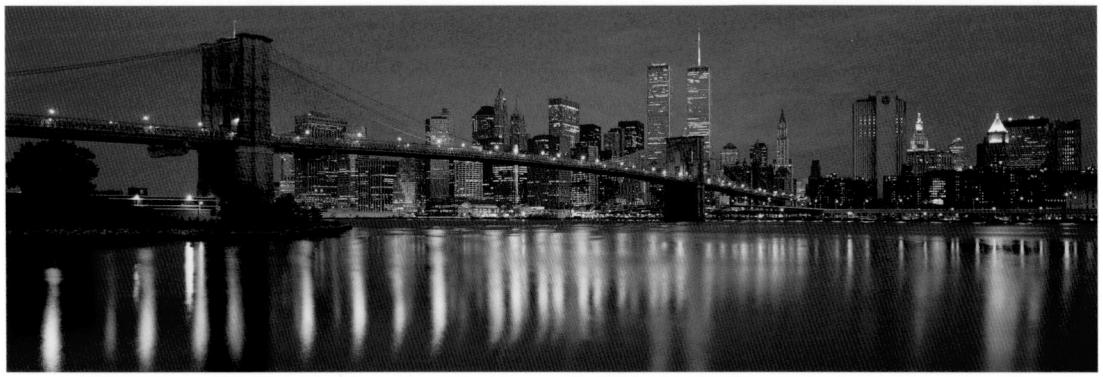

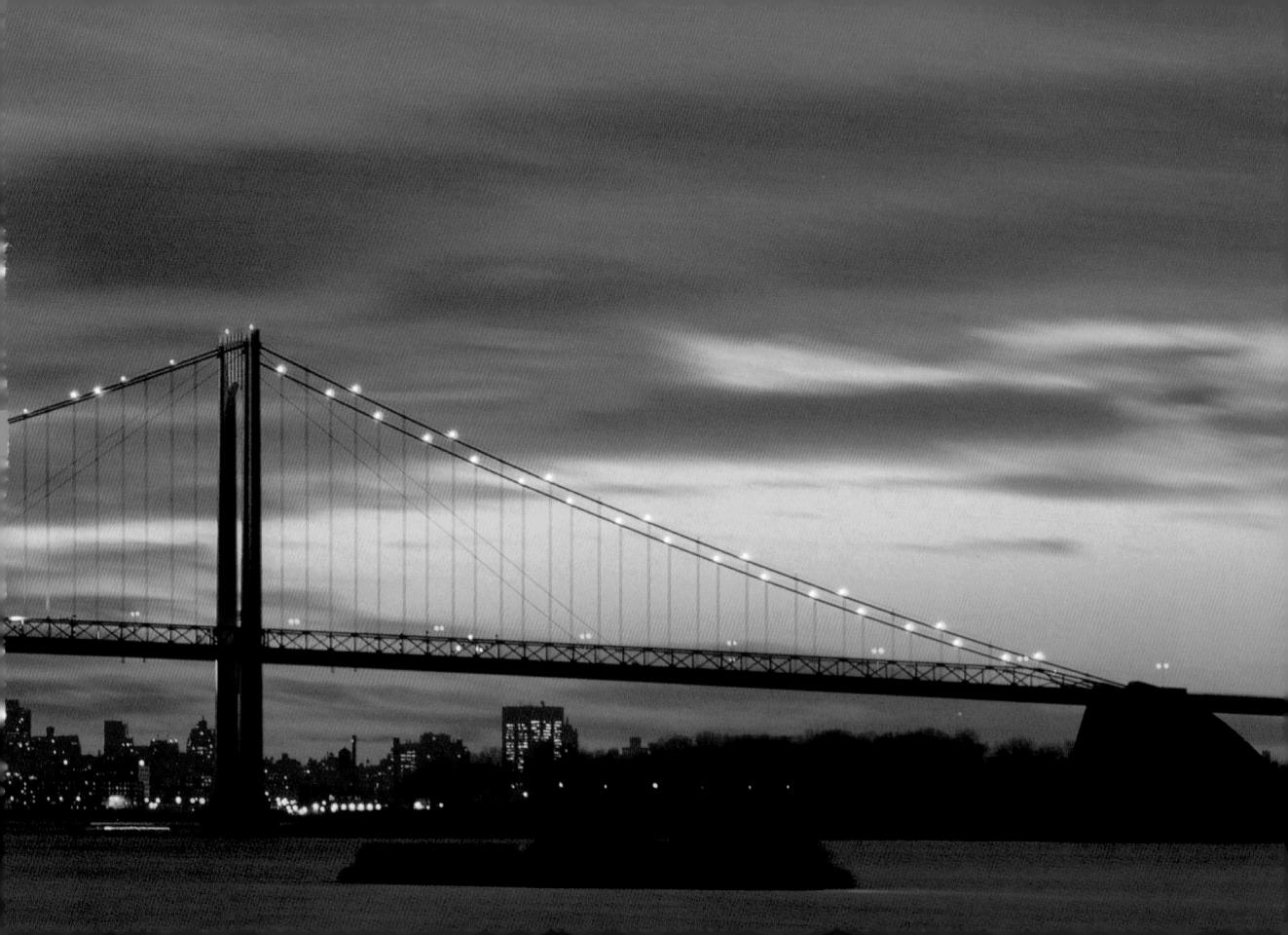

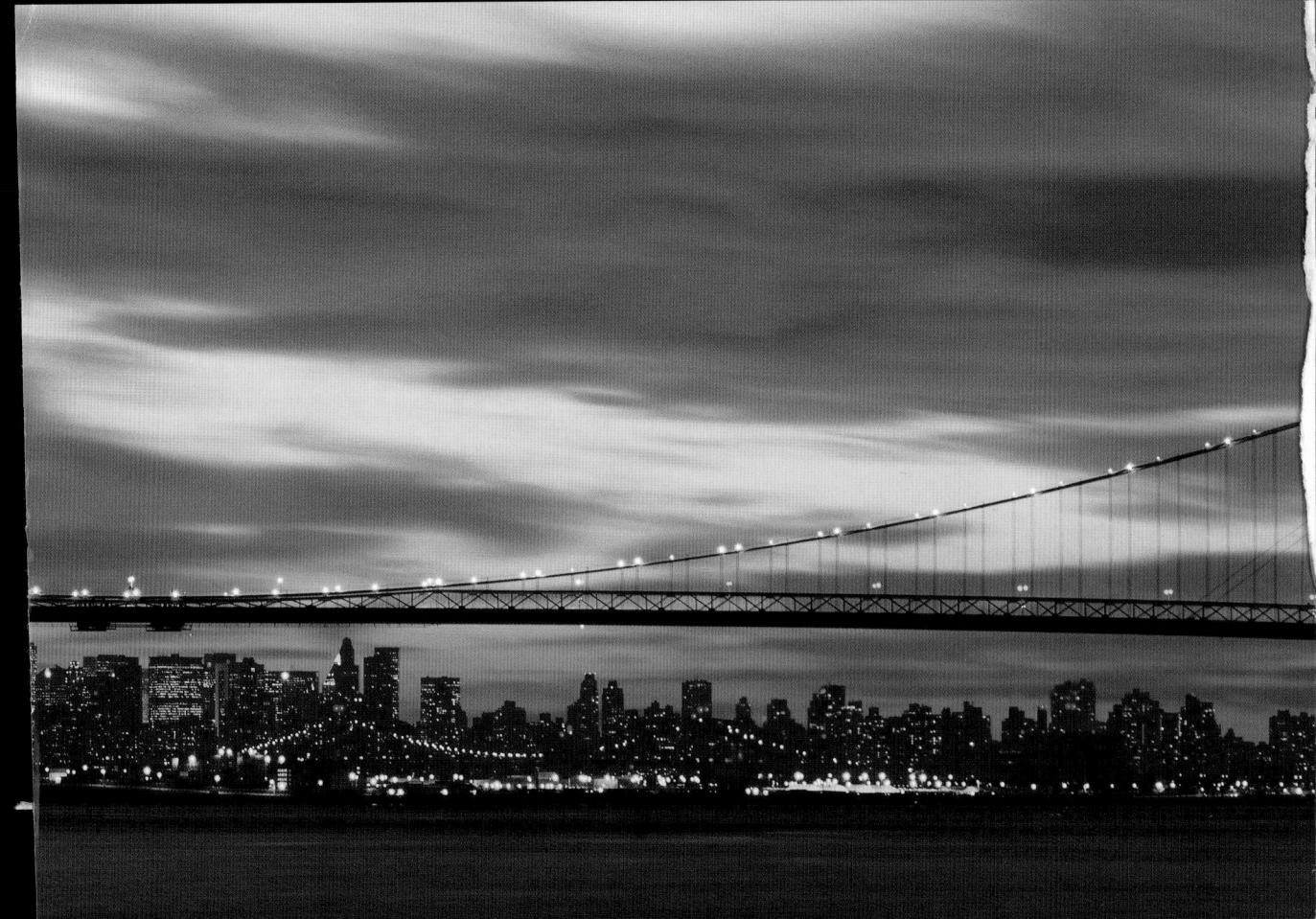

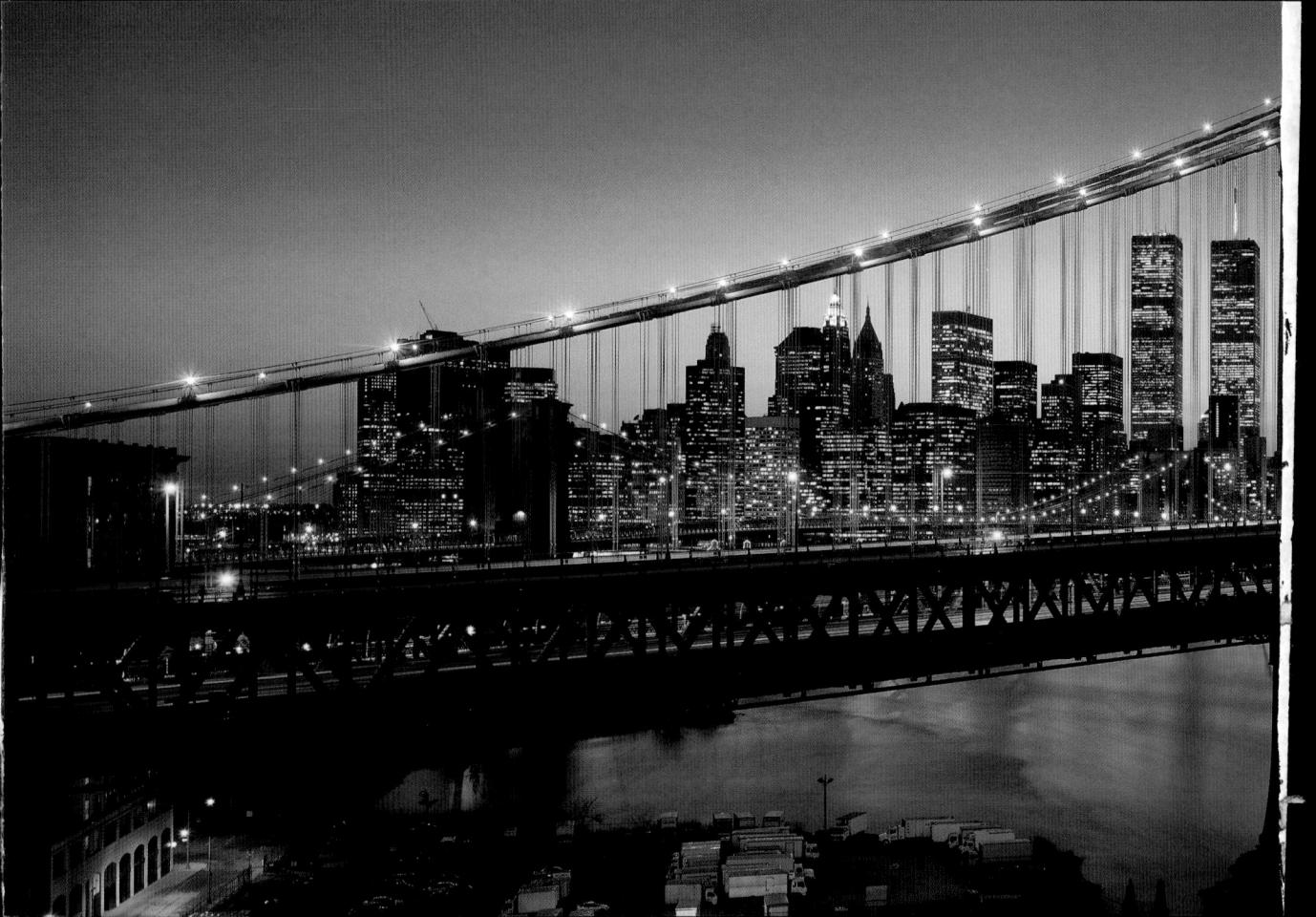

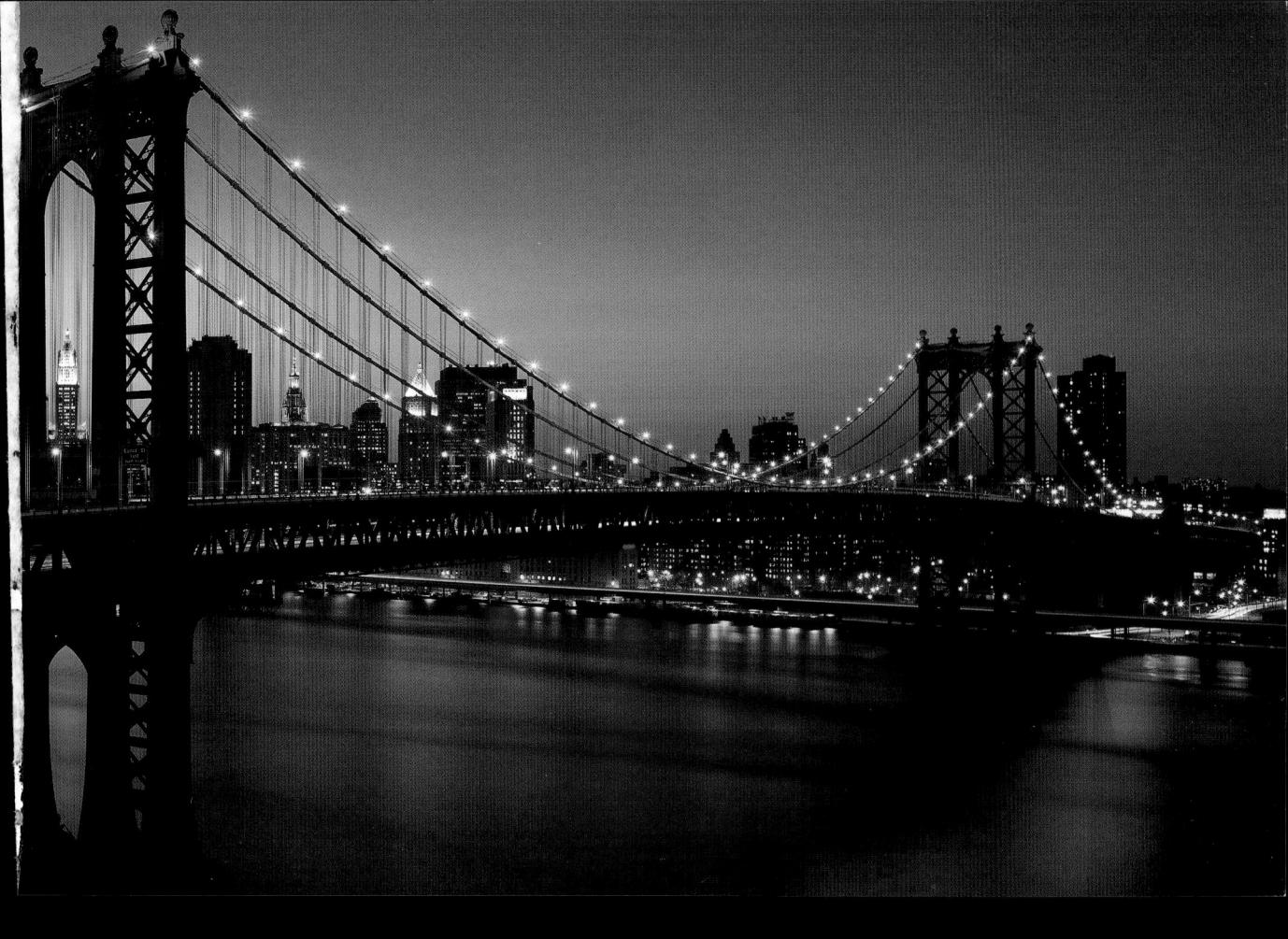

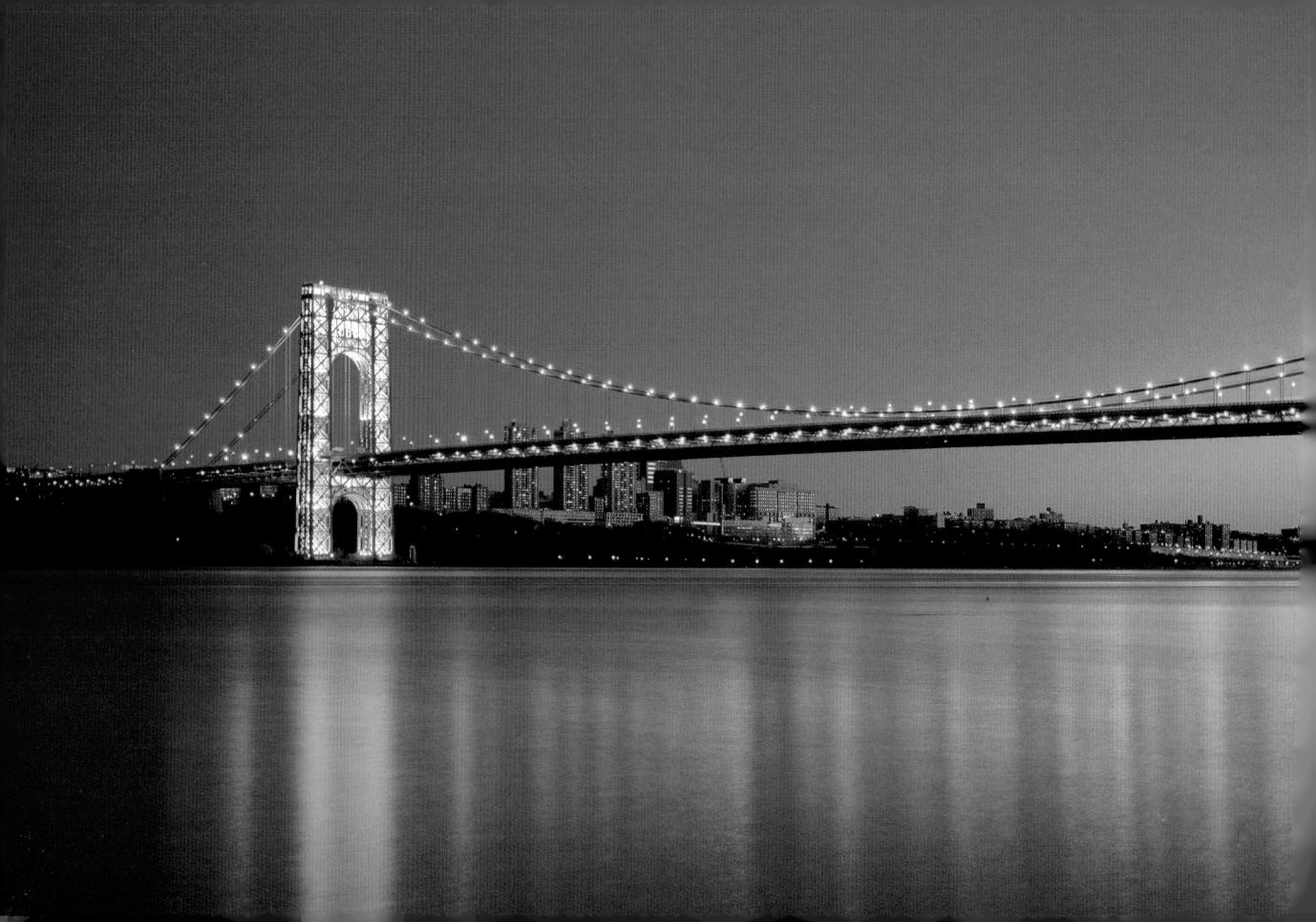

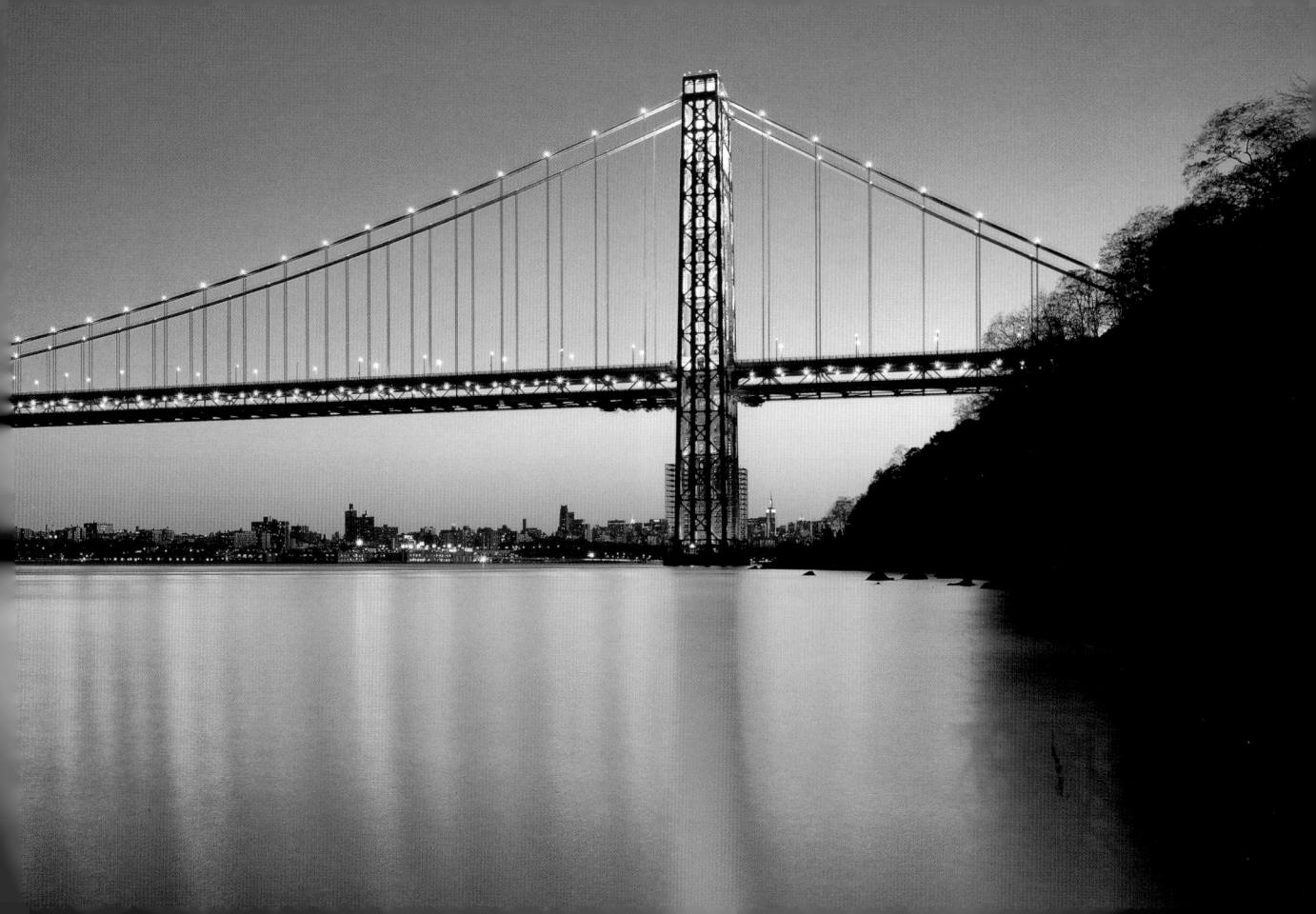

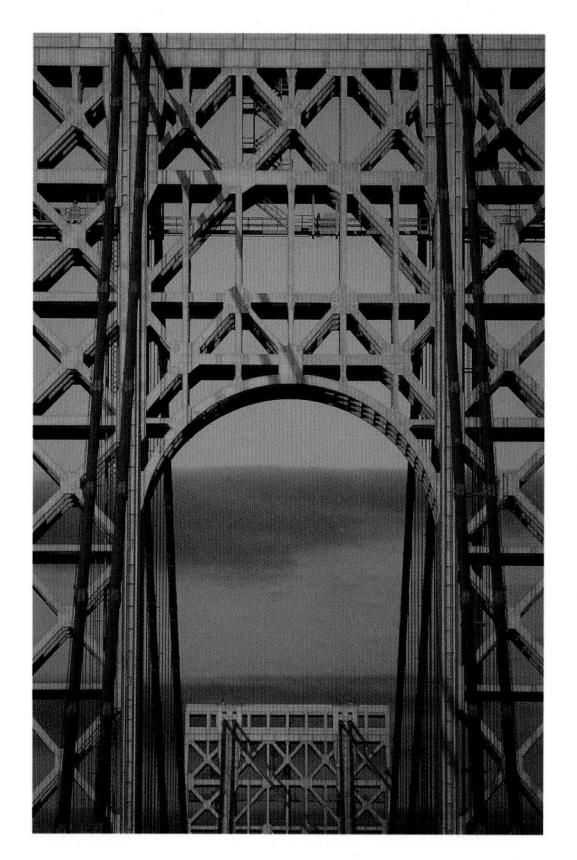

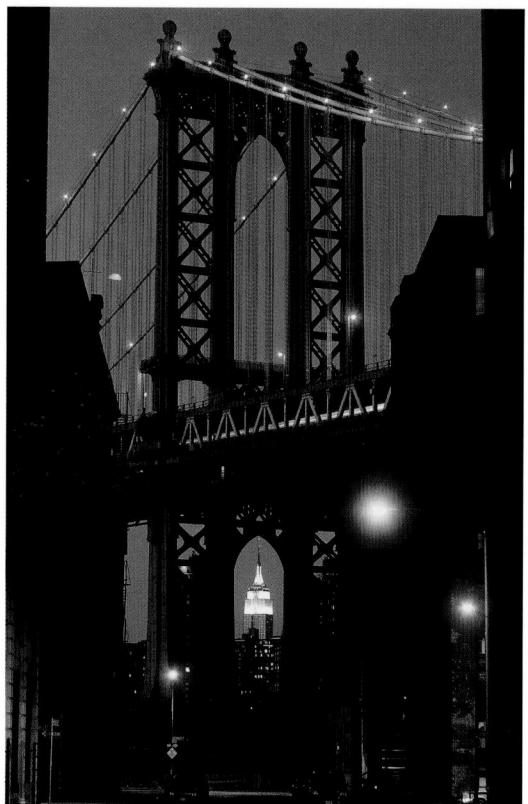

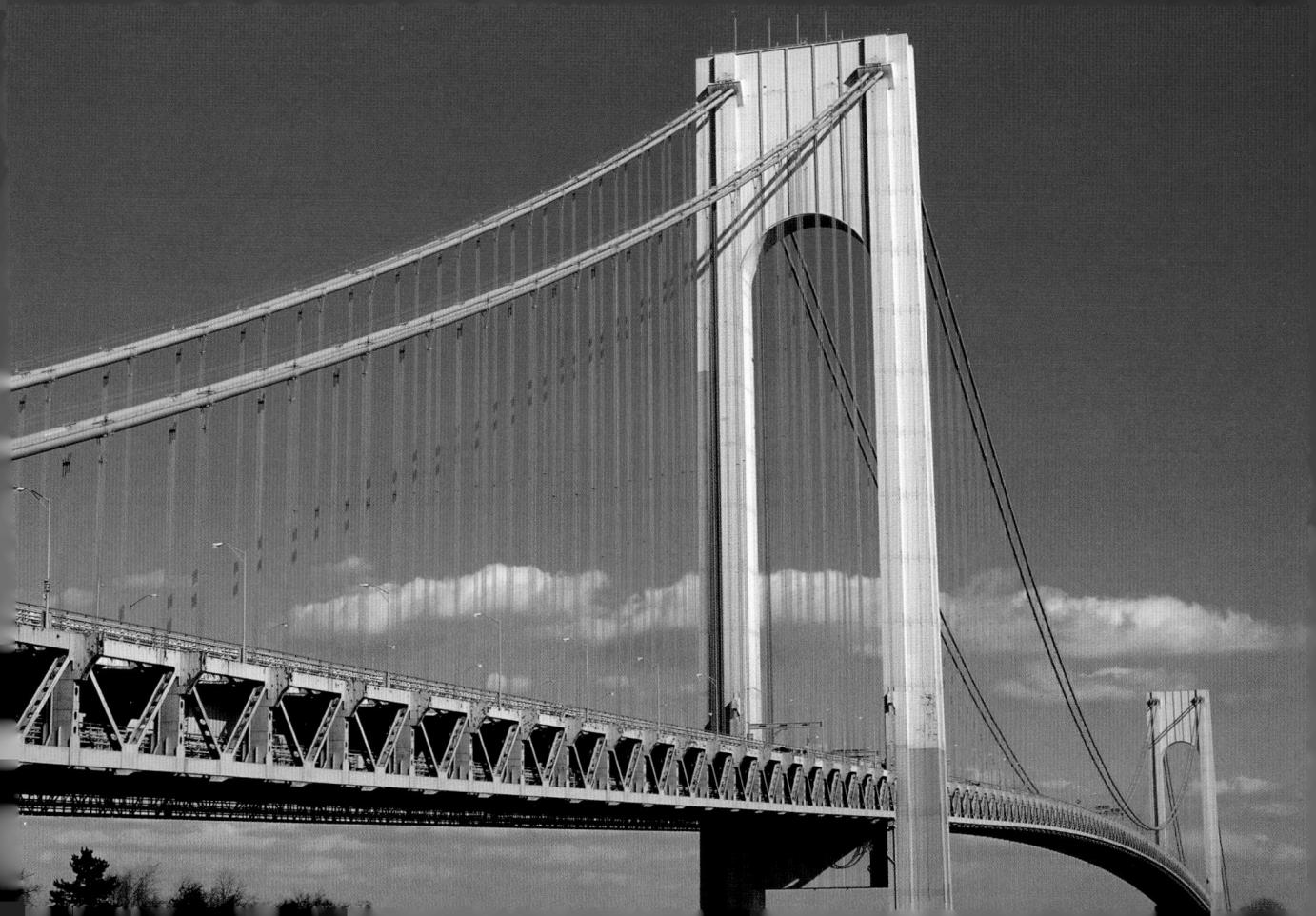

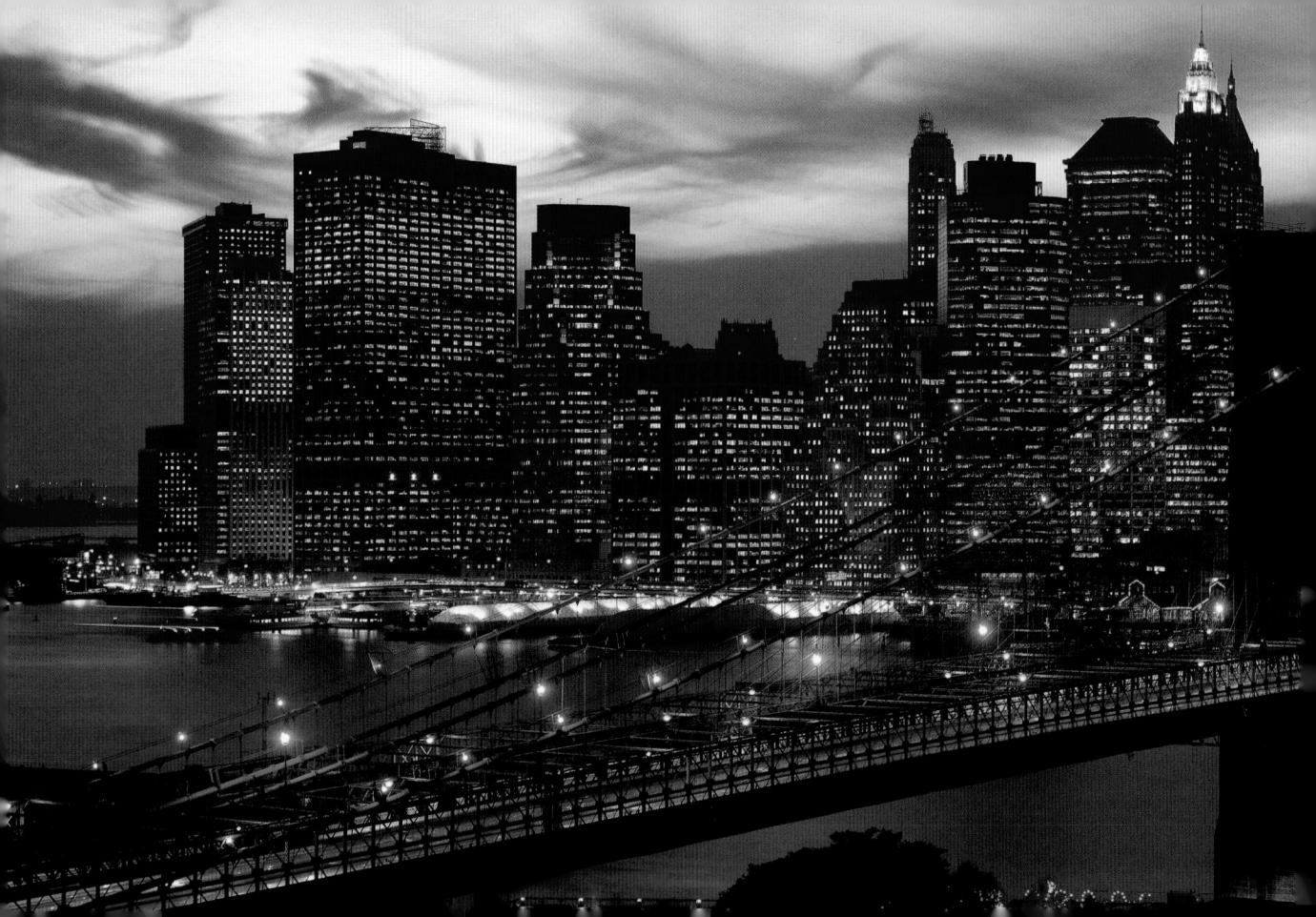

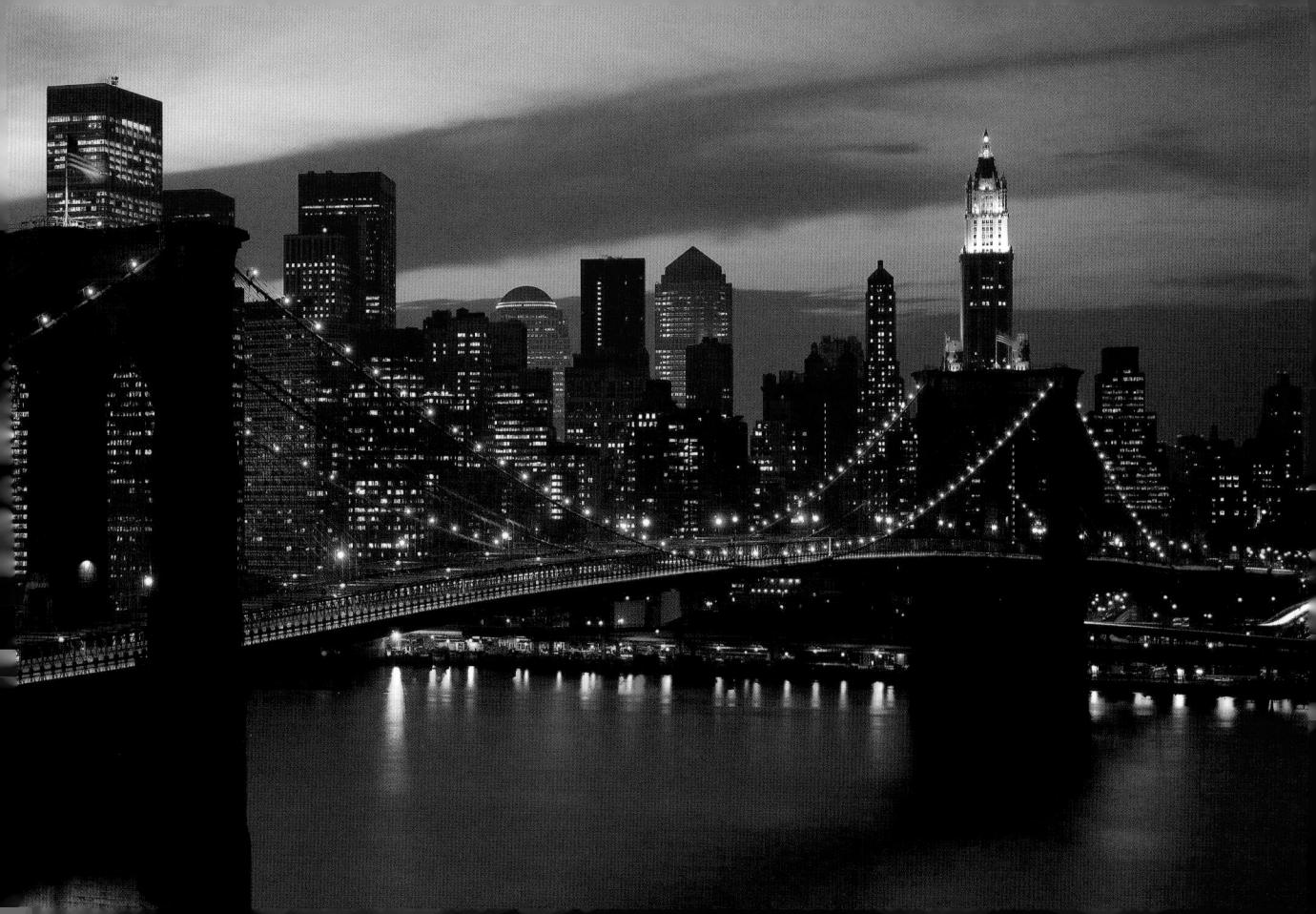

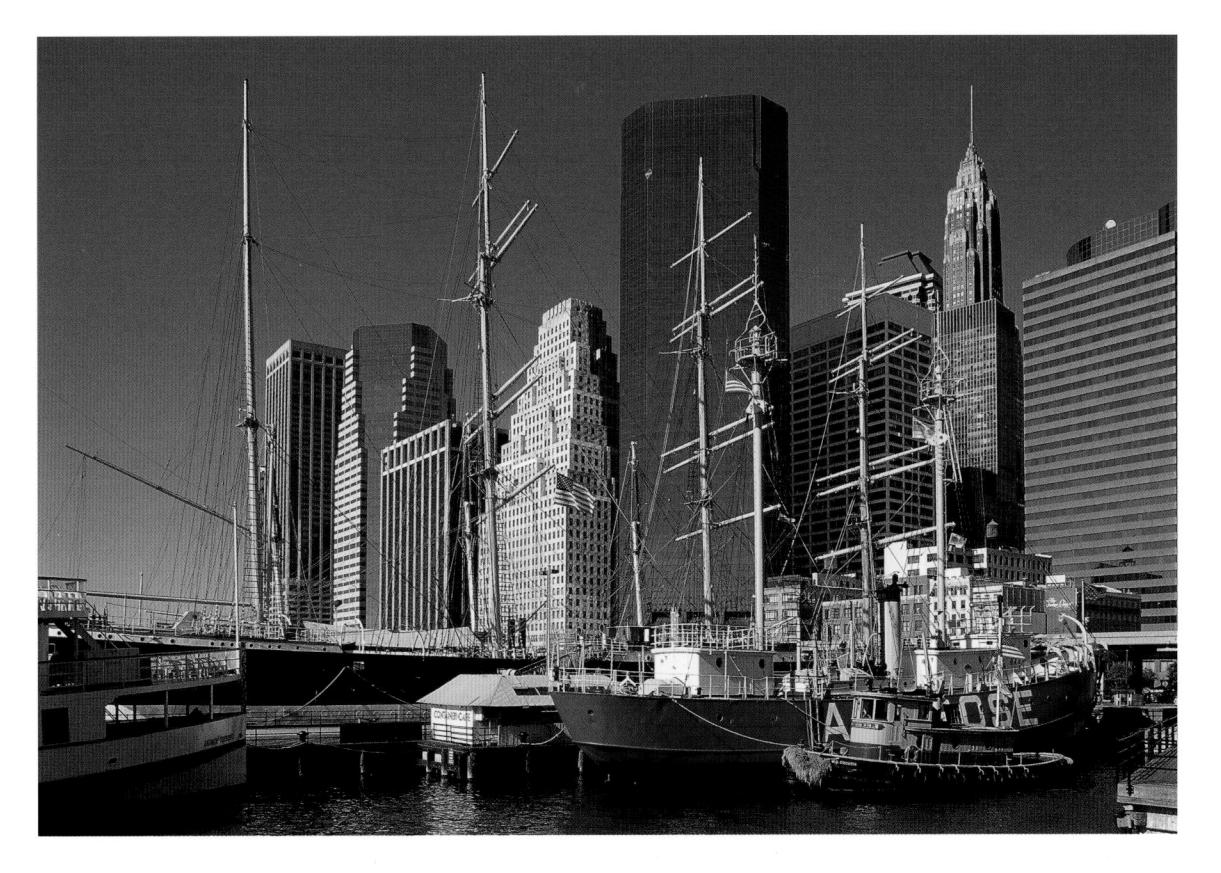

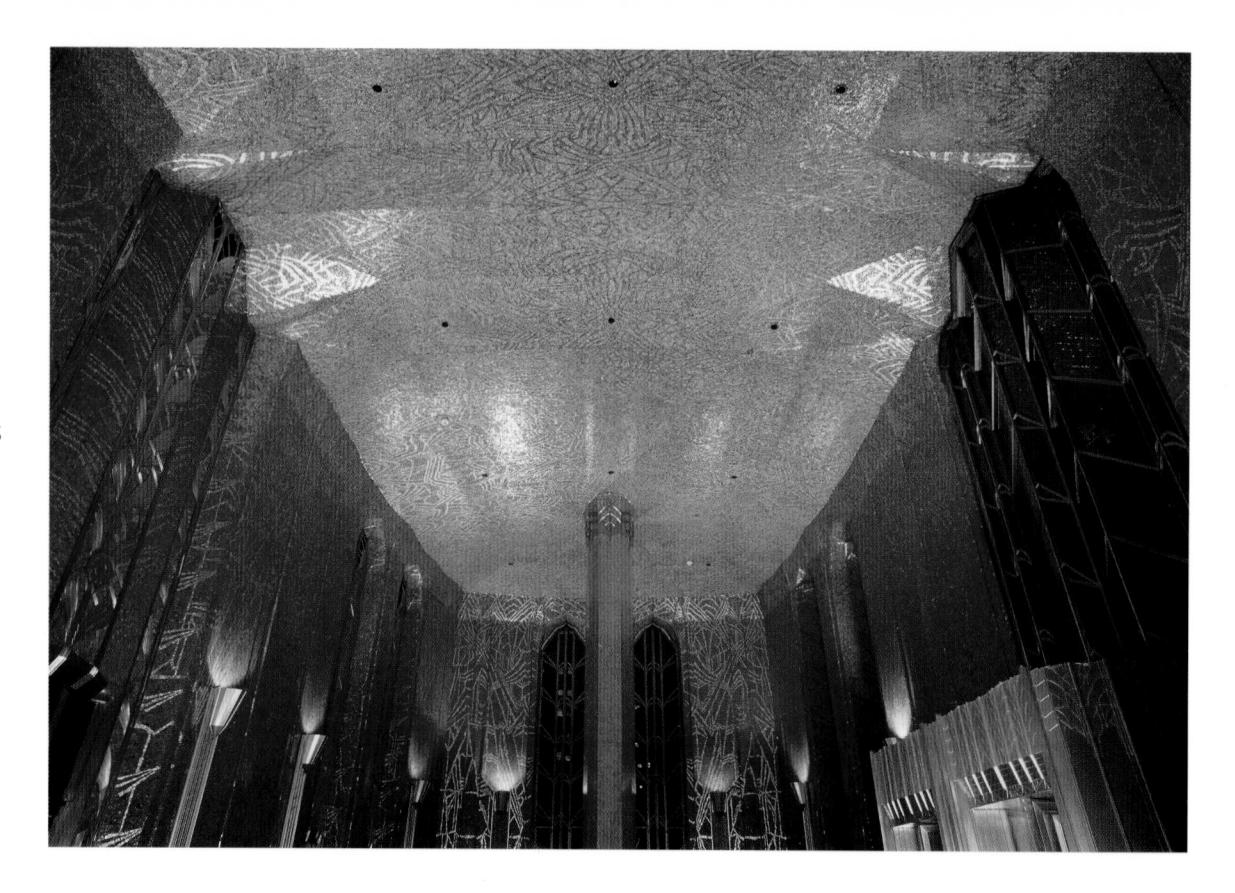

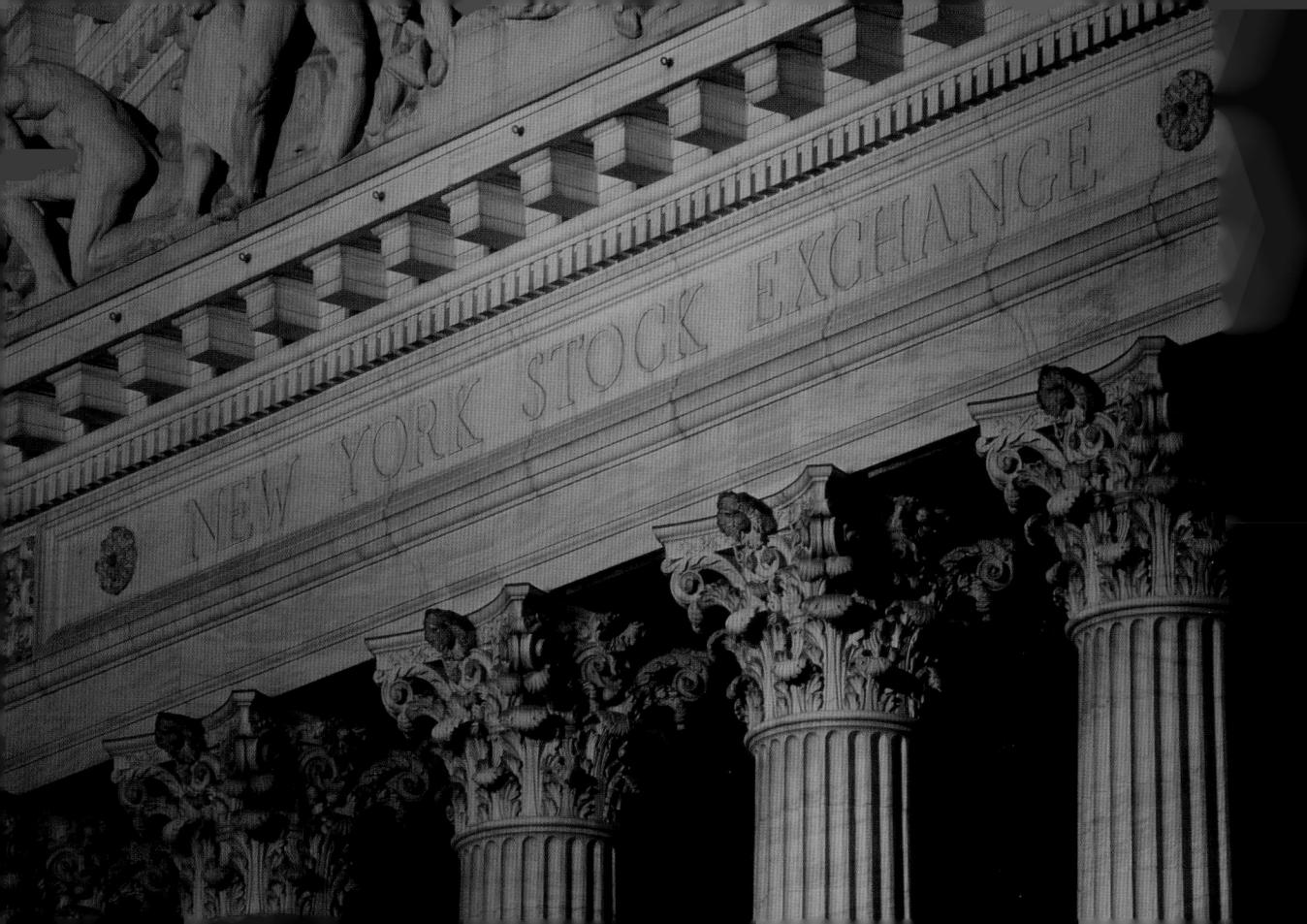

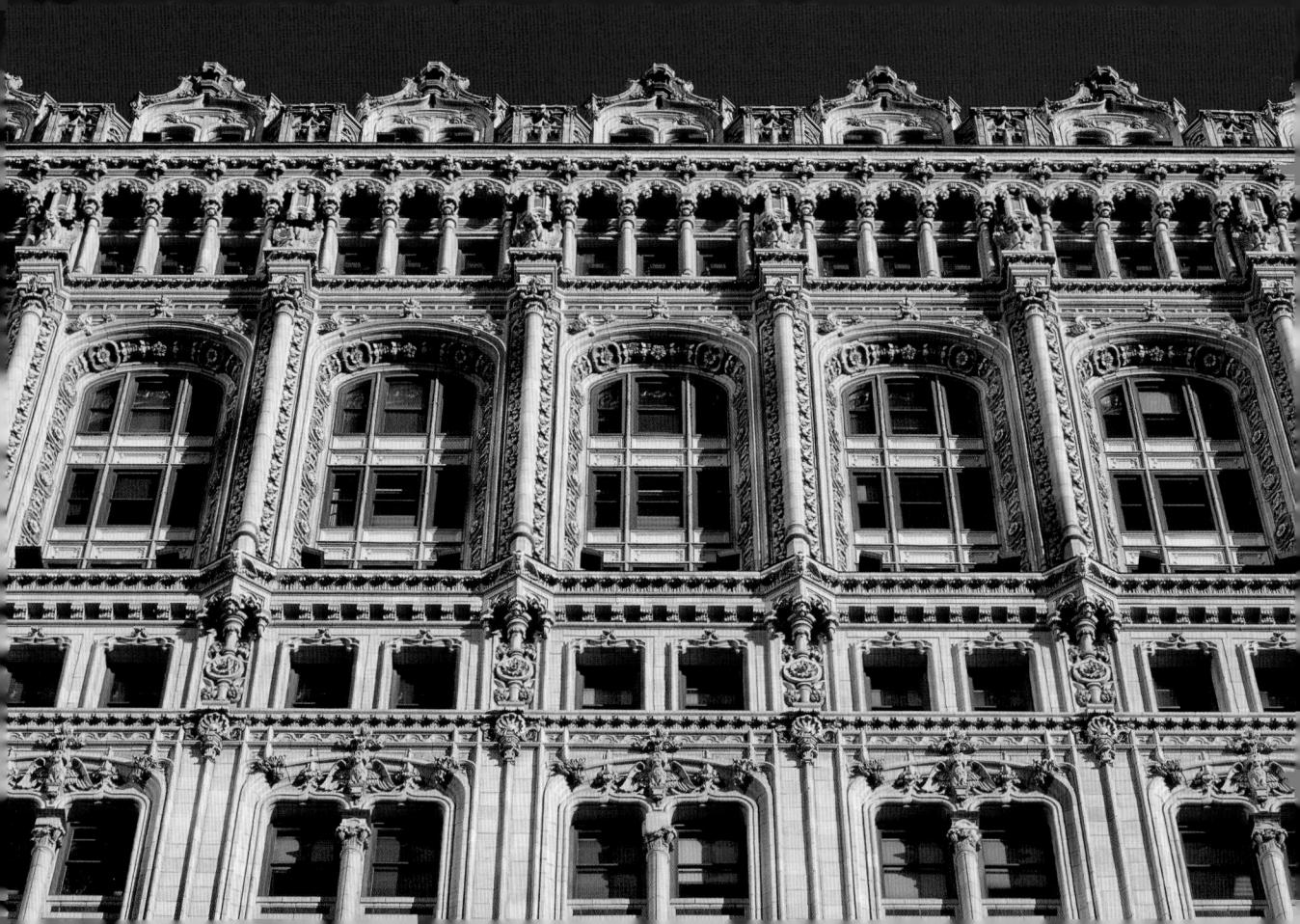

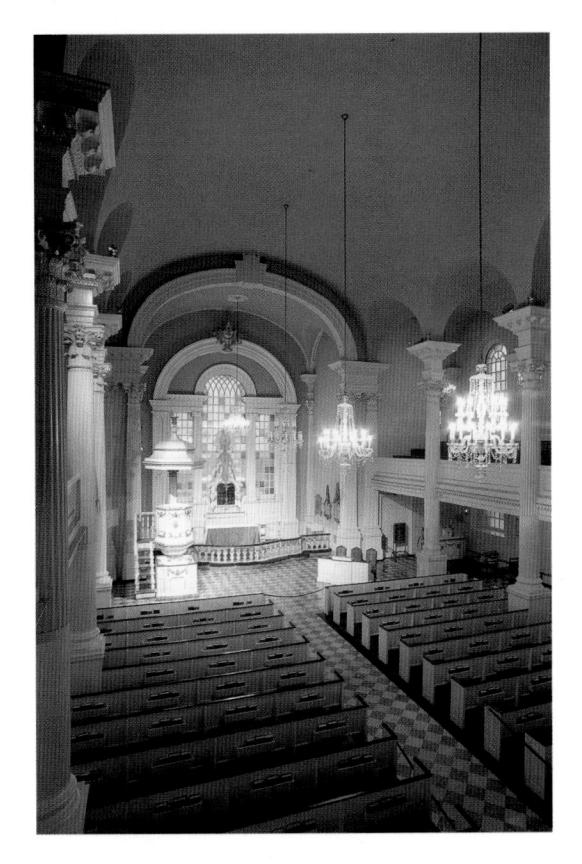

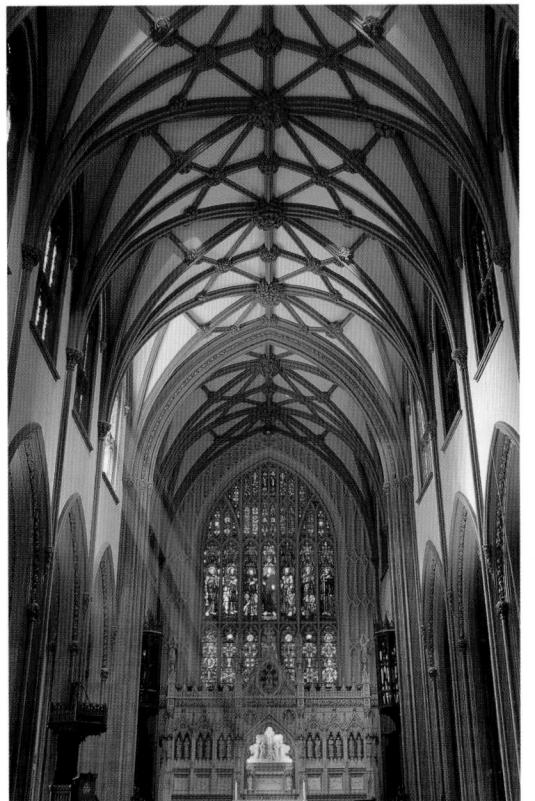

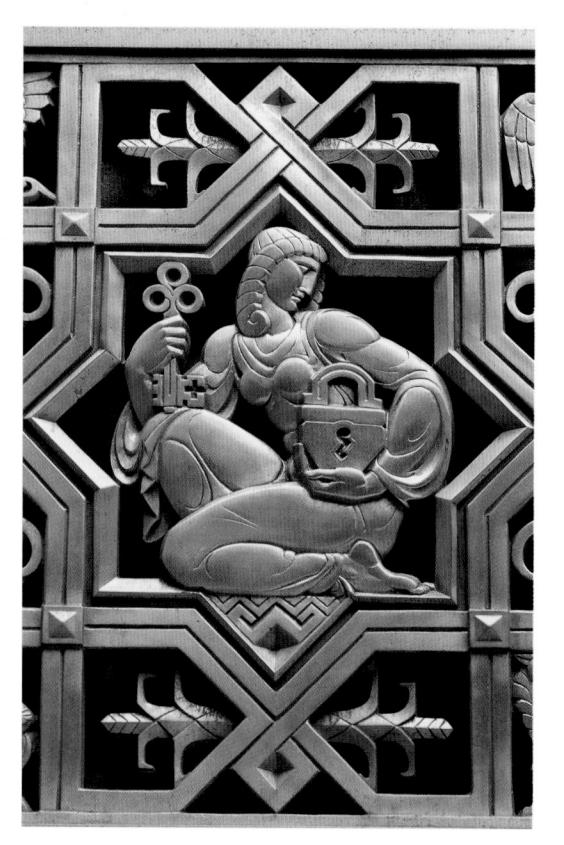

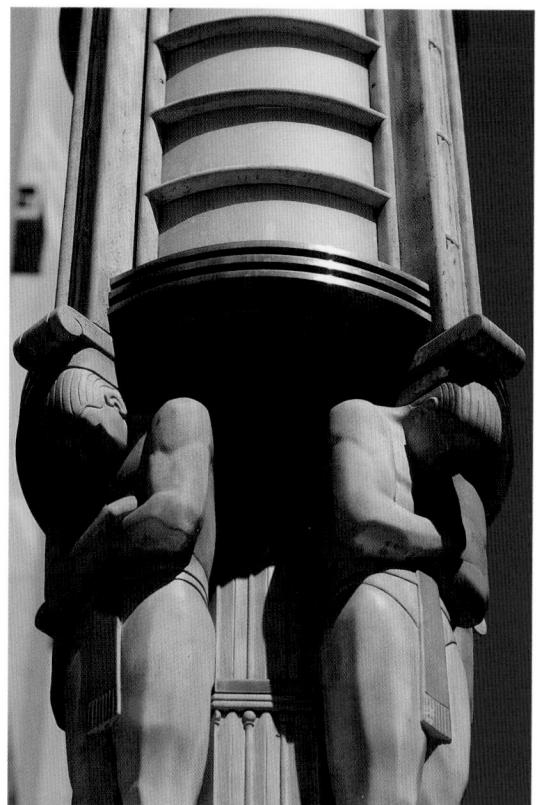

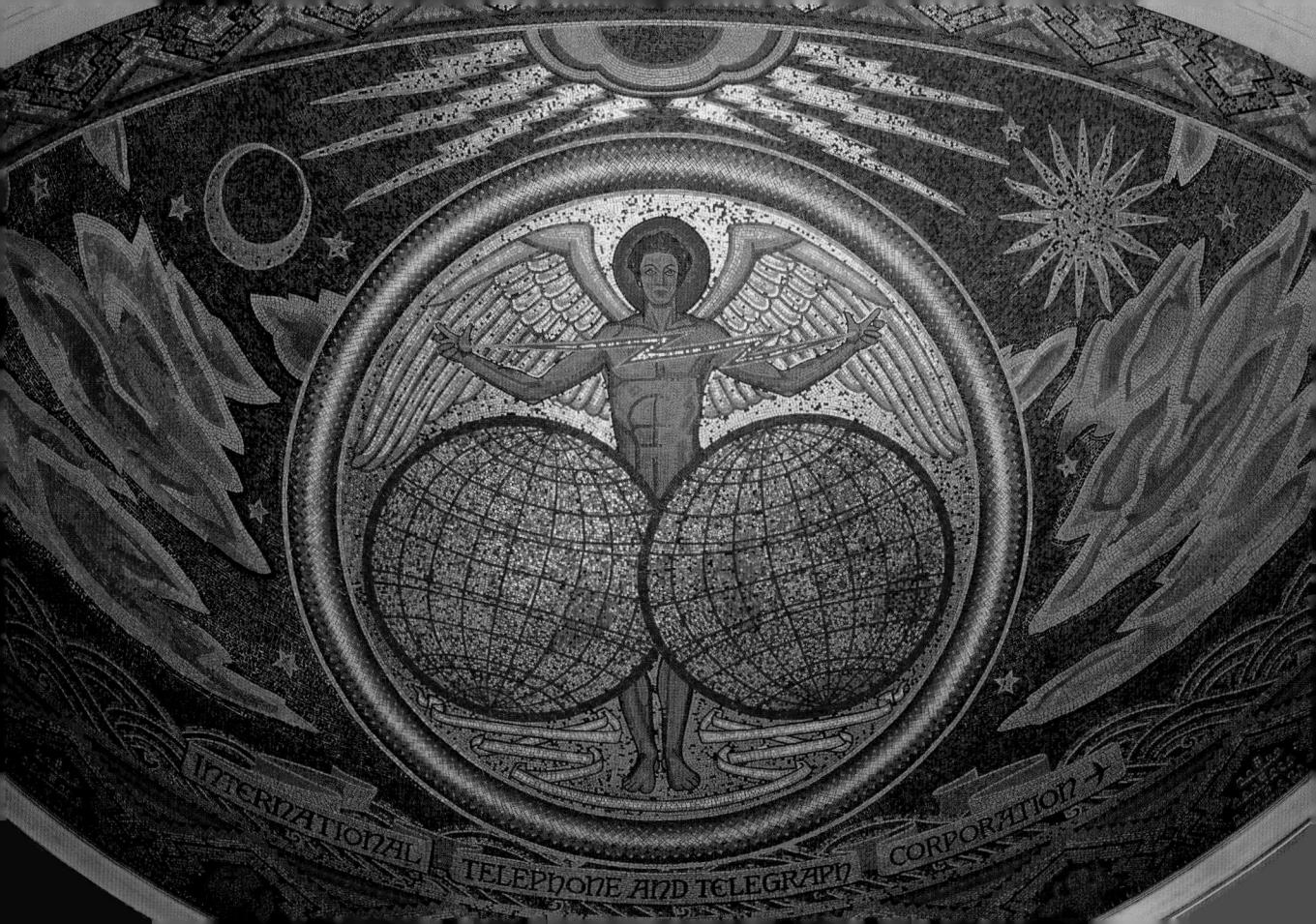

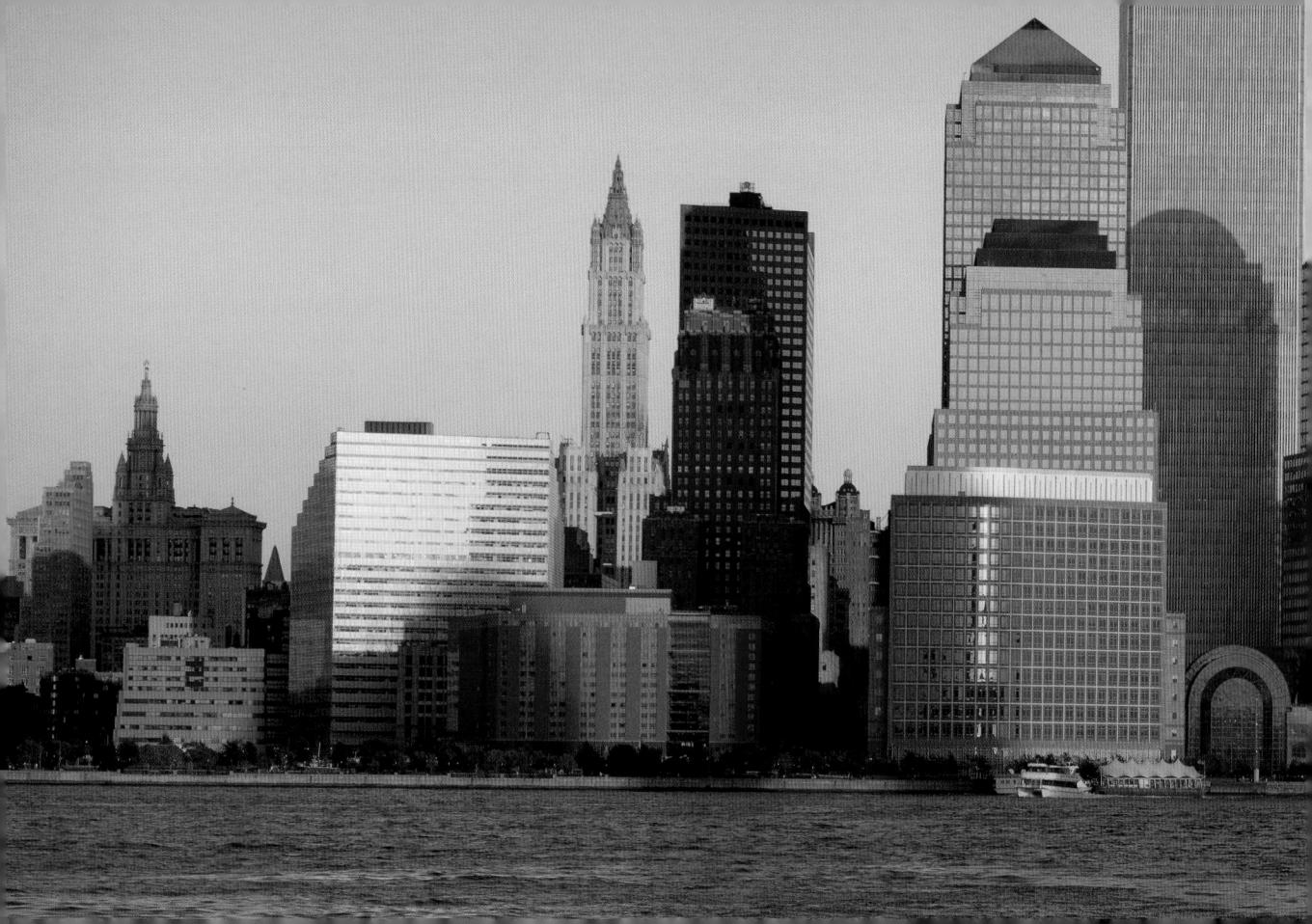

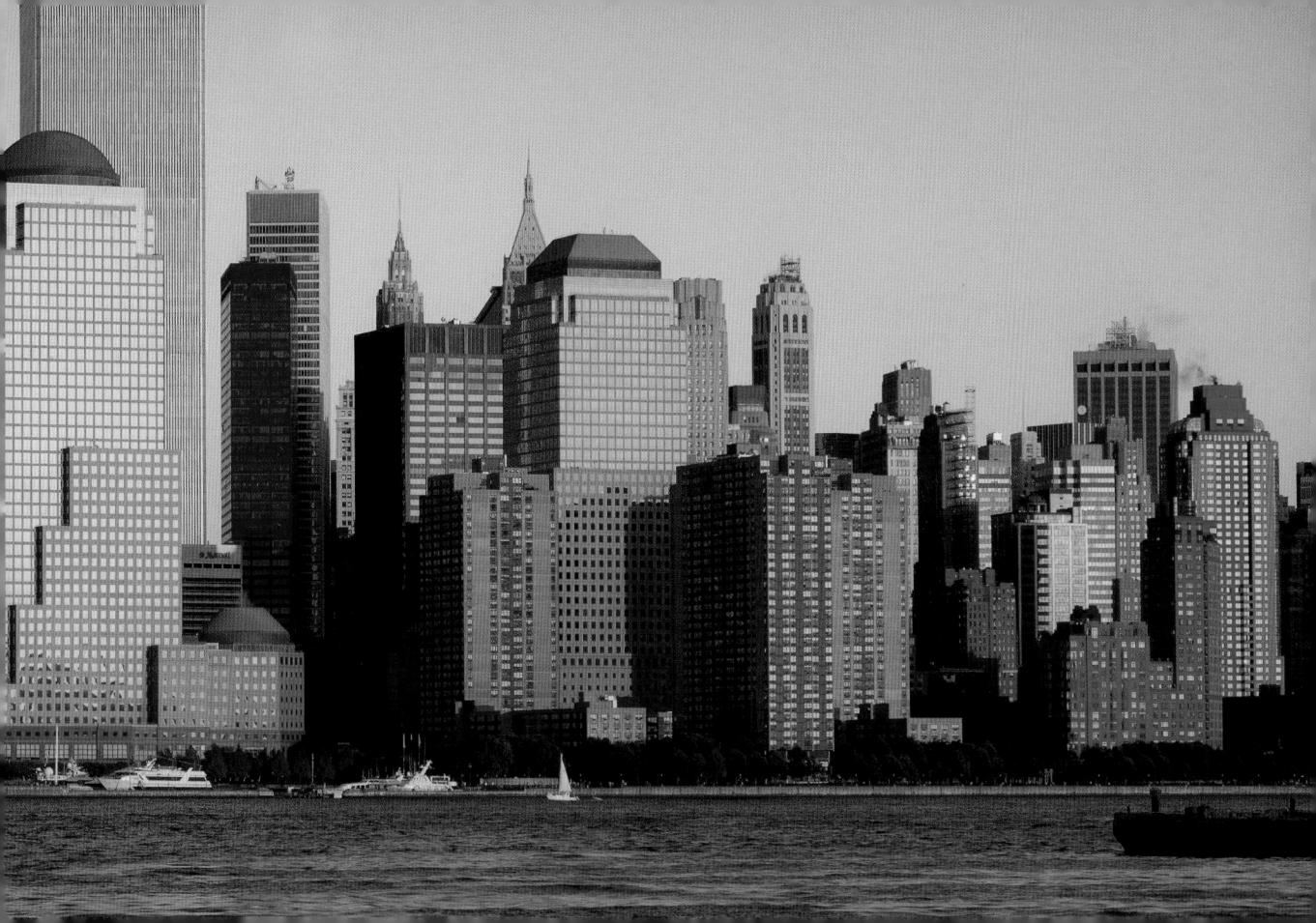

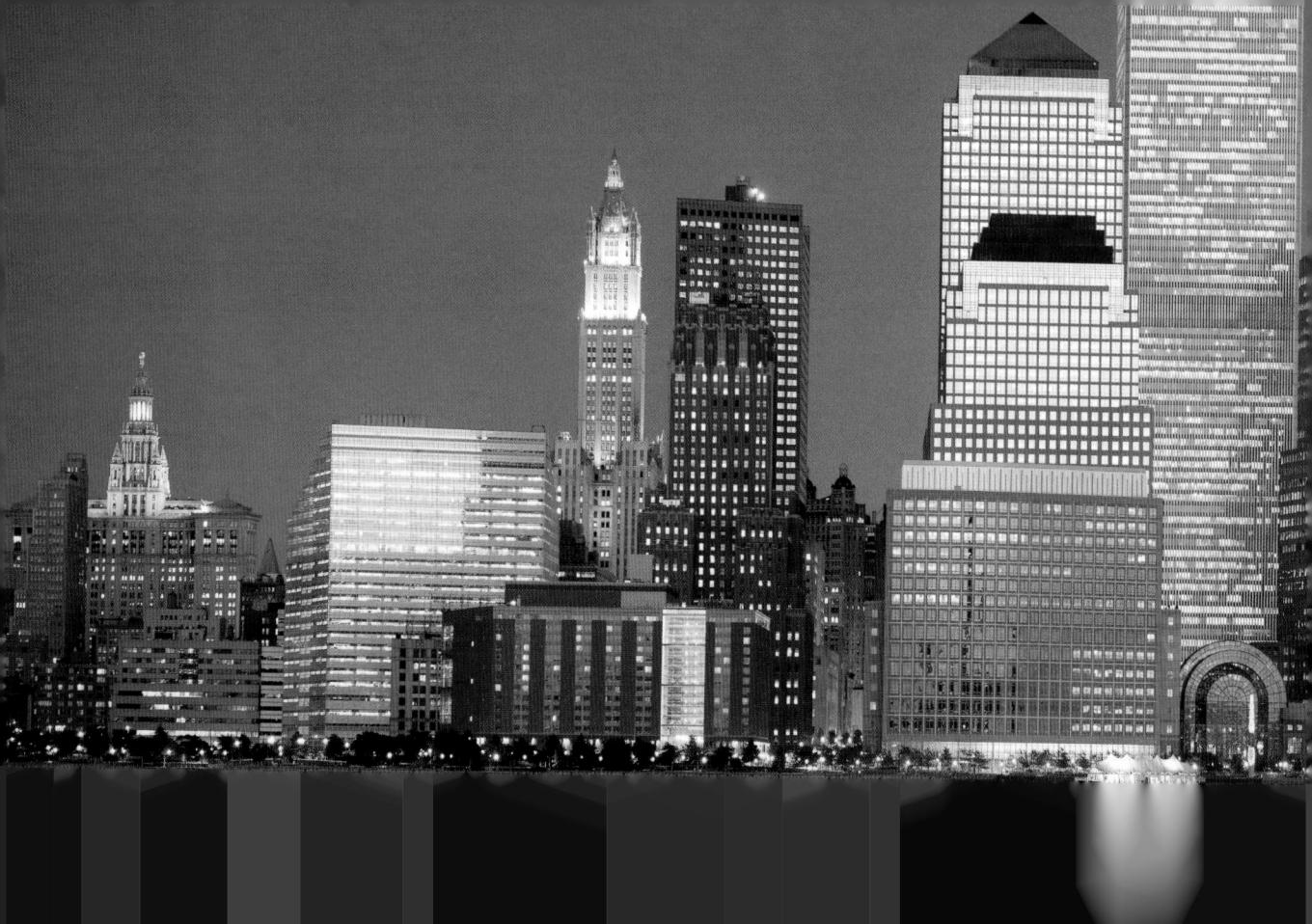
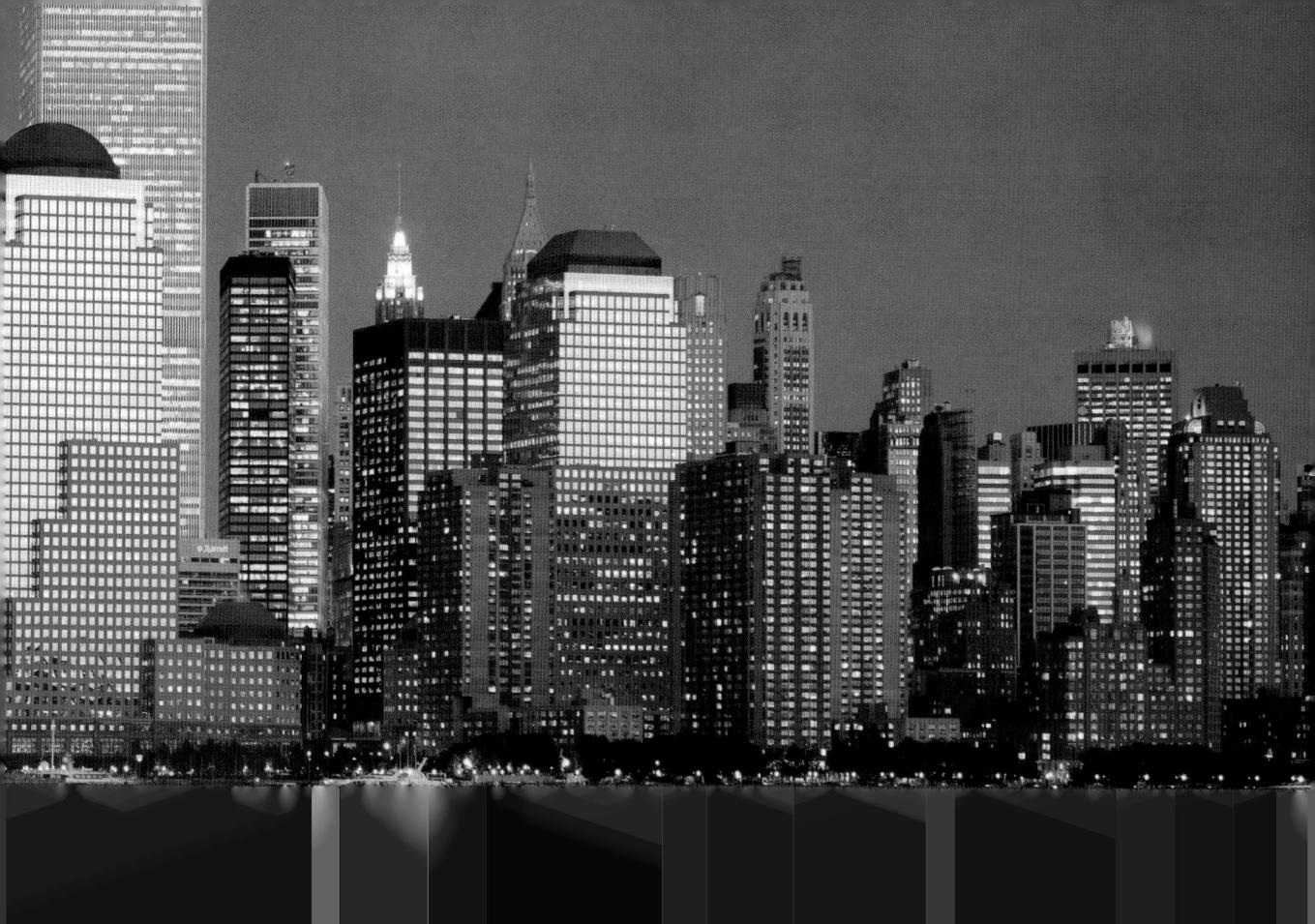

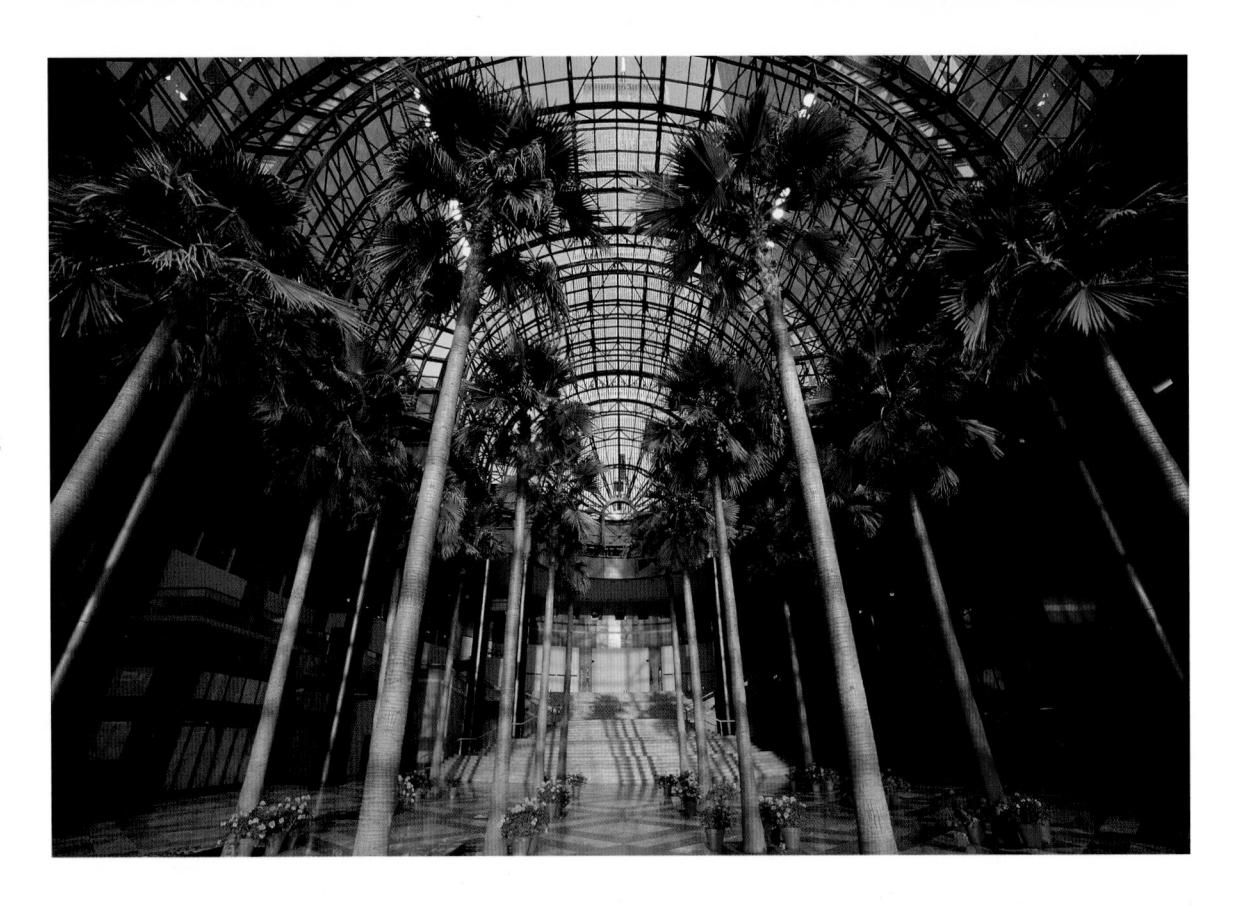

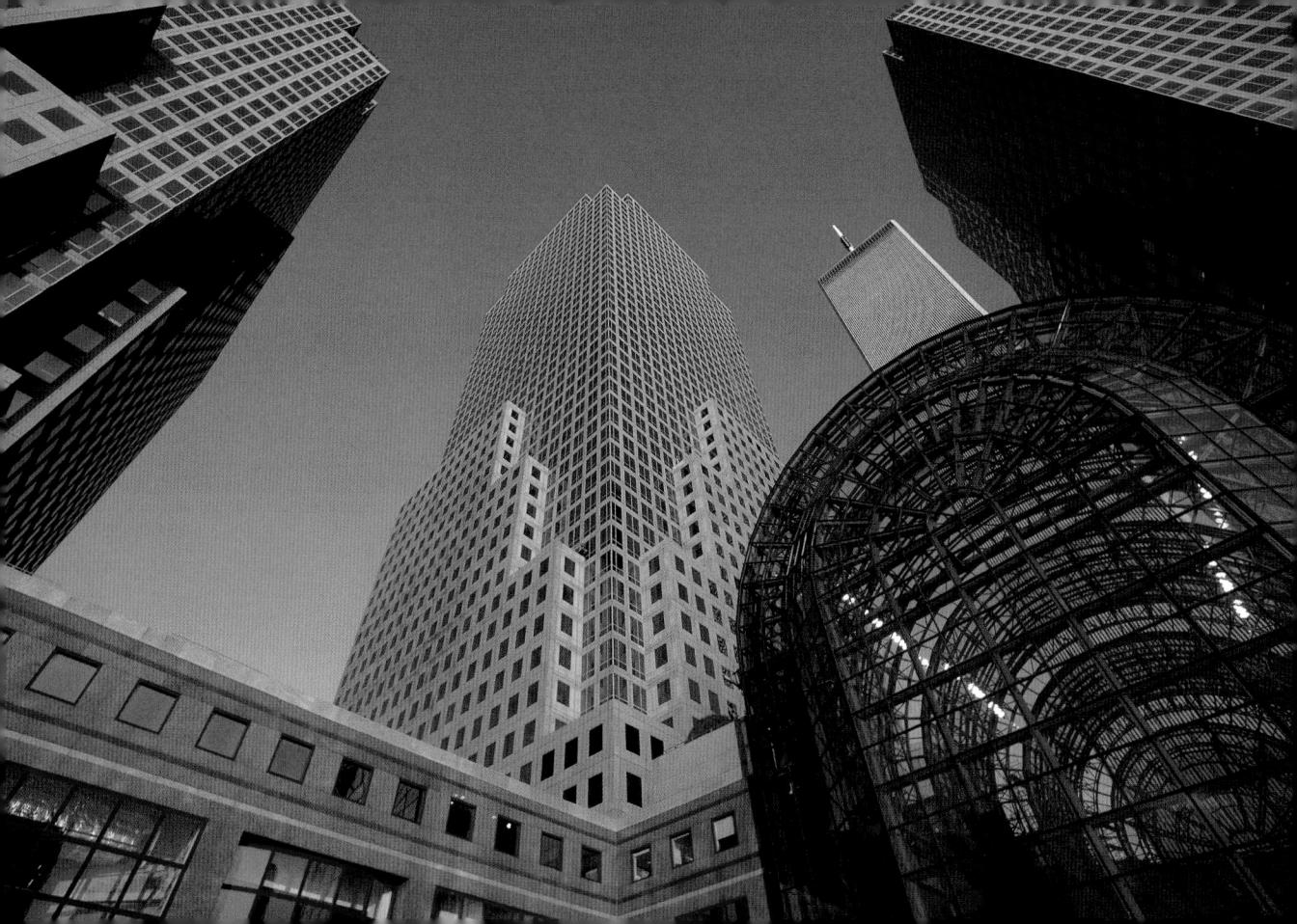

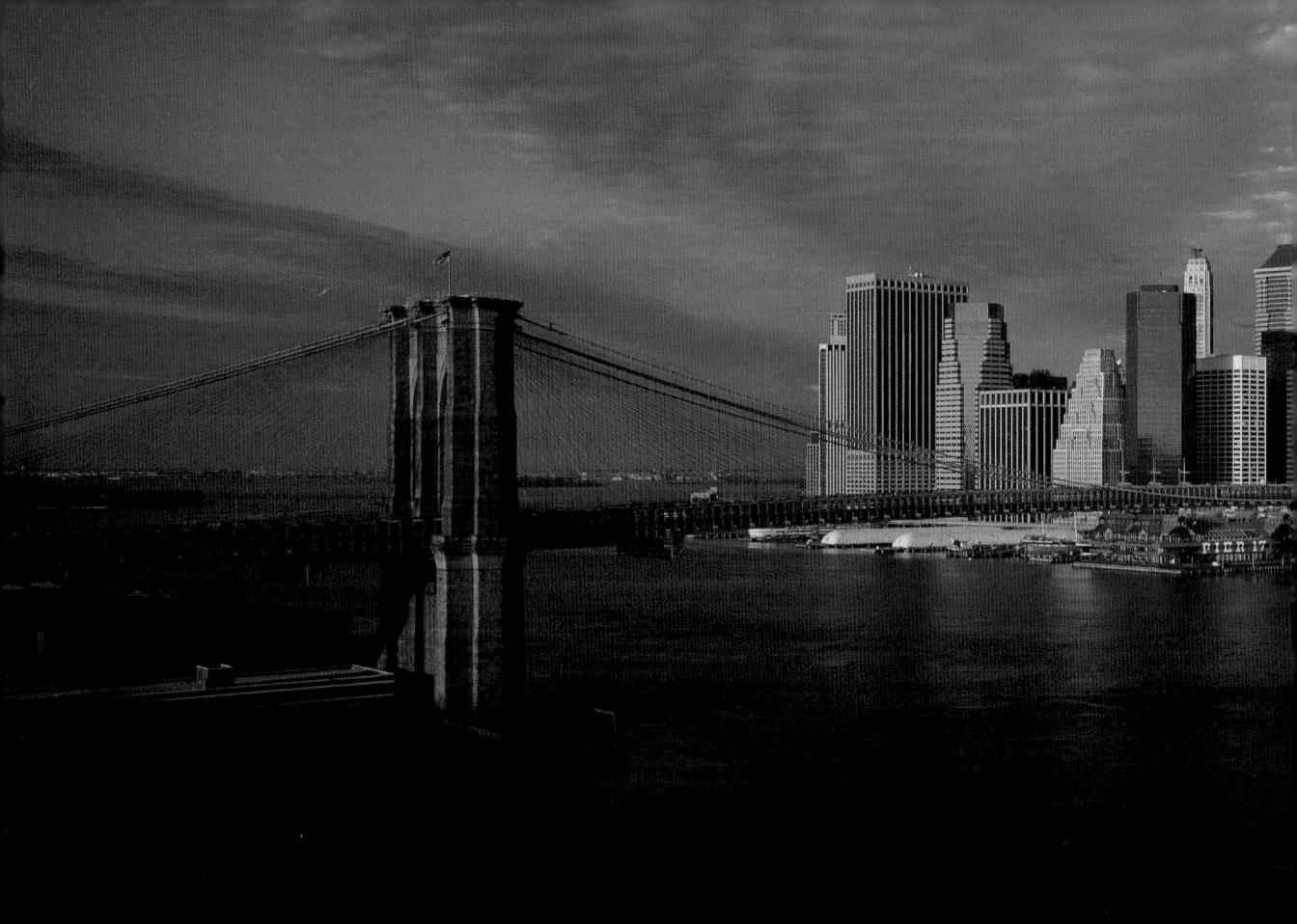

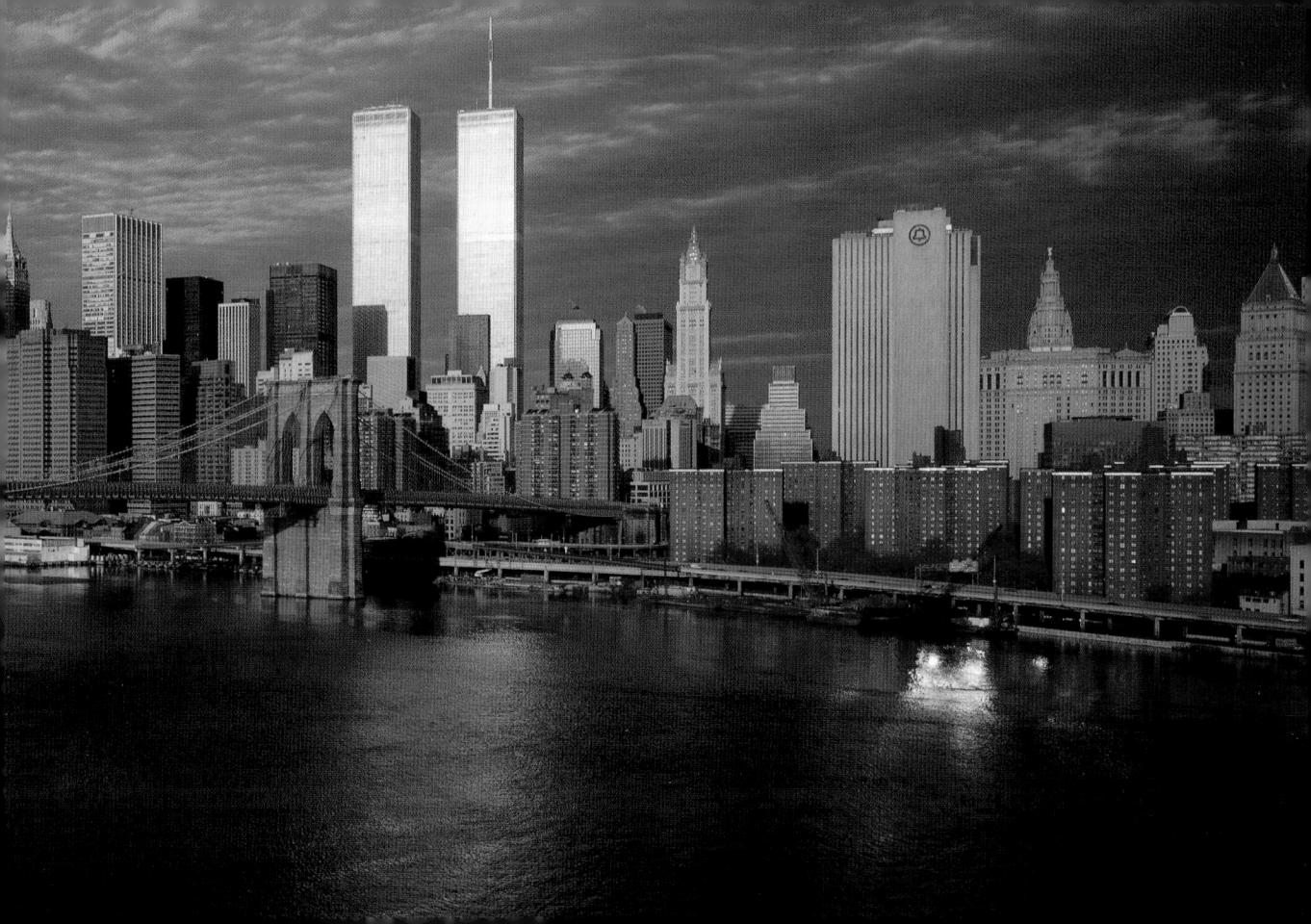

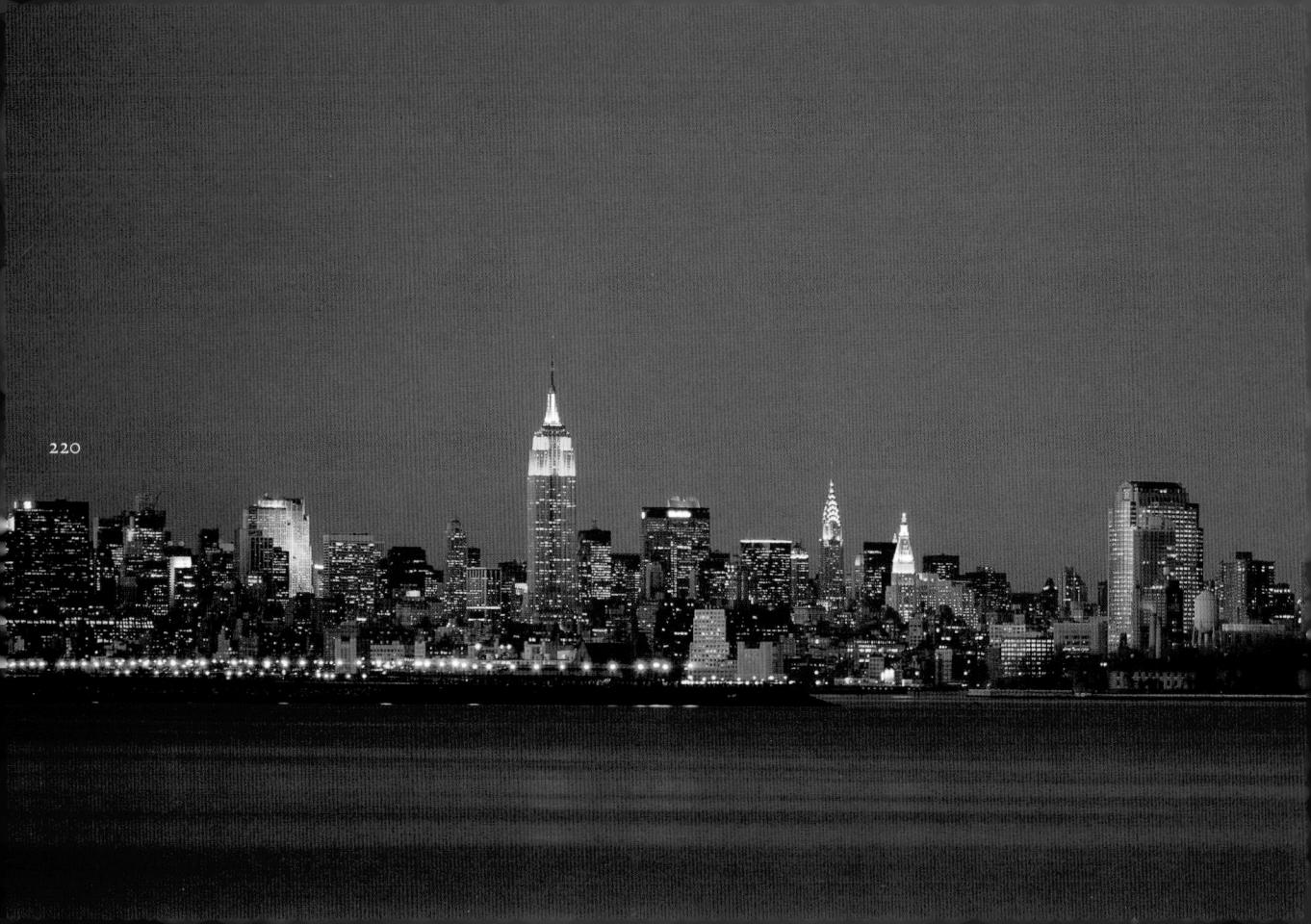

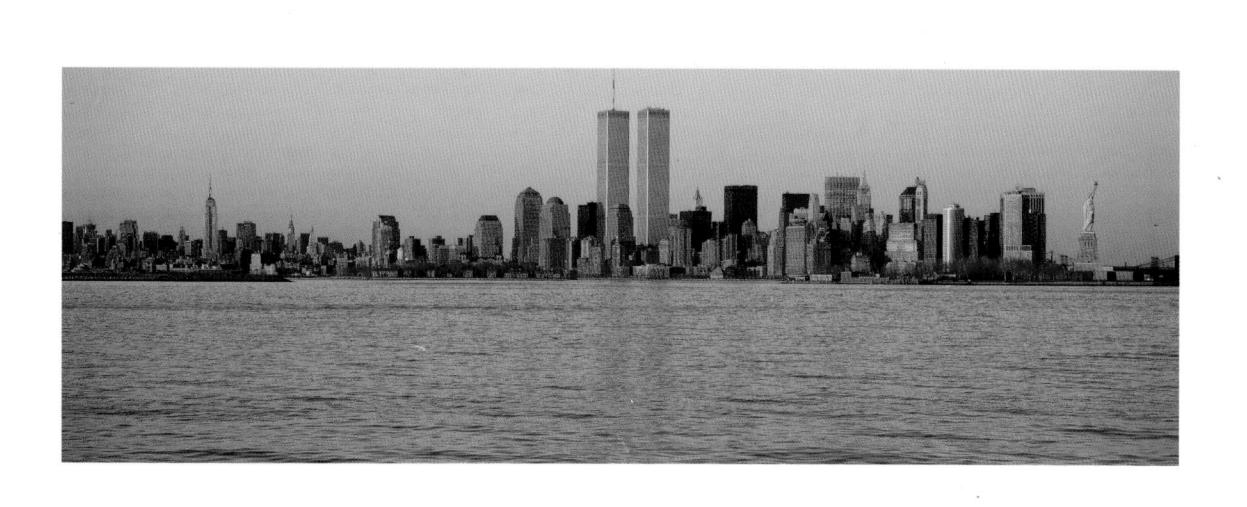

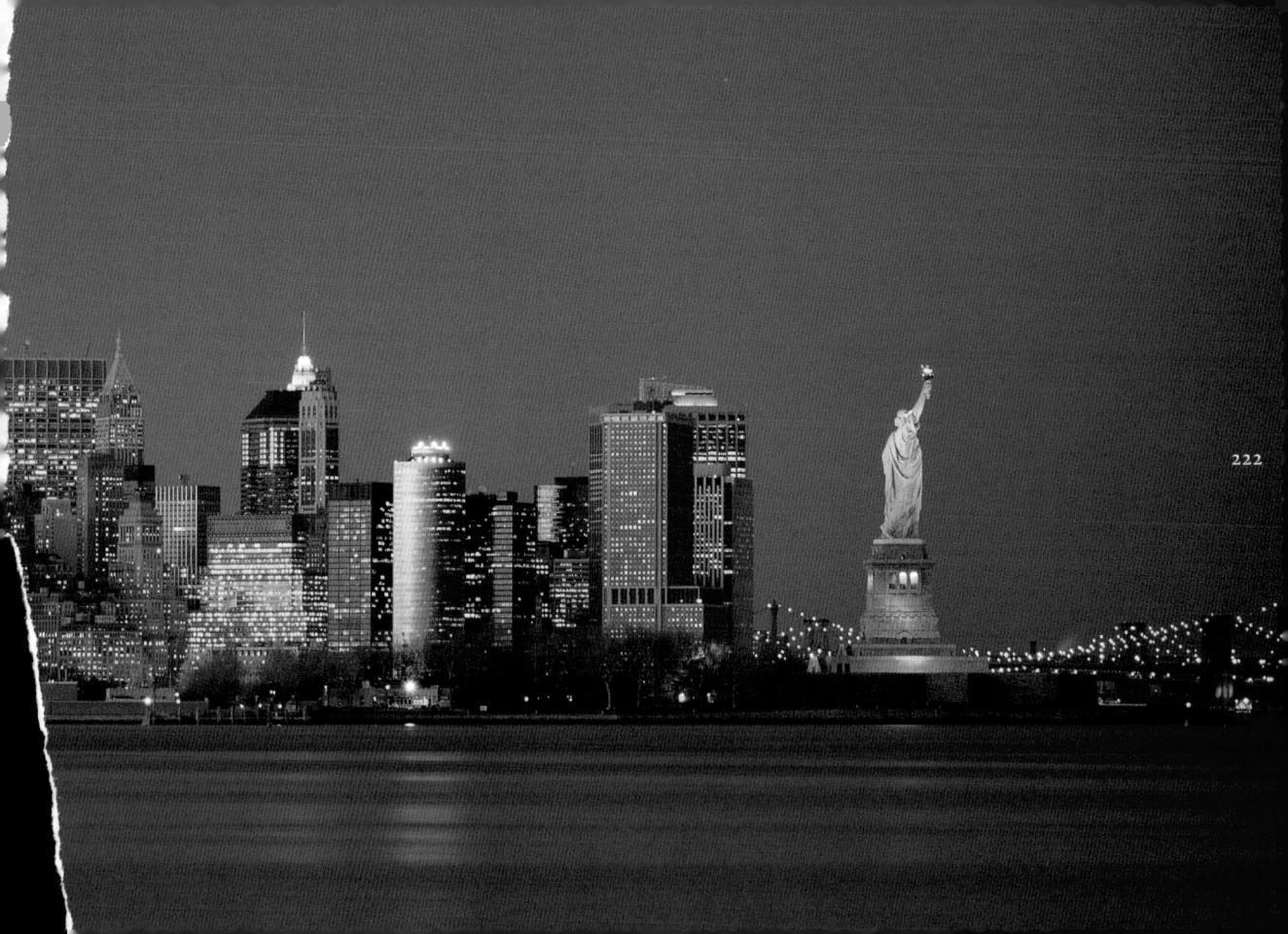

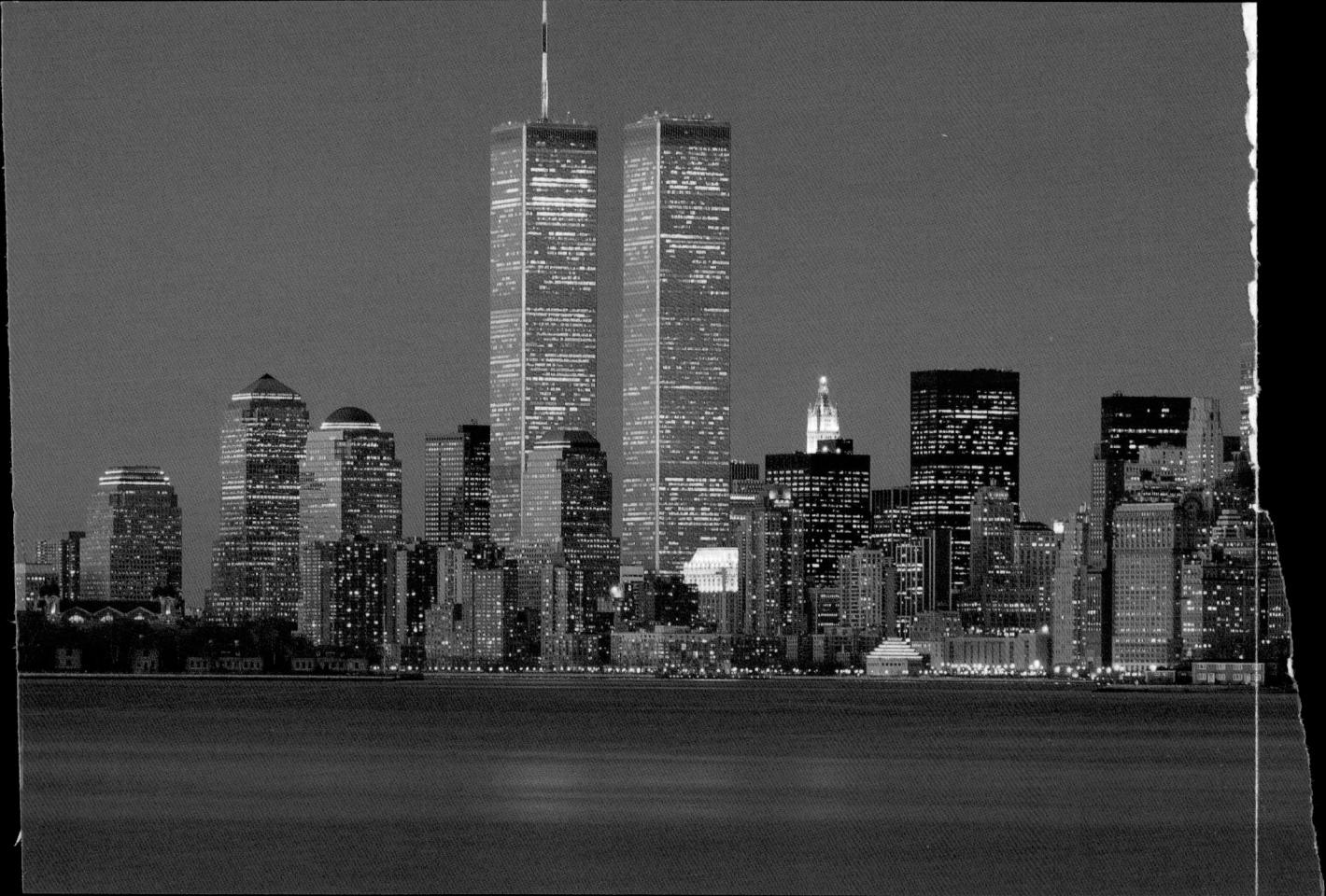

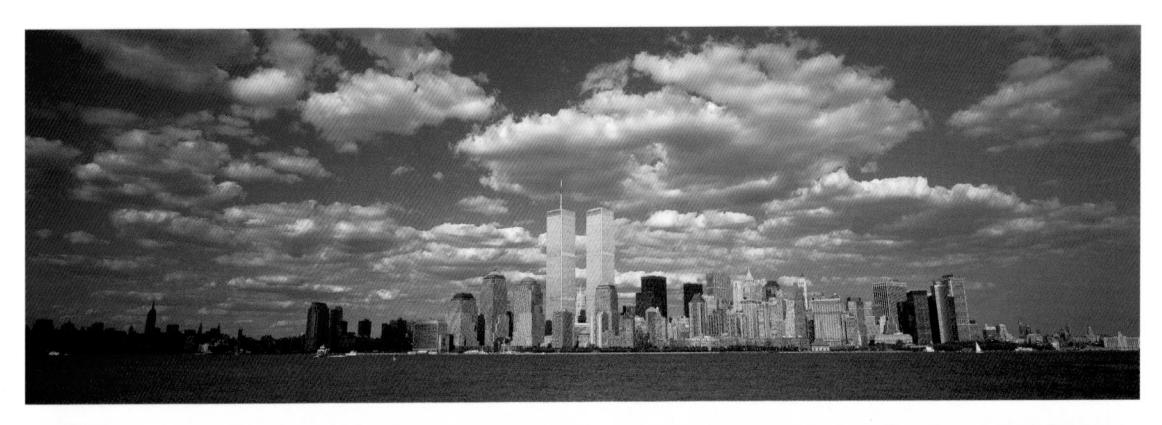

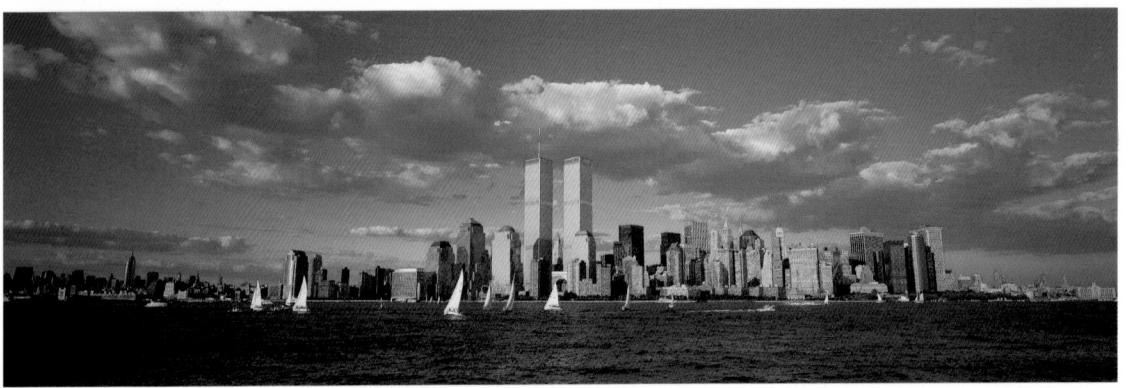

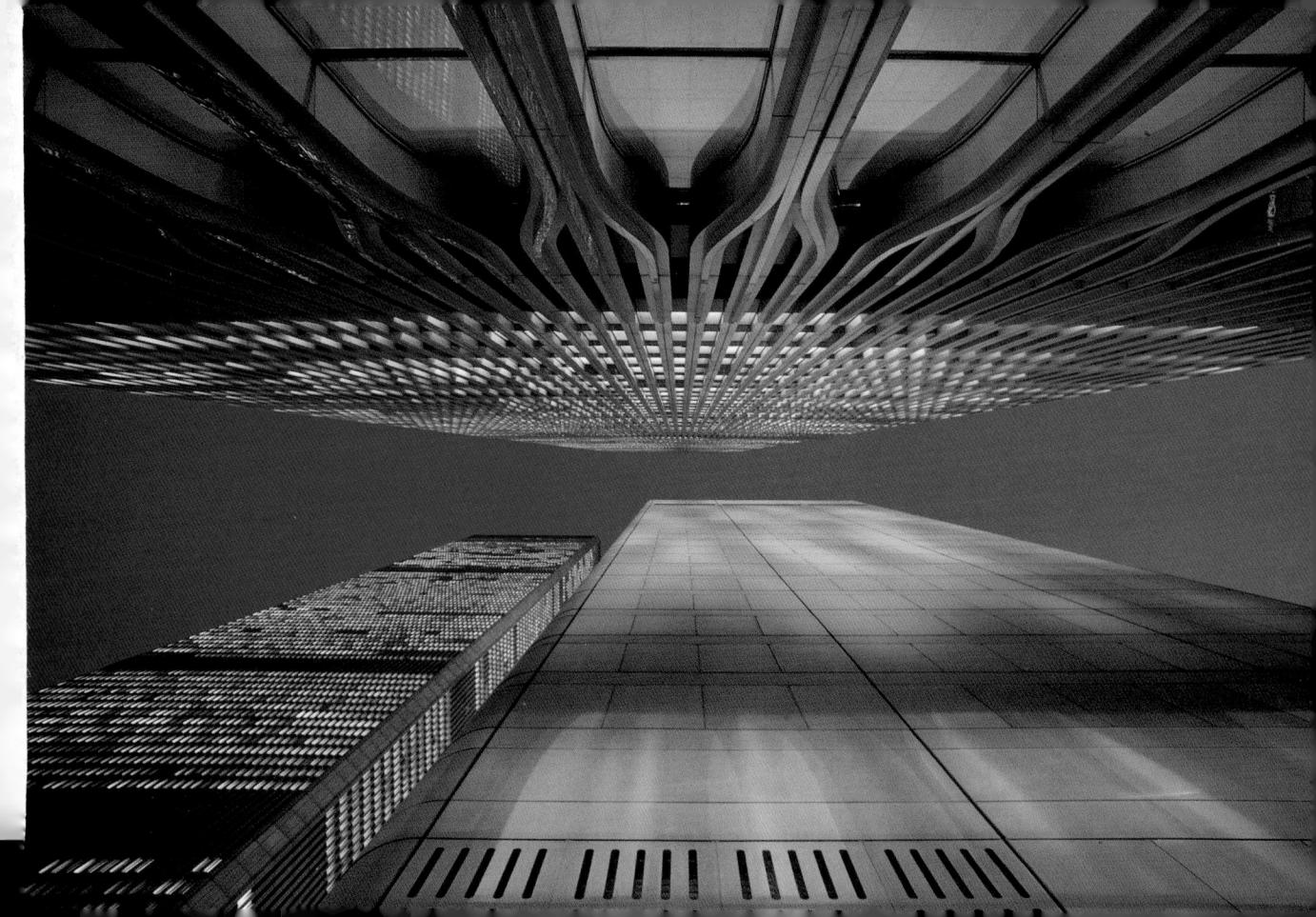

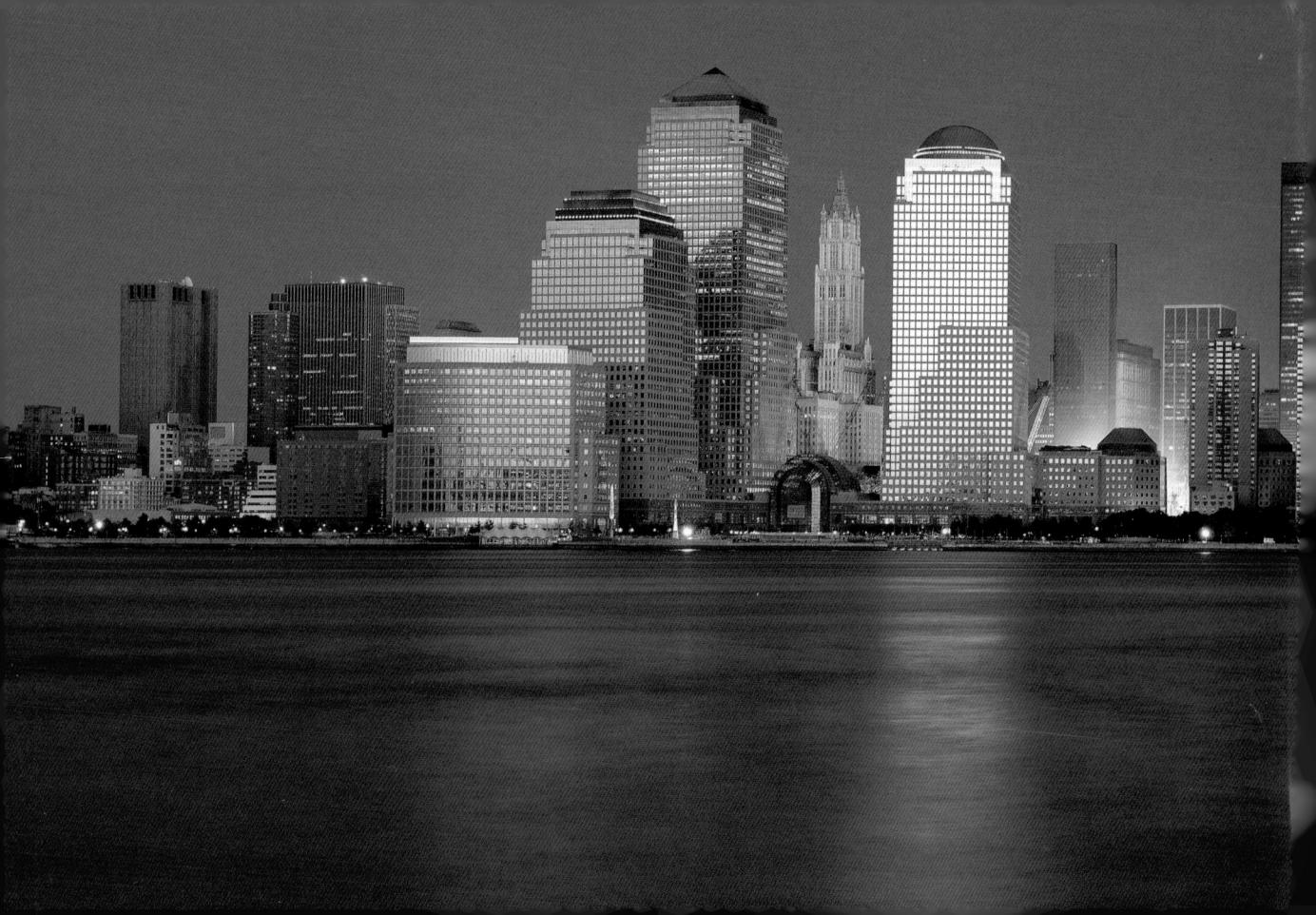

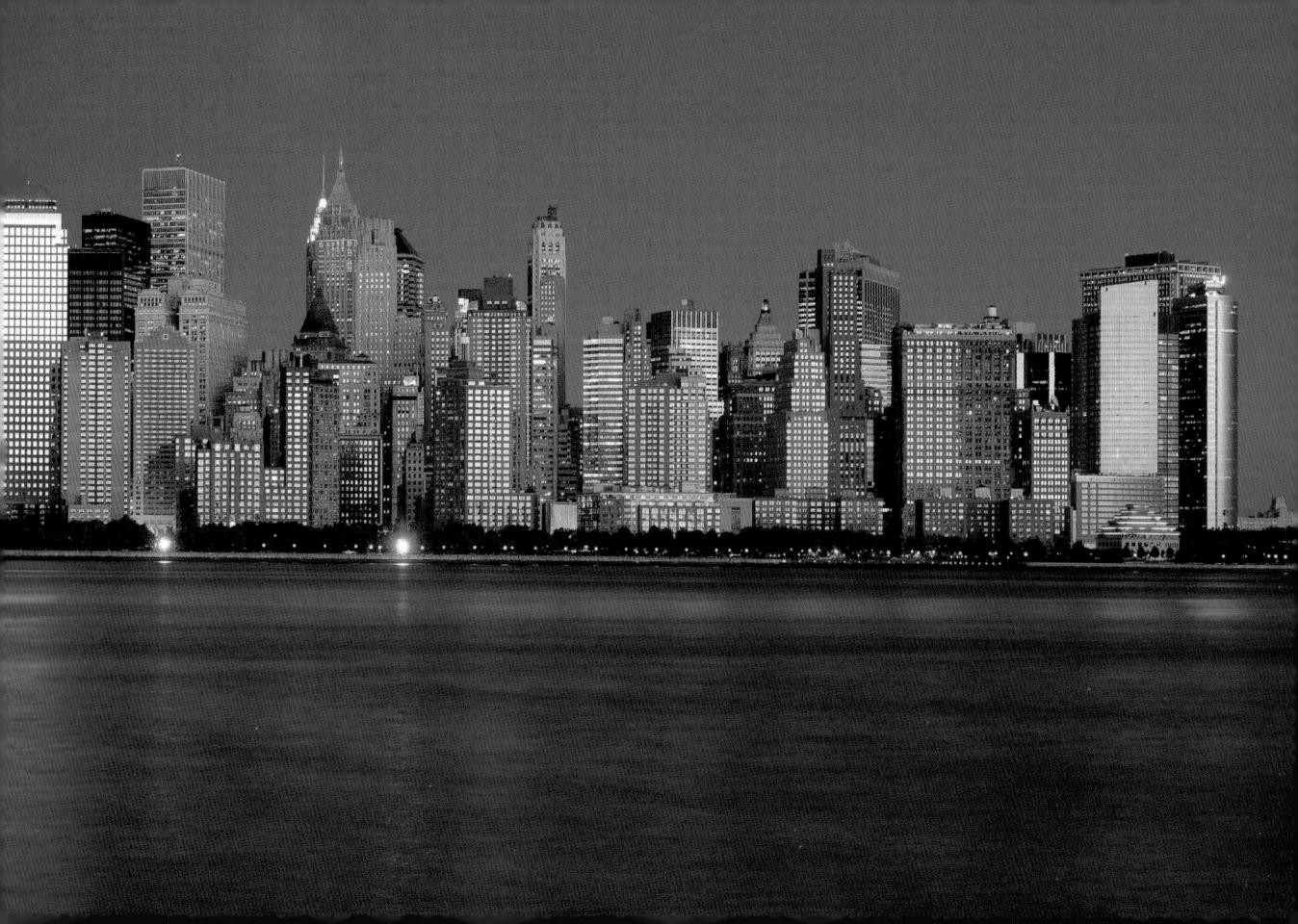

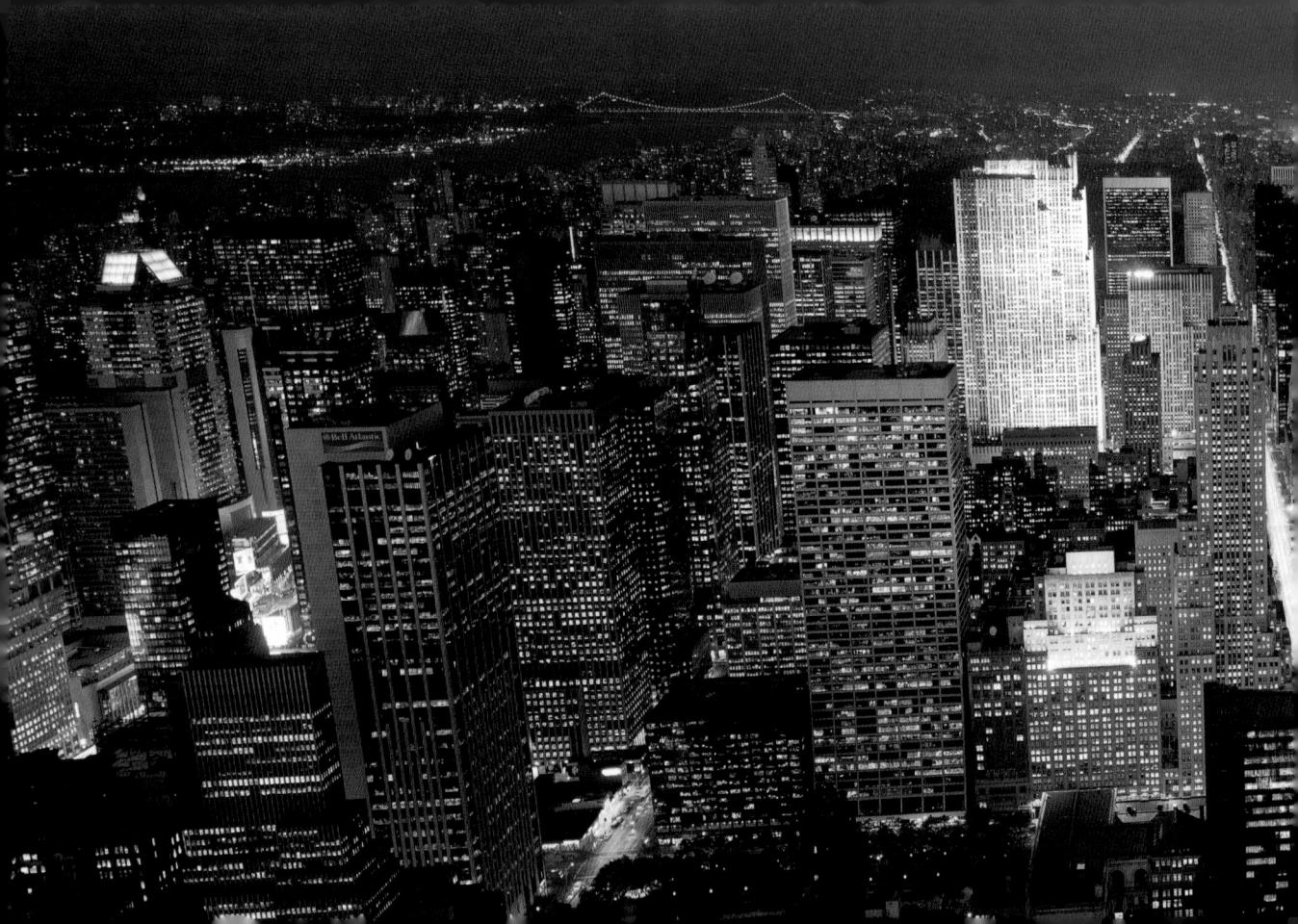

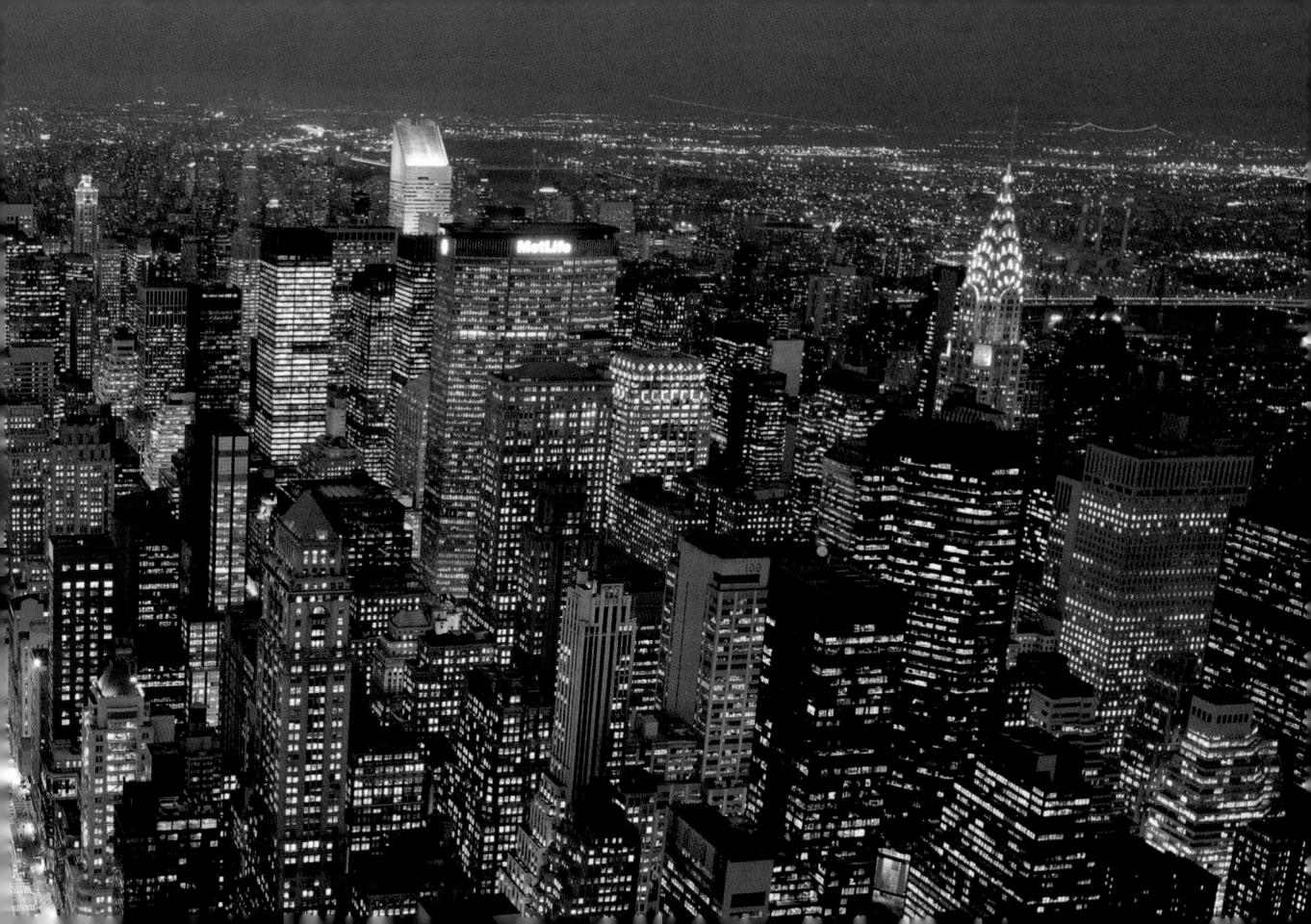

INDEX

- 1 Top of one of the Waldorf Astoria's twin towers at night (Schultze and Weaver, 1931).
- 2-3 View of Manhattan from the observation deck of the World Trade Center in the late afternoon.
- 6-7 View of Manhattan from the observation deck of the World Trade Center at dusk.
- 8-9 Statue of Puck, sculpted by Casper Buberl, on the Puck Building (Albert Wagner, 1893), SoHo.
- 11-14 Midtown Manhattan skyline from Weehawken, New Jersey, at dusk.
- 18–19 View of Lower Manhattan from Jersey City, New Jersey, at dawn.

- 20-21 Exterior and interior of the National Museum of Immigration on Ellis Island (Boring & Tilton, 1900).
- 22–23 Details of the Statue of Liberty (Frédéric Bartholdi, 1886).
- 24, 27 Details of the Statue of Liberty.
- 25-26 Statue of Liberty from Liberty Island at dusk.
- 28–29 Midtown Manhattan skyline from Weehawken, New Jersey at 7:50 p.m. and 8:35 p.m.
- 30-31 Midtown Manhattan at dusk. The Empire State Building at night and uring the day (Shreve, Lamb and Harmon, 1931).

- 32-33 Chrysler Building (William Van Alen, 1930). Left to right: building top; eagle statue by Kenneth Lynch; and daytime and dusk details.
- 34-35 Chrysler Building lobby. Page 34, left to right: ceiling mural detail (Edward Trumbull); elevator doors; and ceiling mural detail.
- 36–37 Exterior of Grand Central Terminal (Warren and Wetmore, 1913) with Hyatt Hotel and Chrysler Building in background.
- 38-39 Interior of Grand Central Terminal.
- 40-41 Ceiling details in Grand Central Terminal.
- 42-43 Clock at Grand Central Terminal (Jules Alexis Coutan, 1929). Page 43, clocks, clockwise from top left: Helmsley Building (Warren and Wetmore, 1929); building on Avenue C; building on East 4th St.; and Central Savings Bank (York & Sawyer, 1928).

- 44-45 Clocks, from left to right: Schwarzenbach Building; 52nd Police Precinct, Bronx (1906); and Tiffany's (Harry Frederick Metzler, 1853).
- 46-47 Left to right: Exterior of the 21 Club (1929); detail of Macy's (1902); and exterior of Saks Fifth Avenue (Starrett & Van Vleck, 1924).
- 48–49 Terra-cotta ornamentation on Fred F. French
 Building (Sloan & Robertson, 1927). Lee
 Lawrie's Atlas (1937), Olympic Tower
 (Skidmore, Owings & Merrill, 1976) and St.
 Patrick's Cathedral (James Renwick Jr. &
 William Rodrique, 1888).
- 50-51 Ceiling painting by José Maria Sert in 30 Rockefeller Plaza (G.E. Building). Rockefeller Center (Reinhard & Hofmeister; Corbett, Harrison & MacMurray; Raymond Hood; Godley & Fouilhoux, 1940).
- 52-53 Details from Rockefeller Center.

- 54-55 Midtown Manhattan at night.
- 56–57 Prometheus statue by Paul Manship (1934), Rockefeller Center. Promenade at Christmas, Rockefeller Center.
- 58-59 Bow Bridge, Central Park (Calvert Vaux, 1859).
- 60-61 "Angel of the Waters" at the Bethesda
 Fountain, Central Park (Emma Stebbins,
 1873). Page 61, clockwise from top left: the pond
 in Central Park; the Gapstow Bridge (Howard
 Caudwell, 1896); Central Park landscapes.
- 62–63 Allée of crab apples in the Conservatory Garden, Central Park.
- 64–65 Bow Bridge, Central Park, with Central Park West in background.
- 66-67 Friedsam Carousel carved by Solomon Stern and Harry Goldstein (1908; transferred from Coney Island to Central Park in 1951).

- 68–69 Untermeyer Fountain with Bronze by Walter Schott in the North Garden of the Conservatory Garden, Central Park (1947).
- 70–71 Reflections of Midtown Manhattan in the Central Park lake at sunrise and at dusk.
- 72–73 Central Park South at sunrise and at dusk.

 Tavern on the Green, which was originally a sheepfold (Jacob Wrey Mould, 1870).
- 74-75 Central Park in autumn.
- 76, 79 Metropolitan Museum of Art (Calvert Vaux & Jacob Wrey Mould, 1880). Left: facade.
 Right: American Wing (Roche, Dinkeloo and Assoc., 1980).
- 77–78 Metropolitan Museum of Art's Great Hall (Richard Morris Hunt, 1902).

- 80-81 Left to right: Museum of Modern Art (Philip S. Goodwin and Edward D. Stone, 1939);
 Cooper Hewitt Museum (Babb, Cook & Willard, 1903); and Frick Museum's formal garden (Russell Page, 1977).
- 82–83 The Cuxa Cloister, Fort Tyron Park (reconstructed from a 12th-century Benedictine monastery in the Pyrenees, 1925).
- 84-85 Interior and exterior of Grant's Tomb (John H. Duncan, 1897).
- 86–87 New York Public Library (Carrere and Hastings, 1911). Left: Lion Statue by E.C. Potter. Right: McGraw Rotunda.
- 88–89 Rose Planetarium, The Museum of Natural History (James Stewart Polshek, 2000).
- 90–91 Exterior and interior of the Guggenheim Museum (Frank Lloyd Wright, 1959).

- 92-93 Guggenheim Museum.
- 94-95 Building details.
- 96, 99 St. John the Divine (Heins & Lafarge, Ralph Adams Cram, 1941). Left: main entrance facade. Right: angel detail.
- 97-98 Interior of St. John the Divine.
- 100–101 Church of the Guardian Angel (John Van Pelt, 1930).
- 102–103 Left to right: Church of St. Paul & St.
 Andrew, Upper West Side; St. Patrick's
 Cathedral with Olympic Tower; and Park East
 Synagogue (Schneider & Herter, 1890).
- 104–105 Exterior of Riverside Church (Allen & Collens, Henry C. Pelton, 1930).
- 106-107 Interior of Riverside Church.

110–111 Williamsburg Savings Bank, "Cathedral of Thrift," Brooklyn (Halsey, McCormack & Helmer, 1929). The elevator lobby in the Waldorf Astoria (Schultze and Weaver, 1931).

112–113 Left to right: University Club Library
(McKim, Mead and White, 1899); The
Pierpont Morgan Library (Charles McKim,
1906); and the lobby ceiling of the Woolworth
Building (Cass Gilbert, 1913).

114–115 Radio City Music Hall (Edward Durrell Stone, 1932).

234

116–117 Women's and Men's Lounges designed by Donald Deskey, Radio City Music Hall. 118–119 Times Square, looking north between Broadway and Seventh Avenue.

120-121 Interior of Rizzoli Bookstore. Park Avenue, looking south.

122–123 Lincoln Center at dusk (Harrison & Abramovitz; Philip Johnson; Eero Saarinen; Pietro Belluschi; and others, 1969).

124-125 Airline Diner (Jackson Hole Wyoming), Astoria, Queens (1954). McSorley's Old Ale House, East Village (1854).

126, 131 View of Manhattan looking south from the Chrysler Building at dawn and at dusk.

127–130 View of Manhattan from Long Island City, Queens, at dusk.

132-133 Vesuvio Bakery, SoHo.

134-135 The Puck Building, SoHo.

- 136-137 Street facade, SoHo. Apartment building detail, East 14th Street.
- 138–139 Railing at the Players Club, Gramercy Park (Stanford White, 1889). Washington Square townhouses (1833).
- 140–141 Bayard-Condict Building on Bleecker Street (Louis Sullivan, 1899).
- 142–143 Building ornamentation, East 16th Street. Railing at the Dakota on Central Park West (Henry J. Hardenberch, 1884).
- 144-145 Left to right: brownstones, Upper West Side; Striver's Row, Harlem (James Brown Lad; Bruce Price; Clarence S. Luce; and McKim, Mead & White, 1891); and brownstones, Upper West Side.
- 146–147 The "Gargoyle Building," Upper West Side.

 Pomander Walk, Upper West Side (King & Campbell, 1922).

- 148, 151 Building details, from left to right: Upper West Side YMCA; Pythian Temple (Thomas W. Lamb, 1927); and Pythian Temple.
- 149–150 Original Audubon Theater and Ballroom (Thomas W. Lamb, 1912).
- 152–153 Building details. Page 152, clockwise from top left: Lafayette Street; West End Avenue; Columbus Avenue; and 8th Avenue. Page 153, Park Avenue.
- 154–155 View of Midtown Manhattan skyline from Brooklyn Heights at sunset and at dusk.
- 156–157 Subway stations. Left: original City Hall station (1904). Right: Borough Hall station (1933).
- 158–159 The Japanese Garden at the Brooklyn Botanic Garden (Takeo Shiota, 1915).

- 160–161 Page 160, Japanese Garden footbridge and walking path. Page 161, Soldiers' and Sailors' Memorial Arch at the Grand Army Plaza (John H. Duncan, 1892) and the Bailey Fountain at the Grand Army Plaza (Eugene Savage, 1932).
- 162–163 The Cyclone rollercoaster at Surf Avenue, Coney Island (1927).
- 164–165 Yankee Stadium, Bronx (Osborn Engineering, 1923).
- 166–167 Enid Annenberg Haupt Conservatory at the New York Botanical Garden, Bronx (William R. Cobb, 1902).
- 168, 171 Exterior and interior of the Jacob K. Javitz Convention Center (I. M. Pei and Partners, 1986).
- 169-170 Jacob K. Javitz Convention Center.

- 172–173 Building reflections. Left to right: the Fuller Building; a World Trade Center Tower in the windows of the World Financial Center; Lower Manhattan.
- 174–175 Building reflections. Page 174, clockwise from top left: Park Avenue; Lower Manhattan;
 Midtown; and Midtown. Page 175, reflection of the "Lipstick Building" in Midtown.
- 176-177 Avenue of the Americas, Midtown.
- 178–179 Looking up from Broadway in Lower
 Manhattan. Page 179, clockwise from top left:
 Avenue of the Americas; Avenue of the
 Americas; Third Avenue in Midtown; and East
 53rd Street.
- 180–181 Towers of 15 Park Row (R.H. Robertson,
 1899) with the Transportation Building (York
 & Sawyer, 1927) and Woolworth Building.

- 182–183 Building tops. Left to right: Original G.E.
 Building (Cross and Cross, 1931); New York
 Life Insurance Building (Cass Gilbert, 1928);
 Fuller Building (Walker and Gillette, 1929);
 and the Police Building (Hoppin and Koen,
 1909).
- 184-185 Building tops. Left to right: The Bryant Park
 Hotel, original American Radiator Building
 (Hood and Fouilhoux, 1924); Ansonia Hotel
 (Paul E.M. Duboy, 1904); Flatiron Building,
 original Fuller Building (Daniel H. Burnham
 and Co., 1902); and Citicorp Center (Hugh
 Stubbins and Assoc., 1978).
- 186–187 Building tops. Left to right: Crown Building
 (Warren and Wetmore, 1921); Met Life Tower
 (LeBrun and Sons, 1909); original Paramount
 Theater Building (Rapp and Rapp, 1927); and
 the Woolworth Building (Cass Gilbert, 1913).
- 188–189 The Brooklyn Bridge (1883).

- 190, 195 Page 190, Queensboro "59th Street" Bridge (1909) from Long Island City; the Manhattan Bridge (1909). Page 195, Williamsburg Bridge (1903) from Williamsburg, Brooklyn; Brooklyn Bridge (1883) from Manhattan.
- 191–194 The Whitestone Bridge (1939) from the Bronx at dusk.
- 196-197 The Manhattan Bridge.
- 198–199 George Washington Bridge (1931) from the Palisades, New Jersey.
- 200–201 Left to right: The George Washington Bridge from Manhattan; the Manhattan Bridge from Brooklyn Heights; and the Verrazano Narrows Bridge from Staten Island (1964).
- 202–203 The Brooklyn Bridge from Brooklyn Heights.
- 204–205 Broad Street in Lower Manhattan. South Street Seaport (1984).

- 206–207 Art deco lobby of the Bank of New York on Wall Street, which was the original Irving Trust Co. (Ralph Walker, 1932). New York Stock Exchange at Broad Street, (George B. Post, 1903).
- 208–209 Left to right: 90 West Street (Cass Gilbert, 1907); St. Paul's Chapel (1766); and Trinity Church (Richard Upjohn, 1846).
- 210–211 Left to right: Building door, Financial District;
 Art deco lamp in front of the Department of
 Health Building (Charles B. Meyers, 1955);
 and detail from the original International
 Telephone and Telegraph Building on Broad
 Street (Louis S. Weeks, 1930).
- 212–213 Lower Manhattan skyline from Jersey City, New Jersey, at sunset.
- 214–215 Lower Manhattan skyline from Jersey City, New Jersey, at dusk.

- 216–217 Wintergarden at the World Financial Center (Cesar Pelli, 1988). Exterior of the World Financial Center.
- 218–219 View of the Brooklyn Bridge with Lower Manhattan from the Manhattan Bridge at sunrise.
 - 223 Manhattan skyline from New Jersey at sunset.
- 220–222 Manhattan skyline from New Jersey at dusk.
- 224–225 Lower Manhattan skyline from Liberty State
 Park, New Jersey, in the late afternoon and at
 sunset. Looking up at the World Trade Center
 Towers (Minoru Yamasaki, 1972) and the Vista
 Hotel (Skidmore, Owings & Merrill, 1901).
- 226–227 Lower Manhattan skyline and "Ground Zero" from Jersey City at dusk, October 8, 2001.
- 228–229 Midtown Manhattan skyline from the Empire State Building at dusk.
 - 239 The Statue of Liberty at dusk.

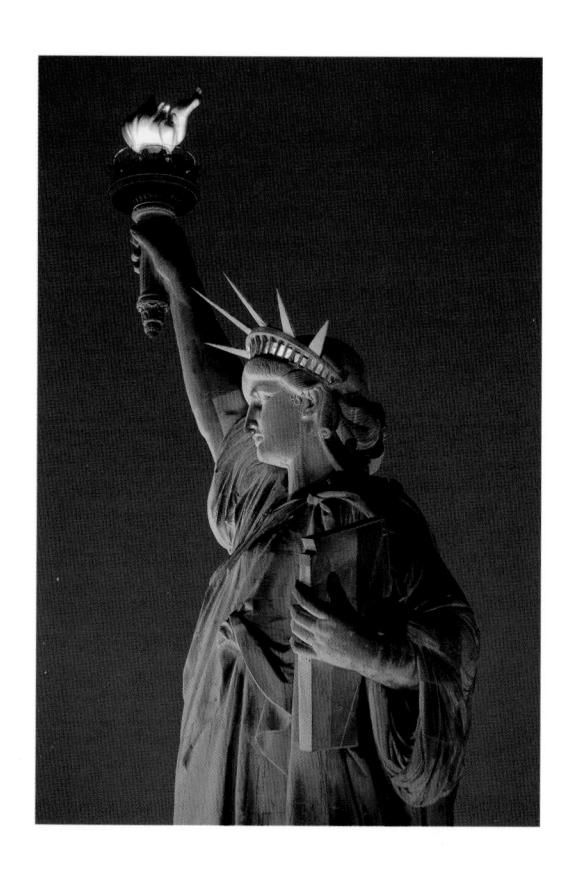

First published in the United States of America in 2003 by Rizzoli International Publications, Inc. 300 Park Avenue South, New York, NY 10010 www.rizzoliusa.com

© 2003 Rizzoli International Publications, Inc. Photographs copyright © 2003 Richard Berenholtz

www.photographynewyork.com

All rights reserved. No part of this publication may be reproduced, stored in a retrieval system, or transmitted in any form or by any means, electronic, mechanical, photocopying, recording, or otherwise, without prior consent of the publishers.

Rizzoli Editor: JESSICA FULLER

Produced by Welcome Enterprises, Inc. 6 West 18th Street, New York, NY 10011

Project Director: KATRINA FRIED Designer: GREGORY WAKABAYASHI Assistant Designer: NAOMI IRIE

ISBN-13: 978-0-8478-2576-9 ISBN-10: 0-8478-2576-0 Library of Congress Catalog Control Number: 2003104979 2006 2007 / 10 9 8 7 6 5

To puchase original prints by Mr. Berenholtz, please contact Welcome Enterprises at 212.989.3200

Printed and bound in China

ACKNOWLEDGMENTS

A special thank-you to my family and friends for their encouragement and support: Jim Berenholtz, Nanette Cohen, Gerald Kantor, Mickey and Lindsey Spatz, John Steffy, Catherine Noren, and Christine Cody.

I also wish to express my gratitude and appreciation
to my friends at Rizzoli and Welcome Enterprises:
Charles Miers and John Brancati, who shared the vision and said, "Yes!";
Lena Tabori, without whom this book could never have been done;
Katrina Fried, for her tireless efforts; and Gregory Wakabayashi, the best designer
I've had the privilege of working with.

R.B.